# The Ritual
## of
## Interpretation

*The Fine Arts As Literature in Ruskin, Rossetti, and Pater*

# The Ritual
## of
# Interpretation

*The Fine Arts As Literature in Ruskin, Rossetti, and Pater*

Richard L. Stein

*Harvard University Press*   *Cambridge, Massachusetts*
*and London, England*   *1975*

For all the Steins:
Carole,
Rebecca, Sarah,
Lorayne, and Jay

# *Preface*

All references to the works of Ruskin, Rossetti, and Pater are included in parentheses in the text. Ruskin is quoted from the Library Edition of his *Works*, edited by E. T. Cook and Alexander Wedderburn, 39 vols. (London, George Allen, 1903–1912). For the poems in Rossetti's *The House of Life*, I rely on the edition by Paull F. Baum (Cambridge, Harvard University Press, 1928); all other works by Rossetti are taken from William Michael Rossetti's edition of the *Collected Works*, 2 vols. (London, Ellis and Elvey, 1886). Quotations from Pater are based on the Library Edition of his *Works*, 10 vols. (London, Macmillan, 1910).

This book involves many personal and intellectual debts. I am grateful to Peter Serenyi, who first introduced me to the Pre-Raphaelites. My study of Ruskin began under the guidance of Herbert Sussman, whose writings and suggestions have always proved stimulating. From Frederick Crews I received wise editorial advice during the preparation of an earlier essay on Pater. L. D. Ettlinger shared his broad knowledge of literature and the fine arts during the preparation of my dissertation, an embryo version of the book. Portions of Chapter 3 were read to the Harvard Victorians, who made valuable observations. Brooke Hopkins read and commented helpfully on parts of the manuscript.

Maynard Mack, Jr., read it in its entirety and annotated copiously; to his generous labor are due many felicities and the absence of numerous flaws. Thomas Flanagan and Masao Miyoshi comprised the main audience for the first versions of the book, and have continued to supply insight and encouragement; to them I owe special thanks for advice, criticism, and above all, patience. Thanks are also due to Virginia LaPlante of the Harvard University Press for her penetrating and judicious editorial advice.

I should also like to express my gratitude for generous financial support during various stages of the research: to Amherst College and the University of California for assistance during my initial studies; to Harvard University and the Canaday Foundation for summer grants during the process of revision; and to the American Council of Learned Societies, whose fellowships for research in new disciplines are models of contemporary intellectual patronage, for the opportunity to gain a final perspective on my work from studies in the history of art.

Portions of Chapters 4 and 5 appeared in my article "Dante Gabriel Rossetti: Painting and the Problem of Poetic Form," *Studies in English Literature* 10, no. 4 (Autumn 1970), 775–792, and are reprinted here by permission of the editors. A very different analysis of Pater's *Renaissance* was contained in an essay I contributed to *Psychoanalysis and Literary Process* (Cambridge, 1970), edited by Frederick Crews; Winthrop Publishers have extended permission for any echoes of that discussion.

# Contents

# Illustrations

# The Ritual
## of
## Interpretation

*The Fine Arts As Literature in Ruskin, Rossetti, and Pater*

# I

## Introduction

By the last decade of the nineteenth century it was becoming apparent that the literary response to painting, architecture, sculpture, and music constituted a significant chapter in the intellectual history of the age. In 1889 Oscar Wilde referred confidently to the young tradition as an independent genre, "what has been called the art-literature of the nineteenth century."[1] Shortly before, Walter Pater had identified the assimilation into English of "the phraseology of pictorial art" as a source of the continuing vitality of the language—a source he mentioned alongside Wordsworth's creation of a new poetic diction, the impact on English of German metaphysics, or the contemporary influence of physical science.[2] Wilde and Pater were particularly qualified to comment on the importance of this literature. Largely through their examples in the late eighties and early nineties, a new aesthetic movement grew out of the Victorian literature of art. And from this movement would emerge, in turn, the work of the young Yeats and the beginnings of what we now consider the modernist movement in English writing.

The Victorian literature of art, evolving between the greater revolutions of the Romantic periods and the early twentieth century, embodies a transitional phase in nineteenth century

writing and, indeed, in nineteenth century thought as a whole. It is related to broad shifts in taste and belief, to the emergence of new classes of artists and art consumers, to new theories and practices within all of the fine arts, and to new theories and practices of literature. But the transitional quality of the genre is not simply a matter of its literary innovations: the signs of a new beginning are balanced by traces of decline. It may be that every new mode expresses simultaneously conservative and revolutionary impulses; language, as Pater observes in the essay "Style," must "expand at once and purify its very elements."[3] The Victorian literature of art entails, as Pater recognizes, a search for new sources of literary vitality; in this sense it renews the innovative strengths of the Romantic tradition. But at the same time, the very tendency to refocus art upon itself removes literature a step further from an external world and advances it one step closer to decadence. The demands of the genre themselves imply a tension between an attenuated form of Romanticism and a new classicism, if we accept Pater's distinction between these types of art according to the predominance either of subject or of form. It is, in fact, the discovery of a new subject or focus for literature which produces the formal refinements associated with the late practitioners of the genre. If Ruskin, Rossetti, and Pater deserve to be included in that elect company which Yeats terms "the last Romantics," they are no less deserving of mention among the sources of the classicist tendency in the modern movement, as exemplified by Pound and Joyce and even Yeats himself.[4]

In this book I examine the Victorian literature of art in terms of the three chief practitioners of the genre—John Ruskin, Dante Gabriel Rossetti, and Walter Pater. In their work it is possible to find answers to the fundamental questions raised by the very existence of so much nineteenth century writing on the fine arts: Does the literary response to painting, architecture, sculpture, and music take characteristic forms? In what ways does the subject of the fine arts itself open new literary possibilities? What new assumptions about the nature and purpose of poetry and prose develop with the literary treatment of other arts? The answers to such questions are suggestive not only for an understanding of Victorian aesthetics but for an assessment of the place of aesthetics in the intellectual development of the age.

The uniqueness of this Victorian genre—and of the work of

Ruskin, Rossetti, and Pater specifically—is best viewed at first against the background of previous literary treatments of the fine arts. For the use of the fine arts as a literary theme began well before the mid-nineteenth century and, indeed, well before the writing of such conspicuous Romantic precursors of the genre as Blake, Wordsworth, Keats, Hazlitt, and Lamb, all of whom touch upon other arts at some point in their writing. Jean Hagstrum has traced from classical Greece to the eighteenth century the history of "iconic" poetry and prose, writing based on the description of specific works of art. He identifies two branches of a "continuous tradition" of "literary pictorialism," both of which appear in the work of the three figures considered in this book. One branch of the iconic tradition is descriptive and naturalistic in emphasis; the other is evocative and psychological. Hagstrum explains that the former, "the roots of which lay in the naturalism of antiquity and the Renaissance, may be exemplified by the rhetorical and critical notion of *enargia*, or lifelike vividness. The other, primarily characteristic of the medieval centuries and of the baroque seventeenth century, tended to remove the pictorial from the external and natural and associate it with the internal and supernatural."[5]

Before the writing of Ruskin, Rossetti, and Pater, these two tendencies of the iconic tradition remained fairly distinct and detached from one another. In the eighteenth century, for example, despite a growing interest in psychology and evocative literary effects, most references to the arts emphasized fidelity to nature; and in the writing on the fine arts of such Romantic authors as Hazlitt or Lamb, the second, internal branch of the tradition emerged dominant. Similarly, the art that seemed most closely allied to literature for the eighteenth century was painting, with its potential for realism, allegory and didactic expression; while for the Romantics, literature seemed most akin to music, the quintessentially evocative medium.

Ruskin initiates the Victorian literature of art with one foot in each camp, for *Modern Painters* demonstrates Turner's fidelity to nature while also dramatizing the emotive power of his pictures through the use of richly evocative prose. Still, in another important sense Ruskin steps beyond the iconic tradition entirely by expanding his consideration of painting into a full volume, one not confined to either descriptive or evocative passages or, for that matter, to specific references to individual works of art. When single works are under consideration by

Ruskin, or by Rossetti or Pater, description and evocation never can be fully separated; the two tendencies of literary pictorialism fuse in a simultaneous emphasis on the capacity of art to represent something external and to stimulate a vivid psychic response. Indeed, specific works often fade into the background as the contemplation of art becomes a premise for new, varied forms of discourse. A literature of art almost necessarily evolves toward the most complex modes of poetry or prose; it is, after all, a mixed medium, responsible in different ways to the demands of several art-forms, viewing the world outside art from what is in effect a double aesthetic perspective. The complexity of the literary form thus heightens our sense of the multiplicity of reality; it is no accident that the development of a literature of art parallels the growth of relativism, both within and beyond the sphere of aesthetics.

By the Victorian period, it is not simply that the rational eighteenth-century world view has been shaken: there has been a shift, even from the time of the Romantics, in the writer's understanding of his own role. For the neoclassic aesthetic of the eighteenth century, the arts sought general truths and found their "sisterhood" in holding a mirror up to nature. This view changed in Romantic art, where the mirror also reflected the private consciousness of the artist himself. The Victorian literature of art retains something of both positions, for the writer now mediates between an external object, an acknowledged personal perspective on it, and a felt need to create a new public context of values in which a post-Romantic artist can rediscover the sort of broad audience that was available to the eighteenth century writer. That inescapable presence of an audience is the essential ingredient in the proliferation of writing about nonliterary arts. The reference to a second art gives a new and important role to the reader-spectator, who shares the writer's contemplation of an external artifact. The mirror of art thus retains its Romantic psychological focus, while regaining something of the popular reference of the eighteenth century. Indeed, the concept of mirror itself takes on a new didactic import, for art becomes a medium of aesthetic instruction in a world where broad standards of taste and value no longer exist. Hagstrum points out that already in Johnson's *Dictionary* the word "mirror" involves a second meaning. It is not merely "A looking-glass; anything which exhibits representations of objects of reflection," but also a "pattern . . . that on which the

eyes ought to be fixed . . . an exemplar; an archetype." This second type of mirroring coexists with the first in the nineteenth-century literature of art and perhaps assumes even greater importance. The relation of the arts, that is, depends on a common relation not simply to external subjects but also to an audience. As Oscar Wilde comments in the preface to *Dorian Gray,* "It is the spectator, and not life, that art really mirrors."

The literature of art of Ruskin, Rossetti, and Pater stands apart from the iconic tradition in another, more general way: their use of the arts in literature carries them far beyond explicitly iconic treatments of specific works of art. The ranging, varied texture of *Modern Painters* typifies all three writers, who only begin with specific works or with passages in which individual artifacts are treated directly. Their writing explores the whole range of experiences associated with the apprehension of art, the wide variety of facts, ideas, and feelings that ought to be associated in the act of contemplating a great masterpiece. The fine arts become metaphoric for the whole of experience; specific works of art provide the imaginative links between many levels of a complex discourse on reality. The literary genre that they thus create around the focus of the fine arts is here called the "literature of art" to emphasize the differences between it and a more specialized genre of iconic writing. Even the term "art criticism" is too restricted to apply to the many complex forms of poetry and prose they employ in response to the fine arts.

Variety, in fact, is functional in a medium which is, from its very conception, mixed. As in Blake's composite art, the attention to different forms of aesthetic activity necessitates a fuller response by the reader, engaging a larger portion of his imagination. Treating the fine arts in a variety of literary modes, with frequent shifts in form and style, further multiplies the nature of the reader's aesthetic experience. The complexity of the Victorian literature of art thus comes to symbolize the potential range of human feeling and thought. This theme is already apparent in the first volume of *Modern Painters,* where Ruskin is clearly committed to exploring the states of mind in which art is both produced and perceived. The importance of this inquiry grows more evident as the genre expands: that an entire branch of literature can be centered around the fine arts suggests that aesthetic response comprises an essential human activity. The totality of experience included in the literature of art by Ruskin, Rossetti, and Pater finally demonstrates that our capacity to

apprehend and appreciate the fine arts reflects the fullness of our inner lives.

The concerns of aesthetics have never been far from those of psychology. All art, according to I. A. Richards, provides structures for "organizing our impulses."[6] With Ruskin, Rossetti, and Pater, the arts—separately or in their interrelations—become instruments of mental integration, at once extending the range of our intellectual concerns and supplying perspectives from which to view conflicting interests. They translate the various fine arts into literature to define new modes of apprehension, which they hope to inculcate in their readers. The interpretation of art thus becomes an essential exercise in understanding all experience. It may at first seem surprising to ascribe so didactic a program to Pater or Rossetti; yet even in their most sensuous, evocative writing it is difficult not to discern an implicit rhetoric, one which subtly argues for our participation in and imitation of certain modes of feeling and thought. Even Rossetti's "aesthetic poetry" (the phrase is Pater's) directs itself to an audience over which the poet attempts to exert a kind of spiritual authority. Each in his different ways, Ruskin, Rossetti, and Pater adopt the stance of the sage that John Holloway has ascribed to the most publicly-minded Victorian prose-writers. The very reference to taste encourages the writer to address a broad audience. And the balance between exposition and evocation, between rational and subrational appeals, which characterizes the Victorian literature of art, is precisely the blend that Holloway identifies as the central mode of the didactic prose of the age. The goal of the sage, as Holloway defines it, is identical to that of the writer on the fine arts—to address the widest range of the reader's faculties: "His main task is to quicken his reader's perceptiveness . . . What he has to say is not a matter just of 'content' or narrow paraphrasable meaning, but is transfused by the whole texture of his writing as it constitutes an experience for the reader."[7]

The awareness of a public suggests that Victorian writers generally have deeper roots in the eighteenth century than is usually admitted; and such intellectual debts are particularly apparent in a genre that bases itself on a concern for taste. But the most immediate source for the themes and methods of Ruskin, Rossetti, and Pater lies in the writers of the first decades of the nineteenth century. The very intensity of style evident throughout their work marks them as Victorian Romantics, to

use the phrase Oswald Doughty has applied to Rossetti.[8] Even the particular form of moral appeal in their writing shows debts to the Romantics as well as to Victorian earnestness. The distinction between prior moral uses of poetry and those implicit in Romantic theory and practice—as M. H. Abrams has explained it—illuminates the implicit moral rhetoric of Ruskin, Rossetti, and Pater as well: "Earlier critics had defined poems primarily as a delightful way of changing the reader's mind; the Wordsworthian critic, primarily as a way of expressing his own. The product effects human betterment, but only by expressing, hence evoking, those states of feeling and imagination which are the essential conditions of human happiness, moral decision, and conduct. By placing the reader in his own affective state of mind, the poet, without inculcating doctrines, directly forms character."[9]

Ruskin announces the Romantic, and specifically the Wordsworthian, heritage of the literature of art by beginning *Modern Painters* with an epigraph from *The Excursion;* and Ruskin is also deeply indebted to eighteenth century aesthetics.[10] Yet especially in his work it is also clear how the amalgam of modes in the Victorian literature of art defines a new genre. The consistent emphasis on external works of art in itself suggests a more public context than that which can be observed in Romantic literature. Despite the epigraph from Wordsworth and a decidedly Romantic intensity of style, Ruskin's awareness of an audience marks him as more Victorian than Romantic; his comments on pictures never lose touch with an audience. The breadth of Ruskin's appeal contrasts strongly with Wordsworth's own iconic poetry, which displays an opposite tendency. For example, Wordsworth's "Elegiac Stanzas, Suggested by a Picture of Peele Castle, in a Storm, Painted by Sir George Beaumont"—an eighteenth century title, perhaps because Beaumont was, as both Ruskin and Blake point out with some hostility, an eighteenth century painter—remains largely within the poet's consciousness. The poem is "suggested by" the picture but not really based on it: there is no detailed description, nor any invitation to correlate the poet's feelings with the outlines of an actual, external work of art. Thus, although the "source" artifact is named, the situation is much like that in an even more famous Romantic iconic poem, Keats's "Ode on a Grecian Urn," where the anonymity of the vase on which the poem is based helps preserve the independence of the verse as a

complete expression of the poet's state of mind. There is, as Abrams notes, "something singularly fatal to the audience in the romantic point of view."[11] In Ruskin, Pater, and even Rossetti, the reader is far more aware of the necessity for an audience: the introduction of an artifact outside the text helps to define the relationship between writer and reader; the reader is not merely invited but required to measure his response against the second work of art and thus participate in the meaning of the prose or verse.

It is, then, the end of the literature of art always to return to the original work in question, against which the reader can measure the development of his own sensibility. As G. Robert Stange has observed, the presence of another work outside the literary text leaves the description of art "active and unfinished," inviting the reader to complete the writer's meaning for himself. "This extra step of perception on the reader's part may enhance or modify his response to the text, but the fact that it is optional gives to the total process an aspect of open-endedness, of incompleteness, which is characteristic of Romantic art."[12] With Ruskin, Rossetti, and Pater, however, this final step becomes almost mandatory. That the Victorian literature of art represents a compromise with Romantic practice is largely owing to the inevitability of reference back to the original work: the existence of the external work creates a necessary public context for the interpretation of art.

The Victorian literature of art thus represents a new direction for Romantic tradition. The new genre centers around moments of intense apprehension, dramatizing states of consciousness in which the world is suddenly seen with greater richness and clarity of insight. But while the reader of a Romantic lyric can admire and even participate in a moment of such emotional and intellectual wholeness, he cannot recover its source in a particular scene or experience, nor can he expect to duplicate the quality of the vision in his own responses to the world. The Romantic moment is fleeting and circumscribed; the Romantic vision, like Keats's nightingale, must vanish. The literature of art, in contrast, seeks permanence and deliberately leads the reader toward imaginative independence. Its object in the largest sense is education—to train an audience to apprehend art and experience as fully as possible, until the intercession of the writer is no longer necessary. Ruskin, Rossetti, and Pater encourage the reader to return to the works on which some of their

most intense, personal writings are based (or at least to examine reproductions of those works). The possibility of this return itself makes the feelings of the writer more available to the reader; and the permanence of the source-artifact holds forth the promise that the experience of the writer may be reproduced.

To speak of the public context of the literature of art may seem to underestimate the differences between Ruskin, Rossetti, and Pater, or between their diverse uses of art. This is not my intention. Rossetti and especially Pater, for instance, seem less concerned than does Ruskin with describing art, and more interested in using particular works or themes to evoke intensely personal visions and expressions. Nevertheless, in the literature of art evocation cannot exist wholly independent of description. Even the slightest reference to a work of art implies the existence of an "objective correlative" to the private emotion of the writer. This external point of reference suggests in turn that literature, like the other arts, is not merely a creation out of nothing but a transformation of impulses received into order, aesthetic shape, and meaning. As readers of literature and spectators of art, we are permitted to see both the beginning and end points of the writer's experience, and in this sense to glimpse the crucial stages of the creative process. Ultimately, then, the literature of art demonstrates the nature and validity of artistic creation itself. By revealing both the source and consequence of his own complex and personal aesthetic experience, the writer makes the nature of such experience less mysterious and remote. If the reader traces the connections between a work and a passage written from it, he can himself engage in a process very close to the writer's.

All literature aspires to objectivity of this sort. For a writer to express himself successfully, he must give his words a formal shape that organizes the experience of a reader. One danger conspicuous in much Romantic and post-Romantic writing, however, is for the necessity of literary structure to be overlooked under the pressure of strong feeling. Indeed, Ruskin, Rossetti, and Pater have all been accused of pursuing evocation for its own sake, letting the structure develop spontaneously, if at all. But even the notion of spontaneous structure is a contradiction, reflecting what Ivor Winters and R. P. Blackmur have called the "fallacy of imitative form." Blackmur particularly faults D. H. Lawrence's poetry for this assumption, the "faith . . . that if a thing is only intensely enough felt its mere expres-

sion in words will give it satisfactory form." Shakespeare, by contrast, imposes "a rational structure which controls, orders, and composes in external or objective form the material of which it is made." Lawrence, "the extreme victim of a plague affecting the poetry of the last hundred and fifty years," typifies the weakness of much modern literature. Yet even Lawrence, according to Blackmur, surmounts the problems of expressive form when he bases his poetry on the objective, external reality of a specific work of art.[13]

In Lawrence's poem "Corot," a picture supplies an "objective" equivalent to the emotion represented; the poem is written, Blackmur explains, "at the second remove from the experience involved . . . Corot—the accumulation of impressions, attitudes and formal knowledge with which Corot furnishes the attentive mind—is the medium through which the poem transpires." Corot's art "composed his material better than he was ever able to compose in terms of mere direct apprehension however intense . . . That the poem may have been as personal for Lawrence as anything he ever wrote makes no difference; for the reader the terms of conception are objective, and the poem could thus not help standing by itself."[14]

These observations provide an important clue to the literary significance of art for Ruskin, Rossetti, and Pater—and more generally for the progress of nineteenth century literature. The work (or works) from which a poem or prose passage takes its imagery, themes, or subject provides the writer with an "objective principle" for making his personal vision coherent to the reader. The very reference of a work of literature to something specific, identifiable, and observable outside itself implies an objectivity of sorts; it is a way of making literature at once personal and concrete. The availability of the source or subject of the writer's feelings suggests that they have substance and reality, however subjective or even confused they may at first appear. The attempt at once to objectify and to personalize literature by organizing it around a specific external point of reference indicates how the literature of art plays an important role in the progress of Romantic poetry toward the aesthetic of imagism and related forms of modern verse.

The problem of objectivity reappears in various guises throughout the writing of Ruskin, Rossetti, and Pater. The Preface to Pater's *Renaissance* examines the relation of the feeling of beauty to its source in a specific object or experience; the

introductory sonnet in Rossetti's *The House of Life* describes an ideal poem in which the description of a specific moment is balanced against the poet's evocation of his own soul; and Ruskin begins the chapter on "pathetic fallacy" in *Modern Painters III* by complaining about the artificial distinction implied in the very terms "objective" and "subjective." All three writers introduce nonliterary arts into their work to avoid such false dichotomies, to permit the merger of relatively "objective" and "subjective" modes into one allusive, complex form of discourse. The balanced concerns of the literature of art culminate the exploration, observable throughout Romantic writing, of the relation of the artist's consciousness to the external, phenomenal world. Similarly, the simultaneous focus on objective and subjective elements, a work of art and feelings inspired by it, helps to clarify the problematic relation of artist and audience which haunts Romantic and post-Romantic writers. The external artifact mediates between the writer interpreting it and his audience, creating a middle ground on which the most elusive personal vision can become accessible and convincing.

Perhaps the very presence of a second work of art encourages the writer to experiment more freely with his own creation, as both a stimulus and a control for certain literary energies. Stange has credited the art criticism of Ruskin and Pater with opening the way for some of the prose techniques of modern fiction, and the claim of modernism can be extended to Rossetti as well.[15] But it is not simply that a new literary genre elicited new styles. Experimentation is fostered by the inevitable reference within it to another, actual work of art, which keeps the literature of art at arm's length from solipcism. The writer gains freedom to innovate in his poetry or prose by virtue of the presence of that second artifact, which implicitly asserts that his feelings have meaning beyond what Pater calls "the narrow chamber of the individual mind" (*The Renaissance*, p. 235).

Exactly how this process operates can be shown in detail by examining one example from each of the three writers—Ruskin's account of Turner's "The Slave Ship," Rossetti's sonnet on Giorgione's "Fête Champêtre," and Pater's prose-poem on the "Mona Lisa." The diversity of these selections is representative of the different temperaments of the three writers, as of their different treatments of art in general. But in these passages there are also common emphases that define the central methods and goals of the literature of art. In fact, certain isolated passages

reveal each writer's most characteristic and distinctive modes of treating art. At various points in their writing, the discussion of art acquires a new intensity, and the interpretation of a specific work of art takes on a quality of ritual. Invariably the writings about art of all three authors move toward central, self-contained rituals of interpretation, in which the contemplation of art under the guidance of literature is endowed with an almost magical power to transform the being of the spectator. The simultaneous acts of reading and viewing are meant to involve a totality of response that in turn can produce a harmony of perception, all the faculties of the reader becoming attuned, if momentarily, under the joint influence of art and literature. The ritual quality of the styles of all three writers forces the reader to experience the contemplation of art as an all-consuming act, one that can involve a fundamental reorientation of the self.

English readers might have been expected to be familiar with "The Slave Ship" (see illustration), which had been exhibited at the Royal Academy in 1840, three years before the first volume of *Modern Painters* was published. Ruskin discusses it there (III, 571–572), in a section titled "The Truth of Water," as an example of Turner's fidelity to nature. Yet it also contains proof of the painter's imaginative power—"the noblest sea that Turner has ever painted, and if so, the noblest certainly ever painted by man." Ruskin demonstrates the interdependence of these virtues: Turner's "nobility" depends on his mastery of natural phenomena; his art translates physical "facts" into harmonious expressions of his imagination.

Ruskin's description begins with the "facts," the weather conditions and topography of the scene: "It is a sunset on the Atlantic, after prolonged storm; but the storm is partially lulled, and the torn and streaming rain-clouds are moving in scarlet lines to lose themselves in the hollow of the night. The whole surface of sea included in the picture is divided into two ridges of enormous swell, not high, nor local, but a low broad heaving of the whole ocean, like the lifting of its bosom by deep-drawn breath after the torture of the storm." Ruskin is careful to allude to the spiritual qualities of the scene only after noting its specific naturalistic reference. It is as if his own response to the power of the painting follows from his understanding of Turner's command of time, place, and weather conditions. Earlier in the chapter he had discussed the importance of representing the massiveness of the ocean as a sign of its physical

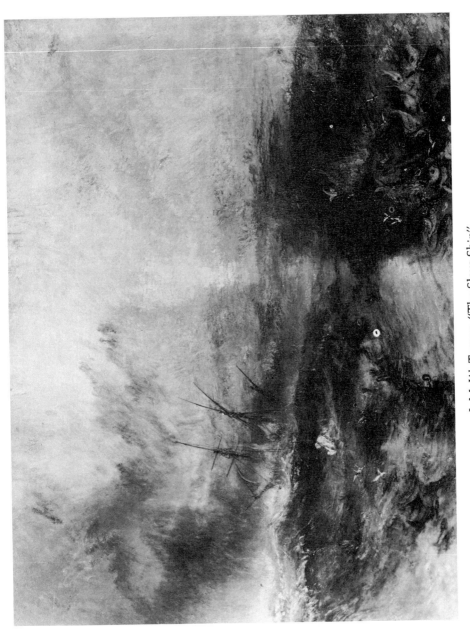

J. M. W. Turner, "The Slave Ship"

power and sublimity. Turner's ability to reproduce that "enormous swell . . . a low broad heaving of the whole ocean" represents his simultaneous insight into the facts and moral of the sea; and Ruskin's prose begins to be more emotive with the description of this double insight.

The passage underscores Turner's control of natural phenomena in its reference to his division of the sea—and the entire canvas—by a brilliant shaft of light from the sunset, cutting across the sky and the swells. A comparison of Ruskin's subsequent language with the painting itself shows that this center-line organizes not only the images in the painting but his own responses to "The Slave Ship." His eyes seem to move back toward and away from the center of the picture as he tries to describe Turner's visual effects and their relation to moral insights:

> Between these two ridges the fire of the sunset falls along
> the trough of the sea, dyeing it with an awful but glorious
> light, the intense and lurid splendour which burns like
> gold, and bathes like blood. Along this fiery path and valley,
> the tossing waves by which the swell of the sea is restlessly
> divided lift themselves in dark, indefinite, fantastic forms,
> each casting a faint and ghastly shadow behind it along the
> illumined foam. They do not rise everywhere, but three or
> four together in wild groups, fitfully and furiously, as the
> under strength of the swell compels or permits them; leaving
> between them treacherous spaces of level and whirling water,
> now lighted with green and lamp-like fire, now flashing
> back the gold of the declining sun, now fearfully dyed
> from above with the indistinguishable images of the burning
> clouds, which fall upon them in flakes of crimson and scarlet,
> and give to the reckless waves the added motion of their
> own fiery flying.

The necessary motion of our eyes following Ruskin's description of the painting has become part of the natural energy of the scene. Within the canvas itself, for example, the clouds are not "flying," although they may be represented as in a state of motion. But as we glance from point to point in the sky and in the sea, we begin to experience the different quantities of light as changes in light, and the picture gains energy and life. Different points in space are translated by Ruskin's prose into different points in time: "Now flashing back the gold of the

declining sun, now fearfully dyed from above with the indistin-guishable images of the burning clouds." Similarly, he interprets the alterations in tone within the painting—becoming darker toward the left—as alterations over time.[16] Ruskin's verbal adjectives transform Turner's picture of sunset into a narrative of the sun setting:

Purple and blue, the lurid shadows of the hollow breakers
are cast upon the mist of night, which gathers cold and low,
advancing like the shadow of death upon the guilty ship as it
labours amidst the lightning of the sea, its thin masts written
upon the sky in lines of blood, girded with condemnation in
that fearful hue which signs the sky with horror, and mixes
its flaming flood with the sunlight, and, cast far along the
desolate heave of the sepulchral waves, incarnadines the
multitudinous sea.

By the end of this passage, the clouds no longer seem to be "moving in scarlet lines to lose themselves in the hollow of the night." Rather, the night-mist "gathers cold and low, advancing like the shadow of death upon the guilty ship." From our refer-ence point at the center of the picture, the storm seems to move toward us, making the moral connotations of the subject active and even more threatening. It is, then, primarily the narrative element in Ruskin's prose that enables him to "read" "The Slave Ship" for its moral meaning. There are, in fact, two narratives— the account of a changing natural scene and the story of a divine judgment passed against a "guilty" ship—and the passage dramatizes their interdependence. Neither Ruskin nor Turner would ascribe a moral value to such scenes without first under-standing them in phenomenological terms: in nature and in art, a physical "reading" precedes a moral one; we must understand facts before we can interpret their meaning.

Consider the way in which Ruskin introduces the most ex-plicit moral judgment in his prose. Throughout the passage we have been directed to the power and sublimity of Turner's scene, often manifested only in "indistinguishable images." But by the end, natural fury finds a specific object: "the mist of night" is "advancing like the shadow of death upon the guilty* ship." The asterisk is Ruskin's. His footnote elucidates the nature of the ship's guilt: "She is a slaver, throwing her slaves overboard. The near sea is encumbered with corpses." Just as our eyes have

moved to the bottom of Ruskin's page, so has his prose shifted our attention in a long diagonal line from the upper-left to the lower-right corner of the picture, where Turner includes what seem to be vague outlines of manacled limbs and other floating animal or human forms. Returning again to the writing, we find our focus diverted upward again, to the ship's masts and the sky behind them; but it is difficult not to glance down once more to the grotesque seaborn figures in the foreground. The layout, as well as the content of the prose, dramatize the visual balance Turner creates between these portions of his painting. As our eyes move between them, we see the slave ship itself, integrated into this visual relationship by its size, shape, and color.

Ruskin's prose, then, shows how Turner gives aesthetic substance to his moral vision. The footnote provides another demonstration that moral generalizations must have a source in facts. But the primary facts of "The Slave Ship" are its formal components, and Ruskin calls attention to the way these contribute to the primary meaning of the picture. Turner organizes "The Slave Ship" around the relationship of storm-cloud, corpses and flotsam, and the slaver itself. Ruskin's prose makes us feel that the clouds advance on the ship *because of* those abandoned corpses. As his note indicates, a slave ship is an appropriate victim of such natural wrath. Certainly as we follow the progress of Ruskin's writing and return from the foreground in the lower-right canvas to the relation between cloud and ship, we feel more intensely the threatening, overhanging power of the sky in the picture.

In the description of "The Slave Ship" Ruskin is "reading" moral messages in both nature and art. Throughout *Modern Painters*, he refers to nature as an artist, and he clearly believes that the most powerful natural forms, colors, and "effects" are divinely intended as lessons for man. God might well summon up the elements to pass final judgment on a slave ship in just the way Turner has described; and it is of no small importance to Ruskin's treatment that the picture is based on the artist's reading about the shipwreck of an actual slaver. But Ruskin is also insisting that such a scene could be represented only by an artist of Turner's imaginative power. Indeed, at some points in the passage it is difficult to separate Turner's role as the painter of an actual storm and God's role as its controller. By whose art are the ship's "thin masts written upon the sky in lines of blood"? The force of the entire passage is to assert that without the

intervention of a great artist a scene of this sort would be beyond our ability of comprehension. Just as Ruskin guides the reader in understanding Turner, so the painter (with Ruskin's aid) instructs us in the art of seeing nature and "reading" her moral narratives.

In this sense, the passage on "The Slave Ship" is not merely a moral narrative but an artistic one as well. Its energy defines not simply the moral ideas in nature, but the process that gives them power, substance, and order in art. Ruskin's subject is the act of creation itself—and the analogy of Turner's creation and God's is implicit here and throughout *Modern Painters*. The drama of the prose recreates the imaginative insight from which Turner painted "the most sublime of subjects and impressions . . . the power, majesty, and deathfulness of the open, deep, illimitable sea." A central goal—if not the central goal—of the passage is to create the illusion that we have shared this vision with its creator. The language of interpretation generates a ritual which endows the reader and spectator with an intensity of consciousness approaching that of Turner or Ruskin himself. And in the sense that Ruskin invites us to repeat the process, his account of the painting provides an almost magical formula for experiencing this heightened state of being.

I am labeling this formula "ritual," not so much to suggest the sanctity of art in Ruskin's aesthetics (although that element is clearly present), as to indicate the almost religious value he assigns to the act of interpretation itself. Both Pater and, to a slightly less extent, Rossetti share this conviction of the necessity of interpretation for producing an ultimate aesthetic response, greater than either art or literature alone could supply. In the description of "The Slave Ship," the act of apprehension supplies the reader, when in the presence of the artifact, with a method for repeatedly experiencing a condition of imaginative grace, a Romantic fullness and intensity of vision that Ruskin finds distant from the imaginative capacities of his own age.

It is the combination of this goal with a specific technique for achieving it that distinguishes the literature of art as a genre. Like Ruskin, both Rossetti and Pater exhibit in their accounts of pictures highly mannered rhythms, a tendency to turn static images into narratives, and a combination of descriptive and evocative techniques. All three draw attention to the artist's transformation of experience into a harmonious aesthetic object, and to the parallel transformation of art into literature. But all

these qualities of their literature of art are directed toward the ultimate transformation of the reader; and for this he must be placed in a particular relationship with an artifact. By erecting a complex structure of experience around a work of art, the writer creates a secular ritual, one in which the reader-spectator can fully immerse himself so as to achieve a transformation of sensibility. As ritual, an intricate sequential pattern of response to a specific object, such a passage creates a momentary but total aesthetic invironment in which, still only for an instant but fully and intensely, the reader can achieve wholeness of being. The literary passage expresses a formula for what Pater calls "passionate contemplation," the process that necessarily brings into play all the faculties of the audience.

Emile Durkheim has defined ritual as "the rules of conduct which prescribe how a man should comport himself in the presence of . . . sacred objects."[17] Many of the traditional religious and magical overtones of the ritual process are evident in the treatment of the arts by Ruskin, Rossetti, and Pater. All three have been associated with a Victorian "religion of art," and, in an obvious sense, they implicity "worship" masterpieces as the repositories of some sort of ultimate values. Ruskin's attitude is the most explicitly religious of the three: he regards great painting as revelation and great painters (like Turner in "The Slave Ship") as prophets. Yet even with Ruskin it is apparent that art contains not official, formal religion but a substitute for it, a quasi-religious experience, valued not simply for its truth but for its expression, its power to address and move an audience. The rituals of interpretation in Ruskin as well as in Rossetti and Pater are, in this sense, fundamentally secular. The emphasis tends to fall on the quality rather than on the meaning of our contact with art; intensity of response becomes an end in itself. The goal is not so much the worship of a single beautiful object as it is the transformation of the reader-spectator's entire being into an order modeled on the wholeness of the work, the wholeness of the artistic imagination that created it, and the wholeness of the consciousness directing the entire ritual. But this is not simply an exercise in empathy; the artifact itself is always before the reader, to remind him that after he understands the writer's "ideas," he must also experience them in a new, fuller apprehension of an object outside the written work. Ritual thus implies that perception ought to be an ongoing activity which, if properly enacted, should involve the

*The Ritual of Interpretation*

entire being. If the object toward which perception is directed possesses sufficient power, then the organizing of vision and thought under the direction of literature will initiate a fundamental reorganization of the self.

This concern is even more explicit in Pater and Rossetti than in Ruskin's description of "The Slave Ship." Both tend to write about paintings that center around human figures rather than nature; both take these figures as embodying the potential of life to be transformed into art. With Ruskin, such a transformation is almost wholly an internal action, achieved as a state of consciousness, in a form of vision. Pater and Rossetti use art to describe the possibility of giving an aesthetic wholeness to all of life. Their rituals of interpretation hold forth the promise that one can use art not merely to see but to live with more unity and intensity.

Rossetti's sonnet "For a Venetian Pastoral," on Giorgione's "Fête Champêtre" (see illustration), seems to address both the reader and the figures in the picture, implicitly joining our lives to theirs and obscuring the distinction between art and life. As did Ruskin, Rossetti transforms the painting into a narrative, which is especially striking in view of the artificial and static relationships on the canvas:

Water, for anguish of the solstice:—nay,
     But dip the vessel slowly,—nay, but lean
     And hark how at its verge the wave sighs in
Reluctant. Hush! beyond all depth away
The heat lies silent at the brink of day:
     Now the hand trails upon the viol-string
     That sobs, and the brown faces cease to sing,
Sad with the whole of pleasure. Whither stray
Her eyes now, from whose mouth the slim pipes creep
     And leave it pouting, while the shadowed grass
          Is cool against her naked side? Let be:—
Say nothing now unto her lest she weep,
     Nor name this ever. Be it as it was,—
          Life touching lips with Immortality.[18]

Like Ruskin's, Rossetti's language moves from descriptive to interpretative statements; but the sonnet, unlike Ruskin's prose, divides its attention between nature and man, as well as between what can be seen on the canvas and what can merely be conjectured from it. He begins by alluding to the standing nude figure

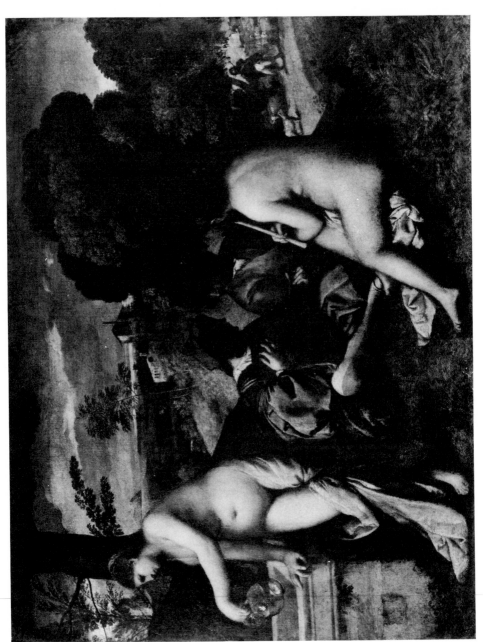

Giorgione (or Titian), "Fête Champêtre"

at the left of the painting, relating her pitcher half-filled with water to the suggestion of heat in the heavy summer sky. The "nay . . . nay" phrases (compare Ruskin's use of "now . . . now") hint at an ongoing action: Rossetti separates the woman's act of dipping the pitcher from the pensive leaning of her body. In the painting, the vessel of water is poised above the edge of the well, and we do not see the water in the well itself. Rossetti imagines the pitcher slowly filling and compares the soft "reluctant" sound to the silence of the distant horizon, "beyond all depth away." Furthermore, that metaphor of distance relates our perception of the depth of the picture to the woman's contemplation of the depth of the well. Our attention has thus been shifted from the woman to the sky behind her, following the line of the triangular relationship of her head and hand. Returning our gaze down the opposite side of the same compositional triangle, we next examine the hand "upon the viol-string/That sobs" to break the silence. Finally our eyes describe a similar triangular path in examining the smaller arrangement at the painting's right—moving from the player's hand to the brown face (above and to its right), then down again to the face and hands of the second nude figure, finally stopping to concentrate on the "shadowed grass" at her right.

As in Ruskin, Rossetti's poem suggests ways to "read" these visual interrelationships as intellectual ones. But our progress through the details of Giorgione's painting is not as carefully organized as is the interpretation of "The Slave Ship." Rossetti seems concerned primarily with defining a particular mood. The sonnet does not describe a hierarchical structure of details and ideas in the picture but instead points out the general network of associations that contribute to the painting's governing emotional effect. The pitcher and well, for example, draw our attention visually and metaphorically to the "depth," fullness, and heat of the distant morning sky. This scene, incidentally, is usually interpreted as depicting a late afternoon; but Rossetti reads it as morning to make the setting consistent with the general sense of expectancy in the figures. In the first version of the sonnet, printed in *The Germ* (the Pre-Raphaelite journal), the concluding line sums up the pervasive mood of the poem, with special reference to the dictum of Simonides that poetry creates speaking pictures and paintings silent poems: "Silence of heat, and solemn poetry." Similarly, the reference earlier in the sonnet to "silent" heat stresses the visual drama of the pause in

music. Even the invisible eyes of the second nude figure (we see only the back of her head) seem to "stray" toward the horizon; by postulating this glance, Rossetti makes the anguish of the season illustrate the intensity of her emotions. Her feelings are emphasized in turn by those of the man beside her, "sad with the whole of pleasure." The sonnet uses these details to define the pervading melancholy of the canvas and to connect this mood to a setting that seems literally to overshadow the figures in it with an uncertain, oppressive, half-threatening background sky.

It is not just the vagueness of this mood that distinguishes Rossetti's use of art from Ruskin's. In the later, enigmatic version of the sonnet's concluding lines, and through the general obscurity of its language, Rossetti implies that all the details of the painting add up to an ultimate mystery. He delights in precisely the sort of impressionistic power Ruskin usually condemns. Giorgione's importance for Rossetti depends on his suggestiveness, the power of effects that cannot be explained verbally. Art is finally irreducible to language—and this constitutes the clearest "message" of the poem. In the strange and unexpected exclamation "Let be," for example, he seems to warn the reader against examining a suggestive work of art too closely. The emotion in the picture on which the sonnet focuses most intensely is the one Giorgione avoids representing: the feeling expressed in the invisible, averted features of the second nude figure. Rossetti encourages us to admire sources of feeling too powerful to be explained. Quite the opposite of Ruskin, he writes about this work of art to underscore a quality for which he has no name; indeed, he implores us not to "name it ever," whatever "it" is. The next-to-final line in the sonnet can be read as a kind of anti-invocation, releasing the painting from the ritual of interpretation and returning art to its own, powerful, self-contained existence: "Be it as it was."

For all this deference to mystery, the sonnet still concludes with an interpretation, although one that is deliberately ambiguous. The penultimate line suggests that this final statement refers to the mystery itself, the power in art existing prior to the writer's intrusion upon it:

> Be it as it was,—
> Life touching lips with Immortality.

Syntactically, this may be translated as "Life kissing Immortality" or "Life bestowing Immortality upon lips" (presumably also with a kiss). The line thus may refer to the painting—meaning that it represents life attaining an immortal condition in art, that its creation was an act in which immortality came into contact with life, that the painter himself reaches immortality through this achievement. But the line may also signify the transformation that occurs when viewers are moved by the powerful mysteries of art: *we* have embraced immortality through an immersion in the spirit of the painting, which has transformed our lives as it has the lives of the figures it depicts.[19] The closing lines underscore the capacity of art to create new forms of life—in the worlds it describes, in its own existence as immortal artifact, and in the lives of its audience.

Like Ruskin, then, Rossetti writes about a painting to enable us to become parts of its ongoing life. The sonnet "for" Giorgione's pastoral dramatizes the response of an ideal viewer. The frequent asides emphasize the importance of the reader's presence in this process: "Hush! . . . Let be . . . Say nothing now unto her lest she weep,/Nor name this ever." These remarks may also be addressed to the figures in the painting, or even, after the model of Keats's "Ode on a Grecian Urn," to the artifact itself. But this ambiguity itself reminds us of the importance of the reader to the meaning of the poem: we are responding to the same power that suspends the lives of the four figures in a moment of intense contemplation; we are part of the same drama. The analogy between their contemplation and ours depends largely on the visual metaphor of music in Giorgione's painting; the picture itself examines various responses to art. Rossetti insists that only an art—music, the painting, or his poem—can provide such an instant of contemplative vision. The fusion of several arts makes that instant all the more potent. Our ritual of interpretation, therefore, does more than describe a painting. It immerses us in a world in which lives are transformed under the influence of art. As viewers, we not only participate in the contemplation depicted in the painting, but momentarily partake of its "immortal" existence.

Pater's debts to Rossetti are apparent in his account of the "Mona Lisa" in *The Renaissance* (pp. 124–126). His prose account displays only slight fidelity to the actual details in the picture and creates its own mysterious texture of allusions to

emphasize the mysterious charm of Leonardo's work. Considered as ritual, Pater's literature of art seems closer to Rossetti than to Ruskin. Ruskin's is a ritual of energy, transforming the participant by bringing him to an ecstatic discovery of the divine beauty in art and nature. But the language of interpretation in Pater and Rossetti is more sedately mannered, their rhythms more pensive, their tones more artificial and controlled. As Max Beerbohm has observed with penetrating wit, Pater writes English as a "dead language," in a "sedulous ritual wherewith he laid out every sentence as in a shroud."[20] Perhaps the appropriate response to this style in the treatment of art is that of Oscar Wilde, who is reported to have chanted the passage on the "Mona Lisa" while reverently standing before the painting in the Louvre.

Pater's account follows Rossetti in associating the greatness of the "Mona Lisa" with its mystery and suggestiveness (see illustration). Using adjectives that are deliberately vague, he refers to the woman as a "presence," appearing "strangely" and possessed by great "expressive" power: "The presence that rose thus so strangely beside the waters, is expressive of what in the ways of a thousand years men had come to desire. Hers is the head upon which all 'the ends of the world are come,' and the eyelids are a little weary. It is a beauty wrought out from within upon the flesh, the deposit, little cell by cell, of strange thoughts and fantastic reveries and exquisite passions." These metaphors imply that the painting has a life of its own, so that even Leonardo himself is not wholly responsible for the range of ideas, moods, and suggestions embedded in the portrait. Like the artist, a critic can do little more than give that ultimately ineffable existence a tentative shape and substance:

All the thoughts and experience of the world have etched
and moulded there, in that which they have of power to
refine and make expressive the outward form, the animalism
of Greece, the lust of Rome, the mysticism of the middle age
with its spiritual ambition and imaginative loves, the return
of the Pagan world, the sins of the Borgias . . . The fancy of
a perpetual life, sweeping together ten thousand experiences,
is an old one; and modern philosophy has conceived the
idea of humanity as wrought upon by, and summing up in
itself, all modes of thought and life. Certainly Lady Lisa might
stand as the embodiment of the old fancy, the symbol of
the modern idea.

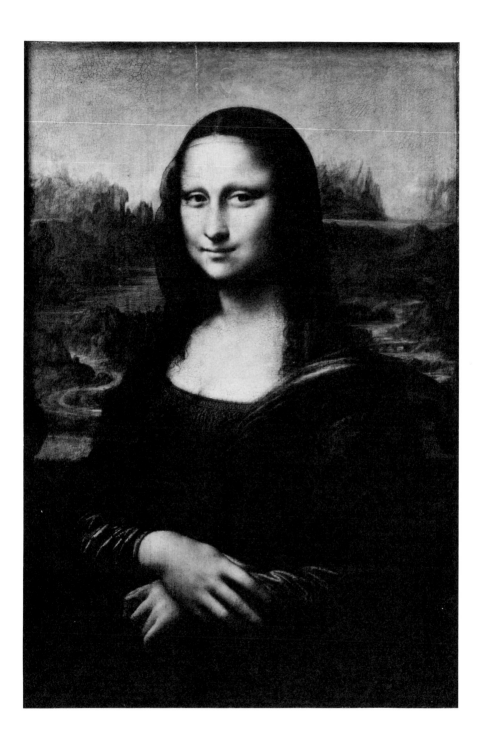

Leonardo da Vinci, "Mona Lisa"

This form of beauty is far more ambiguous than anything in Ruskin or Rossetti. The morbid imagery reveals a fascination with the grotesque, placing Pater's Gioconda in the tradition of *femmes fatales* that Mario Praz has traced throughout nineteenth century literature and art.[21] But her ambiguity only adds to the need for Pater's ritual of interpretation to tame the image and to keep it at the proper aesthetic distance. Here, as in Ruskin, the intensity of beauty is the precondition for its mediation in stylized writing. Ian Fletcher has identified this tension behind "Pater's lifelong concern with ritual as the most efficacious of man's instruments for spiritual communication: ritual provides life with a set of ideal symbols, and at the level of ritual the otherwise frightening and destructive experiences of beauty and terror can be related, however frailly, to daily habit."[22]

Pater labels the "Mona Lisa" a "symbol" in a modern, technical sense, largely derived from contemporary French writers, with whom he was familiar. According to Frank Kermode, the "true importance" of these lines "lies in their adumbration of a complete aesthetic of the Image."[23] But Pater's dramatization of the idea of symbolism is also close to the attempts of Ruskin and Rossetti to define the intellectual depth of great works of art. The literary treatment of other arts in the writing of all three moves toward the values and assumptions of the various symbolist movements at the end of the nineteenth century. Suggestive, overdetermined artifacts are valued for an almost magical quality. All three writers draw attention to this compact allusiveness, although only Pater labels it "symbolic." For him the "Mona Lisa" is a kind of universal image: its importance within Leonardo's career, as well as its subsequent appeal, depends on a capacity to embody some sort of unconscious racial memory, for which the artist becomes a mere instrument. Its life as symbol is thus independent of any single moment of artistic labor; its existence is out of time. "Was it," Pater asks, "in four years and by renewed labour never really completed, or in four months and as by stroke of magic, that the image was projected?"

Pater also suggests that the "magic" of this symbol is an illusion created by the artist. Leonardo's genius was to make the labor of years—really the labor of a lifetime, as the rest of the essay shows—appear to be instantaneous, and to condense a wide range of speculations and feelings into a single image. By

symbolism, Pater thus means that great artists must filter an almost infinite quantity of ideas and experiences through their minds, then control and condense them, before they can create a concrete, consummate image. His account of the "Mona Lisa" illustrates this aspect of the painting's history. The prose can be called descriptive only in the sense of tracing the various cultural elements Leonardo fused in his greatest work. Implicitly, Pater describes that act of fusion itself. Like Ruskin and Rossetti, he writes about art to enable us to share and participate in the process of creative vision.

One of the difficulties of this passage, a favorite anthology piece, is that it must be read in the context of the entire chapter on Leonardo in *The Renaissance*. Many of Pater's most arcane allusions turn out to be references to specific incidents and interests of the artist's prior life. Consider, for example, what is perhaps the most difficult and eccentric section in the entire passage on the "Mona Lisa': "She is older than the rocks among which she sits; like the vampire, she has been dead many times, and learned the secrets of the grave; and has been a diver in deep seas, and keeps their fallen day about her; and trafficked for strange webs with Eastern merchants; and, as Leda, was the mother of Helen of Troy, and, as Saint Anne, the mother of Mary." Most of these details allude to two facets of Leonardo's career that Pater has discussed elsewhere in the essay: the painter's fascination with nature and its "secrets," and his use of the mysterious smile in many paintings and drawings. The rock studies behind the figure of La Gioconda are products of the first phase of Leonardo's career, in which he painted natural grotesques like lizards and vampires. The smile and general expression of her face recreate the features of Leonardo's paintings of Leda, or "St. Anne and the Virgin," in which the figures are also set in a rocky landscape. Earlier, Pater had also described the unearthly light cast on subjects by the painter's unique imagination: "Through Leonardo's strange veil of sight things reach him so; in no ordinary night or day, but as in faint light of eclipse, or in some brief interval of falling rain at daybreak, or through deep water." This imagery explains the references to "deep seas" and "their fallen day" in the "Mona Lisa" passage; they are descriptions of the picture's atmospheric effect. But as "a diver in deep seas," the image of the lady also becomes a symbol for the imagination of the artist himself. The painting, then, is not simply his supreme imaginative product; it

becomes, in Pater's prose, a symbol of Leonardo's imagination, representing its uniqueness and power. Pater's references make the "Mona Lisa" an image of all the tendencies, possibilities, and achievements of Leonardo's life and art.

What Pater admires most about the painting is its subtle fusion of imagination and fact. "La Gioconda" is a portrait as well as the receptacle of many feelings, ideas, and achievements. In her features Pater discovers art and life wholly mingling, until it is impossible to distinguish between the products of Leonardo's imagination and the "real" lady in the picture. We can trace the history of the famous smile, for example, but never unravel its mysterious nature: "From childhood we see this image defining itself on the fabric of his dreams; and but for express historical testimony, we might fancy that this was but his ideal lady, embodied and beheld at last. What was the relationship of a living Florentine to this creature of his thought?" Pater suggests, as did Ruskin, that the greatest painters ally their imaginative powers with attention to external facts. But in his world of "impressions," it is impossible to separate what is factual from what is not. Ruskin praised Turner in order to teach men to discover the artistic and moral order in the phenomena of external nature; the painter, with the help of literature, guided men toward truth. Pater's literature of art contains an almost totally opposite view of experience. His account of the "Mona Lisa" persuades us to admire the power of art to transform everything around it to the requirements of a personal vision.

Pater goes so far as to hint that the power of art controls even the being of the lady herself, as separated from her image in the painting. Her features seem classic, containing an artificial perfection. Pater remarks on "the legend that by artificial means, the presence of mimes and flute-players, that subtle expression was protracted on the face." It is as if the lady herself, or else the musicians nearby but invisible in the painting, were responsible for her bewitching expression. This is, perhaps, part of what Pater has in mind in his essay on Giorgione when he writes that "all art constantly aspires to the condition of music." "The School of Giorgione" celebrates art in which form and content become indistinguishable. Pater defines Leonardo's portrait as achieving this ideal "condition"—for the very beauty of the lady embodies an artistic effect. Pater's reference to those invisible musicians only increases our sense of the complexity of her

being. As in Rossetti's description of Giorgione's "Fête Champêtre," the presence of musical effects in painting represents the possibility not merely of transforming one art into another but also of treating life in aesthetic terms.

Indeed, when Pater alludes to Leonardo's use of music in the passage on "La Gioconda," it is uncertain whether he describes effects produced by music, by painting, or by the arts of the lady herself: "All this has been to her but as the sound of lyres and flutes, and lives only in the delicacy with which it has moulded the changing lineaments, and tinged the eyelids and hands." There is an intentional confusion between the woman sitting for Leonardo and the figure appearing in the finished painting. Who, at last, controls those elusive features? Either the brush of the painter or the cosmetic brush could have "tinged the eyelids and the hands." The beauty of "La Gioconda" is partly of her own‧ creation, as Pater may have hinted by describing it as "wrought out from within upon the flesh." His account, like the painting itself, becomes an image of the potential of life as well as of the power of art. The highest art is that which creates an expressive symbol from human personality and treats life itself as a work of art; the supreme use of pictures is to provide an image of man as an aesthetic object.

Similarly, the function of the passage on the "Mona Lisa" is to teach us to employ such images in art to transform our attitudes toward our own lives. To some extent Pater achieves this end in the same way as Rossetti: by identifying the spectator's contemplation of art through the medium of literature with the act of serene self-contemplation embodied in the lady herself, he defines passionate contemplation as a model for the aesthetic wholeness that life can achieve. But the main argument in *The Renaissance* is for an artistic view rather than an artistic conduct of life. Responding to art under Pater's guidance serves as an exercise in this aesthetic attitude. His point in the purple description of the "Mona Lisa" is that we should refer all our own experiences, ideas, and desires to consummate works of art in order to view our own lives with the fullest intensity. We treat life in an aesthetic spirit when we understand it through art. The power of great art is revealed to us only when we discover its capacity to symbolize and give order to the confused and uncertain impressions of our own experience.

There is, then, a kind of circular argument in the lush description of the "Mona Lisa." Pater himself supplies the "experi-

ences" we are to find resolved in the painting; his own language provides the network of allusions and ideas that make the picture, for us, "the symbol" of a view of "humanity as wrought upon by, and summing up in itself, all modes of thought and life." The fact that many of these allusions seem vague or unconnected to the painting only underscores its power to transform diverse forms of life. Unlike Ruskin, Pater expects us to appreciate the discrepancies between the painting and his treatment of it, and most of the details in his account are not visible in the picture. But these discrepancies only testify further to the compression and transformation of experience in great art. The simplicity of the painting when compared to Pater's intricate prose-poem reminds us that the concrete forms of art are, in reality, abstractions. Even if we do not imitate Wilde by chanting Pater in front of the "Mona Lisa" in the Louvre, referring to the two art works at the same time creates the illusion that we are witnessing the transformation of one form of experience into another, in other words, observing the actual process of artistic creation. Simultaneous response to both works gives them a psychological proximity that is a large part of what Pater means by symbol in the first place. Thus, the process through which the meaning of art is revealed forms an important part of that very meaning: the ritual of interpretation confirms the interpretation itself.

To designate as ritual these most intense accounts of art in Ruskin, Rossetti, and Pater emphasizes several general aspects of their writing. Ritual implies an indistinguishability of form and content; manner becomes matter, and the act of participation itself constitutes an essential ingredient of meaning. Anthropologists suggest that "any form of secular activity, whether practical or recreational, can be stylized into dramatic performance and made the focus of a ritual sequence." Ritual thus serves not so much to distinguish a realm of sacred things from a realm of the profane as to designate certain essential activities that man wishes to dramatize and communicate powerfully to his fellows. Jane Harrison, in fact, has identified the origins of ritual with the origins of art. She points out that the Greek word *drama* derives from *dromenon* (meaning religious ritual, literally "things done"). "Primitive man," she explains, "tends to re-enact whatever makes him feel strongly; any one of his manifold occupations . . . provided it be of sufficient interest and importance, is material for a *dromenon* or

rite." In this sense, the literature of art embodies not simply a ritual but a process of ritualization, what Edmund Leach calls a "magical dramatization" of a particular response to art in order to give it currency and power for the widest possible audience.[24]

The literature of art of Ruskin, Rossetti, and Pater does not qualify as religious or social ritual in the usual sense. In terms of the most obvious meaning of the word, there is no common body of beliefs and practices among the three, or in a community outside them, to which their literary rituals correspond. The newness of the genre itself is symptomatic of a changing world, in which traditional practices are being abandoned rather than perpetuated; the appearance both of new forms of specialization, like the study of art, and of new forms of literature parallels the dissolution of larger conventional intellectual frames. Ruskin, Rossetti, and Pater acquiesce in different ways to the shifts in their world, yet all use their writing to define new forms of order and community; conceptually at least, all three seek to heal the most conspicuous divisions in their culture. There is, in other words, an implicit utopianism in their quest for new values—a tendency that also shows an important affinity with traditional ritual practices; for as V. W. Turner has observed, ritual invokes a complex of values which frequently leads to various forms of utopianism or millenarianism.[25]

It is in terms of such implicit utopianism that these three writers are most readily associated with a "religion of art." Not only does the ritual of interpretation imply a worship of the works of art treated, but more importantly, it implies that through such a controlled appreciation the observer of art can attain a new form of being. From the first volume of *Modern Painters*, to Rossetti's most exotic medieval pictures of the 1850s, and finally to Pater's essay on Winckelmann in 1867, it is apparent that the contemplation of art provides a model for new modes of conscious life, which, partly because of their very removal from contemporary social mores, require some sort of ritual to initiate the audience into a posture of acceptance. As V. W. Turner explains, the "liminal" condition of the ritual initiate provides "a time and place of withdrawal from normal modes of social action . . . a period of scrutinization of the central values and axioms of the culture in which it occurs." Such speculative detachment only enhances the internal power of the ritual experience. "The wisdom . . . that is imparted in sacred liminality is not just an aggregation of words and sentences; it

has ontological value, it refashions the very being of the neo-phyte."[26]

In the literature of art, as in traditional religious movements, such moral-psychic utopianism expands to encompass not just isolated individuals but men and women linked in a community of belief. Ruskin's writing on the arts provides the model for this development, beginning with *Modern Painters,* and in *The Seven Lamps of Architecture* and *The Stones of Venice,* he outlines an entire society constructed on his individual ideal of a moral-aesthetic being. By the end of his career, this community reappears as The Guild of St. George, a neo-Gothic English society that Ruskin conceived and actually established as a pattern for modern political organization. Rossetti's interest in following Pre-Raphaelitism in a "Brotherhood" (and the choice of that term seems to have been made at his insistence) illustrates the same tendency, as does the creation of an ideal pattern for an entire life in *The House of Life.* Similarly, Pater's last work—which he believed to be his best—is a study of *Plato and Platonism,* focusing on the creation, in *The Republic,* of an ideal community of aesthetic beings as Plato's highest intellectual achievement.

Thus, the ritual of interpretation merely begins with the individual reader-spectator. The transformation of self under the guidance of literature and art forms a model for a transformation of society, an idea of culture as all-encompassing as that of Matthew Arnold. Such ideals have surfaced throughout the humanist tradition in the west. Yet there are significant historical links between these renewals of utopian vision and the attempts to discover relations between the arts. Fritz Saxl has shown, for example, how the revival of the ideal of "a humanist dreamland" in the first part of the sixteenth century followed from translations of descriptions of paintings by Petronius. The eighteenth century as well, by its own classicist "ordering of the arts," as Lawrence Lipking has written, "revived a dream: the dream of a unified culture in which all great works of art could be securely ranked and placed within one great idea of art."[27] A similar dream of a newly integrated culture underlies the growing interrelation of the arts in the nineteenth century. Ruskin, Rossetti, and Pater locate in the fine arts radical alternatives for the lives of their contemporaries—alternatives not merely in supplying new objects of contemplation but also in evoking the

prospect of a new world, which might be entered from or superimposed upon the world of Victorian England.

By the end of the nineteenth century, the last permutations of this vision shift their focus increasingly from aesthetics to politics. William Morris, in his writings or in the Arts and Crafts Movement that he founded in the 1880s, attempts literally to recreate the environment and thus restructure the relations of man, nature, and the state; and if Morris' composite art grows out of the tradition I have been discussing, his radical aesthetics herald the beginnings of modern British socialism. The Kelmscott Press reprint of "The Nature of Gothic" in 1892 helped to increase Ruskin's influential role in contemporary political thought. Indeed, the reform Labour Parliamentarians elected in 1906 named Ruskin's *Unto This Last* as the book that had most strongly shaped their views; his twentieth century disciples include Clement Atlee and Mahatma Gandhi.[28] Historically, then, as well as in the work of its individual practitioners, the literature of art extends its focus from consciousness to community. That ideal end of restructuring the inner life becomes a means for reshaping the world of human relations. The ritual quality in the writing of Ruskin, Rossetti, and Pater illuminates both a fundamental impulse and an ultimate goal of their interpretation of the fine arts.

Part One

*John Ruskin*

# II

## *The Two Landscapes*

### *of*

## Modern Painters

*Modern Painters* celebrates vision, both the physical faculty and the spiritual instinct that grasps truths behind tangible appearances. The "power of the imagination in exalting any visible object," Ruskin explains in *Modern Painters III*, constitutes, "as it were, a spiritual or second sight" (V, 355). The single organizing principle in the book is the movement between these two fundamental levels of perception, what John Rosenberg has called Ruskin's "subtle dialectic of truth."[1] Throughout the five volumes, two styles alternate with each other. There are precise and extensive catalogues of natural phenomena— lengthy accounts of the forms of clouds, mountains, and plants —and evocative hymns to the power of such "truths" to reflect the divine presence in the landscape. In a sense, there are two landscapes in *Modern Painters*, one material and the other sacramental. Ruskin arranges the entire book to dramatize the connection between these two landscapes, and between the two levels of vision potentially available to man.

As in his description of "The Slave Ship," Ruskin uses art to define the interdependence of these visions of the world. Turner takes on heroic proportions in this argument, for Ruskin begins by asserting that Turner's art fuses all the facets of reality, then concludes by offering the painter himself as a model of unified

sensibility. Turner's imaginative genius depends on fidelity to physical nature, yet he avoids both the "false ideal" of Poussin and Claude Lorrain and the deceitfulness of Dutch "imitation." His individual paintings and drawings anatomize the pathway leading toward an intense, spiritual apprehension of nature from a detailed examination of its physical characteristics. Thus, in describing his works, Ruskin manages to fuse his own literary styles into a single expression, simultaneously descriptive and evocative, visionary while at the same time grounded in the reality of nature and the actuality of a particular artifact.

Ruskin's focus on specific works of art, and through art on natural facts, is one way he attempts to control the digressiveness of *Modern Painters*. But even the formlessness of his venture involves an element of choice, for a wide range of reference is necessary to demonstrate the extent to which he intends to revolutionize our consciousness. He multiplies the concerns of *Modern Painters* in order to multiply the modes of addressing the reader. The argument flows from aesthetic principles to those of science; from modern painters to Renaissance and classical writers, to discussions of history, religion, economics, and psychology, including numerous interspersed passages of autobiography and philosophic meditation. For Ruskin, no form of human interest or thought can be excluded from a study of the fine arts. The apprehension of art provides a model for a new apprehension of all experience. Graham Hough has observed that "Ruskin is trying to bring about a psychological revolution, one of those revolutions which, according to the psychology of Jung, must periodically occur in individuals and in cultures if the flow of psychic life is to continue without being blocked and frustrated."[2] In *Modern Painters III*, subtitled "Of Many Things," Ruskin makes clear that his appeal to the senses is a means of addressing the entire being. It is precisely the capacity to awaken the whole consciousness that comprises "greatness" in art:

> It is literally great. It compasses and calls forth the entire
> human spirit, whereas any other kind of art, being more or
> less small or narrow, compasses and calls forth only *part* of
> the human spirit. Hence, the idea of its magnitude is a
> literal and just one, the art being simply less or greater in
> proportion to the number of faculties it exercises and
> addresses. And this is the ultimate meaning of the definition

*John Ruskin*

I gave of it long ago, as containing the "greatest number of the greatest ideas." (V, 66)

Modern Painters deserves to be considered a pioneering text in the history of the literature of art, despite prior examples of Romantic art criticism by Lamb and Hazlitt, and despite the contemporary surveys of art history by Lord Lindsay and Alexis François Rio.[3] Ruskin is indebted to all of these writers; yet his work achieves uniqueness precisely because—like the "great" art he praises—it contains more, merging the different concerns of earlier writers on art and going beyond them. Modern Painters is not simply a collection of powerful expressive accounts of paintings; nor is it a catalogue of visual techniques and effects, iconographical motifs, or even particular characteristics of landscape. All these are aspects of the book, but all are subsumed within an analysis of landscape painting and an explanation of its value. Some of the obvious models for the book are the literature of travel and the motif of the journey that spills over into much Romantic poetry (Wordsworth's in particular); to a great extent, Modern Painters is a journal of Ruskin's own "excursions" into nature and various art galleries. But the travel motif has value chiefly in lending support to the theme of integrated sensibility that stands behind all of Ruskin's various investigations; all the journeys through the world and nature prepare us for a fuller comprehension of Turner. M. H. Abrams has shown that the theme of journey in Romantic literature itself embodied the tradition of the spiritual quest: it is the search for oneness in God translated into the search for personal spiritual wholeness, "redemption as progressive self-education."[4] Ruskin was the first to incorporate this Romantic ideal as the essential foundation of systematic art-criticism. Modern Painters achieves its unique literary status by identifying painting as a vital medium of aesthetic reintegration and the critic as a necessary guide in this process.

At least as much of Modern Painters is devoted to the study of landscape as to the study of art; yet the constant reference to painting is precisely what makes it more than a Romantic nature poem. Although Ruskin considered himself a Wordsworthian of sorts when he began the book, his exaltation of the artist in itself suggests a limited faith in the unmediated relation of man and the landscape. Wordsworth, in the preface to the Lyrical Ballads, had acknowledged new social conditions that tended to

corrupt mental and moral life; yet in spite of these he retained faith in an intrinsic relation of the mind to nature, which makes the material world a permanent source of spiritual regeneration. There are, he wrote, "certain inherent and indestructible qualities of the human mind, and likewise . . . certain powers in the great and permanent objects that act upon it, which are equally inherent and indestructible."[5] *Modern Painters* is predicated on the assumption that this relation has deteriorated. The public's failure to appreciate Turner stems from a failure to sympathize with, understand, and respond to nature. By the third volume of *Modern Painters*, Ruskin makes clear that the decline of the modern imagination has blunted the response even to those "great and permanent objects" mentioned by Wordsworth. In a chapter on "Modern Landscape" he laments the lost "sense of solemnity in mountain scenery" and "a general profanity of temper in regarding all the rest of nature" (V, 320). The fourth volume details a condition termed "the mountain gloom," in which even the inhabitants of the most sublime portions of the Alps find themselves depressed and overpowered by landscape, their minds fatigued by the intensity of such beauty (VI, 157–172, 385–417). Ruskin discusses in *Modern Painters III* the lapse of his own "landscape instinct," a failure that reflects the diminished mental powers of his age.[6] The imagination, he concludes, is "eminently a weariable faculty" (V, 182), and the nineteenth century seems to mark the historic moment of its exhaustion.

To revitalize the imagination of his age, Ruskin directs his audience not to nature alone but to nature modified by and represented in art. Painting and architecture supply theraputic media through which the mind can regain gradually something of its former health in the time of Wordsworth. Even from *Modern Painters I*, Ruskin's most Wordsworthian book, art implicitly provides a substitute for those "great and permanent objects" which Wordsworth found sufficient in themselves to awaken man's spiritual being. In *The Seven Lamps of Architecture*, published in 1849, shortly after the second volume of *Modern Painters*, Ruskin echoes Wordsworth's observations on the mental effects of urbanization; but instead of sending man back to nature for rejuvenation, he posits architecture as a "lamp of memory" to remind us of a landscape that seems to have been banished from our experience forever:

*John Ruskin*

The very quietness of nature is gradually withdrawn from us; thousands who once in their necessary prolonged travel were subjected to an influence, from the silent sky and slumbering fields, more effectual than known or confessed, now bear with them even there the ceaseless fever of their life . . . All vitality is concentrated through . . . throbbing arteries into the central cities; the country is passed over like a green sea by narrow bridges, and we are thrown back in continually closer crowds upon the city gates. The only influence which can in any wise *there* take the place of that of the woods and fields is the power of ancient Architecture. (VIII, 246)

Architecture functions as a substitute for nature. Fifty years after publication of *Lyrical Ballads* the world, and with it the imagination, have been irrevocably changed.

By the third volume of *Modern Painters*, the implicit treatment of painting as a medium between man and the landscape has become explicit as well. Here for the first time Ruskin feels the necessity of justifying his focus on landscape art rather than on landscape itself, and explaining what he calls "The Use of Pictures." He asks whether the love of nature is finally consistent with a love of art: is it not necessary to choose between the reality and the artifice? Ruskin answers in several ways. Of course, he admits, actual landscape is to be preferred to any version of it. He would gladly exchange his finest Turners for the scenes they represent, *if* such an exchange were possible. But clearly it is not: no location in the world could command as many great scenic views as Ruskin can observe in a few of his best Turner drawings and oils. Here he seems to acknowledge a problem implicit in all the rhetoric of *Modern Painters*, that most readers could never travel to view the scenes he urges us to contemplate. Painting, then, enables us to overcome geography and immerse ourselves in the most magnificent portions of nature; but it also enables us to respond to such scenes more intensely and coherently than we might in viewing an actual landscape. For, Ruskin warns, the human imagination is easily deceived. He mentions Wordsworth's admiration for the inferior paintings of Beaumont as an instance of the modern tendency to respond passionately to unworthy objects. If we judge images according to their ability to excite "impressions," we might as well praise the "power" of a stain left by an inkbottle thrown at

a wall—and here Ruskin prophesies some of the modern conse-
quences of a Paterean impressionistic aesthetic. Similar decep-
tions can occur in nature too. Ruskin narrates a kind of autobio-
graphical fable about his own mistaken discovery in Chamonix
of a grander Alp than any he had ever seen: it turned out to be
an optical illusion, produced by the sun's reflection off some
glass roofs and filtered through smoke. The implication seems to
be that modern man is mentally too unreliable to be trusted to
seek inspiration in nature: "Examine the nature of your own
emotion (if you feel it) at the sight of the Alp, and you find all
the brightness of that emotion hanging, like dew on gossamer,
on a curious web of subtle fancy and imperfect knowledge" (V,
177).

To counteract such emotional instability, and to enable men to
benefit from the power and "truth" of nature, is the principal
"use" of pictures for Ruskin. Thus, the first obligation of art is
not to mislead the viewer. "The duty of the artist," Ruskin
explains, "is not only to address and awaken, but to *guide* the
imagination; and there is no safe guidance but that of simple
concurrence with fact" (V, 179). The italics in that remark,
Ruskin's own, point toward the second "duty" of the painter. If
he remains true to "fact," the artist must never "imitate," as by
creating the illusion that a picture actually is a window over-
looking nature; it is on this basis that Ruskin elevates Turner's
art above Constable's. Instead, while never violating the truth of
a given scene, the painter should alter it to some extent, both to
show the limits of his own powers and to make the beauty of
landscape comprehensible for the limited powers of a spectator.
The artist, then, can never neglect his audience: if his capacity
of vision is vastly above theirs, his work should embody some
mediation between the two extremes. Great artists, Ruskin
insists, present their own "discovery and apprehension of the
purest truths" in a way that makes them accessible to less acute
observers, "arranged as best to show their preciousness and
exalt their clearness." Visual art provides a kind of textbook for
the interpretation of nature. Ruskin asks us to admire the "great
imaginative painter" not so much for bringing us close to nature
but for allowing us to see it at a distance, rearranged and trans-
formed. We should appeal to him to "come between this nature
and me—this nature which is too great and too wonderful for
me; temper it for me, interpret it to me" (V, 187). Similarly, in a
letter of 1844, Ruskin explains that the aim of *Modern Painters*

is to show nature as "interpreted and rendered stable by art" (III, 665).

In *Modern Painters* itself, as in the work of the great painters Ruskin admires, we never approach the most powerful scenes in nature directly, without mediation. Beginning with the very first volume, the book is organized to lead us through various stages of vision in order to bridge the gap between the intensity of actual nature and the weakened condition of the modern mind. The travel motif running throughout Ruskin's works, and the metaphor of the journey itself, define an intellectual pilgrimage that is necessary if we are to move between the two landscapes and progress from one level of vision to the next. "There are no degrees of truth," he explains in the first volume, "only degrees of approach to it" (III, 106). Ruskin's "approach" to natural "truth" through the medium of Turner's art is constructed with particular clarity in the first volume. In the section titled "Of Truth," for example, the argument progresses quite directly from dry facts to moral discoveries, from detailed descriptions of mountains, clouds, water, and plants to accounts of such "facts" transformed into spiritual ideas in Turner's greatest works. Descriptions of individual works of art, like "The Slave Ship" in the chapter on "Truth of Water," are introduced by careful analyses of the natural materials they transform to create powerful aesthetic expressions. Throughout the volume, as through most of the rest of the book, Ruskin takes pains to derive insight from sight, imaginative flights from precise observation, the achievements of art from detailed scientific study. As he announces in the introductory pages of the book, he sees it as his "duty . . . to declare and demonstrate, wherever they exist, the essence and the authority of the Beautiful and the True" (III, 4).

We respond to only half of the spirit of *Modern Painters* by reading the collections of descriptive set-pieces popularized by Ruskin's admirers in the last hundred years or so.[7] Even *Praeterita*, Ruskin's autobiography, supports the legend of it as an inspired book, and canonizes the young writer as a Wordsworthian child in nature. But a more careful look at *Modern Painters* itself, or particularly at the diaries on which many of its most "poetic" passages are based, reveals the painstaking, detailed observation and recording of fact that prepared the way for these evocative moments. One writer has noted that in 1842, when Ruskin was preparing the first volume, he "was working

almost with the eye of a prospective botanist or geologist."[8] Ruskin's ideal reader is expected to respond to this scientific dimension, as well as to the "poetic" aspects of the book. It is an important lesson of *Modern Painters* that the second, more inspired, style would be impossible without the first: for Ruskin, the ecstatic, quasi-religious vision of nature is prepared for, even guaranteed and released, by his dry, painstaking accounts of material phenomena and "appearances."

Like Wordsworth, Ruskin opposes himself to total materialism, that dominance of scientific attitudes Blake attacked as "Newton's sleep." Ruskin stresses his membership in the Romantic circle of anti-Lockeans by selecting an epigraph for *Modern Painters* from *The Excursion* (IV, 978–992), a passage in which Wordsworth engages in one of his frequent assaults on those who "murder to dissect":

> Accuse me not
> Of arrogance . . .
> If, having walked with Nature,
> And offered, as far as frailty would allow,
> My heart a daily sacrifice to Truth,
> I now affirm of Nature and of Truth,
> Whom I have served, that their Divinity
> Revolts, offended at the ways of men,
> Philosophers, who, though the human soul
> Be of a thousand faculties composed,
> And twice ten thousand interests, do yet prize
> This soul, and the transcendental universe,
> No more than as a mirror that reflects
> To proud Self-love her own intelligence.

It is not simply that rationalism narrows man's vision of nature; such a distortion simultaneously limits man's view of himself. Like Wordsworth, Ruskin wishes to derive a new-found unity of man from the unity of nature; and also like Wordsworth, he recognizes that the diversity of the external world implies a corresponding diversity of the human spirit. No single point of view offers an adequate vision of the world or brings into play the wholeness of man. As Ruskin remarks in *Modern Painters IV*, all men see the world differently, but "all the differences are there" (VI, 367–368). Every new perspective achieved enlarges our understanding of nature and of human potential.

Ruskin also follows Wordsworth in adopting the Baconian

view that scientific knowledge can be reconciled with more transcendental interpretations of nature. Science in the eighteenth century, as Basil Willey has pointed out, contributed directly to the "divinizing" of nature that ultimately led to the attitudes of Romanticism.[9] Similarly, the rhetoric of *Modern Painters* continually asserts the necessity of incorporating science into an imaginative naturalism. In Ruskin's most systematically naturalistic writing—in the first, fourth, and fifth volumes—it is evident that the analytic treatment of material phenomena is a first step for an understanding of the visionary concept of landscape glimpsed through art. As he writes in the section of the first volume entitled "Ideas of Truth," "It is possible to reach what I have stated to be the first end of art, the representation of facts, without reaching the second, the representation of thoughts, yet it is altogether impossible to reach the second without having previously reached the first" (III, 136). The point is not simply that science constitutes a basic level of perception, beyond which one can advance to discover higher forms of truth. Ruskin insists that such knowledge must be extended to serve "higher ends"; indeed, that those ends cannot be attained without this preparatory, perfunctory level of understanding. The many dry, factual sections of *Modern Painters* constitute preparatory exercises for the reader in his task of aesthetic reintegration. They objectify, in a sense, the visionary claims made for landscape art.

Humphrey House has faulted Ruskin's objectification of Romantic vision for an extreme misreading of Wordsworth involving a basic error of logic: "Because the Romantic tradition said that Nature was somehow the source of important spiritual experience, and because the habit of mind of the following generation (with an empiric scientific philosophy) was to dwell lovingly on factual detail, a suspicion came about that perhaps the cause of the spiritual experience lay in detail."[10] But Ruskin never suggests that the data presented in *Modern Painters* contain a sufficient or independent basis for visionary response. He creates instead a complex machinery for aesthetic apprehension, in which the ritual of interpretation plays the conclusive and essential role. Through the different phases of his argument, he attempts to shape our perceptions of natural "facts" in the landscape or in landscape art. The only "cause of . . . spiritual experience" within the book is the network of rhetoric that leads us from one phase of vision to another. This dramatic structure

of *Modern Painters* embodies a logic of its own, one to which Ruskin ascribes an almost mathematical precision. The introduction insists that even his boldest assertions about painting depend on "demonstrations which must stand or fall by their own strength, and which ought to involve no more reference to authority or character than a demonstration in Euclid" (III, 5).

Parallel claims are made for Turner's scientific knowledge and precision. Within his work Ruskin locates the same ladder of perception which he creates for the reader in the structure of *Modern Painters*. Ruskin declares, for example, in a discussion of mountains in the first volume that Turner is "as much of a geologist as a painter" (III, 429). Later in the same volume he praises a picture of "The Upper Fall of the Tees" on scientific grounds: "A geologist could use this engraving to give a lecture on the whole system of acqueous erosion, and speculate as safely upon the past and future states of this spot, as if he were standing and getting wet with the spray" (III, 488). To paint mountains convincingly, Turner had to comprehend, if only instinctively, the nature of geologic structure and formation. In representing nature, the painter must literally reconstruct it, as Ruskin explains with reference to precipices in *Modern Painters IV*: "every great pictorial impression in scenery of this kind is to be reached by little and little; the cliff must be built in the picture as it was probably in reality—inch by inch" (VI, 317–318).

The necessity for such imaginative precision governs the shape of *Modern Painters* as a whole. Ruskin's digressiveness is stabilized by a simple structure of thought which remains fundamentally constant through all the varying concerns and modes of the different volumes. This pattern is essentially that found in the passage on "The Slave Ship," only vastly enlarged. Ruskin organizes chapters and entire volumes of *Modern Painters* around the movement between two levels of reality, to dramatize the activity of a unified sensibility in perceiving the world. His descriptions, arguments, and even aesthetic theories are structured around the process by which the greatest imaginative intellects connect the two landscapes and fuse the two levels of vision. Underlying this movement between the two landscapes is Carlyle's concept of "natural supernaturalism," presented in *Sartor Resartus*. Ruskin's version of that dualistic principle, latent from the first pages of *Modern Painters*, is defined in the third volume as the "naturalist ideal." Even a visionary artist

*John Ruskin*

must in some sense see what he depicts: "the whole power to describe rightly what we call an ideal thing, depends upon its being thus, to him, not an ideal, but a real thing. No man ever did or ever will work well, but either from actual sight or sight of faith; and all that we call ideal in Greek or any other art, because to us it is false and visionary, was, to the makers of it, true and existent" (V, 114).

The concept of two landscapes, then, implies a rhetorical movement between two styles, a drama of perception which leads a reader toward visionary insight. Invariably this stylistic drama culminates in the description of art, in a ritual of interpretation in which Ruskin guides us in a full exercise of our mental faculties. Such a "use" of pictures makes them "symbols" for Ruskin in much the same way that they are for Rossetti and Pater: they condense the artist's wisdom into a complex personal experience, and the structure of that experience can be articulated through a study of their details. A work of art holds forth the promise of the integration of sensibility, the total (if momentary) realization of human potential through aesthetic response. In the particular idiom of *Modern Painters*, great landscape painting represents the completed Romantic pilgrimage through the two landscapes. It is for this reason that Ruskin takes particular note of our "ease of movement" through Turner's works (III, 491). If we can understand Turner's works well enough to imagine ourselves physically moving through them, we have initiated that process of intellectual motion which should culminate in a new organization of self.

Thus, merely observing a Turner masterpiece leads us into the moral level of natural fact, from the first to the second landscape; merely describing Turner's work draws Ruskin's styles between the two poles of vision, from fact to metaphor, from distinctness to mystery, from calm objectivity to prophetic intensity. The account of "The Slave Ship" is only the most famous instance of a rhetorical process that is repeated throughout the book. At another point in the first volume, for example, Ruskin uses one of Turner's illustrations to a novel by Scott to condense all the observations on the "inferior mountains" into a single moment of vision: "The whole elevation of the hills depends on the soft lines of swelling surface which undulate back through leagues of mist, carrying us unawares higher and higher above the diminished lake, until, when we are all but exhausted

with the endless distance, the mountains make their last spring, and bear us, in that instant of exertion, half-way to heaven" (III, 468). We literally climb through this landscape, following the path laid out by Turner's "soft lines" and the growing rhythms of Ruskin's prose. He intends his final words literally, for it is through such imaginative exertions that art communicates its inspired truths.

What strains our belief in Ruskin is not so much the intensity of this aesthetic drama as his insistence on focusing it exclusively on Turner, as the central exemplar of that perfect relationship between "the Beautiful and the True." For nineteenth century readers, no proof could be convincing enough to make Turner, especially in the works produced around the time when *Modern Painters* began to appear, seem faithful to nature; and in the twentieth century Ruskin's defense seems almost philistine, for we are reluctant to abandon the image of Turner as the father of impressionism. In fact, the extreme differences between these two interpretations (and the nineteenth century mainly admired the early, naturalistic Turner) should alert us to the complexity of the painter himself. We need only juxtapose the extreme and varied tendencies of his career to discover how judicious and balanced is Ruskin's composite view. A major value of the drama of *Modern Painters* is to define the different sorts of mastery incorporated into Turner's varied sensibility. In different sections of the book, we can read Ruskin on Turner's naturalism, his artifice, his energy or repose, his command of light and color, his understanding of history and literature, his memory, his speed of composition, his unique command of atmosphere, his comprehension of the relation of man and nature, the infallability of his instinct, the depth of his thought. The ongoing drama of the book allows us to apprehend all these characteristics as integral parts of a unified artistic genius.

The structure of *Modern Painters* also defines what might be called the intellectual history of Turner's art. Ruskin shows how particular styles came to be evolved over time, and how specific works were composed out of prior studies and experiences. In a sense he employs two styles to try to connect two extreme phases of Turner's career. The first defense of Turner against *Blackwood's Magazine* was composed in 1836, at about the time when the painter had finally abandoned his topographical style in favor of a total commitment to a more impressionistic, eccentric, and original manner. By the time of *Modern Painters I*

seven years later, Ruskin finds himself looking back to the earlier, more easily explicable stages of Turner's career as a way of explaining his later development. Despite his praise for "The Slave Ship," Ruskin shows some uneasiness about the sort of work Turner was doing increasingly in the late 1830s and especially after 1840, involving swirling, luminous images defined less by form than by light and color. Although some of the most ecstatic prose (like the "Slave Ship" passage) in *Modern Painters* describes Turner's more expressionistic work, Ruskin devotes even more attention to earlier, more precise, and hence more conventional drawings of landscape. At the end of the first volume, he advises young landscape artists to make "the early works of Turner their example, as his latest are to be their object of emulation" (III, 623–624). *Modern Painters* warns against separating the most distinct phases of his genius. Ruskin's shifts of focus from natural science to intense, evocative passages may represent an attempt to embody, rationalize, and even justify the varied and changing career of Turner himself.

The shape of this argument brings us increasingly closer to the mind behind a work of art. We are urged to modify our sensibilities after a model based on the temperament of the artist himself. The harmonious relation of impulses in a great picture comes to stand for the fuller development and organization of our own faculties, achieved under the influence of art with the indispensable orchestration of the critic. There are repeated invitations to test our aesthetic growth against certain vital "passages" of nature. Similarly, Ruskin frequently constructs episodes that might be termed fables of perception, in which an imaginary spectator travels through nature while we measure his capacity for assimilating various aspects of the "truth." Ruskin narrates his own "excursions" into the countryside as well, but in these the breadth of his sensibility is almost always gauged against that of Turner's. One of his most brilliant critical techniques is to follow many of Turner's drawings back to their sources in nature, particularly in the Swiss mountains where the artist did much of his best work. Ruskin can measure accurately the power of Turner's mind against his own; by studying the transformation of detail, he can assess exactly how much Turner's subjects have been invested with a unique vision.

In the chapter on "Turnerian Topography" in the fourth volume, Ruskin compares Turner's drawing of a valley beneath one of the most precipitous Alpine passes to his own sketch of

the same scene, "The Pass of Faido" (see illustrations). By this test, Turner's drawing proves to be unfaithful to its natural source in several important respects: but Ruskin shows how it is greater art despite, or perhaps because of, these alterations. Turner removes the few visible trees from the landscape; but the resulting unrelieved bareness emphasizes the constant threat of avalanche in the Alps. Similarly, he exaggerates the apparent height of the distant peaks; yet this makes us more keenly aware of the steepness of the valley itself. Turner's picture conveys far more intensely than Ruskin's more accurate drawing the feelings that would necessarily accompany our view of the scene *in nature*. A tiny carriage at the center of the picture seems to Ruskin to express more perfectly than any real detail might have done the inherent drama surrounding our presence in this rocky, threatening gorge. This image reminds us that all the other transformed facts in the picture were accumulated only after the day's ride that was required to approach the valley over the St. Gothard Pass. The drawing focuses on this "great fact" (VI, 38), the necessity of arriving by road, as the experience that shapes our response to the entire setting. It thus achieves the power "of producing on the far-away beholder's mind precisely the impression which the reality would have produced"; it puts "his heart into the same state in which it would have been, had he verily descended into the valley from the gorges of Ariolo" (VI, 35–36).

Ruskin employs Turner's drawing to give the reader a vision of nature through the medium of art. We even sense that Ruskin's own response to the scene depended on Turner's interpretation of it. The prose describing the actual setting is a mere "topographical delineation of the facts," Ruskin admits, a straightforward naturalistic catalogue. He offers a glimpse of the second level of landscape only when he arranges his prose account according to the terms of Turner's picture:

There is nothing in this scene, taken by itself, particularly interesting or impressive . . . But, in reality, the place is approached through one of the narrowest and most sublime ravines in the Alps, and after the traveller during the early part of the day has been familiarized with the aspect of the highest peaks of the Mont St. Gothard. Hence it speaks quite another language to him from that in which it would address itself to an unprepared spectator: the confused

J. M. W. Turner, "The Pass of Faido"

John Ruskin, "The Pass of Faido"

stones . . . become exponents of the fury of the river by which he has journeyed . . . the defile beyond . . . is regarded . . . with awe. (VI, 35)

Although Ruskin claims to present the "reality" of the mountain pass, he here relies on Turner's "arranged memories" of an experience of the setting (VI, 41). What appears to be a description of nature turns out to be a disguised interpretation of art. I take this passage—and others like it—to represent one of the most significant compromises with Romanticism implicit in the method of *Modern Painters*. Ruskin claims that his object is to freshen man's vision of nature, that he praises Turner to teach men to love nature as God's work (VII, 9). Yet his strategy leads him to endorse the primacy of aesthetic experience and the necessity of understanding divine art in terms of human art. In the structure of his argument, painting becomes a substitute for landscape, although Ruskin insists that his intention is exactly the opposite.

Logically, only a slight shift in tone is required to change the assertion that one should study nature through Turner to a demand that one should study Turner in nature. Ruskin himself made this step well before publication of *Modern Painters* when, in his diaries, he began to note "Turnerian" effects in actual seascapes and sunsets. Similarly, the "excursions" into nature in *Modern Painters* seem to take on new overtones as they lead more and more regularly to Turner's works. At first, Ruskin carries us into the landscape for confirmation of Turner's accuracy as a guide to natural effects; but it does not take long for us to feel that the aim of these journeys shifts from the appreciation of nature to the appreciation of art. The message and thrust of the book ceases to be, "Look at Turner to understand nature," and instead becomes, "Examine nature to appreciate the parts of Turner you could never understand," or else simply, "Look at Turner, for that experience is the closest equivalent to looking at nature with insight and awareness." Toward the end of the first volume, Ruskin remarks that "there is no test of our acquaintance with nature so absolute and unfailing as the degree of admiration we feel for Turner's painting." The passage goes on to suggest that the proper "use" of all natural experience is to enlarge our grasp of Turner's wisdom: "We may range over Europe, from shore to shore, and from every rock that we treat upon, every sky that passes over our heads, every local form of

vegetation or of soil, we shall receive fresh illustrations of his principles, fresh confirmation of his facts" (III, 610). The title of the chapter itself, "The Truth of Turner," implies the equivalence of his landscape to the real one. And the position of this chapter at the conclusion of the first volume suggests that all Ruskin's lessons about mountains, rocks, and clouds culminate in our informed appreciation of one of Turner's masterpieces. The section on "Truth of Skies" in *Modern Painters I* concludes with an elaborate catalogue of some sixty "effects of light" at various periods of the day, beside which are titles of "representative" works by Turner in which these effects can be observed. Turner's art becomes a kind of second nature, a necessary and perhaps even sufficient object for our study and admiration.

*Modern Painters* comes closer to being an "aesthetic" book than Ruskin would have liked to admit, principally because of the intensity of his prose. Repeatedly he uses nature as an occasion for his own verbal landscape painting; and while the energy of language provides an index to the energy in nature or in Turner, it is also meant to be appreciated for its own sake—at least we cannot help doing so. It is true that Ruskin never advocates anything like art-for-art's-sake, a doctrine he was to attack toward the end of his career. The second landscape, after all, is sacramental: we enter it, not for the sake of art, but to experience a glimpse of the divine. Yet we seem to be closer to God when viewing art than when viewing nature; and the greatest passages of Ruskin's prose stand as tributes to the power of the human artist who made divine visions accessible to a ritual of interpretation. The first volume, for example, exhibits the strongest traces of the youthful, Romantic-evangelical Ruskin, whose intense perception of nature validates a personal condition of spiritual grace. Yet many of the most religiously expressed accounts of nature in *Modern Painters I* are in fact disguised accounts of landscape art. A striking example is one of the longest fables of perception—a passage that Ruskin himself claims to have had an autobiographical basis. It seems designed to test his principles against the "truth" of nature, but it actually reveals nothing less than the "truth" of art. In this vivid portrait of a "real" scene from nature, Ruskin "uses" pictures to create a substitute landscape, one in which our own response to his ritual of interpretation can be ideally heightened. The passage shows some of the consequences of Ruskin's examination

of art both for his perception of nature and for the texture of his prose.

At the end of his detailed analysis of the "Truth of Skies," Ruskin sums up his observations in a single, rich description. He begins by insisting, as elsewhere, that the reader himself go to nature to test the assertions of the book, whereupon he will find that "every scene which rises, rests, or departs before him . . . will illustrate to him, at every new instant, some passage which he had not before understood in the high works of modern art." Then Ruskin offers a beautiful example from nature, in a passage too intense and intricate to be duplicated by any artist except Turner:

> Stand upon the peak of some isolated mountain at daybreak, when the night mists first rise from off the plains, and watch their white and lake-like fields, as they float in level bays and winding gulfs about the islanded summits of the lower hills, untouched yet by more than dawn, colder and more quiet than a windless sea under the moon of midnight; watch when the first sunbeam is sent upon the silver channels, how the foam of their undulating surface parts and passes away, and down under their depths the glittering city and green pasture lie like Atlantis, between the white paths of winding rivers; the flakes of light falling every moment faster and broader among the starry spires, as the wreathed surges break and vanish above them, and the confused crests and ridges of the dark hills shorten their grey shadows upon the plain. Has Claude given this? (III, 415–416)

What is curious about the passage is that Ruskin's energy stems not only from his love of wild nature but also from his delight at finding in nature something quite different, a kind of art, a potential for illusion. We are learning to examine the landscape aesthetically by searching for effects which are most like those produced in human art; the governing analogy between art and nature suggests that nature itself has unreal qualities. Between that mountain peak and the plains below, the "night mists" shape and reshape themselves into an atmospheric montage, in which clouds imitate the other natural world beneath them. In this second landscape—defined more by the presence of artifice than by its higher moral plane—we see "fields . . . gulfs . . . channels . . . [and] rivers," so that when glimpses of the distant land appear between the clouds, it

is impossible to determine if the "white paths of winding rivers" are located on the earth or in the sky. Ruskin's language accentuates this ambiguity and even adds to the confusion by transforming the real "glittering" city into a place half-imagined, "like Atlantis."

Some of the imagery and part of the confusion is explained in footnotes. Ruskin identifies many of the specific visual "effects" with particular works by Turner. In the first two editions of *Modern Painters I* a note about the section reads, "Vignette to Milton: Temptation on the Mountain." There are eleven note references to other pictures, with subjects ranging from England to the Alps and even the Andes, in explanation of the presumed natural events Ruskin claims we would see from our "isolated" perch. But even with these notes, the meaning of the scene is not fully explained. How closely related is the writing to the pictures? Does the prose describe art or nature? In this case, the problem is complicated by Ruskin's reference to a picture illustrating another author, Milton. The references to Turner may mean that we will see and comprehend such complex displays of natural energy only after we have seen them expressed in art. But they also suggest that by viewing those artistic works we can experience the power of landscape as intensely as we would on the mountain itself.

Ruskin's intention seems clearer as the passage proceeds. A narrative controls the structure of the scene. Marginal notations in the book reveal that it is divided into four phases, following the passage of time: we progress from "Morning on the Plains" to "Noon with gathering storms," "Sunset in tempest, Serene midnight," and finally "Sunrise on the Alps." As the account proceeds toward dawn, there are more footnotes to Turner's drawings, and the artifice of the prose becomes increasingly obtrusive. But the moral content of the scene also grows more apparent. It is as if the joint presence of Ruskin and Turner "behind" the seemingly real landscape must be established before we can be introduced to its inherent "messages." Indeed, many of those "messages" seem more dependent on the artist, the subject, or the associations of the scene in the picture referred to, than on the particular qualities of a natural event. The next footnotes, referring to Turner's "St. Maurice (Rogers' Italy)," "Vignette, the Great St. Bernard," "Vignette of the Andes," and "St. Michael's Mount (England Series)," seem to embody a complex pattern of moral allusions, which carry us

well beyond the limited moral suggestions of Ruskin's "scene."

The concluding prose links this complex interaction between art and nature to a growing religious perception "in" the landscape. The time, as the marginal notation explains, is "Sunset in tempest":

> as the sun sinks, you shall see the storm drift for an instant from off the hills, leaving their broad sides smoking, and loaded yet with snow-white, torn, steam-like rags of capricious vapour, now gone, now gathered again; while the smouldering sun, seeming not far away, but burning like a red-hot ball beside you, and as if you could reach it, plunges through the rushing wind and rolling cloud with headlong fall, as if it meant to rise no more, dyeing all the air about it with blood. Has Claude given this? (III, 417–418)

The note to the first half of the passage (up to the semicolon) refers us to Turner's "Illustration to the Antiquary" and to one of Ruskin's favorite pictures, the "Goldau, a recent drawing of the highest order." The other half is related to Turner's "Vignette to Campbell's Last Man." It would seem that we are meant to respond to this natural melodrama not only in terms of Ruskin's imagery and rhetoric but also in light of the ominous subject of Campbell's poem, the sublimity of the Goldau drawing, and the stern moral authority (as Ruskin reads him) of Scott. The passage thus combines description and evocation with allusion, and in this sense the scene dramatizes not only Turner's fidelity to natural phenomena but the depth and complexity of his moral imagination.

Finally, as "the east again becomes purple," the medium of art enables Ruskin to glimpse an actual divine presence in the landscape. The ritual tone merges with specific religious content. As if in further recognition of the vastness of the subject, he refers us to other works by Turner—"Alps at Daybreak (Rogers' Poems): Delphi, and various vignettes." "Watch," he tells us,

> the white glaciers blaze in their winding paths about the mountains, like mighty serpents with scales of fire: watch the columnar peaks of solitary snow, kindling downwards, chasm by chasm, each in itself a new morning; their long avalanches cast down in keen streams brighter than the lightning, sending each his tribute of driven snow, like altar-smoke, up to the heaven; the rose-light of their silent

domes flushing that heaven about them and above them, piercing with purer light through its purple lines of lifted cloud, casting a new glory on every wreath as it passes by, until the whole heaven, one scarlet canopy, is interwoven with a roof of waving flame, and tossing, vault beyond vault, as with the drifted wings of many companies of angels: and then, when you can look no more for gladness, and when you are bowed down with fear and love of the Maker and Doer of this, tell me who has best delivered this His message unto men. (III, 418–419)

Ruskin intends us to be dazzled by writing of this sort, and to answer that final question with his name as well as Turner's. For by the final lines of this "description" we have wholly abandoned any physical landscape: there are no traces of the original "scene" or of its representation in any works of art. It is for this second landscape—of which, in his Puritan theology, the phenomenal landscape is only a type—that Ruskin must invent a language of his own. As if to contrast this journey through the veil of physical nature with the descriptions at the beginning of the mountain scene, Ruskin again allows us to glimpse a city between the clouds. But this time, between the light of sunrise and its reflections off the peaks, we discover the architecture of a celestial city, its "scarlet canopy . . . interwoven with a roof of waving flame . . . tossing, vault beyond vault, as with the drifted wings of many companies of angels." Each stage of this vision takes us another remove from nature—and it is only after we have seen the clouds forming a palace that we can see its roof as a lattice of angel wings. The use of the simile itself suggests that Ruskin is depicting effects as much beyond the power of language as beyond the power of sight. Finally, we can "look no more," our eyes lowered as our heads are "bowed down with fear and love." What we "see," then, is no longer before us. Ruskin later provides the theoretical justification for such unseeing vision in his discussion of pathetic fallacy in *Modern Painters III.*

At this point in the natural description, Ruskin includes few references to specific works of art. It is as if painting (and his own prose) has carried us beyond a precisely identifiable scene: we glimpse the landscape of the creative imagination. Ruskin's footnotes, which elsewhere in this passage clarify his language by pointing to its source in specific pictures, only add to our

confusion here. The reference to "various vignettes," for example, seems deliberately obscure, an allusion to a quality of Turner's art in general rather than to characteristics of specific works. Even the editors of the Library Edition failed to identify the reference to a work called "Delphi"; perhaps Ruskin selected the name in a semiconscious allusion to the mystery and oracular power of the greatest art. Thus, the entire passage moves away from a single description of nature and toward an evocation of an ideal response to it, one engaging a broad range of faculties in the act of apprehension. Our experience transpires through many media simultaneously: the actual landscape, visual art, and a variety of Biblical and literary allusions, all contained in the rich medium of Ruskin's prose. This almost archetypical mountain-top vision engrosses the whole being of the reader through the composite art of the ritual of interpretation.

As in Blake's composite art, illustrations are required to address the reader, and express the writer's vision, in the widest range of available modes. Ruskin's illustrations to *Modern Painters* form an essential dimension of the book's rhetorical structure. They first appear in the third and fourth volumes, published simultaneously in 1856; Ruskin had already illustrated his own work, beginning with *The Seven Lamps of Architecture* in 1849 and later in *The Stones of Venice*. By the mid-fifties, Ruskin's tastes in art have altered: other painters share the rank he first extended only to Turner; landscape painting no longer dominates all other modes. Yet Ruskin's illustrations for the last three volumes embody an extended visual demonstration of the relation between the two landscapes, factual and visionary, predominantly exemplified in pictures by Turner and by Ruskin himself. It is as if he was actually illustrating *Modern Painters I*. He is, in fact, giving visual form to what remains the central concept of the book.

The illustrations for *Modern Painters* are of two sorts: full-page engravings (including a frontispiece to each of the last three volumes) and woodcuts incorporated with the text. Almost all of the woodcuts (225 in all) are images of the first kind of landscape—pictures showing details of the formation of rocks, mountains, clouds, or plants, occasionally taken from paintings but usually drawn from nature by Ruskin himself. The full-page engravings more frequently show famous works of art discussed in the text. Of these 90 plates, half are by Ruskin and more than

58                                                            *John Ruskin*

25 by Turner. As we might expect, the drawings by Ruskin tend to be pictures of the landscape of fact, just as those by Turner tend to portray the landscape of vision. Thus, as in Ruskin's prose, detailed attention to the "facts" of nature prepares us for a few consummate portraits of its meaning and power. The plate appearing as the last illustration in the final volume (although included only in 1888), Ruskin's own etching of Turner's "The Lake of Zug" (see illustration), seems to embody that pure form of nature we have been prepared to glimpse by the simultaneous dramas of words and images through the rest of *Modern Painters*.[11]

The pattern of Ruskin's illustrations, then, is no less educative than the pattern of his prose. The entire cycle of plates forms an exercise book for students of Ruskin's landscape vision: to absorb the lessons of the text, the reader must learn to trace with him the various aspects of Turner's own greatest pictures of nature, until their hierarchy of "truths" can be grasped. This visual program is not far removed from the technical exercises arranged in *The Elements of Drawing*, published in 1857 while the final volume of *Modern Painters* was being prepared. Even in his manual, Ruskin does not view the craft of drawing as an end in itself. The physical process of recording external forms activates and guides deeper responses to the vital "truths" of nature. The object of the book is not so much accurate drawing as "seeing truly . . . I would rather teach drawing that my pupils may learn to love Nature, than teach the looking at Nature that they may learn to draw" (XV, 13). The various studies are designed to "lead" the reader to "discoveries of natural loveliness" (XV, 131).

*The Elements of Drawing* illuminates the comprehensive role Ruskin assigns to visual art in modern society. What might be expected to read as a dry, technical manual turns out to be an ambitious aesthetic program in which the labor of the hand activates and trains the entire consciousness. "You may always render yourself more and more sensitive to . . . higher qualities by the discipline which you generally give to your character" (XV, 206). Drawing exercises comprise a ritual for mental education, a controlled framework in which Ruskin educates the whole being: "Habits of patient comparison and accurate judgment will make your art precious, as they will make your actions wise; and every increase of noble enthusiasm in your living spirit will be measured by the reflection of its light upon the

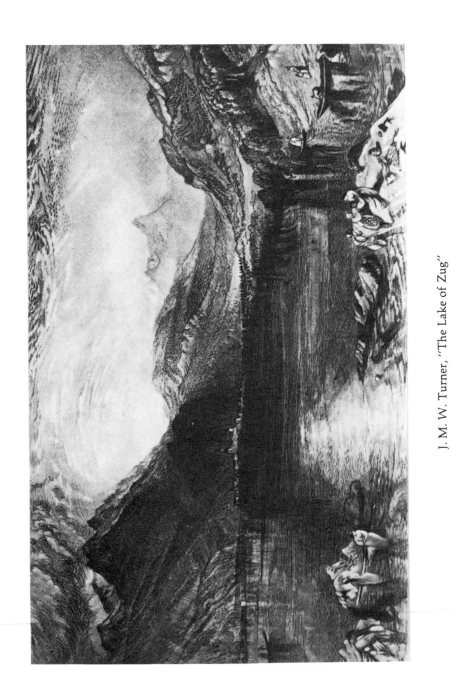

J. M. W. Turner, "The Lake of Zug"

works of your hands" (XV, 211). As Ruskin writes a year later in *The Two Paths*, "Fine Art is that in which the hand, the head, and the *heart* of man go together . . . Thoroughly perfect art . . . thus brings out the whole man" (XVI, 294–295).

### The Rhetoric of Aesthetics

There is increased attention to aesthetic theory after the first volume of *Modern Painters*, but there is no corresponding diminution of Ruskin's rhetoric. He treats theoretical discussions as another mode of exhortation, and even his most abstract accounts of art or the mind invite the reader to transform his sensibility. Most typically Ruskin defines imagination hierarchically, ranking different levels of thought in terms of various responses to a single subject or theme. But invariably the scale becomes a ladder; the analytic distinctions between greater and lesser intellects become stages of progress in a graduated lesson in self-culture. Thus, his major aesthetic discussions place special emphasis on the relations between genius and average minds: Ruskin must demonstrate that everyone can understand some of the impulses behind great art and assert that such appreciation, for most readers, can form the basis of a fundamental transformation of the self. If the materials of genius are universal psychic property, then Ruskin's own rituals of interpretation have validity for the widest possible audience.

In this sense the essential argument of *Modern Painters* alters very little over five volumes, despite the growth of the project well beyond the initial defense of Turner's "truth." By the second volume, published in 1846, for example, Ruskin has discovered the "purist" religious painting of the early Renaissance; corresponding to this less parochial focus, the tone of the book is calmer and more meditative, with few of the oratorical rhapsodies employed in the youthful descriptions of nature. Yet despite a new emphasis on analysis and abstract theory, Ruskin continues to address his audience in the accents of the sage, the tones audible in *Modern Painters I*. His goal, according to the opening pages of the second volume, remains public: "to summon the moral energies of the nation to a forgotten duty, to display the use, force, and function of a great body of neglected sympathies and desires, and to elevate to its healthy and beneficial operation that art which, being altogether addressed to them, rises or falls with their variableness or vigour" (IV, 28).

*Modern Painters*                                                             61

Ruskin thus begins his analysis of the theoretic faculty, and his most thorough definition of the imagination, by insisting on the "utility" of a full and healthy response to beauty.

Of course the "use" of theoretic faculty is in setting "the glory of God more brightly before us" (IV, 29); Ruskin's is, in the words of Jerome Buckley, a "moral aesthetic."[12] He develops the concept of *theoria* to indicate the links between a healthy imagination and the divine. There are, in fact, two different forms of perception, and it is only by popular error that the capacity of responding to beauty has been labeled "aesthetic." The aesthetic faculty is a lower order of mind, apprehending "mere" sensual (and as it turns out, superficial) qualities of things, the other entering into the nature and life of what it perceives. Beauty, he insists, is a moral quality; the perception of the beautiful through the theoretic faculty is a moral act. Only the sensual world reaches us through *aesthesis*, "the mere animal consciousness of . . . pleasantness." As his language suggests, this is a lower form of awareness. But having defined this hierarchy of consciousness, Ruskin suggests that in fact it is a continuum of mental states. *Aesthesis* and *theoria* are separable only in the abstract; they ought to merge in the exercise of the theoretic faculty itself. Much of the chapter on *theoria* explains how the more common faculty, *aesthesis*, can be "elevated" to the higher "rank"—how, that is, a mind can transform itself. Ruskin explains: "when the pleasures of sight . . . instead of being scattered, interrupted, or chance-distributed . . . are gathered together, and so arranged to enhance each other as by chance they could not be, there is caused by them not only a feeling of strong affection towards the object in which they exist, but a perception of purpose, and adaptation of it to our desires; a perception, therefore, of the immediate operation of the Intelligence which so formed us, and so leads us" (IV, 47). The distinction is of degree rather than kind. Indeed, Ruskin's final phrase implies that man is constantly being led to this higher level of perception, if only he would respond. *Theoria* comes to stand for a human potential realized, a form of perception that includes the activity of man's entire consciousness, indeed, the whole of his being. George Landow has explained that in the tradition of "the emotionalist moral philosophers," Ruskin uses the "term 'moral' to mean simultaneously 'ethical' and 'referring to all mental processes.' "[13] In

this sense the analysis of *theoria* can be seen as another appeal for imaginative health through unified sensibility.

By *Modern Painters III*, this tone has altered somewhat. The plea for health becomes an attack on sickness. The chapter on pathetic fallacy especially reveals a deep ambivalence (even hostility) toward the imagination itself, largely because of its potential to be excessive and to be deceived. Once again, however, Ruskin is simply insisting on the necessity of keeping the two landscapes in contact with one another. He argues for the importance of distinguishing between metaphor and fact to avoid mistaking one for the other; poets fail when they confuse their imagined landscapes with those in reality. This confusion is what the phrase "pathetic fallacy" is all about. The sensitive and overly sympathetic imagination of many nineteenth-century poets tends to project its own pathos upon nature, producing false descriptions of nature as endowed with human emotions. Ruskin quotes as an example a line from Kingsley's *Alton Locke* referring to the "cruel, crawling foam." Although forceful as an expression of the poet's grief, the phrase describes foam inaccurately—the ocean is not "cruel." Such misconstructions reveal the alienation of modern man from nature; poetry has lost touch with the external world.

Like many Romantic critics before and after him, Ruskin insists that such an alienation of man and his universe betrays the alienation of man from himself. He echoes the Romantics in appealing for what Yeats would later call "unity of being"; and the chapter "Of the Pathetic Fallacy" bears a strong resemblance to T. S. Eliot's remarks on dissociation of sensibility in his essay on the Metaphysical Poets. Like Eliot after him, Ruskin finds modern art corrupted by the dominance of feeling over thought. Both find a major source of this imbalance in what Ruskin calls the "fatal" seventeenth century. Each urges his contemporaries to return to unembellished "descriptive" styles to combat the failure to distinguish reality from views of it. Their language becomes strikingly alike as both men denigrate the authors of "dissociated" verse. Eliot attacks the school of poets that "thought and felt by fits, unbalanced."[14] Ruskin characterizes the authors of pathetic fallacies as "of a mind and body in some sort too weak to deal fully with what is before them; borne away, or overclouded, or over-dazzled by emotion" (V, 208). In "The Moral of Landscape," another chapter from *Modern*

*Painters III*, he describes them as "not of the first order of intellect," writers whose "feeble power of thought" perhaps develops "itself most at times when the mind is slightly unhinged by love, grief, or some other of the passions" (V, 360).

Yet like Eliot, Ruskin channels his critical energy into the presentation of a revolutionary aesthetic. The rhetorical structure of *Modern Painters* as a whole demonstrates the vital connection both between two forms of reality and between two seemingly disparate methods of perceiving the world. The chapter on pathetic fallacy—at the center of the middle volume of the book—expresses Ruskin's theoretical justification for a new mode of apprehension and provides its fullest definition. After demonstrating the unhealthiness and fragmentation of the world view implicit in modern art, Ruskin outlines the process by which a fragmented sensibility can once again become whole. Thus, the description of a flawed modern psyche becomes a prescription for its renewal. The chapter begins by attacking certain popular categories of aesthetic experience that Ruskin views as symptomatic of the divided modern sensibility: "German dullness, and English affectation, have of late much multiplied among us the use of two of the most objectionable words that were ever coined by the troublesomeness of metaphysicians,— namely, 'Objective,' and 'Subjective' " (V, 201). The essay as a whole represents an attempt to merge objectivity and subjectivity, not merely as aesthetic categories but also as attitudes toward experience which ought to coexist in the balanced products of the greatest art. Ruskin searches for a larger and higher category to encompass both of them, a frame of mind in which the distinction between objective and subjective becomes meaningless. This imaginative condition is at once the type of the greatest art and the attitude toward which the reader ought to strive to broaden his own perception of reality.

Simultaneously, then, Ruskin describes different levels of artistic genius and distinctions among the mental habits by which all men live. To dramatize the human meaning of his aesthetic categories, he presents them through a series of characters, in what Landow calls "psychological portraits" of the different sorts of artists he has in mind.[15] The mere fact of describing art forms psychologically extends the implications of Ruskin's argument: there is a continuum between the most universal psychic conditions and the mental processes expressed in the greatest masterpieces of art. Analyzing the arts enables

*John Ruskin*

Ruskin to catalogue various fundamental modes of human consciousness and perception. The fine arts provide a standard against which anyone can measure his own aesthetic capacity. With a frame of reference so broad, it is a small step for Ruskin's analysis to become rhetorical, for description to encompass prescription as well. The ranking of various levels of imaginative power implicitly defines another pathway, or ladder, to vision. As soon as he begins to compare different forms of imagination, it is clear that he is referring not only to different types of minds, but also to different phases of development through which anyone's imagination might pass. The "classes" of imagination he describes are "united each to the other by imperceptible transitions, and the same mind, according to the influences to which it is subjected, passes at different times into the various states" (V, 209).

Ruskin at first lists three levels of imagination. His standard is the response to a single flower. Lowest is the man "who perceives rightly because he does not feel, and to whom the primrose is very accurately the primrose, because he does not love it. Then, secondly, the man who perceives wrongly, because he feels, and to whom the primrose is anything else than a primrose." This man commits the pathetic fallacy. Finally, "there is the man who perceives rightly in spite of his feelings, and to whom the primrose is for ever nothing else than itself—a little flower apprehended in the very plain and leafy fact of it, whatever and how many so ever the associations and passions may be that crowd around it" (V, 209). But imaginative clarity of this sort requires strict intellectual control, which is achieved only when the entire imagination functions harmoniously. In that "grand" condition when "the intellect also rises, till it is strong enough to assert its rule against, or together with the utmost efforts of the passions," the artist creates a new harmony within himself: "the whole man stands in an iron glow, white hot, perhaps, but still strong, and in no wise evaporating" (V, 207).

What makes this analysis so significant is that, even after defining the personal wholeness implied in artistic control, Ruskin extends his imaginative hierarchy to posit a fourth and highest level of expression. For "however great a man may be, there are always some subjects which *ought* to throw him off his balance." There is an art, that is, which resembles pathetic fallacy without being either pathetic or fallacious, for its subjects necessitate strained, intense, even incoherent expression. In

the face of certain visions, an artist's "poor human capacity of thought should be conquered, and brought into the inaccurate and vague state of perception, so that the language of the highest inspiration becomes broken, obscure, and wild in metaphor" (V, 209). It is appropriate, Ruskin explains, that the author of the book of Isaiah should be "stunned" and impelled "into a confused element of dreams." He is properly bewildered in the presence of God. Isaiah's language is inaccurate as physical description but nevertheless justified. The false metaphors provide a true expression of the mind's vision of nature in a moment of divine inspiration: " 'The mountains and the hills shall break forth before you into singing, and all the trees of the field shall clap their hands' " (V, 215–216).

At this stage in his argument Ruskin would seem to have abandoned prescriptive aesthetics. Yet it is difficult not to read this discussion as an explanation, or even a defense, of the excesses of his own prose. I have in mind not only the joyfully visionary moments in the first volume of *Modern Painters* but the terrible, apocalyptic glimpses of the destruction of civilization and nature that become more dominant around the time of *The Stones of Venice*. Ruskin seems anxious to find an aesthetic category which will demonstrate the veracity of his most personal, and sometimes pathological, interpretations of the world. He is defining as the highest level of aesthetic utterance a form of art whose truth can only be verified internally, according to style.

There is another description of different levels of imagination in *Modern Painters III*, but this account is of different perceptions of reality, not of different styles. For this reason, perhaps, Ruskin makes it even more explicit that each category embodies one aspect of what should be a fuller, integrated, apprehension of the world. And he even suggests how such a unified perception might be obtained. In the chapter on "The Moral of Landscape," Ruskin gives a fictional account of the approach of four men to a clump of pine trees. Each sees the object differently from his companions. An engineer views the trees in practical terms; an artist, in terms of line and color; a third man lets his memory stray and loses sight of nature altogether in his revery. Only the last man truly sees—and he blends all three perspectives into one.

This "fable" of vision implies that literature can solve the problem of representing the complexity of art or nature by the

use of personae or masks. As shown by the ranging styles of *Modern Painters* itself, a variety of perspectives only enhances the harmony with which we view any subject: "The power . . . of . . . fully perceiving any natural object depends on our being able to group and fasten all our fancies about it as a centre, making a garland of thoughts for it, in which each separate thought is subdued and shortened of its own strength, in order to fit it for harmony with others; the intensity of our enjoyment of the object depending, first, on its beauty, and then on the richness of the garland" (V, 359). Successful art must, as Wordsworth had written, both half-create and half-perceive.

Ruskin's notion of the "garland" of art provides his clearest articulation of the meaning of the stylistic drama of *Modern Painters*, but it also suggests the inevitable weakness of the book. To convince us of their wholeness, diverse images must focus on an appropriate object, one that adequately symbolizes their complexity. Ruskin's problem throughout *Modern Painters* is to demonstrate that his many interests are one, and that his argument is not simply "Of Many Things," as the third volume is titled. His subject is the unity of the human imagination when ordered by the perception of truths outside itself. The main weakness of the volumes stems from their lack of a single, compelling focus around which to define this wholeness. But by the time Ruskin wrote the third volume, he had already discovered a subject embodying the unity as well as the diversity of his complex vision. In a sense, this subject can be seen as a single work of art, as rich as the whole of Turner's opus, yet symbolically, if not physically, one. The subject is Venice.

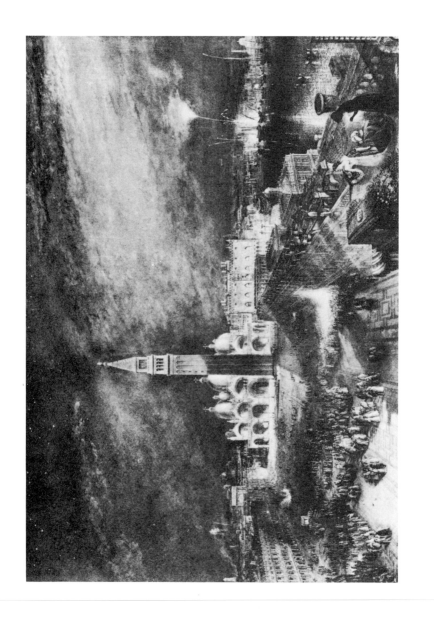

J. M. W. Turner, "Juliet and Her Nurse" (engraving by George Hollis)

# III

*Venice:*
*The Drama*
*of*
*Architecture*

From his first attempt to reply to Turner's critics, it was inevitable that Ruskin would write about Venice. The painting he defends specifically in the abortive article of 1836, "Juliet and Her Nurse" (see illustration), is set in Venice rather than Verona, and the description suggests a response not only to Turner but to the enchantment of the city:

> Many-coloured mists are floating above the distant city, but
> such mists as you might imagine to be aetherial spirits, souls
> of the mighty dead breathed out of the tombs of Italy into
> the blue of her bright heaven, and wandering in vague and
> infinite glory around the earth that they have loved . . .
> And the spires of the glorious city rise indistinctly bright
> into those living mists, like pyramids of pale fire from some
> vast altar . . . That this picture is not seen by either starlight,
> sunlight, moonlight, or firelight, is perfectly true: it is a light
> of his own, which no other artist can produce, —a light which
> seems owing to some phosphorescent property in the air. The
> picture can be, and ought only to be viewed as embodied
> enchantment, delineated magic. (III, 638–639)

In "Juliet and Her Nurse" the young critic extolls a painting representing the middle period in Turner's artistic development.

The night sky over the glowing city prophesies the brilliant confusion of later pictures, while the main scene—as in earlier paintings—remains more sharply defined, filled with figures moving in carefully delineated space, beside detailed renderings of architecture. This painting contains all the aspects of Turner's art Ruskin tries to illustrate in the ranging styles of *Modern Painters:* energy and control, prophetic vision and naturalistic detail, allusions to literature and morality. For Turner, one senses that all these possibilities were fused by the presence of Venice itself, as if Verona were too small to contain the picture's Shakespearean theme. His mislocation of the action is explained in part by the "embodied enchantment" of the city. When Ruskin later compares the "mightiness" of Turner's imagination to Shakespeare's, he pays tribute not just to painterly skill but to the aesthetic commitment, before the actual moment of creation, to a site appropriate to the richness of the artist's vision.

There is an even earlier discovery of Venice in Ruskin's life, again through the medium of Turner. A Turner vignette of a canal-level view of the Piazza San Marco and the Ducal Palace illustrates Samuel Rogers' poem on Venice (see illustration), part of the gift edition of *Italy* that moved Ruskin profoundly in 1832. In *Praeterita* Ruskin writes that the volume first revealed to him the beauty of landscape art and the power of Turner; clearly it also prepared for some of his central insights into the meaning of Venice. Reading the poem alongside the tiny engraving creates the illusion that we are observing the genesis of Ruskin's literary masterpiece:

> There is a glorious City in the Sea,
> The Sea is in the broad, the narrow streets,
> Ebbing and flowing; and the salt sea-weed
> Clings to the marble of her palaces.
> No track of men, no footsteps to and fro,
> Lead to her gates. The path lies o'er the Sea,
> Invisible; and from the land we went,
> As to a floating City—steering in,
> And gliding up her streets as in a dream,
> So smoothly, silently—by many a dome
> Mosque-like, and many a stately portico,
> The statues ranged along an azure sky;
> By many a pile in more than Eastern pride,
> Of old the residence of merchant-kings;

## VENICE.

THERE is a glorious City in the Sea.
The Sea is in the broad, the narrow streets,
Ebbing and flowing; and the salt sea-weed
Clings to the marble of her palaces.
No track of men, no footsteps to and fro,
Lead to her gates. The path lies o'er the Sea,
Invisible; and from the land we went,
As to a floating City—steering in,
And gliding up her streets as in a dream,

Page from Samuel Rogers, *Italy,* with J. M. W. Turner, "The Doge's Palace, Venice"

The fronts of some, tho' Time had shattered them,
Still glowing with the richest hues of art,
As tho' the wealth within them had run o'er.

The most moving chapters of *The Stones of Venice* employ
precisely these sights, these themes, and this tone and cadence.
Like Rogers, Ruskin devotes special discussion to the Ducal
Palace, to St. Mark's, and to the peculiar ceremony in which the
nobles of the town give their daughters in marriage on the same
day each year. Ruskin, like Rogers, describes the approach to
the city from Padua and its miraculous distant beauty when first
sighted across the water. Indeed, it was in *Italy* that he probably
first found an allegorical account of the city's historical decline:

Then she felt
Her strength departing, yet awhile maintained
Her state, her splendour; till a tempest shook
All things most held in honour among men,
All things the giant with the scythe had spared,
To their foundations, and at once she fell.

As Ruskin declares in a footnote to the first volume of *The
Stones of Venice*, "There is more true expression of the spirit of
Venice" in Rogers' *Italy* "than in all else that has been written of
her" (IX, 28).[1]

Just as Ruskin always assigned a symbolic importance to his
first looking into Rogers' *Italy*, so Venice always maintained a
symbolic identity in his mind. The city he finds in Rogers and
Turner represents beauty and the power of imagination, the
capacity to dream as well as man's need to give his dreams
shape and substance in art. This symbolism is central to the
meaning of *The Stones of Venice*. Venice is at once a more
tangible and more elusive subject than the art and nature
anatomized in *Modern Painters*. It has a literal solidity, that
monumental quality implicit in the title's reference to "stones."
But Venice also possesses a shimmering, misty, Turnerian
vagueness.[2] Ruskin hints repeatedly that its beauty is the
beauty of illusion. In the end it is this enchanted city that "falls"
—to use one of the central metaphors of the book—from Gothic
purity into the materialism of the Renaissance. But at the height
of its powers, Venice embodies that precarious balance between
reality and imaginative experience which Ruskin idealizes in
Turner and tries to dramatize in the prose of *Modern Painters*. It

is a kind of visible dream, an ideal given actuality, an "embodied enchantment." The city represents the sort of medium between man and nature that Ruskin also identifies in Turner's landscape painting. It is "a city in the sea," a half-natural artifact. Venice possesses at once a varied, organic life and a frozen unity, as of a perfectly carved icon, a static beauty which anticipates that of Yeats' Byzantium.

*The Stones of Venice* may be seen as the legend of an ideal civilization, from its rise to its moral, social, and artistic collapse. Readers frequently concentrate on the last phase of this history; but Ruskin devotes at least as much time, and possibly more care, to a portrait of the city's virtues as to the anatomy of its vice. Although much of the energy of the book is consumed attacking Renaissance degradation, this intensity reflects the extent of the achievements attributed to Venice before its fall. Ruskin adulates fourteenth century Venice as a social work of art. Mirroring the grace and energy of its architecture, Venetian life seems to have attained harmony and perfection. In the opening chapter, he details the many strengths of character that prevailed in the charmed, Gothic moment: "noble individual feeling" and "vitality of religion in private life," "dignity" in commercial transactions, "a healthy serenity of mind and energy of will expressed in all their actions, and a habit of heroism which never fails them, even when the immediate motive of action ceases to be praiseworthy." Venice contained "a people eminently at unity in itself" (IX, 23–27). Ruskin enlarges on this praise while lamenting the ultimate disappearance of the qualities that had made the Gothic city a model of personal and social grace: "the glowing life and goodly purpose . . . the whole majesty of humanity raised to its fulness . . . That mighty Humanity, so perfect and so proud, that hides no weakness beneath the mantle, and gains no greatness from the diadem; the majesty of thoughtful form, on which the dust of gold and flame of jewels are dashed as the sea-spray upon the rock, and still the great Manhood seems to stand bare against the blue sky" (X, 178–179).

Between his visions of the Gothic and the Renaissance city, Ruskin's experience of Venice is deeply ambivalent. A predictable evangelical guilt succeeds his spontaneous aesthetic delight in what his puritan conscience would have recognized as the "immoral" arts of an "impure" religion. The letters to his parents written in the period of *The Stones of Venice* allude to

this conflict, containing repeated assurances that Ruskin, despite the appeal of Catholic iconography, is not tempted by Catholic religion. Similarly, the structure of the book balances rapture with fiery puritanical harangues. In a personal reading of the book, the culminating "fall" is Ruskin's as well as the city's. His shrill moralism seems the consequence, and the forced termination, of the earlier hymns to the lush Catholic paradise illustrated in St. Mark's porticoes. The history of a civilization parallels the autobiographical record of the repudiation of his first instinctive assent to the spell of Venetian beauty. Certainly the changes in tone within *The Stones of Venice* help explain some of Ruskin's new attitudes toward imagination in *Modern Painters III*, particularly his attack on the moral dangers of surrender to the pathetic fallacy.

But it would underestimate Ruskin to treat his different attitudes in *The Stones of Venice* as pathology. The strength of the book as a work of art is that it contains more than simply an evangelical voice, or more than just an ecstatic account of the city's grace. Ultimately, we are given many cities, many views of Venetian history, a variety of responses to its rich and complex identity. Even its beauty is complex, real but ineffable, pervasive yet in no single location fully tangible. Ruskin's intention is to present a diverse and changing image of Venice by offering a series of perspectives for interpreting it. Thus, the book achieves in extended form the multiple viewpoints he had needed to express the complexity of each of Turner's masterpieces. But while *Modern Painters* never fully conquered its tendency toward digressiveness, *The Stones of Venice* molds its ranging vision into unity and harmony. Ruskin moves the reader from place to place and shifts the grounds of his analysis. But it is always Venice being described, and this unity ensures the wholeness of the book.

The range of *The Stones of Venice*, then, represents an attempt to enumerate all the modes of the city's appeal. This technique strikes that balance between evocation and description, expression of an inner vision and realistic treatment of something external, which characterizes the Victorian literature of art. It possesses what Blackmur calls an "expressive form," but one objectified by the explicit presence of the city as its point of reference. Ruskin implies that Venice is larger than any single view of it. Yet all the views he presents are part of the mysterious totality of any full experience of the city. To put it

another way, *The Stones of Venice* is only a book; and no book—indeed, no single work of art—can fully portray the richness of this city.

In this respect not only is Ruskin close to his use of Turner and his view of nature in *Modern Painters,* but he treats Venice itself as a kind of second nature, a world or even universe in miniature. But as he explains in the chapter "The Nature of Gothic," no artist should strive to represent his universe perfectly; and Ruskin humbly refuses to offer a complete portrait of the Venetian world. Although his analysis is intricate, he strives to depict a city of Gothic, not Renaissance, richness and detail; his descriptions become complex not out of pride but from an implicit reverence for truths larger than one work of art can contain. Venice in this way becomes a double symbol, standing for the complexity of the world and for the difficulty of perceiving it or representing it in art.

The same deliberate complexity extends to the book's historical arguments. *The Stones of Venice* offers a collection of histories rather than a uniform historical perspective. Thus, the historical portrait of the city is composite; Ruskin comments at the outset on "the breadth of interest which the true history of Venice embraces" (IX, 18). There is a general chronological framework: Ruskin traces the history of the city from its "foundations" in barren swamps through three major periods, Byzantine, Gothic, and Renaissance (the period of the "fall"). But the reader is more conscious of shifts in theme and method of analysis than of shifts in time. Similarly, one could argue that the book is unified by the theme of architecture; yet the three volumes treat Venetian architecture in radically different theoretic and stylistic modes. The most significant arrangement of *The Stones of Venice* is imaginative, and to discern it, one must read each of the separate volumes in its own special terms.

There are three dominant historic modes in *The Stones of Venice,* and three corresponding styles. Ruskin alternately writes functional, social, and moral history, addressing us in technical, lyric, and sermonic styles. The relationships between these modes vary, and each appears to a different extent in the different volumes. But generally each comprises one volume's dominant voice, so that the book as a whole progresses through three distinct analytic modes. Volume I is largely technical, almost in the manner of a professional monograph. In it Ruskin examines architecture in terms not of specific monuments but of

its parts, tracing the development of different members of a building as a history of the adaptation of form to function. The second volume shifts in focus from function to beauty, and Ruskin employs his most evocative language to help us empathize with the spirit in which the finest buildings of the city were constructed. Although his subject is now a specific chronological span—the "First, or Byzantine Period" and the "Second, or Gothic Period" in the history of Venice—we are less conscious of time than of place (most of the chapters are named after islands or buildings); indeed, both periods seem to coexist in a kind of eternal present of aesthetic delight. The final volume is the most time-oriented; but there careful attention to chronology provides an ominous rhythm to underscore the steady decline of Venice into Renaissance depravity. Toward the center of the book, in the accounts of St. Mark's and "The Nature of Gothic," Ruskin's different modes and voices interpenetrate one another, but that is because in the central moments of Venetian history all the aspects of the city's complex identity seem to stand in articulate harmony with one another. The different treatments of history and civilization throughout *The Stones of Venice* enable us to understand the ingredients of its highest achievements.

The first stage of this argument is almost wholly technical, a kind of textbook of architectural forms. The initial volume of *The Stones of Venice*, which appeared by itself in 1851, returns to the most tediously factual style of *Modern Painters I*. It might be addressed solely to professionals (and Ruskin seems to speak specifically to architects at several points); but this in fact is quite the reverse of Ruskin's aim. The matter-of-factness of the volume has a clear educational function: it trains a general audience in a basic architectural vocabulary. And as in *Modern Painters*, factual prose prepares us for the more intense and superficially less exact interpretative writing that will follow. Here the "facts" are the different parts of a typical architectural form. Ruskin shows how their adaptation to various needs of site and function produces the whole range of Western architectural styles. We learn to view every architectural element as the product of a functional consideration, every building in terms of its adequacy to the needs of the builder. The volume itself is arranged like a building, working from the bottom up to reconstruct the practical basis of historic architectural styles. Beginning with a chapter on "The Wall Base," Ruskin describes in

separate chapters the essential functions and characteristics of walls, cornices, piers, shafts, capitals, arches, roofs, and different kinds of aperture; he adds an equally long section on ornament, again describing the conditions from which typical forms result. These are, as the title of the volume declares, *The Foundations*, a term that refers not only to the historical and physical foundations of Venice but to the methodological "foundations" needed to establish Ruskin's full interpretation of history. The first volume introduces what he calls the "foundations of criticism" (IX, 57), providing an objective standard for evaluating architectural styles and indeed for evaluating the state of culture itself.

Ruskin concedes in several places that this sort of analysis is not strictly historical. But although *The Foundations* does not describe the process by which forms actually evolved, its analysis in terms of materials and structural purpose enables Ruskin to derive standards of "abstract architectural perfection" (X, 92), against which history can be measured. He leads the reader "from the foundation upwards," to enable him to "find out for himself the best way of doing everything . . . I shall assure him that no one in the world could, so far, have done better, and require him to condemn, as futile and fallacious, whatever has no resemblance to his own performances" (IX, 73). The built-in values of a functionalist analysis of architecture are easily translated into an analysis of history: forms that serve their functions most fully but most simply, using available materials to the best advantage, meeting the needs of their builders while conforming to the demands of their site, are in some sense "noble," a virtue which extends to their builders as well. Ruskin's implicit historical judgments become apparent in the specfic buildings he selects to illustrate his technical points. Almost invariably it is a Gothic example that most fully combines the different needs and purposes under discussion, and that example is frequently Venetian. It is as if Ruskin has recreated, through an exploration of technical principles alone, the ideal city that will form the focus of the book. He demonstrates that Venice is an inevitable city, the best and only conceivable product of correct building and intelligent consideration of site and material.

The "drama of architecture" (IX, 395) thus becomes a metaphor for history, although not enacted in exact parallel to it. Even though forms do not develop in the stages Ruskin describes, the hierarchy of forms that he outlines serves as a basis

for determining whether the development of civilization represents genuine progress of moral decline. It is in this sense that he echoes Pugin's claim that the history of architecture is the history of the world.³ Ruskin's functional history can be used to measure the state of culture at any particular place and time. Generally such judgments are reserved for the last volumes of the book, but they are implicit in the examples Ruskin chooses in *The Foundations* to illustrate forms in a condition of great refinement and forms misshapen due to a failure to understand materials, function, or site. Whereas his examples of the former are almost always Venetian Gothic, it is no less significant that the examples of the latter are most frequently English. Discussion of tracery, for example, arrives at the "forms of perfect Gothic tracery without the smallest reference to any practice of any school, or to any law of authority whatever . . . They are eternal forms, based on laws of gravity and cohesion" (IX, 226). But then, recalling all the styles of arrangement he has rejected as "weak, dangerous, and disagreeable," Ruskin warns the reader that if he should "collect all these together, and practise them at once . . . you have the English perpendicular" (IX, 229). In this way, technical distinctions between two styles set the stage for moral comparisons between the histories of London and Venice in the volumes to follow. John Rosenberg has shown how this "theme of the two cities" passes from earlier tributes to Gothic by Pugin and Carlyle into *The Stones of Venice*.⁴ Visual allusions to England in images of past civilizations also run through the work of Turner.⁵ To this tradition Ruskin contributes a historical analysis conducted wholly in architectural terms. His focus on the elements of building gives his comparisons concreteness and objectivity; his moral standards seem intrinsic in architectural good sense.

There are, then, hints of Ruskin's full-blown theory of the history of Venice apparent in the first volume. But his aim in *The Foundations* is not so much to trace that history or develop the theory behind it as to establish an iconography, a language of interpretation through which architectural detail may be "read" for its moral content. In the structure of *The Stones of Venice*, the opening volume is essential to stress the act of interpretation itself; it establishes the importance of Ruskin's method, a method in which he hopes to instruct his audience and with which he hopes to alter their response to the contemporary environment. When moral judgments do appear in *The*

*Foundations*, the emphasis falls on the architecture from which they are derived; Ruskin is inculcating a technique of moral-architectural deduction. Here is one example: "The arch line is the moral character of the arch, and the adverse forces are its temptations . . . this, in arch morality and in man morality, is a very simple and easily to be understood principle,—that if either arch or man expose themselves to their special temptations or adverse forces, *outside* of the voussoirs or proper and appointed armor, both will fall" (IX, 157). Further, the decreasing clarity of ornament toward the top of a Gothic cathedral, which prevents us from attaining a perfect view from the ground, testifies to the willingness of the humble spectator or builder to "stay in his place" (IX, 298). Similarly, the distinct shafts in Gothic columns represent the uniqueness of each human soul as it is prized in Ruskin's very Protestant version of the medieval church. He discovers cornices in which this element seems "struggling" to emerge, but is still limited by Greek abstraction and "the Formalism of the Papacy." Naturalism reveals the genuine Christian element: "The good in it, the life of it, the veracity and liberty of it . . . are Protestantism in its heart; the rigidity and saplessness are the Romanism of it" (IX, 371). Early in the first volume Ruskin announces his determination to make "the Stones of Venice touch-stones" for "detecting, by the mouldering of her marble, poison more subtle than ever was betrayed by the rending of her crystal" (IX, 57). These early analyses of architectural detail provide methodological "foundations" for what he calls, after Shakespeare, his "sermons in stones."

Thus, although *The Foundations* introduces Ruskin's interpretation of the transition from the Middle Ages to the Renaissance, the emphasis remains upon art and technique, and upon the act of interpretation itself. As in *Modern Painters*, Ruskin narrates autobiographical fables of perception, in which his efforts to decipher Venetian art symbolize the aims and difficulties of interpreting art and life. He relates that one of the first monuments he sought out was the tomb of Andrea Vendramin, whose brief reign was "the most disastrous in the annals of Venice" (IX, 49). Historians had praised his tomb as "the very culminating point to which the Venetian arts attained by ministry of chisel." But Ruskin quickly learns that this attainment is corrupt. One hand of the doge's sleeping figure falls awkwardly across the body, solely to display "its fine cutting."

Even this workmanship is wasted, since "it has been entirely bestowed in cutting gouty wrinkles about the joints." In fact, the statue has no second hand and is "a mere block on the inner side. The face, heavy and disagreeable in its features, is made monstrous by its semi-sculpture" (IX, 51). It is not merely the spiritual deformity of Vendramin which shocks Ruskin, but the aesthetic failure of the sculptor. The "semi-sculpture" of the mask is what makes it "monstrous," an image of artistic depravity as well as official corruption: "Who, with a heart in his breast, could have stayed his hand as he drew the dim lines of the old man's countenance—unmajestic once, indeed, but at least sanctified by the solemnities of death . . .?" (IX, 52). In the final volume of *The Stones of Venice*, the failure to reverence death provokes Ruskin's strongest denunciations of Venetian depravity, but here he focuses on the offense against art. Indeed, the subsequent history of the sculptor adds a kind of aesthetic moral to Ruskin's fable of viewing the tomb: the sculptor was banished from Venice in 1487, for forgery!

Ruskin's second discovery of an aesthetic embodiment of the moral of history also concerns the spirit in which great art must be produced. It seems to imply an attack on the sort of audience that might read the first volume of *The Stones of Venice*—or even *The Seven Lamps of Architecture*—as a blueprint for architectural imitation; and Ruskin's books on architecture condemn imitation as vigorously as *Modern Painters* condemned imitation in visual art. Indeed, Ruskin views architectural imitation as a contradiction in terms: genuine architecture must be intrinsic; it must grow from real needs and an honest approach to the demands of materials, function, and environment. Mere duplication of style is doomed to aesthetic failure; and the late history of Venice supplies conclusive proof of this principle. Ruskin's researches reveal that the portion of the Ducal Palace on the Piazetta San Marco was completed in the fifteenth century, under the direction of Doge Tomaso Mocenigo, whose reign began at the time of the city's fall in 1423. The stones of the masonry completed at this time are less delicate than in earlier portions of the building, and the shafts grow correspondingly thicker. Indeed, the new architect "had not the wit to invent new capitals in the same style" as those in the rest of the palace, so he "clumsily copied the old ones."

For illustration, Ruskin compares two capitals from the Ducal Palace, a fifteenth century imitation and its fourteenth century

*John Ruskin*

original. The octagonal sides of each are decorated with figures of the Virtues. Those of the fourteenth century, although "somewhat hard-featured," have "vivid and living expression" and are dressed in plain contemporary clothes. Those of the fifteenth century have lost their austere features, "have now all got Roman noses, and have had their hair curled. Their actions and emblems are, however, preserved until we come to Hope." The motto "Spes optimo in Deo" is illustrated by a figure kneeling in reverent prayer. In the earlier version of the capital her prayers are answered by the visible hand of God "emerging from the sunbeams" of heaven in the relief above her. But in the fifteenth century version "she is praying to the sun only; *The hand of God is gone*" (IX, 55).

By the completion of all three volumes of *The Stones of Venice* such episodes confirm an analysis of history, and Ruskin calls the falsely imitated capital "accidental evidence" of "the inferiority of character of the Renaissance workmen." But there is a crucial *ad hominem* argument here as well, especially considering that the first volume was published in 1851, two years before the rest of the book. Ruskin is establishing a vocabulary of interpretation and also using architecture as a metaphor for the frame of mind he hopes to create in his audience. He is teaching us to have reverence for architecture as such, to be watchful for its insincere use. As he did with landscape painting, he is dramatizing the possibility that human sensibility may be refined through a study of architecture. If we learn to accept his first mode of analysis, the contemporary form of the mental failure evident in the Renaissance may be averted.

The interpretation of architecture, then, ought to be a moral act, both for the individual and for the state. *The Stones of Venice* begins by establishing the political necessity for an accurate "reading" of stones: "Since first the dominion of man was asserted over the ocean, three thrones, of mark beyond all other, have been set upon its sands: the thrones of Tyre, Venice, and England. Of the first of these great powers only the memory remains; of the Second, the ruin; the Third, which inherits their greatness, if it forget their example, might be lead through prouder eminence to less pitied destruction" (IX, 17). Both the historical comparison and the modern appeal are to be found in Byron's description of Venice in "Childe Harold's Pilgrimage" (IV, xiv, xvii): "In her youth she was all glory,—a new Tyre"; but now


thy lot<br>
Is shameful to the nations,—most of all<br>
Albion! to thee: the Ocean queen should not<br>
Abandon Ocean's children; in the fall<br>
Of Venice think of thine, despite thy watery wall.


But it is only in Ruskin that a prescription is given to avert a third such historical collapse.

The problem of history is one of distance: we can easily forget the lessons of the past. The Biblical accounts of Tyre affect us "only as a lovely song"; we "close our ears to the sternness of their warnings." Thus, the very concreteness of the remains of Gothic Venice give it a special "use" for the modern observer. Tyre's "successor,"


like her in perfection of beauty . . . is still left for our beholding in the final period of her decline: a ghost upon the sands of the sea, so weak—so quiet,—so bereft of all but her loveliness, that we might well doubt, as we watched her faint reflection in the mirage of the lagoon, which was the City, and which the Shadow.

I would endeavour to trace the lines of this image before it be for ever lost, and to record, as far as I may, the warning which seems to me to be uttered by every one of the fast-gaining waves, that beat like passing bells, against the STONES OF VENICE. (IX, 17)


The motif of the mirage recurs throughout the book, reminding us of both the difficulty and the necessity of understanding Venice. The motif also underscores the importance of Ruskin's exercise in perception for "reading" illusory images in the modern world. The city stands as a test of the capacity of England and its citizens to apprehend the nature of the world they inhabit. That the preservation of the first requires the reawakening of the second is the fundamental premise of Ruskin's book.

Yet the regeneration of England must involve more than new ways of thinking. The dual emphasis of *The Foundations* on interpretation and building technique makes Ruskin's Gothic Revival a comprehensive ritual with a potential to transform both the individual and society, internally and in terms of the physical realities of daily life. Kenneth Clark traces Ruskin's use of Gothic as a social model to Pugin's *Contrasts*, published in

1836: its plates contain "the germs of Christian Socialism and [Ruskin's] St. George's Guild," and from the entire volume "we may date the whole attempt to judge the value or a work of art by the moral worth of its creator."[6] But Ruskin goes beyond the mere relation of architecture and society, a building and its builders. He treats architecture as an instrument for reshaping the state through its citizens, educating them by its continued presence in the community. Interpreting buildings as we would paintings, with the guidance of Ruskin's prose, modern men and women can perpetually come into contact with natural, moral "truths," the ideals necessary for the achievement of a unified society. More important, perhaps, the process of construction itself makes architecture a living symbol for the entire community. As the focus of united labor, organized by shared beliefs, architecture calls into being the sort of organic world that Ruskin locates in the Gothic period. The act of building translates that recurrent dream of unified sensibility into a physical process, in which every member of society can, at some level, engage. Venice itself was "built by iron hands and patient hearts" (X, 9): a Gothic Revival, in Ruskin's terms, will use manual labor to awaken its necessary spiritual counterpart. *The Stones of Venice* begins with technical analysis to insist that the Gothic world can be reconstructed literally, and the Gothic mind recreated, by the work of modern Englishmen.

### Romantic History: Ruskin's "Sea-Stories"

"And so Barnabas took Mark, and sailed unto Cyprus" (X, 69). Opening the richly evocative chapter on St. Mark's Church —the central chapter in the central volume of *The Stones of Venice*—this quotation from Acts might well serve as the epigraph for all of the second volume, titled *The Sea-Stories*. Ruskin's subject is the rise of Venetian civilization, from its beginnings as a swamp settlement of fugitive tribes to its growth into the Byzantine and then Gothic city of the Middle Ages. But this history is related less as a chronicle of facts than as a magnificently ordered fiction, an epic or sacred legend. Ruskin's themes are of ocean and journey. As they reappear throughout the city's history, we sense that St. Mark's original voyage contained the pattern for all the subsequent events in the life of Venice. There is, first of all, the series of dramatic ocean journeys that led to the founding of Torcello, Murano,

and finally Venice itself. Other voyages mark the flowering of the city as "The Throne" of mercantile and political power, as the first chapter is titled. But Ruskin also narrates his own symbolic voyage into Venice, one that recapitulates Venetian history and enables us to perceive its essential meaning. This imaginative journey into the past provides our most vivid confirmation of the sacred quality of the Byzantine and Gothic periods: Ruskin's progress across the seas, into Venice, and finally up to one of its central monuments is presented as a return to Paradise.

The journey can serve as a metaphor for history in *The Sea-Stories* because there Ruskin is dramatizing the living quality of the Venetian past. Byzantine and Gothic architecture transform the events, values, and ideals of their contemporary life into permanent forms, which maintain a vivid existence in the present. This means not only that Ruskin can "read" Venetian history in its architecture, but that a sensitive appreciation of the monuments of the city enables him to enter history. This notion of living history is embodied in the title of the second volume which, as Ruskin wrote his father in 1851, has "the same kind of double meaning" as the title of the first.[7] The architectural reference in the phrase "sea-stories" is to the bottom levels of Venetian buildings, the architectural "stories" that come into contact with the sea. Thus, in *The Sea-Stories* the city's vital relationship with the sea as well as the epic of its written history is described in terms of a modern journey along its physical sea-stories. Ruskin shows that the weather-stained canal façades of Venice themselves embody the essential meaning and spirit of the city's past.

By the second volume of the book, then, the use of history has changed. Venice is first defined by the technical rhetoric of *The Foundations* as the ultimate refinement of architectural tradition, a process that eventually overrefines itself into the gaudiness, degeneracy, and pride of the Renaissance. In *The Foundations*, history unfolds according to the logic of architectural necessity: civilization advances when it discovers a higher step on the abstract ladder of architectural progress. But *The Sea-Stories* is more lyric, less concerned with function than with beauty, and thus, in a sense, is less historical even though concerned with a specific period of time. Ruskin looks at architectural monuments not as stages in a gradual process but as exquisite moments taken out of history, to be valued for their

expressive power. Even Gothic civilization, the central "period" around which the volume is constructed, is viewed as a kind of extended moment, when time pauses. The Ducal Palace embodies the precarious balance of history between progress and decline: "the majesty of this single building was able to give pause to the Gothic imagination in its full career; stayed the restlessness of innovation in an instant, and forbade the powers which had created it thenceforth to exert themselves in new directions, or endeavour to summon an image more attractive" (X, 328).

Ruskin justifies his lyric response according to history, in terms of the actual conditions of the Venetian past. Its greatest architecture was constructed in an age when life itself seemed to attain grace and perfection, the harmony of art. Ruskin is referring to this order, as well as to the integrated political system of the fourteenth century, when he portrays Gothic Venice as an organic society. He argues, in fact, that this wholeness was itself fostered and secured by architecture. Gothic buildings embodied the values cementing the society into a beautiful unit. The allusions of Gothic structure and ornament reminded Venetians of their history, their past and present ideals, their links to nature, and their bonds and duties to mankind. By describing architecture as a "book," and its decorated surfaces as "pages," Ruskin implies that Venetian life was guided by this sublime "document." He writes of St. Mark's, "Never had city a more glorious Bible" (X, 141). He refers to the sculpture of the vine angle on the Ducal Palace as a "course of divinity and of natural history" which, "being at a height of little more than eight feet above the eye, might be read, like the pages of a book, by those (the noblest men in Venice) who habitually walked beneath the shadow of this great arcade at the time of their first meeting each other for morning converse" (X, 365). The hint contained in the parenthesis (and echoed throughout the book) is that the once efficacious symbolism of this organic world might awaken a corresponding nobility in modern man. The "life" of Venetian architecture thus implies the efficacy of its forms as a source of value and order in the nineteenth century. This is, perhaps, the most grandiose claim Ruskin makes for a ritual of interpretation, though even as he makes it, he seems to sense its futility. "The idea of reading a building as we would read Milton or Dante, and getting the same kind of delight out of the stones as out of the stanzas, never enters our minds for a moment" (X,

205). At least some of the tension toward the end of *The Stones of Venice* seems due to Ruskin's consciousness that, as in the Venetian Renaissance, such moral symbolism does not always function correctly.

*The Sea-Stories*, then, explores the possibility that history can assume an imaginative shape, and that art can influence and become part of the meaning of reality. Ruskin's architectural pun in the title reminds us that this transformation actually occurred on the streets of Venice and suggests that it can be repeated. Our first step in changing history is to discover new ways of perceiving it. As Ruskin implies on the first page of the book, any "revival" of the nineteenth century depends on first learning to understand the fourteenth. Our own progress along the Venetian sea-stories becomes a test and training grounds for our imaginative health. It is in this sense that an intense lyric response to Venetian architecture constitutes an imaginative journey into history. Our enthusiasm for and understanding of Gothic buildings involves a regression into the imaginative conditions of the past: "It is not . . . possible to make expressional character any fair criterion of excellence in buildings, until we can fully place ourselves in the position of those to whom their expression was originally addressed" (IX, 61). When we are moved by the great monuments of the city, we have experienced the meaning of its history. Similarly, the chief remains of the Byzantine and Gothic city constitute permanent embodiments of those eras, to which we can refer to grasp the genuine quality of the past. The Ducal Palace, for example, contains the "last representation" of the city's historic power (X, 337). In St. Mark's, Ruskin explains, whatever "arrests the eye, or affects the feelings, is either Byzantine, or has been modified by Byzantine influence" (X, 78). Although this sort of historicism seems impressionistic, Ruskin is not trying to be what Pater would call later an "aesthetic critic," whose first responsibility is to the accurate representation of his own mental states. He describes his response to Venice because he believes this reveals something fundamentally true about the city and its past. He encourages us to join in his lyric appreciation because even the most extravagant personal narrative can only begin to account for the emotional power really contained in Venetian architecture.

As in *Modern Painters*, Ruskin narrates an autobiographical journey into the landscape. It is another fable of perception, with himself as central character, an extended dramatic lesson in

viewing the world. Only now the landscape has merged with architecture, and space has fused with time: our physical movement across the seas and toward the center of the city parallels the narrative of the first five hundred years of Venetian history. Thus, the journey itself is a metaphor for history—a remarkably apt one, considering all the voyages involved in the founding and rededication of the city's major monuments. In one sense, Ruskin's journey enters history through an eternal present where the essence of the past maintains permanent existence. But at the same time he uses the metaphor of voyage to recreate a historical state of mind, the temperament of the Byzantine and Gothic builders. He imbues his own style with many of the qualities he associates with medieval Venetian art. Reading his narrative thus becomes an exercise in historical sympathy. Our response to Ruskin's journey tests our comprehension of his entire historical, moral, and architectural argument.

The first volume closes by starting the extended, almost mythical journey from the West that will finally culminate in the description of St. Mark's Church. It is a pilgrimage self-consciously recalling those of Dante and Bunyan. Ruskin sets Venice in a charmed poetic landscape to transform it wholly into a symbol. We feel the portentousness of this ritual as he begins: "Come with me, on an autumnal morning, through the dark gates of Padua, and let us take the broad road leading towards the East" (IX, 412). Our progress seems to be on some sort of allegorical life-road, in a time of harvest (with appropriate Biblical connotations), out of darkness and toward the eastern light. As the description continues, the metaphorical shadow that surrounds us grows into a full-blown, mythic underworld. Outside Padua ruined Gothic villas line the river Brenta. One of them, a "Kew Gothic" monstrosity, reminds us of the connection between the bleak landscape and the ambiguous moral potential of an English Gothic Revival. We reach Maestre, where Ruskin lets us enter an inn for refreshment; but the meal is overpowered by a "close smell of garlic and crabs" (IX, 414). The horror of the rite of passage assaults another of our senses when we prepare to pass a last obstacle to entering Venice, its keepers of the gate. Outside the inn is a noisily bickering, anarchic mob. From it Ruskin selects a porter to move us and our baggage toward the docks: "We have but walked some two hundred yards when we come to a low wharf or quay at the extremity of a canal, with long steps on each side down to

the water, which latter we fancy for an instant has become black with stagnation." But "another glance undeceives us,—it is covered with the black boats of Venice" (IX, 414). With even Venice seeming a demonic presence, we feel that our senses have not yet been cleansed, and that we have not yet learned how to perceive the city.

Once on the water, the landscape becomes almost too portentous, overdetermined as in a dream. Ruskin even plays on the dreamer's consciousness of the unreality of the details around him, which nonetheless have power to compel belief. We approach those "black boats" and finally

> enter one of them, rather to try if they be real boats or not, than with any definite purpose, and glide away; at first feeling as if the water were yielding continually beneath the boat and letting her sink into soft vacancy. It is something clearer than any water we have seen lately, and of a pale green; the banks only two or three feet above it, of mud and rank grass, with here and there a stunted tree; gliding swiftly past the small casement of the gondola, as if they were dragged by upon a painted scene. (IX, 414)

Ruskin's infernal metaphors have prepared us for this ambiguous moment on the waters between imagination and reality. The borders between art and life have dissolved. We are meant to feel the confusion as well as the power of an experience at once fictional and true, vivid and substantial at the same time as it is vague and atmospheric. In a sense, we are now in Turner's Venice. Alongside the "mud and rank grass" and occasional "stunted tree" are the seductive emerald waters of the lagoon.

This mythic journey supports a concept of history, both past and present. The journey motif dramatizes the idea that our world, like that of Venice, is symbolic, one in which every object and experience is endowed with meaning, the same notion of reality as was implicit in *Modern Painters*. But Ruskin also suggests that the precise shape of this myth and the final meaning of this symbolic world depends finally to a large degree on our powers of interpretation and imaginative response. Venetian architecture records the efforts of men to give history imaginative shape and meaning; and as we enter Venice in the present, the lesson not only of its art but of its surrounding landscape seems to be that the possibilities of such an imaginative partici-

*John Ruskin*

pation in history remain open. Looking across the waters from Maestre to Venice, we glimpse both the city and its symbolic potential as a model for the nineteenth century:

> Now we can see nothing but what seems a low and
> monotonous dockyard wall, with flat arches to let the tide
> through it;—this is the railroad bridge, conspicuous above
> all things. But at the end of those dismal arches there rises,
> out of the wide water, a straggling line of low and confused
> brick buildings, which, but for the many towers which are
> mingled among them, might be the suburbs of an English
> manufacturing town. Four or five domes, pale, and
> apparently at a greater distance, rise over the centre of the
> line; but the object which first catches the eye is a sullen
> cloud of black smoke brooding over the northern half of it,
> and which issues from the belfry of a church.
>     It is Venice. (IX, 415)

The first volume closes here. The final ambiguity of the city makes it an effective symbol for the nineteenth century and justifies the comparison to London with which the volume began. It is deliberately vague whether Venice is being identified with the smoke seen in the distance, its source in a defiled because industrialized church, or with the larger city it clouds. Depending on our own vision, interpretation, and response, Venice as well as its modern English successor may assume a positive or negative meaning as a symbol in history.

As this journey continues at the beginning of *The Sea-Stories*, it is impossible to distinguish between an actual place and the world Ruskin imagines. His rhythmic language seems to transport us completely from history to romance: "In the olden days of travelling, now to return no more" (X, 3). Prose of this sort operates through a kind of incantation, and he ascribes a similar magic to the city's creation: "Well might it seem that such a city had owed her existence rather to the rod of the enchanter, than the fear of the fugitive; that the waters which had encircled her had been chosen for the mirror of her state, rather than the shelter of her nakedness" (X, 6–7). Later he personifies Venice as a mythical goddess and describes the creation of the Byzantine city as a kind of miraculous birth: "The glorious robe of gold and purple was given to her when first she rose a vestal from the sea" (X, 177). The city was then "that first and fairest Venice which rose out of the barrenness of the lagoon, and the

sorrow of her people; a city of graceful arcades and gleaming walls, veined with azure and warm with gold, and fretted with white sculpture like frost upon forest branches turned to marble" (X, 171). This image of the pristine city may derive from Samuel Rogers, who in *Italy* describes the "birth" of Venice. "Where the sands were shifting," he writes, there

> Rose, like an exhalation from the deep,
> A vast Metropolis, with glistering spires,
> With theatres, basilicas adorned;
> A scene of light and glory, a dominion,
> That has endured the longest among men.

And here again both Rogers and Ruskin draw upon Byron. The first glimpse of Venice in the fourth canto of "Childe Harold's Pilgrimage" discloses a miraculous emanation:

> I saw from out the wave her structures rise
> As from the stroke of the Enchanter's wand . . .

> She looks a sea Cybele, fresh from Ocean,
> Rising with her tiara of proud towers
> At any distance, with majestic motion,
> A Ruler of the water and their powers;
> And such she was;—her daughters had their dowers
> From spoils of nations, and the exhaustless East
> Poured in her lap all gems in sparkling showers:
> In purple was she robed, and of her feast
> Monarchs partook, and deemed their dignity increased.

The journey into the city in *The Stones of Venice* diverges from Byron's, however, since he paid little attention to the vital Ruskinian distinction between the cultures of the Middle Ages and the Renaissance. It is more in the spirit of Rogers to link the miraculous appearance of the Byzantine city and its subsequent Gothic perfection. Our metaphoric journey in *The Sea-Stories* leads us toward the historic center of the city where its greatest Byzantine and Gothic monuments exist side by side: St. Mark's and the Ducal Palace. Ruskin's evocative prose culminates in a description of the earlier church, as if it contains within itself the germs of Venetian historic greatness. By the time we reach St. Mark's, we have glimpsed Venice as what John Rosenberg calls "a Gothic Eden."[8]

After Ruskin's boat touches the canal side, he deliberately leads us through cramped and hellish back alleys, to underscore the difference between the church and the life around it. Noise, darkness, and confusion dominate the people of Venice in their homes, shops, and streets: the description concentrates all the earlier hints of hell in the distant approach to the city. But suddenly the vertiginous activity of the modern city stops, and time stops with it. We become passive spectators before the eternal, heroic vitality of great architecture. It is as if Venetian history suddenly repeats itself before our eyes: the rough landscape is again conquered by the power of ideals transformed into art; we observe a second "birth" of the city. All "the rugged and irregular houses" we have passed seem to have been "struck back into sudden obedience and lovely order." And, Ruskin declares, "well may they fall back, for beyond these troops of ordered arches there rises a vision out of the earth, and all the great square seems to have opened from it in a kind of awe, that we may see it far away" (X, 82). Everything other than this single building seems to vanish in order, as the language implies, to provide us a central epiphany of the city and the history of its origin in the lagoon. In contemplating St. Mark's, we experience the sort of prophetic vision Ruskin attributes to Turner in *Modern Painters*. This is partly because our journey through a symbolic landscape has prepared us to engage in the highest form of perception. But it is also because St. Mark's *is* "a vision." The church embodies the composite vision of the Byzantine race, transforming ideals into living architectural forms. It also represents the imminence of God in history. The building is miraculous; the description itself shows it to be a joint product of man and nature. St. Mark's symbolizes all the values and achievements of Venetian culture, while the ecstatic description of it forms the central ritual of interpretation in the book.

The very ecstasy of Ruskin's language is part of the meaning of St. Mark's. In both the discussion of the grotesque and the analysis of pathetic fallacy in *Modern Painters III*, he distinguishes between true and false sources of impassioned utterance. Extravagant art tends to betray the vagueness of mind in which it was produced and hence to be excessive. But there are some objects before which an artist must lose control. Intense, distorted imagery is justified in the description of "truths" infinitely above the power of human perception or art. Ruskin

labels the expression of such truths "visions" to suggest that their subjects are outside of the artist who perceives them and, in some sense, given to him. The account of St. Mark's seems deliberately to abandon precision and control in order to prove that such a vision has been granted; the very energy of the style implies that the church is a divine artifact and that Ruskin is engaged in an act of prophecy. He attributes "awe" to the rest of the plaza not in a pathetic fallacy but out of a visionary insight into the ruling spirit of St. Mark's in the panorama of Venetian architecture and history. The ritual of interpretation invites us to contemplate the church as a living presence as well as an expression of the divine meaning of Venetian history.

As the passage continues, Ruskin's language progresses toward the highest mental states outlined in the discussion of pathetic fallacy, becoming most intense as he discovers a supernatural presence in the imagery of the church porticoes. The piazza opens into

> a multitude of pillars and white domes, clustered into a
> long low pyramid of coloured light; a treasure-heap, it seems,
> partly of gold, and partly of opal and mother-of-pearl,
> hollowed beneath into five great vaulted porches, ceiled with
> fair mosaic, and beset with sculpture of alabaster, clear as
> amber and delicate as ivory,—sculpture fantastic and involved,
> of palm leaves and lilies, and grapes and pomegranates,
> and birds clinging and fluttering among the branches, all
> twined together into an endless network of buds and
> plumes; and in the midst of it, the solemn forms of angels,
> sceptred, and robed to the feet, and leaning to each other
> across the gates, their figures indistinct among the gleaming of
> the golden ground through the leaves beside them,
> interrupted and dim, like morning light as it faded back
> among the branches of Eden, when first its gates were angel-
> guarded long ago. (X, 82–83)

By the conclusion of the passage, the miracle is complete. Nature and art have fully merged; the power of the vision makes it "indistinct." It is impossible at the end to disentangle the actual imagery of the walls from the effects of light at the moment Ruskin describes, or from the tendency of his language to give a Biblical allusion to every detail of the scene. But the indistinctness is the essential meaning of the passage: we are meant to feel that with him we have glimpsed heaven on earth. We are

also meant to refer this perception back to the original Edenic fact of Venetian civilization, of which the splendor of St. Mark's is a first instance and for which it remained, in the Gothic period, as a model. The ritual of interpretation enables us to experience the underlying power of Venetian history through the contemplation of its central artifact.

The passage continues its upward movement to describe St. Mark's most famous statuary, the Greek horses carried to Venice by sea from Constantinople in 1205, symbolizing the epic historic triumph of the Byzantine period. Above the porticoes the "breasts of the Greek horses are seen blazing in their breadth of golden strength, and the St. Mark's lion, lifted on a blue field covered with stars, until at last, as if in ecstasy, the crests of the arches break into a marble foam, and toss themselves far into the blue sky in flashes and wreaths of sculptured spray, as if the breakers on the Lido shore had been frost-bound before they fell, and the sea-nymphs had inlaid them with coral and amethyst" (X, 83). In this sea-story the ocean itself seems to pay tribute to the power of the Venetian state. It is a description of nature as much as one of architecture. Indeed, much of the imagery of *The Sea-Stories* testifies to the continuity of Ruskin's "landscape instinct" well after the period that he claimed in *Modern Painters III* marks its irretrievable loss. But here nature does not exist alone, or even for its own sake. It is *in* architecture. The editors of the Library Edition have explained that this passage reflects a belief that the Venetians "were always influenced in their choice of guiding lines of sculpture by their sense of the action of the wind and sea." But the energy of the prose asserts something far stronger. St. Mark's is a product of nature. This is perhaps the last meaning of the title of the second volume. The pages of Venetian history, like the "book" of its architecture, contain "stories" composed by the ocean as well as by man, made possible by the guiding presence of nature in the life of the entire civilization. It is this sense of the relationship of the city to its environment that Ruskin makes explicit in the chapter on "The Nature of Gothic."

Indeed, it is easy to forget, as we read the account of St. Mark's, that it is not a Gothic church. The Gothic style that Ruskin admires in Venetian architecture is more graceful, more colorful, and more delicate than the Gothic north of the Alps; the Byzantine elements remaining in Venetian architecture well after 1300 distinguish it from most Gothic works in Europe. St.

Mark's is the most perfect expression of the spirit that merged with the rougher spirit of northern Gothic to create a uniquely balanced architectural style. Fourteenth century buildings in Venice combined northern energy with southern grace and abstraction, a more Italian style of "Surface Gothic" with a more ornate "Linear Gothic" closer to the delicate architecture of France (X, 241–242, 254). True Gothic involves what Ruskin calls a love of fact, which in Venice blends with a more Eastern delight in "the harmony of colours and forms" (X, 215). But even that love of color demonstrates a pre-Gothic "seriousness" in the "Oriental mind" in Venice (X, 175–177). And this serious use of color reveals in Byzantine architecture the roots of much of the future depth of Italian art. Its intricacy of line and color contains the first recorded instance of that unity of effect "which was brought to its most intense expression in the compositions of the two men in whom the art of Italy consummated itself and expires—Tintoret and Michael Angelo" (X, 151). Ruskin's point is that the rich and colorful character of Byzantine ornament indicates a nation "in a state of progress" (X, 154). It is especially at St. Mark's that we sense this progress leading directly toward the organic art of Gothic. Its "great outer entrance" illustrates "a series of subjects altogether Gothic in feeling, selection, and vitality of execution, and which show the occult entrance of the Gothic spirit before it had yet succeeded in effecting any modification of the Byzantine forms" (X, 315).

The essential connection between the two styles is what Ruskin calls their "universality." Like Gothic, Byzantine is not simply an ecclesiastical or public style; it is accessible to use everywhere, in all forms and levels of buildings, in all kinds of societies. Without understanding this, we can easily misjudge St. Mark's, or even the Ducal Palace, as somehow "strange." But nothing could be further from the intention of their builders: "churches were not separated by any change of style from the buildings round them, as they are now, but were merely more finished and full examples of a universal style, rising out of the confused streets of the city as an oak tree does out of an oak copse, not differing in leafage, but in size and symmetry" (X, 121). This is perhaps the most important form of Gothic naturalism prefigured in Byzantine architecture. In the chapter on "Byzantine Palaces" Ruskin prints a woodcut showing the "natural architecture" of a cluster of seven leaves: its "grace is

*John Ruskin*

simply owing to its being proportioned like the facade of St. Mark's" (X, 154).

*The Sea-Stories* suggests that one of the guarantors of the organic harmony of the Gothic period from 1301 to 1423 was the continued presence of major Byzantine works in the architecture of the city, keeping Venice literally in contact with its roots. Ruskin shows that the "fall" of the city coincided with the destruction of the last portion of its first great Byzantine palace, the original portion of the Ducal Palace restored and enlarged under Doge Sebastian Ziani in the last years of the twelfth century. In 1422 "the decree passed to rebuild the palace." In the next year, after the death of Doge Tomaso Mocenigo, a new Great Council chamber was used to replace the Byzantine: "the Gothic Ducal Palace of Venice was completed. It had taken, to build it, the energies of the entire period which [was] the central one of her life" (X, 346). Finally, on March 27, 1424, "the first hammer was lifted against the old palace of Ziani":

> That hammer stroke was the first act of the period properly called the "Renaissance." It was the knell of the architecture of Venice,—and of Venice herself . . . A thousand palaces might be built upon her burdened islands, but none of them could take the place, or recall the memory, of that which was first built upon her unfrequented shore. It fell; and, as if it had been the talisman of her fortunes, the city never flourished again. (X, 352)

Breaking with the traditional designation of the parts of the Ducal Palace, Ruskin insists on calling the side of the building where the Gothic council chamber was built the "sea-façade" (X, 330). This last detail completes the thematic unity of his book, for it makes the closing event of the Gothic period, in 1423, the final sea-story in Venetian history.

Natural Gothic

All the analytic modes of *The Stones of Venice* appear at once in its most famous chapter, "The Nature of Gothic." The unity of medieval Venetian culture is what allows Ruskin to speak of Gothic simultaneously in technical, lyric, and moral language. For "Gothic" is one of those richly overdetermined words he invariably uses to suggest the complexity of what he considers

the highest truths. It is at once an architectural style, a stage of aesthetic consciousness, and a phase of moral and political history. Noun or adjective, it refers to an art form as well as to a sociological condition—and that second reference encompasses the state of society in general as well as the status of individual citizens. The point of this fusion is both descriptive and propagandistic: aesthetic, social, and personal values ought to be reflexes of one another, just as they were in fourteenth century Venice. Within the rigid but benevolent hierarchy of the state, as Ruskin sees it, the citizen of Gothic Venice found himself at peace with his environment and with himself,. and the surest proof of this harmony is the vitality of Gothic art.

Ruskin was never to stop idealizing benevolent authoritarianism. By the time of *Fors Clavigera* in the 1870s, he had proposed himself as the charitable tyrant of The Guild of St. George. But *The Stones of Venice*, although his first expression of this tendency, never reads like an authoritarian book, largely because Ruskin has most to say about men at the bottom rather than at the top of the social structure. The mythical power of Venetian beauty depicted in *The Sea-Stories* is at least as much the triumph of workmen as of doges and nobles. He concentrates on the decorated surface of the city, created by the limited but inspired efforts of masses of citizen-artists. Only rarely does he examine architecture in terms of elevation, mass, proportion, or ground plan—in terms, that is, of a general design. A large part of Ruskin's inability to respond to buildings of the Renaissance can be traced to his instinct to view architecture in terms of its details, not as a coherent aesthetic whole. In his romantic and individualistic aesthetic, it is almost assumed that in architecture the whole is determined by the parts, as if buildings could somehow take shape spontaneously. There are occasional references to the guiding hand of a chief architect, particularly in connection with the Ducal Palace; but Ruskin finds it much more significant that within some given plan individual artisans instinctively understood and enjoyed their own roles. This view of Gothic architecture, translated into political and social terms, also constitutes his theory of the medieval state.

Ruskin's aesthetic history reads art for signs of human involvement first, and only then, from the thought and labor art involves, generalizes about the quality of the state. He deduces the compassion of medieval religion and social organization— one might say the charity of Gothic—from architecture. The

point of view is more intimate than is usually expected of history. Since Venice is too large to be interpreted as a whole or through written history alone, he approaches it on a human level, at the "sea-stories" where men lived and worked in the past, to discover precise and detailed evidence of the Gothic mind in the rough carving of its surfaces. Throughout Gothic architecture Ruskin finds signs of tolerance and Christian egalitarianism in the incomplete and often flawed work of individual craftsmen. For him, this is an unmistakeable indication that medieval art acknowledged and accepted its necessary limits. Gothic architecture, that is, solicited the humblest efforts of its workmen. By refusing to make perfection an end of art, Gothic proves itself the pre-eminently Christian style, for in light of medieval (and evangelical) religion, all men are considered fallen and imperfect. The symmetry and polish of Renaissance art for Ruskin embodies a failure to respect the uniqueness of each human soul; indeed, its regularity expresses nothing less than the "slavery" of the workers who constructed it (X, 189). He admires Gothic for "only bestowing dignity upon the acknowledgment of unworthiness" and thus giving a willing "confession" of the limits inevitable in all works of art (X, 190). Thus, despite the magnitude of Gothic edifices, Ruskin insists that their builders enjoyed freedom of expression; and despite the organization of the medieval state, he is convinced that its citizens found true liberty of spirit. An organic society is one that recognizes and employs imperfect human nature for what it is. No man is free whose work denies the essence of his humanity.

The most significant social and moral dimension of Gothic is its proximity to human nature, which is the largest meaning of the phrase "The Nature of Gothic." Ruskin praises the style not merely for its grace and energy but for its capacity to appeal to every human instinct and satisfy every human need. Gothic awakens the imagination of its builders and fosters that of its spectators, giving it a perpetual historic life. The corollary of this in the social message of "The Nature of Gothic" is that Gothic is an infinitely adaptable style, not only for all uses but for all potential users. The chapter begins by defining a Gothic spirit or "mental power," which embodies essential or universal psychological traits. Ruskin lists six characteristics of this spirit, both "as belonging to the building" and "as belonging to the builder." These "material" and "mental" traits together are:

savageness or rudeness; changefulness or love of change; naturalism or love of nature; grotesqueness or disturbed imagination; rigidity or obstinacy; and redundance or generosity. As is the case with most of Ruskin's aesthetic categories, this list is both descriptive and prescriptive: that art is greatest which contains the widest range of essential human traits.

The point of Ruskin's psychological analysis of Gothic seems very modern: life or art is unhealthy when it denies expression to fundamental human impulses. This is a direct conclusion from his arguments about the necessity for full perception of reality and for the integration of human faculties. His attack on nineteenth-century industrial society is largely an attack on its violent disjunction of the human psyche, turning men into machines: "We have much studied and much perfected . . . the great civilized invention of the division of labor; only we give it a false name. It is not, truly speaking, the labour that is divided; but the men:—Divided into mere segments of men—broken into small fragments and crumbs of life . . . And the great cry that rises from all our manufacturing cities, louder than their furnace blast, is all in very deed for this,—that we manufacture everything there except men" (X, 196). Ruskin views Gothic as a ritual device to create better men as well as finer architecture, to restore the unity of the state, of style, and of the self.

The universality of Venetian Gothic architecture derives from its balance of diverse human impulses and cultural traditions. In the merger of various geographical styles in Venice, as East meets West, Ruskin sees a confrontation of different elements of the human spirit, elements that are then molded together in the harmony of Gothic. The hardy, physical race of the Lombards and the more spiritual Arabs, "opposite in their character and mission, alike in their magnificence of energy," at Venice "met and contended over the wreck of the Roman empire." The art of each of the three cultures expressed "a condition of religion . . . erroneous . . . yet necessary to the correction of the others, and corrected by them"—corrected, that is, in the rich forms of high Venetian Gothic: "The Ducal Palace of Venice contains the three elements in exactly equal proportions—the Roman, Lombard, and Arab. It is the central building of the world" (IX, 38).

To explain the unique sensibility of the Italian Gothic workmen, Ruskin catalogues two different types of artists. In stylistic

terms, one can divide artists into "men of design" (southerners predominantly) and "men of fact" (usually northern). As the names imply, the art of each is limited by the exclusion of the other. Similarly, one can distinguish artists according to their subject matter and view of the world, which is either purist or sensualist. Here too each type of imagination addresses only part of nature and man, the good and the evil, respectively. But Ruskin adds a third category of artists, the Naturalist, who "takes the human being in its wholeness" (X, 226). The artists who constructed Gothic buildings are naturalists, he explains, and thus encompass both the purist and the sensualist outlooks within themselves. They also strike a balance in their art between fact and design. "The Gothic builders belong to the central or greatest rank in *both* the classifications of artists" (X, 263). No form of human expression would have been alien to their broad sensitivity. They could have appreciated art as different from their own as the Theseus of the Elgin Marbles, "and would have received from it new life . . . There can be no question that theirs was the greatest school, and carried out by the greatest men . . . The Gothic of the Ducal Palace of Venice is in harmony with all that is grand in all the world" (IX, 188).

Ruskin's concept of Gothic cannot be understood apart from his concept of naturalism. "The Nature of Gothic" (both the chapter and the phrase itself) condenses his greatest intellectual achievement, the analysis of Venetian civilization, into another crucial double meaning. Although "naturalism" is only the third of six characteristics of Gothic, the other five might easily be subsumed under it. Savageness, changefulness, grotesqueness, rigidity, and redundance ascribe to Gothic the roughness and energy of a mountain landscape, which suggests the style's primary relation to nature. Gothic actually resembles nature, for the medieval artisans sought spontaneously to represent the forms of mountains, vegetation, and, in the case of Venice, water that made up their environment. On almost every surface of the Gothic city are signs of the accuracy and care with which the average workman looked at nature. But by the time of the Renaissance, the representation of nature in architectural ornament lost its instinct for truth. Renaissance materials are disguised: stones are painted to resemble more precious materials; stucco is treated to look like wood. On the Casa Contarini delle Figure, lovely pieces of marble seem "absurd" in the form they are introduced into the façade: "these, instead of being simply

and naturally inserted in the masonry, are placed in small circular or oblong frames of sculpture, like mirrors or pictures, and are represented as suspended by ribands against the wall" (XI, 21). Medieval artisans expressed their perfect understanding of nature by never representing materials as being other than what they actually were: wood, marble, or stucco were even mixed without disguise when it was necessary that they be used together.

The resemblance of fine architecture to nature has a conscious and unconscious source. As a public art, its professed function should be to remind us of nature even when we are forced to live in cities. *The Stones of Venice* repeats the message of *The Seven Lamps:* "We cannot all have our gardens now, nor our pleasant fields to meditate in at eventide. Then the function of our architecture is . . . to replace these; to tell us about Nature; to possess us with memories of her quietness; to be solemn and full of tenderness, like her, and rich in portraiture of her; full of delicate imagery of the flowers we can no more gather" (IX, 411). But even when these allusions are not apparent, architecture succeeds or fails according to its fidelity to natural law. In remarking on tracery, Ruskin praises the finest work as "eternal forms, based on laws of gravity and cohesion" (IX, 226). Similarly, he recommends arch forms based on permanent natural shapes: "The good architects have generally been content . . . with God's arch, the arch of the rainbow and of the apparent heaven, and which the sun shapes for us as it sets and rises" (IX, 159). An accompanying plate shows the changing outline of the sun as it rises, illustrating the abstract models for all arch design. Elsewhere Ruskin illustrates ten other "abstract lines" from nature, which form the basis of all fine decorative styles: four are taken from leaf outlines, two from shells, one from a fir-tree branch, and three from mountain outlines. At the end of the analysis of capitals, Ruskin rediscovers in one "exquisite" capital profile from St. Mark's the "simplest" of the forms "nature set by chance before me . . . this lily, of the delicate Venetian marble, has but been wrought, by the highest human art, into the same line which the clouds disclose, when they break from the rough rocks of the flanks of the Matterhorn" (IX, 387).

Gothic is also natural insofar as it assumes a natural life of its own. A building can be considered truly Gothic not simply when it has pointed arches, vaulted roofs, flying buttresses, but when these and other elements "come together so as to have life" (X,

182). Medieval buildings in general seem alive, as the description of the pre-Gothic vitality of St. Mark's implied. But Gothic buildings are even more vital; for functionally they grow to fill the demands of their builders. The adaptability of Gothic is a sign of life: "Undefined in its slope of roof, height of shaft, breadth of arch, or disposition of ground plan, it can shrink into a turret, expand into a hall, coil into a staircase, or spring into a spire, with undegraded grace and unexhausted energy; and whenever it finds occasion for change in its form or purpose, it submits to it without the slightest sense of loss either to its unity or majesty,—subtle and flexible like a fiery serpent, but ever attentive to the voice of the charmer" (X, 212). Ruskin's sense here of organic architecture made him an appealing model for Frank Lloyd Wright: in Gothic, as in any great architecture, form adapts to function, naturally.[9] And the imagery and energy of this passage suggests once more that Gothic architecture gains life through its enduring power to move those who admire and use it.

An even broader meaning of "The Nature of Gothic" is dramatized in the ecstatic description of St. Mark's, which itself was a prophetic instance of Gothic beauty. Gothic is a creation *of* nature, literally a part of the landscape. "The Nature of Gothic" demonstrates the relation of history, morality, and aesthetics to their setting. Society itself becomes a function of environment, influenced by its shapes and colors, molded by its forces like a mountain or a tree. As he would again in *The Bible of Amiens*, Ruskin binds all phases of human life to the landscape; the scope of his historical determinism forecasts the work of some Marxist historians. For example, in the opening pages of *The Sea-Stories* he translates his own painstaking measurements of the levels of the tide into a stunning interpretation of the founding of Venice as a sea-miracle. Ruskin assesses the economic basis of the earliest settlements in the swamplands, the political condition of Europe generally, and the resources available to create a city. But he insists finally that the action of the waters is what permitted these different factors to cooperate, allowing the city to flourish. Had the sea risen higher, foreign armies could have entered the city for conquest; had the tides been lower, Venice's precarious but valuable mercantile traffic never could have been sustained; and the fluctuation between high and low tide is slight enough to permit architecture. These details epitomize not only the history of the city but also the

character of Gothic, both divinely appointed from their beginnings. The Gothic "fellowship" with nature contains that blend of human and cosmic powers which Ruskin tries to represent in Turner's paintings. But at Venice, nature has created not merely a single artifact but an entire city, a model of perfection for the individual and the state.

"The Nature of Gothic" thus provides the final tableau in Ruskin's pilgrimage, or medieval dream-vision, in *The Sea-Stories*. Ruskin offers one last imaginary initiation into the magnificent unity of Venetian Gothic civilization. To allow us to experience the pre-lapsarian (i.e. pre-Renaissance) clarity of insight dramatized in the description of St. Mark's, he presents a fictional journey into a scene that even Turner might not have dared to depict. Ruskin urges us to rise above the level of bird-flight and discover in all the earth's varied surfaces a series of symbolic motifs, of which human art and civilization provide only faint echoes. From this perspective, Syria, Greece, Italy, and Spain seem "laid like pieces of a golden pavement into the sea-blue, chased, as we stoop nearer to them, with bossy beaten work of mountain chains, and glowing softly with terraced gardens, and flowers heavy with frankincense, mixed among masses of laurel, and orange, and plumy palm, that abate with their grey-green shadows the burning of the marble rocks, and of the ledges of porphyry sloping under lucent sand" (X, 186). The abrupt foreshortening, blending plants and continents into a single fabric of vision, dramatizes the unity of macroscopic and microscopic nature achieved in Gothic.[10]

It is a divine perspective, in fact, and by the end we discover the superhuman connotations of the buildings that form an integral part of the landscape. The Gothic architect, like Turner, creates a second nature; and from our visionary height we can observe the resemblance of human art to the divine creation. Ruskin asks us to imagine man in the warm regions as

he sets side by side the burning gems, and smooths with
soft sculpture the jasper pillers, that are to reflect a
ceaseless sunshine, and rise into a cloudless sky; but not
with less reverence let us stand by him, when, with rough
strength and hurried stroke, he smites an uncouth animation
out of the rocks which he has torn from among the moss of the
moorland, and heaves into the darkened air the pile of iron
buttress and rugged wall, instinct with work of an imagination

*John Ruskin*

as wild and wayward as the northern sea; creatures of ungainly shape and rigid limb, but full of wolfish life; fierce as the winds that beat, and changeful as the clouds that shade them. (X, 187–188)

In those final phrases Ruskin's syntax makes architecture come alive—the "creatures" may be either the builders or their buildings, for both are a part of nature. It is only from this vantage point that we can fully discern "the look of mountain brotherhood between cathedral and Alp" (X, 188).

This vision prepares us to view Venice as the richest jewel set in a divine geographical gold-work, the "throne" cradled by ocean and Alps and ruling by divine right. It also explicitly aims to delineate the less attractive dimensions of the naturalism of Gothic. Ruskin offers the aerial vision as an illustration of "savageness," the first characteristic of the Gothic spirit. But his vocabulary shifts into a description of "changefulness," and his tone seems to imply that he is also explaining "grotesque," "this wildness of thought" (X, 188). Similarly, Ruskin's Gothic portrait as a whole must itself progress toward the darkest forms of Gothic expression. His interpretation of nature implies that the city modeled on it must enter a final stage of deformity and, finally, death. This lesson is derived from at least one natural hieroglyph: "imperfection is in some sort essential to all that we know of life. It is the sign of life in a mortal body, that is to say, of a state of progress and change. Nothing that lives is, or can be, rigidly perfect; part of it is decaying, part nascent. The foxglove blossom,—a third part bud, a third part past, a third part in full bloom,—is a type of the life of this world" (X, 203). It is inevitable that Ruskin's account of natural Gothic will lead to a portrait of the death of Gothic art; that next step is itself part of the "nature of Gothic." The foxglove's triple structure thus mirrors the three versions of Venice presented in Ruskin's book. Through his functional, architectural history, the city buds; as an artifact, an ideal past society existing through art in the modern world, it blooms in splendid and immediate prose; and decaying, a shadow of its own past, a symbol of immorality and death, it produces the violent evangelical tract titled *The Fall*. There, confronting the most fearful aspect of Venetian history, Ruskin's style as well as his subject becomes grotesque. But even in its almost pathological conclusion, Ruskin attempts to base the form of *The Stones of Venice* on the unity of nature.

I understand not the most dangerous, because most attractive
form of modern infidelity, which pretending to exalt the
beneficence of the Deity, degrades it into a reckless infinitude
of mercy, and blind obliteration of the work of sin: and which
does this merely by dwelling on the manifold appearances of
God's kindness on the face of creation. Such kindness is
indeed everywhere and always visible; but not alone. Wrath
and threatening are invariably mingled with the love; and
in the utmost solitudes of nature, the existence of Hell seems
to me as legibly declared by a thousand spiritual utterances,
as that of Heaven. (XI, 164)

*The Fall* presents an evangelical sermon on pride and infidel-
ity. Ruskin's final volume excoriates the sins of Venice as
vigorously as the previous one had extolled its perfections. His
chief antagonist is the Renaissance, which he calls a "Roman
Renaissance" to suggest another parallel to the city's decline and
fall. By the fifteenth century, the harmonious ceremony of
Gothic life had withered into sensuality and corruption. All the
vital arts of medieval Venice had degenerated—except perhaps
painting, which Ruskin admits was some fifty years behind the
rest of society. His medieval dream-vision is supplanted by a
Renaissance nightmare; instead of the entrance into Paradise, he
now narrates the discovery of Hell. To properly represent the
distorted lineaments of this actual underworld, his style becomes
deliberately strained and intense. It is a mode that deserves to be
called Ruskinian grotesque, one which persists into his last and
most pathological writings.

The principal theme of *The Fall* is death; the primary artifact
used for historic evidence is the sepulcher. Like *The Sea-Stories*,
this volume contains a metaphoric journey through Venice. But
this last metaphoric passage through history takes us past the
tombs of successive Venetian doges; in the revised "Travellers'
Edition" these descriptions are condensed into a single chapter
titled "The Street of the Tombs." Indeed, the volume ends with
a portrait of the burial of Venetian civilization itself, for which
the only monuments are the charred remains of its last, sensual
funeral pyre: "By the inner burning of her own passions . . .
consumed . . . and her ashes are choking the channels of the
dead, salt sea" (XI, 195).

The Renaissance is pictured as the enemy of aesthetics as well

as of religion. After the charmed Gothic moment, the ceremonies of church and state as well as the traditional symbols of the arts become meaningless forms. Life becomes a masquerade, art a sham. Ruskin makes his first and least restrained attack on art-for-art's-sake, which for him is only one aspect of the faithlessness and pride saturating the Renaissance. Pride, the deadliest sin, pervades the Renaissance in three forms: pride of science, pride of state, pride of system. All three amount to essentially the same thing. The Renaissance mind glorifies only its own achievements, and the arts are instrumental in this smug celebration. Without ideals, Renaissance art can represent only impieties. Much of Ruskin's evidence is taken from architecture, the mirror of its age even when the age is in decline: "The architecture raised at Venice during this period is among the worst and basest ever built by the hands of men, being especially distinguished by a spirit of brutal mockery and insolent jest, which exhausting itself in deformed and monstrous sculpture, can sometimes be hardly otherwise defined than as the perpetuation in stone of the ribaldries of drunkenness" (X, 135). The Church of Santa Maria Formosa, a crucial symbol of the former Gothic harmony, displays in the Renaissance the first Venetian façade "which appears *entirely destitute of every religious symbol, sculpture, or inscription*" (XI, 146). It is simply "a monument to the Admiral Vincenzo Cappallo," who died in 1542. By this piece of evidence, the late sixteenth century is "fixed as the period when, in Venice, churches were first built to the glory of man, instead of the glory of God."

Renaissance art banishes the spontaneous irregular energy of Gothic along with the fervor of medieval faith. With power centralized in art as well as in society, the architectural workman finds none of the opportunities for free expression he had formerly enjoyed in constructing Gothic buildings. The symmetry that expresses Renaissance humanism for Ruskin constitutes only infidelity and false pride in superficial perfection. Renaissance architectural proportions testify to an overvaluation of the designer's knowledge and a disdain for the intuitive creative potential of the workman. As art, such buildings lack freedom and life; as social expressions, they reveal the "systems" which enslaved Renaissance artisans.

The central term in Ruskin's evaluation of Gothic is "grotesque"; it is also the most important technical term in *The Stones of Venice*. Like the word "Gothic" itself, it comes to

represent an architectural style and a frame of mind as well. Indeed, Ruskin stretches his definition until "grotesque" comes to stand for both the strength of medieval art and architecture and the depravity of the Renaissance. Even in its strictest form, the uncorrupted grotesque art of the middle ages, its expression is ambiguous, combining the fearful and the ludicrous, the least refined as well as the most impressive styles of medieval sculpture. The central quality of grotesque art is humor: "There is jest—perpetual, careless, and not infrequently obscene—in the most noble work of the Gothic periods" (XI, 136). Characteristically, its form is rough, as Ruskin explains in *Modern Painters III*: "A fine grotesque is the expression, in a moment, by a series of symbols thrown together in bold and fearless conviction, of truths which it would have taken a long time to express in any verbal way, and of which the connection is left for the beholder to work out for himself; the gaps, left or over-leaped by the haste of the imagination, forming the grotesque character" (V, 132).

This definition (based on the ideas of *The Stones of Venice*) simultaneously explains the value of medieval art and the corresponding failure of most of the art of the Renaissance. Ruskin's conceptions of the highest art forms invariably balance sincerity and truth, the free exercise of imagination with fidelity to external phenomena; grotesque style is at once the natural form of such composite art and the proof of its integrity. The roughness of grotesque imagery reveals imaginative "haste," and this in turn demonstrates the artist's "conviction" and his perception of external "truths." Ruskin's heated attacks on Renaissance precision and imitation are predicated on an equally energetic appreciation for medieval irregularity and spontaneity. Perhaps most important of all, grotesque art requires our participation to make its meaning complete: the "gaps" in its logic initiate our own imaginative activity and lend themselves perfectly to a ritual of interpretation.

The capacity of grotesque art to stimulate a viewer's response derives from the energy originally involved in its creation. The presence of gargoyles, humorous genre-scenes, eccentric details, and even sadistic imagery in medieval art—especially on the surfaces of medieval buildings—reveals the freedom of Gothic artists to exercise their own imaginations playfully while engaging in a larger, more serious task. In Gothic art, as in any sincere imaginative product, grotesque emerges naturally as the expres-

sion of genuine human needs. When one is engaged in serious work, there is a necessity for psychological release. Gothic permits this relief in grotesque art. Its details embody the "most precious . . . fruits of a rejoicing energy in uncultivated minds" (XI, 159). Most grotesque results from what Ruskin calls "necessary play," by which he means "the comparatively recreative exertion of minds more or less blunted or encumbered by other cares and toils." It is "art of the wayside, as opposed to that which is the business of men's lives" (XI, 157).

This concept allows Ruskin to explain away most of the authoritarian quality of the medieval state. Grotesque testifies simultaneously to the restrictions of medieval life—as a worker might have felt them—and to the exhilaration that must have accompanied a discovery of the freedom granted within those limits. Necessary play is a "stretching of the mental limbs as their fetters fall away,—this leaping and dancing of the heart and intellect, when they are restored to the fresh air of heaven, yet half paralyzed by their captivity, and unable to turn themselves to any earnest purpose" (XI, 154). The presence of grotesque is the surest proof of the psychological liberty and health of medieval art, a condition assured by the generosity of the Gothic state toward all its citizens. Ruskin idealizes "the willing confession of imperfection" in medieval art as a symbol of the tolerance of human imperfection in medieval culture.

That Ruskin should make so much of the apparently minor art of grotesque sculpture is not surprising either historically or in terms of his own taste. The revaluation of grotesque, like the rediscovery of Gothic itself, had been underway actively since the eighteenth century; as Wolfgang Kayser has shown, the view that grotesque art discloses deep psychic energies had been developed by Schiller and the German Romantics.[11] In adopting it, Ruskin finds an aesthetic category suited perfectly to his own approach to architecture. He habitually responds to buildings in terms of surface detail, seeking to define the whole in relation to the part. Grotesque becomes the most characteristic microcosm of the macrocosm which is Gothic. Yet it is curious that his fundamental analysis of the genre should be associated with Venice, where Gothic surface detail is synonymous as often with rich inlaid materials in the Byzantine fashion as it is with grotesque sculpture. We hear little of grotesque in *The Seven Lamps of Architecture,* although the book focuses on French and English buildings, which provide fine and abundant

examples. The reason has to do with the ideological structure of *The Stones of Venice* as much as with the character of its subject city. By stretching a point and identifying Venetian medieval art with the fruition of grotesque, Ruskin supports the argument that Venice embodies a fusion of southern and northern spirits. By exemplifying in grotesque the view of architecture as an expression of social conditions, he provides a cultural standard with particular relevance for his English audience. For grotesque, a predominantly northern form, can be found as readily in England as in Venice, especially in the medieval buildings of, say, an Oxford. It is the aspect of the international Gothic style with which his readers would be likely to have the greatest familiarity. And, as a convenient illustration of Ruskin's principles, grotesque provides an accessible test of the distance between the condition of England in the Middle Ages and in the present.

In using grotesque as a term of historical analysis, Ruskin distinguishes between two forms of it—noble and ignoble, true and false. False Renaissance grotesque never results from any genuine feeling of freedom or spontaneous energy. It is contrived; indeed, it is imitated from Gothic models. Its creators seek pleasure in response to their own luxury and idleness, not from necessity. Consequently, their "play will not be so hearty, so simple, or so joyful" as that of Gothic workmen (XI, 161): "Incapable of true imagination, it will seek to supply its place by exaggerations, incoherencies, and monstrosities; and the form of the grotesque to which it gives rise will be an incongruous chain of hackneyed graces, idly thrown together" (XI, 161). The dragons on the tomb of Andrea Vendramin, for example, "are covered with marvellous scales, but have no terror nor sting in them" (XI, 108). Ruskin illustrates the distinction in a plate showing two sculpted lions' heads (see illustration): the Gothic head is rough, naïve, but energetic and convincing; the other is polished and artificial. Indeed, he explains that he "cannot pollute this volume by any illustration of [the] worst forms" of Renaissance grotesque.

Once again the formal excess and perfection of detail in Renaissance sculpture betrays the atrophy of feeling in the age. Nowhere is this gradual degeneration more critical than in funerary art, for there it becomes apparent that Renaissance artists failed to be moved even in the presence of death. In tracing the progress of this declining emotion, Ruskin shows

*John Ruskin*

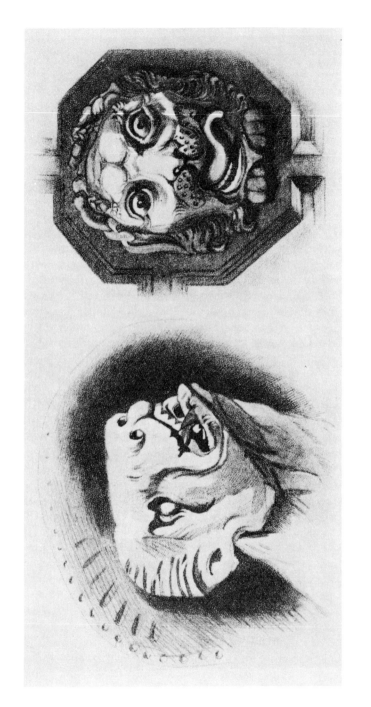

John Ruskin, "Noble and Ignoble Grotesque"

that "exactly in proportion as the pride of life became more insolent, the fear of death became more servile" (XI, 81). To show "the pride of state in its gradual intrusion upon the sepulchre," he summarizes the changes in the traditional imagery of "angels withdrawing the curtains of the couch to look down upon the dead . . . As we draw nearer to the Renaissance period, we find that the angels become of less importance and the curtains more." On the sepulcher of Doge Francesco Foscari, the "first important example of Renaissance art . . . for the first time, the *angels are absent altogether;* while the curtains are arranged in the form of an enormous French tent-bed" (XI, 103–104). The figures of the Virgin and Saints are replaced by those of the Virtues, but the images of Temperance and Justice are each given only one hand. The hypocrisy of representing Virtues at all becomes evident with a glance from them to the features of the doge: "A huge, gross, bony clown's face, with the peculiar sodden and sensual cunning in it which is seen so often in the countenances of the worst Romanist priests; a face part of iron and part of clay, with the immobility of the one, and the foulness of the other, double-chinned, blunt-mouthed, bony-cheeked, with its brows drawn down into meagre lines and wrinkles over the eyelid; the face of a man incapable either of joy or sorrow, unless such as may be caused by the indulgence of passion or the mortification of pride" (XI, 105).

Foscari died in 1457; Vendramin in 1478, "of a pestilence which followed the ravage of the Turks . . . He died, leaving Venice disgraced by sea and land" (IX, 49). Vendramin's tomb, completed in 1484, "is one of the last which shows, or pretends to show, the recumbent figure laid in death. A few years later, this idea became disagreeable to polite minds; and, lo! the figures, which before had been laid at rest upon the tomb pillow, raised themselves on their elbows, and began to look round them. The soul of the sixteenth century dared not contemplate its body in death" (XI, 109–110). This last failure links the analysis of funerary art with the analysis of grotesque, for the serious contemplation of death is one of the principle motives of noble grotesque art.

Two types of noble grotesque are discussed in *The Stones of Venice*, "ludicrous" (the form more commonly associated with the term) and "terrible." It is the perversion of the second that Ruskin most fully condemns. True grotesque serves fundamental human needs by expressing man's delights and his fears,

indeed, often expressing them simultaneously; and despite his religious language, Ruskin's understanding of the connection between these feelings prefigures some of the conclusions of Freud, as does his perception that humor stems from deep unconscious motives. Ruskin views grotesque as an almost compulsive art form, its chief value being the capacity to express deep psychic impulses. The Renaissance, in its failure to horrify or to be horrified, buries a vital instinct of human nature:

> Two great and principal passions are evidently appointed
> by the Deity to rule the life of man; namely the love of
> God, and the fear of sin, and of its companion—Death.
> How many motives we have for Love, how much there is in
> the universe to kindle our admiration and to claim our
> gratitude, there are, happily, multitudes among us who both
> feel and teach. But it has not, I think, been sufficiently
> considered how evident, throughout the system of creation,
> is the purpose of God that we should often be affected by
> Fear; not the sudden, selfless, and contemptible fear of
> immediate danger, but the fear which arises out of the
> contemplation of great powers in destructive operation, and
> generally from the perception of the presence of death.
> (XI, 163)

Medieval art allows these passions to be exercised and developed in grotesque. The Gothic craftsman feels as much instinctive terror as joy, and he must find ways in his art to express his natural sense of awe. Most of his work offers neither the time nor the place to represent the "important truth" of a personal vision; yet some trace of the artist's seriousness will necessarily, involuntarily, emerge. No one who has experienced the power of sin or death can ignore it or work as if he could, even if the depiction of his feelings surpasses the limited capacity of his art. Even the rough finish of medieval naturalistic reliefs suggests to Ruskin the depth of the craftsman's feelings: "He is but carving and gilding, and must not turn aside to weep, but he knows that hell is burning on, for all that, and the smoke of it withers his oak-leaves" (XI, 168).

In the discussion of fearful grotesque, Ruskin begins to describe more than simply a workman's style, more than an art form which only the most limited artists can employ. Forms of grotesque expression also appear in the work of great imaginative artists, where they are signs of the highest levels of vision.

To some extent Ruskin uses the term in this sense to suggest what Pater would mean in his use of the word "symbol"; and Ruskin calls the highest level of such art "symbolic grotesque." The finest grotesque imagery is confusing and intense because of its richness, because of the range and depth of perception embodied in it. It is much the same kind of art as the "prophetic utterance" described in the discussion of pathetic fallacy; chronologically, it appears likely that the analyses of imagination in *The Stones of Venice* formed the basis of the aesthetic theories in *Modern Painters III*, published three years later. As in the chapter on pathetic fallacy, Ruskin identifies four levels of grotesque expression and four types of minds that produce them. The artist (like the medieval workman) who plays "necessarily" is only the third highest in this rank. Lowest is a man who does not play at all, parallel to the man without feeling for nature in "Of the Pathetic Fallacy." Next are those who play "inordinately"; their contrived grotesques are themselves, in a sense, pathetic fallacies, not having been deeply felt. In this category Ruskin includes most of the faithless and insincere artists responsible for Renaissance grotesque. By contrast, "the highest and healthiest state which is competent to ordinary humanity appears to be that which, accepting the necessity of recreation, and yielding to the impulses of natural delight springing out of health and innocence, does, indeed, condescend often to playfulness, but never without such deep love of God, of truth, and of humanity, as shall make even its slightest words reverent, its idlest fancies profitable, and its keenest satire indulgent." Such "wise play" is, clearly, "the condition of a mind, not only highly cultivated, but so habitually trained to intellectual labor that it can bring a considerable force of accurate thought into its moments even of recreation" (XI, 153). As examples of this highest exercise of the instinct for play, Ruskin mentions Wordsworth and Plato.

But at this level of imagination, the "ludicrous" form of grotesque itself becomes rare. Men who "play wisely" actually "play" very little at all: they "hardly ever speak through art, except seriously" (XI, 156). One "whose heart is at once fixed upon heaven, and open to the earth, so as to apprehend the importance of heavenly doctrines, and the compass of human sorrow, will have little disposition for jest" (XI, 152). Similarly, "he can hardly have learned the preciousness of life, who passes days in the elaboration of a jest . . . For all truth that makes us

smile is partial" (XI, 156). Thus in great works like Dürer's "Adam and Eve," "the playfulness or apathy of the painter passes into perfect sublime" (XI, 171).

As in the analysis of pathetic fallacy, Ruskin posits a consummate form of what he considers a universal imaginative impulse. Not only can grotesque be traced into even the most refined forms of art, but its presence becomes a touchstone of creative genius. In the list of "masters" of noble grotesque, only the absence of Turner prevents it from being a catalogue of all the poets and painters Ruskin holds in highest regard: Homer, Bunyan, Shakespeare, Tintoretto, Spenser, and the author of the Book of Genesis. Dante, in whom grotesque "reaches at once the most distinct and most noble development to which it was ever brought in the human mind," is hailed as "the central man of all the world" (XI, 187). As in Ruskin's similar praise for the architecture of the Ducal Palace, centrality is a sign of the artist's sympathy with and mastery of every dimension of nature and the human spirit.

At this level the grotesque becomes "symbolic," its power the product of a visionary experience. In the greatest art the distortion, strangeness, and confusion of grotesque elements testifies to the artist's experience of something beyond his power to describe. At the same time the haste and energy of grotesque imagery demonstrates the reality of that vision, making it less a personal expression than the depiction of truths received. Ruskin explains this balance between the unreality and conviction of grotesque art by comparing it to dreams:

> I believe . . . that the noblest forms of imaginative power
> are also in some sort ungovernable, and have in them
> something of the character of dreams; so that the vision,
> of whatever kind, comes uncalled, and will not submit itself to
> the seer, but conquers him, and forces him to speak as a
> prophet, having no power over his words or thoughts. Only,
> if the whole man be trained perfectly, and his mind calm,
> consistent, and powerful, the vision which comes to him
> is seen as in a perfect mirror, serenely, and in consistence
> with the rational powers. (XI, 178–179)

Such supreme rationality—the command of vision as if it were fact—marks the dividing line between the highest and lowest forms of noble grotesque; indeed, between ordinary and great

artistic expressions. By this definition, in fact, it is difficult to imagine any art that Ruskin would admire and not classify as dreamlike and containing grotesque elements: "so far as the truth is seen by the imagination in its wholeness and quietness, the vision is sublime; but so far as it is narrowed and broken by the inconsistencies of the human capacity, it becomes gortesque: and it would seem to be rare that any very exalted truth should be impressed on the imagination without some grotesqueness in its aspect" (XI, 181). For instance, the *Iliad*, the *Inferno*, *Pilgrim's Progress*, and *The Fairy Queen* all contain the highest forms of grotesque—they are "all of them true dreams" (XI, 179).

As such examples suggest, symbolic grotesque embodies once again the recurrent motif of Ruskin's aesthetics that visionary experience can be made real and available in art. As a universal impulse, shared at all levels of medieval art and society, grotesque also suggests that such vision can be granted to an entire civilization, nurtured and secured by a common artistic style. The word "grotesque" thus encompasses all the beauties and energies Ruskin locates in the charmed Gothic moment. To illustrate, he traces the history of a single, elaborate ritual—an example of "acted grotesque"—in which all the virtues of the medieval state are symbolized. The ceremony is associated with the church of Santa Maria Formosa, which in Rogers' *Italy* is the subject of a poem on "The Brides of Venice." It had been the ancient custom for the noble families of Venice to marry their daughters at one time each year, on January 31, St. Mark's day. But in 943 pirates invaded the city and abducted the brides and their doweries. Fortunately, the pirates were attacked and defeated that same night. Santa Maria Formosa "is connected with the tale, only because it was yearly visited with prayers by the Venetian maidens, on the anniversary of their ancestors' deliverance. For that deliverance, their thanks were to be rendered to the Virgin; and there was no church then dedicated to the Virgin in Venice except this" (XI, 136). Although the "alarm" caused by the pirates' attack caused the custom of the single marriage-day to be discontinued, the festival was still observed "in memory of the deliverance of the brides," and "its main objects were still attained . . . the whole body of the nobility" still gathered to celebrate the marriage of one of their daughters, "rejoicing" (and here Ruskin quotes Sansovino) " 'as at some personal good fortune; since, by the constitution of the state,

they are for ever incorporated together, as if of one and the same family' " (XI, 140).

Thus, the later history of Santa Maria Formosa associates the church with the unity of the Venetian nobility and with the sanctity of marriage in the republic. The story of its founding also links it to the Venetian capacity of vision and to the strength of the city's medieval faith. When the bishop of Uderzo was escaping from the Lombards in 639, he received in prayer a vision of the Virgin, who directed him to build a church on the spot where he would see a white cloud rest. "And when he went out, the white cloud went before him; and on the place where it rested he built a church, and it was called the Church of St. Mary the Beautiful from the loveliness of the form in which she appeared in the vision" (XI, 137). A note also speculates that the name may have reference to the brightness of the cloud. In either case the church is a monument to the frame of mind in which the highest truths are received with clarity and vividness.

After the defeat of the pirates, new ceremonies were initiated at Santa Maria Formosa which enlarged upon and reiterated the meanings embedded in the history of the church up to that time. The festival had become a procession, beginning at St. Mark's on January 31 and concluding at Santa Maria Formosa on February 2, the day of Candlemas, honoring the purification of the Virgin. For this elaborate festival, called the Feast of the Maries, "twelve maidens were elected, two for each division of the city; and . . . it was decided by lot which contrade, or quarters of the town, should provide them with dresses. This was done at enormous expense, one contrada contending with another, and even the jewels of St. Mark's being lent" (XI, 142). At Santa Maria Formosa, another important part of the ritual, with distinct political meaning, took place. The pirates had been captured with the help of trunkmakers in the district of the church; as their reward, they requested a yearly visit from the doge on the feast of Candlemas. Thus, when the doge arrives each year at Santa Maria Formosa at the conclusion of the procession, the local bishop, "in the name of the people," presents him with two guilded hats—in case of rain—and two oranges and two flasks of malvoisie wine—in case he should be thirsty. These ceremonies make the church also represent the harmony among all ranks and citizens of the Venetian state, a relationship guaranteed and symbolized by its public rituals.

The history of this ritual through the Middle Ages dramatizes

the Gothic respect for ceremony and "symbolic grotesque." The subsequent treatment of the site demonstrates the perversion of such public arts in the Renaissance. The Feast of the Maries grew increasingly lavish until 1379, when the expenses of war forced its abolition. For Ruskin this economy displayed the solemn attitude of the High Middle Ages toward such an important ritual: the people "seem to have been ashamed to exhibit it in reduced splendour" (XI, 144). But by the Renaissance far more than the event had been discontinued. In the church of Santa Maria Formosa not one of the stones is "left upon another" (XI, 136). Indeed, the entire site has been defaced: "As if to do away even with its memory, every feature of the surrounding scene which was associated with that festival has been in succeeding ages destroyed" (XI, 144). In the piazza, "with one solitary exception, there is not a house left . . . from whose windows the festa of the Maries has ever been seen . . . even the form of the ground and direction of the neighboring canals are changed." In place of these sacred monuments, Ruskin finds an emblem of the perverse grotesque art of the Renaissance: "A head,—huge, inhuman, and monstrous,—leering in bestial degradation, too foul to be either pictured or described, or to be beheld, for more than an instant" (XI, 145). He can mention only the most hideous feature of the image: "the *teeth* are represented as *decayed*" (XI, 162).

The portrait of Renaissance Venice, like that of the leering grotesque head, is abbreviated but intense; for the majority of Ruskin's readers it has surely proved to be the most memorable dimension of the book. Its forcefulness reflects all the passion behind Ruskin's condemnation of the Renaissance. Yet the clarity of the description also depends on Ruskin's mastery of a specific aesthetic genre. In depicting the fallen city, his style achieves a prose expression of the grotesque impulse—passionate and personal, yet portraying a historical evil experienced with the immediacy of prophetic vision. The artistic achievement of *The Fall* is to distill all the qualities of the life and mind of Renaissance Venice into a few bizarre images of personified depravity. Perhaps the most impressive example appears on the final page of the chapter on "Grotesque Renaissance," where all Ruskin's analyses of history converge onto an image of post-Gothic civilization as the embodiment of a perverse and inverted ritual, a Satanic ceremony of moral decay. This visionary portrait expresses the terrible consequences of the Renaissance

misappreciation of art, its misuse of the faculties exercised in Ruskin's own rituals of interpretation. The scene depicted, directly mocking the beautiful medieval Feast of the Maries, occurred after the death of Tomaso Mocenigo in 1423, the moment Ruskin had earlier called "the *visible* commencement" of the city's fall (IX, 21).[12] The term "visible" is explained only at the end of the analysis of the Renaissance; Ruskin notes that the doge's death was "marked . . . by a great and clearly *legible* sign" (italics mine, to indicate that here he "reads" not art but life itself for moral content):

> It is recorded, that on the accession of his successor, Foscari, to the throne, "SIFESTEGGIO DALLA CITTA UNO ANNO INTERO:" "The city kept festival for a whole year." Venice had in her childhood sown, in tears, the harvest she was to reap in rejoicing. She now sowed in laughter the seeds of death.
>
> Thenceforward, year after year, the nation drank with deeper thirst from the fountains of forbidden pleasure, and dug for springs, hitherto unknown, in the dark places of the earth. In the ingenuity of indulgence, in the varieties of vanity, Venice surpassed the cities of Christendom, as of old she had surpassed them in fortitude and devotion; and as once the powers of Europe stood before her judgment-seat, to receive the decisions of her justice, so now the youth of Europe assembled in the halls of her luxury, to learn from her the arts of delight. (XI, 194–195)

Renaissance Venice thus compounded her crimes by teaching "the youth of Europe" to perpetuate them. This corrupt aesthetic education sealed the city's fall.[13]

Ruskinian grotesque, which begins in *The Stones of Venice*, culminates in writings like *Fors Clavigera* or *The Storm-Cloud of the Nineteenth Century*, where passion merges with pathology. The tragic failure of his late books is a loss of proportion between the intensity of his tirades and the reality of their subjects. But in *The Stones of Venice*—as in all "true grotesque"—the balance exists, if precariously. It is partly the reality of history which convinces us that Ruskin's energy has a genuine source outside itself. And even if we finally judge his interpretation of history to be mainly that, an interpretation, more personal than accurate, it has an intrinsic balance which helps us accept the fictions in Ruskin's historical world. Although Ruskinian grotesque ends in furious denunciations, it

begins in a charmed portrait of an idyllic world; like medieval grotesque itself, Ruskin's grotesque style encompasses both the fear of death and a vision of delight. His conception of Venice derives from a symbolic view of the entire Gothic world as enacting what Yeats might have called a "ceremony of innocence," the sort of ritual epitomized in the Feast of the Maries. Until the end of his life, Ruskin believed that such a world could be recreated. In founding The Guild of St. George as the prototype of an ideal state, he emphasized codes of dress, manners, and personal behavior and an education in the arts as the cornerstones of utopian public life. The Guild is only the last of his many attempts to harmonize the details of modern life around a central, graceful moral ritual. Ruskin was never to abandon his Gothic dream.

Part Two

# Dante Gabriel Rossetti

# IV

## The Literature

## of

## Pre-Raphaelitism

As would many historians after him, Ruskin credited *Modern Painters* with inspiring the Pre-Raphaelites. Dedicating the book "to the landscape artist of England," he implored them at the end of the first volume to "go to Nature in all singleness of heart, and walk with her laboriously and trustingly . . . rejecting nothing, selecting nothing, and scorning nothing; believing all things to be right and good, and rejoicing always in the truth" (III, 624). One of the decisive moments in the history of the Pre-Raphaelite movement came when William Holman-Hunt read Ruskin and introduced Rossetti to his writing. This meant not only *Modern Painters I*, for by 1848, when the two artists were discussing common aims and interests with John Everett Millais, there was a second volume to read.[1] *Modern Painters II* praised not only naturalism but what Ruskin called "purism," especially in the Italian painters of the Middle Ages. Ruskin's recent enthusiasm for religious art thus provided an in.portant part of the immediate background for the Brotherhood. When Millais showed his fellow art students Carlo Lasinio's engravings of frescoes from the Campo Santo in Pisa—an event frequently identified as the birth of the Brotherhood—it was with Ruskin's implicit sanction.

The "Lasinio incident" of August or September 1848 (the

phrase and date for the inspection of the engravings are William Michael Rossetti's[2]) is a valuable index to the meaning of Pre-Raphaelitism, for Lasinio's engravings contain the first example of art before Raphael which Millais, Holman-Hunt, and Rossetti examined and approved together. Holman-Hunt accounts for their admiration in terms of the primitive naturalism of the frescoes: "The innocent spirit which had directed the invention of the painter was traced point after point with emulation by each of us who were the workers, with the determination that a kindred simplicity should regulate our own ambition, and we insisted that the naïve traits of frank expression and unaffected grace were what had made Italian art so essentially vigorous and progressive."[3]

Benozzo Gozzoli's frescoes portrayed Bible history (see illustration). Although Hunt fails to mention this (perhaps owing to his anxiety to dissociate the Pre-Raphaelites from most practitioners of Victorian Gothic and from Ford Madox Brown's "Early Christian dogma"[4]), a large part of the response of the three painters to what they saw must have depended on the subject of the pictures and more generally on the relation of form and content. The best expression of this aspect of the attraction of the frescoes appears in Ruskin. *Modern Painters II*, while only mentioning the Campo Santo in passing, declares it to be "a veritable Palestine" (IV, 350). There is also a letter to John Ruskin, Sr., written while the second volume was being composed in 1845, which specifies what drew all these young Englishmen to Italian primitive art in general and to this monument in particular:

the Campo Santo is the thing. I never believed the patriarchal history before, but I do now, for I have seen it . . . Abraham and Adam, and Cain, Rachel, and Rebekah, all are there, real, visible, created, substantial, such as they were, as they must have been; one cannot look at them without being certain that they have lived; the angels, great and real and powerful, that you feel the very wind from their wings upon your face, and yet expect to see them depart every instant into heaven; it is enough to convert one to look upon them; one comes away like the woman from the sepulchre, having seen a vision of angels which said that he was Alive. And the might of it is to do this with such fearless, bold, simple, truth, no slurring, no cloudiness, nor darkness; all is God's good light and fair truth; Abraham sits *close* to you,

Benozzo Gozzoli, "The Story of Abraham" (engraving by Carlo Lasinio)

entertaining the angels, you may touch him and them . . .
you may put your finger on the eyes of their plumes, like St.
Thomas, and believe. (IV, xxxi)

Neither Ruskin nor any of the Pre-Raphaelites was converted
by the pictures, but all felt the spiritual force of primitive art. In
the Campo Santo frescoes the Pre-Raphaelites, like Ruskin,
responded to the power of a simple style of painting to convey a
deeply felt belief. The frescoes are a monument to the possibility
that art can create a visionary experience for the spectator. To
define a modern equivalent, in terms of effect and intensity of
belief, would be a major goal both of Ruskin, in later volumes
of *Modern Painters* and *The Stones of Venice,* and of the Pre-
Raphaelites in their literature and visual art.

The Pre-Raphaelites, then, carry out the principles of both
*Modern Painters I* and *II.* They demonstrate their dedication to
natural truth through luminous and detailed studies of land-
scape. But they respond equally to Ruskin's desire for art to
embody spiritual truths in material form, to give the finest
moments in history a renewed modern expression, to bring to
painting moral and philosophic responsibility. Ruskin's essay
"Pre-Raphaelitism" unexpectedly identifies Turner as the chief
exemplar of the new school; but given his definitions of Turner's
aims, this relationship makes sense and provides a fairly accu-
rate description of the Pre-Raphaelite aesthetic. The Pre-
Raphaelites attempt something very close to what Ruskin de-
scribes Turner as achieving: the fusion of different kinds of
reality, distinct levels of perception, separate modes of artistic
style within the same picture. The affinity of the new painters to
Ruskin stems from their attempt to create an art containing
many different impulses, a diversity that Ruskin himself was
among the first to recognize.

Ruskin's later lectures on *The Three Colours of Pre-Raphael-
itism* distinguish between two main tendencies of the movement.
Millais, he says, belongs to an "unlearned" school of naturalistic
painters and poets, including Wordsworth; Holman-Hunt and
Rossetti, because of their literary and historical concerns, are
classed in a "learned" tradition (XXXIV, 166–167). But it seems
more accurate to say that each of the major Pre-Raphaelite
painters combines these dual impulses in his art. Pre-Raphaelite
illustrations to Shakespeare, Dante, the Bible, or modern writers
like Tennyson seek to "materialize" ideal fictional worlds and

make them visually convincing. Their most famous paintings—works like "The Blind Girl," "The Awakening Conscience," Rossetti's pictures of Beatrice or his painting "Found"—use the details of landscape, dress, architecture, or decor to give morals or poetic ideals a vivid physical expression. It is the combined dedication to painting from nature and to literary and historical allusion that characterizes Pre-Raphaelite art (much the same combination as appeared in the early painting of Turner). Of the group, Rossetti is the painter least committed to landscape, perhaps because his interest in nature increasingly finds an outlet in poetry. Nevertheless, the juxtaposition of different expressive modes and different aesthetic impulses creates the principle drama of his Pre-Raphaelite writing and visual art. In order to "read" his painting as well as his poetry, it is necessary to define the connections between the different aspects of his vision and the different phases of his style.

Pater's essay on "Dante Gabriel Rossetti" in *Appreciations* also mentions the variety of modes contained in his art, and even hints at the relation of this variety to Ruskin. Although Ruskin is never named in the essay, his presence is evoked in references to the "grotesque" quality of Rossetti's blend of natural and supernatural effects. "One of the peculiarities of *The Blessed Damozel* was a definiteness of sensible imagery, which seemed almost grotesque to some, and was strange, above all, in a theme so profoundly visionary." Rossetti's "forced and almost grotesque materializing of abstractions" marks his affinity with a Ruskinian medieval tradition: "like Dante, he knows no region of spirit which shall not be sensuous also, or material." Pater delights in an imagery "as naively detailed as the pictures of those early painters contemporary with Dante." The seemingly self-conscious echoes of the vocabularies and categories of both Ruskin and Rossetti remind us of their places, and that of Pater himself, in the tradition of the literature of art. Indeed, Rossetti's "sincerity," the quality of his work Pater finds most unique, is described in a metaphor from visual art, as the "gift of transparency in language—the control of a style which did but obediently shift and shape itself to the mental motion, as a well-trained hand can follow on the tracing paper the outline of an original drawing below it." Most telling of all, Pater locates Rossetti in a highly Ruskinian tradition of visionary art—alongside Dante, "Jacob's Dream in *Genesis,* or Blake's design of the Singing of the Morning Stars, or Addison's

Nineteenth Psalm." The comparison enables Pater to "place" Rossetti historically while still paying tribute to the originality of his art, his "really new kind of poetic utterance."

Innovation, as both Pater and Ruskin recognized, comprises a crucial theme in the work of the Pre-Raphaelites. In rebelling against the Academy and what it represented, Rossetti and the other "Brothers" attacked something larger than mere formality in contemporary painting. The Pre-Raphaelites had an aesthetic message no less broad than Ruskin's, if somewhat less frequently articulated. Opposing artistic conventions provided a social context in which they could oppose more pervasive conventions of feeling and thought. With Pater, they might have complained of their contemporaries that "our failure is to form habits." And the "habits" and rules of academic painting specifically implied a deep hostility to aesthetic experience, a disbelief that either the creation or the appreciation of art might involve spontaneity, richness, conviction, or personal vision. Sir Joshua Reynolds, whether or not they read him, and in spite of his disclaimers in the final *Discourses*, represented art's willing submission before authority, its complacent acceptance of stock ideas and subjects as well as prescribed colors and figure arrangements. The Pre-Raphaelite Reynolds was much like the Reynolds caricatured in Blake's diatribes, an assassin of the spirit and bureaucrat of the imagination, a man "hired to depress art."

It is more than a coincidence that Blake's own program for artistic genius in the *Descriptive Catalogue*, which offers his alternative to Reynolds and academic painting, was included in the manuscript Rossetti purchased in the 1840s. Rossetti's career as poet-painter draws on this earlier exemplar; and his concept of the sister arts follows Blake in seeing as their essential connection the artist's grasp of truths beyond nature. In Blake, furthermore, Rossetti found a model of the painter as psychic revolutionary, for whom a distinctive style is an assertion of spiritual vision. The *Descriptive Catalogue* praises luminous color and "the hard outline" as expressions of the vividness and truth of a prophetic imagination. For Blake, the intensity of the created image attests to the reality of the artist's supernatural experience. A similar message could of course have been found in Ruskin. Although the message of most Pre-Raphaelite work is tamer than Blake's, its clarity, like his, entails

*Dante Gabriel Rossetti*

a kind of visual rhetoric, validating a personal insight into history, morality, or human behavior.

The debt to Blake should not be pushed too far, but it is truer of Rossetti than of any other Pre-Raphaelite.[5] Although his verse lacks Blakean simplicity and force, there is a dialectic in both his poetry and painting that seems much like Blake's, frequently supporting his argument for the interconnection of sexual and spiritual love. Rossetti's frankness about love makes him a Romantic in a special sense of the word; it might be considered an anti-Ruskinian extension of Ruskin's insistence on truth to nature; and the open interest in sexuality is one of the clearest signs of the incipient modernism of his verse. Interestingly, the theme of sexuality emerges not only in realistic modern narratives like "Jenny" or "A Last Confession" but in ballads and poems using traditional forms or set in the past, such as "Troy Town" and "Eden Bower." Rossetti employs history to identify the emotional and psychological possibilities he locates in the present, as did both Blake and Ruskin in their very different ways; in fact, Rossetti occasionally seems to discuss one's version of the past to comment on the other's. In his essay on Blake, he associates the poet-painter's love of Gothic with his sexual frankness, and praises him for demonstrating that one need not be an ascetic in the "love of the Gothic form of beauty." Blake's spiritual women "are no flimsy, filmy creatures, drowsing on feather-bed wings, or smothered in draperies." "Large-eyed and large-armed"—like Rossetti's own figures— they are "such as a man may love with all his life" (I, 471). It is only after this tribute to Blake's physicality that Rossetti compares him to Orcagna, Giotto, and the "author" of the Campo Santo frescoes in Pisa, for their common fusion of natural study with imaginative truth (I, 473). The Ruskinian vocabulary supports an argument against a major aspect of Ruskinian medievalism. For Rossetti, the most important belief of the Middle Ages was the identification of flesh and spirit.

Rossetti's medievalism, then, cannot be separated from the "fleshly" themes of his poetry and painting. Like Blake, he locates in Gothic art many of the energies, including sexual energies, he tries to express in his own. To some extent he appeals to the authority of history to validate his own view of love. In any case, his medieval pictures and verse, including the quasi-medieval sonnet sequence *The House of Life*, represent

the Middle Ages in a manner wholly different from that contained in Ruskin. Rossetti's volume of translations, *The Early Italian Poets*, appeared in 1861 as an almost self-conscious counterargument to Ruskin's portrait of medieval Italy, *The Stones of Venice* having been published less than ten years before. The poems emphasize the importance of love as a medieval theme. Much as would Pater's translation of the "Two Early French Stories" in *The Renaissance*, Rossetti's language evokes what Pater would call the "intimacy" of the writing of the Middle Ages, its delicate and intensely personal quality. Rossetti's design for the title page, which he finally rejected, includes a drawing called "The Rose Garden," showing a pair of lovers lightly kissing in a garden (see illustration); it forms a visual emblem for his view of the genuine "nature of Gothic."

Although the other Pre-Raphaelite Brothers did not share Rossetti's view of love, they did use their painting to illustrate further forms of intense emotional experience. In much Pre-Raphaelite art, the expression of powerful feelings is not merely a means but an end in itself; the emotional impact of their pictures is part of their meaning and not simply an accidental side-effect. It is precisely this intensity that marks the revolutionary character of Pre-Raphaelite iconography, in spite of its frequently traditional themes. Harold Rosenberg has observed that one of the first tasks of revolutionary modern art is to demonstrate its position at the frontiers of art, in a new vanguard of expression.[6] New art necessarily involves a large element of shock for its audience, which is forced to confront and readjust its own values if the new work is to be assimilated. The very newness of Pre-Raphaelite painting contains a double assertion: genuine art must spring from deep conviction; genuine art-appreciation must involve a fundamental reassessment of taste, feeling, and belief. In this sense, the contemporary response to Pre-Raphaelite art provides the clearest index to its revolutionary significance. Ruskin himself observes the importance of public uncertainty about the Pre-Raphaelites in a discussion of their illustrations of Tennyson's poetry: "Genuine works of feeling, such as *Maud* or *Aurora Leigh* in poetry, or the grand Pre-Raphaelite designs in painting, are sure to offend you: and if you cease to work hard, and persist in looking at vicious and false art, they will continue to offend you" (XV, 224). The Pre-Raphaelite attack on visual conventions was an attack on the conventionalizing of emotional life, which they

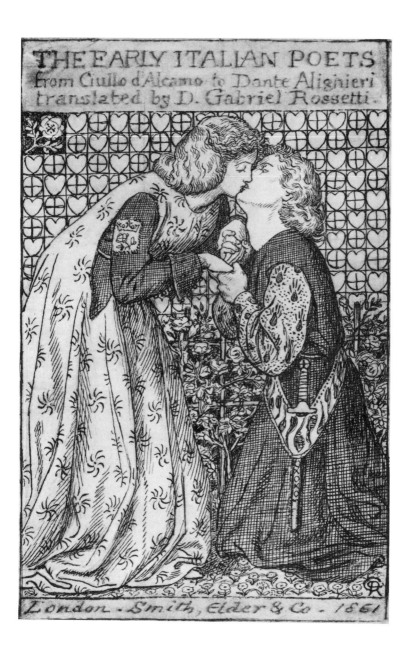

D. G. Rossetti, "The Rose Garden"

considered a by-product of the familiar domestic realism of most Victorian art. The name Pre-Raphaelite itself suggested not a return to the principles of art before Raphael but a revolt against the academic practice of "borrowing" an elegant style or subject from Raphael or any other officially authorized master. With Ruskin they believed that imitation sapped the vitality of the painter; and the sincere expression of personal emotion was to remain a constant goal of Pre-Raphaelite art.

*The Germ* and the "Sonnets for Pictures"

The importance of emotion in the Pre-Raphaelite aesthetic is particularly apparent in *The Germ*, the short-lived "official" journal of the Brotherhood. Although only four issues were published in the early part of 1850, it provides the most candid written expression of the movement's sense of itself during its brief existence.[7] A self-image, however, does not necessarily imply an ideology; and the movement illuminated in the pages of the journal is surprisingly nonideological. *The Germ* stresses feelings rather than ideas; less importance is attached to the few, vague statements of principle than to the cultivation of distinct aesthetic modes and emotional tones. These, in fact, comprise the main aesthetic statement in the journal; as a model for contemporary painters and writers, it urges a return to strong feeling as the basis of modern art. The pictures, poetry, fiction, and essays in *The Germ* cover a limited emotional range, generally falling somewhere between sentimentality and sensationalism. The principal subject is death; one essayist pedantically recommends the contemplation of death as a "noble" theme for contemporary artists.[8] This is a typcal instance of Pre-Raphaelite aesthetic theory: subjects are chosen for their emotional resonance, for their potential impact on an audience; even the familiar note of Pre-Raphaelite morbidity is here defined as a means to an end. When death appears in Rossetti's own poetry for *The Germ*—in, for example, "My Sister's Sleep" or "The Blessed Damozel"—it becomes a premise for close psychological analysis. *The Germ* provides an appropriate vehicle for a writer for whom, in Pater's words, "life is a crisis at every moment" (*Appreciations*, p. 211).

It is possible to view *The Germ* as the reflection of a prevailing climate of taste, an emphasis on *frisson* evident in the "spasmodic" poets or even "Maud," one which would contribute

to Ruskin's fascination with grotesque, the last volumes of *The Stones of Venice* appearing only three years later. But the Pre-Raphaelites go well beyond Ruskin, in their painting as well as in *The Germ*, by an eager cultivation of emotion for its own sake. Even Pre-Raphaelite naturalism partakes of this tendency and thus differs from the type of naturalism Ruskin embraced. As F. G. Stephens explains in an article in *The Germ* on "The Purpose and Tendency of Early Italian Art," artists should "follow nature" in order to demonstrate their own spirit of devotion, the "earnestness" they share with painters before Raphael.[9] This explanation accords with Graham Hough's observation that for the Brotherhood the Ruskinian canon of truth to nature meant in large part "fidelity to inner experience."[10]

Rossetti's contributions to *The Germ* represent his earliest and most self-conscious attempts to translate Pre-Raphaelitism into literature; as such, they also contain his earliest expressions of the relationship between literature and visual art. Whether or not his writing embodies the thought of the other Pre-Raphaelites makes little difference for its importance in the development of the Victorian literature of art. To some extent, in fact, *The Germ* can be considered a Rossetti family venture: Gabriel is the most prolific contributor; he, Christina, and William together supply over half of the journal's contents. It was probably at Rossetti's insistence that the published title always referred jointly to "art and poetry."[11] This theme surfaces in various forms: essays on art history, poems and dialogues on aesthetics, poems written to explain engravings published in *The Germ*, and engravings published to illustrate poems. Most famous of all are Rossetti's own writings on art, the six "Sonnets for Pictures" and the fictional account of a medieval artist entitled "Hand and Soul." In these he takes up the fledgling genre initiated by Ruskin only a few years before and enlarges its possibilities.

The "Sonnets for Pictures" contain Rossetti's most direct translation of painting into poetry. The effort to describe visual effects and to relate the accumulation of detail to the evocation of emotion seems close to criticism à la Ruskin. But Rossetti's object seems to be the avoidance of Ruskinian moral readings of art. His sonnets show clear resemblances to the later "aesthetic criticism" of Pater, in form as well as content. The delicacy of the sonnet limits its rhetorical power; the definition in *The House of Life* of the sonnet as "a moment's monument"

commits his sonnets to delineating "impressions," in Pater's sense of the word. The fundamental argument of the "Sonnets for Pictures" is that the complexity of art raises it beyond simple moral categories. Even when Rossetti's subject is religious painting, his poetry stresses the subtlety of the iconography rather than any message or "truth" conveyed by it. Rossetti's point seems to be, in fact, that great painting creates an intense experience rather than illustrating simple truths, that its complexity as a symbolic whole is finally irreducible. Treating pictures as symbols in Pater's sense of the word, he finds their ultimate value in a compact allusiveness, an ambiguity that is rich and suggestive rather than diffuse, a quality of mystery derived from an abundance rather than an absence of meaning.

The contemplation of art in Rossetti's sonnets raises experience to the highest level of intensity, a condition he seeks throughout his poetry. Curiously, his treatment of painting is almost exactly parallel to his treatment of love, the most predominant theme in his verse. A work of great art marks the point of contact between many levels of experience; it can even become a window between material and transcendent reality. Love possesses an identical symbolic fullness, and Rossetti locates a similarly magical, mysterious power in beautiful women. "True Woman," as one of the sonnets in The House of Life declares, is "a thing . . . man can know/But as a sacred secret." "Beauty," according to another poem in the sequence, "is genius." Indeed, a comment by Rossetti on one of the "Sonnets for Pictures" suggests an analogy between love, metaphysical insight, and the contemplation of art. In defense of the conclusion of the poem on Leonardo's "Virgin of the Rocks," in which he refers to "the bitterness of things occult," Rossetti remarks: "I see nothing too 'ideal' in the present line. It gives only the momentary contact with the immortal which results from sensuous culmination and is always a half conscious element of it."[12]

The similar views of beauty, women, and art account for the fact that these themes frequently appear together; indeed, many of the "Sonnets for Pictures" in The Germ are later incorporated into The House of Life, which contains other poems on the theme of art. Thus, the task of poems on paintings becomes much the same as that of poems on any decisive moment in existence; the interpretation of art becomes an essential aspect

of the interpretation of life. Many of the "Sonnets for Pictures," particularly those composed to accompany Rossetti's own paintings, refer to images of beautiful, mysterious Pre-Raphaelite "stunners," whose almost magical "spell" is cast upon us through the joint media of painting and poetry. Responding to the aesthetic beauty of these figures in art prepares us to comprehend their living significance. The "Sonnets for Pictures" teach us to locate the highest values of symbolic art in certain forms of life.

It is hardly surprising to find the "Sonnets for Pictures" celebrating the atmospheric qualities of Giorgione's "Pastoral," or the seductive ambiguities of Leonardo's "Virgin of the Rocks," in which Rossetti savors "the bitterness of things occult." But less predictably, he also locates the elements of mystery and symbolism in more conventional religious paintings, a pair of pictures by Memling, each of which becomes the subject of a separate sonnet. Both poems begin with the single word "Mystery," capitalized in later versions. The term is deliberately ambiguous: although at first we might interpret it as a reference to the Holy Mystery depicted in each work, the word also comes to stand for the inscrutable mystery of art. The sonnets immerse us in their subjects; and significantly, as in all the "Sonnets for Pictures," they have no independent titles apart from the initial reference to the names of the paintings "for" which they were written.

As in the sonnet "for" the Giorgione picture, Rossetti often questions a painting or the figures in it to dramatize the quality of independent life he finds in art. The sonnet on Memling's "Virgin and Child" asks a question not to but about the picture, and the effect is the same: the question underlines the emotional power of the Virgin's features, their suggestion of life and experience beyond the specific imagery of the work. The painting thus embodies a moment arrested from the flux of time:

MYSTERY: God, Man's Life, born into man
   Of woman. There abideth on her brow
The ended pang of knowledge, the which now
Is calm assured. Since first her task began,
She hath known all. What more of anguish than
   Endurance oft hath lived through, the whole space
   Through night till night, passed weak upon her face
While like a heavy flood the darkness ran?

There is something of Pater's tone in this, as well as a anticipation of his attitudes: the boundaries between art and religion are far vaguer than anywhere in Ruskin. The very concentration on the Virgin's features shifts our attention to the picture's psychological content; and the implicit parallel between her meditations and our own is the first step in making this a Paterean symbol. More important is the freedom with which the sonnet introduces imagery and associations seemingly absent from the painting: as spectators we are, in effect, reanimating the picture through the depth of our involvement. The conjectures of the viewer on the Virgin's past and present emotions become a kind of inverse analogue to Memling's original transformation of this sacred type into a single, consummate image. Our participation in the picture reenacts the process of its creation.

The interrelation of the viewer's experience and the meaning of art is even clearer in the sonnet on Memling's "Marriage of St. Katherine." The living quality of the figures is dramatized by allusions to the passage of time. And St. Katherine, like viewers of the painting, is transfigured under the spell of art, the music of angels:

MYSTERY: Katherine, the bride of Christ.
    She kneels, and on her hand the holy Child
    Setteth the ring. Her life is sad and mild,
Laid in God's knowledge—ever unenticed
From Him, and in the end thus fitly priced.
    Awe, and the music that is near her, wrought
    Of angels, hath possessed her eyes in thought:
Her utter joy is her's, and hath sufficed.
There is a pause while Mary Virgin turns
    The leaf, and reads. With eyes on the spread book,
      That damsel at her knee reads after her.
John whom He loved and John His harbinger
    Listen and watch. Wheron soe'er thou look,
The light is starred in gems, and the gold burns.

By the end the language sounds a bit like Hopkins' as it returns us from the content of the painting to its power as artifact. The ambiguity of the final "thou" makes our experience of the picture an analogue of the religious experience depicted within it. We, like the figures in the painting, visually encounter the luminous presence of divinity in the scene. Its "mystery," then, is only fully realized in the intensity of our own response.

*Dante Gabriel Rossetti*

Rossetti seems to follow Ruskin insofar as he dramatizes the power of visual art to lose us in a world of its own creation. Some of his poems, such as the sonnet on Giorgione, simply trace the viewer's stream-of-consciousness as he becomes increasingly engaged in a particular work. Others concentrate on the emotions seemingly embodied in figures within a painting. But invariably his sonnets draw back at the end to consider a picture as a formal, symbolic whole rather than as a collection of images and allusions. One of the finest examples is the sonnet "An Allegorical Dance of Women" on Andrea Mantegna's painting "Parnassus" (see illustration), in which Rossetti's use of the imagery of dance anticipates the poetry of the nineties:

SCARCELY, I think; yet it indeed *may* be
    The meaning reached him, when this music rang
    Sharp through his frame, a distinct rapid pang,
And he beheld these rocks and that ridged sea.
But I believe he just leaned passively
    And felt their hair carried across his face
    As each girl passed him; nor gave ear to trace
How many feet; nor bent assuredly
His eyes from the blind fixedness of thought
    To know the dancers. It is bitter glad
      Even unto tears. Its meaning filleth it,
      A portion of the most secret life: to wit:—
Each human pulse shall keep the sense it had
With all, though the mind's labour runs to nought.

Essentially the sonnet argues that the painting communicates in the same way as the dance it depicts—its subrational meaning addresses "Each human pulse." The revised version of the poem changes the phrase to "The heart's each pulse," to stress the distinction between this and normal mental experience. The subject of the last sentences in the poem is ambiguous: "it" may refer to the dance, to the pensive figure's "blind fixedness of thought," or to the painting as artifact; each of these is "filled" with meaning. But the point of this confusion is that such a "meaning" is internalized through one's participation in an artistic ritual. Just as the figure beside the dancers is carried "passively" beyond his own being to a "sense" of the meaning of their action, so are we, as spectators and readers of the sonnet, caught up in a ritual of interpretation that provides intuitive knowledge of "A portion of the most secret life." There are

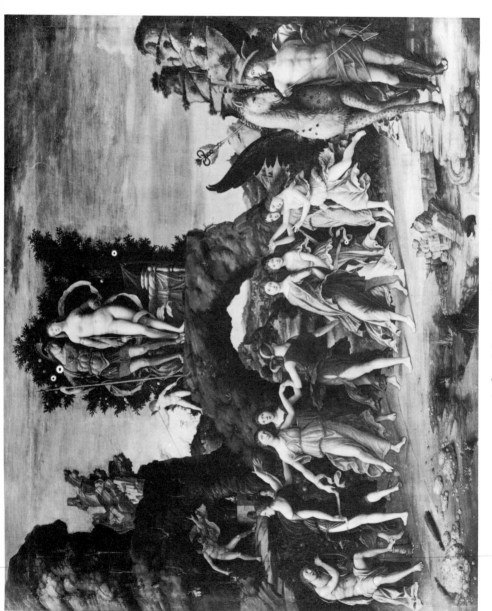

Andrea Mantegna, "Parnassus"

sufficient clues for Rossetti to have deciphered some of the allusions in the painting: the anonymous figure of the sonnet can be identified as Mercury by the caduceus he holds and by the presence of Pegasus. But Rossetti ignores the mythological references and "allegorical" meanings entirely. In a note to the poem in *The Germ* he finds it "necessary to mention that this picture would appear to have been in the artist's mind an allegory, which the modern spectator may seek vainly to interpret." Instead, the sonnet explores the most simple but, for Rossetti, most fundamental analogy between dance, music, painting, and poetry: their common capacity to transform human life at the deepest level. ⟩

These "Sonnets for Pictures," which are among Rossetti's most elusive, suggest some of the goals his literature of art held in common with Ruskin and Pater. But the simpler poems show more exactly how the transformation of art into literature is achieved. For Rossetti also shares a method with Ruskin, one that helps us understand further their common aims. Ruskin uses landscape painting as a controlled framework within which to analyze and enlarge his readers' modes of perception. Rossetti's "Sonnets for Pictures" have a similar psychological intent. And as in Ruskin, each of Rossetti's exercises in multiplying consciousness points toward the multiplicity of all experience, and toward the difficulty of apprehending reality fully or representing it fully in art.

For the painting by Ingres of "Roger Freeing Angelica" (see illustration) Rossetti composed two sonnets to "Ruggiero and Angelica." This fact alone suggests that the visual world is such that no single point of view is adequate to comprehend it. Both poems follow the attention of the implied viewer as his eyes wander from detail to detail. But these different pictoral details turn out to depend on different modes of artistic expression, and hence the act of observation becomes an exercise in different forms of response. No one descriptive mode seems adequate to represent Ingres' painting: like Ruskin, Rossetti implies that the most intense experience can be apprehended only through a kind of multiple perception. And this multiplicity is heightened by the fact that, as in the case of "Parnassus," Rossetti is describing a literary painting: Ingres' story is taken from *Orlando Furioso*.

The first sonnet for "Ruggiero and Angelica" alternates between narrative and allegorical details in the painting, producing several distinct sorts of poetic effects. At first the painting seems

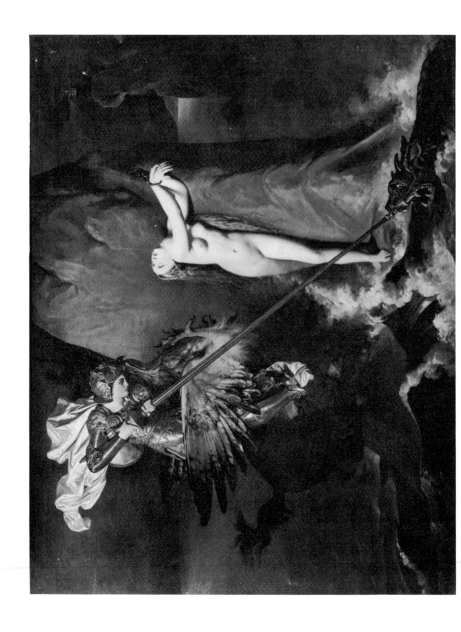

ornately descriptive. Rossetti depicts the rugged medieval landscape in which a knight fights a dragon:

A remote sky, prolonged to the sea's brim:
  One rock-point standing buffeted alone,
  Vexed at its base with a foul beast unknown,
Hell-birth of geomaunt and teraphim.

By the sestet of the sonnet the sky has become "harsh, and the sea shrewd and salt." But at this point the scene is described less as a static allegory, as in the opening lines, than as an active and passionate drama:

          The spear's lithe stem
Thrills in the roaring of those jaws: behind
That evil length of body chafes at fault.

Even given the heightened energy of his verse, Rossetti has portrayed the scene so far through a distinctly moral perspective. In the second sonnet on the picture, this method has been supplanted by a more relativistic, psychological technique. Our attention is focused on the chained lady for whom the knight and dragon fight: the sonnet narrates through her consciousness. As she views it, the confused energy of the scene makes it difficult to know exactly what is being represented.

Clench thine eyes now,—'tis the last instant, girl:
  Draw in thy senses, set thy knees, and take
  One breath for all: thy life is keen awake,—
Thou mayst not swoon. Was that the scattered whirl
Of its foam drenched thee?—or the waves that curl
  And split, bleak spray wherein thy temples ache?
  Or was it his the champion's blood to flake
Thy flesh?—or thine own blood's anointing, girl?

Rossetti concludes with a portrayal of the moment after the fight, but as he imagines the scene again unanimated and silent, his language ceases to describe emotions and records only appearances and the general moods created by setting and the colors on the canvas:

Now, silence: for the sea's in such a sound
  As irks not silence; and except the sea,
  All now is still. Now the dead thing doth cease

> To writhe, and drifts. He turns to her: and she,
> Cast from the jaws of Death, remains there, bound,
> Again a woman in her nakedness.

This "nakedness" is only the absence of all the emotive suggestions made by Rossetti elsewhere in the pair of sonnets. Now the demonic beast is only a "dead thing"; the tense, "heartsick" lady only "a woman in her nakedness." It is as if the figures of the painting have become at last only painted images. This is the final stage in a full perception of art, the point at which we draw back from an intense, visual experience and recognize its artificiality. Such a conclusion reminds us that to achieve the varied, heightened perception of reality Rossetti has dramatized, he needs to filter experience through the lens of another work of art.

Many of the sonnets Rossetti composed to accompany his own paintings belong to a later period than his work for *The Germ*. Just as the style of his pictures gradually changes over his career, so in these poems at least one aspect of his ritual of interpretation has been altered. Most of the subject paintings contain a single image, the figure of a woman, usually gazing intently out of the canvas toward the viewer. The sonnets discussed so far interpret paintings that have a good deal of visual complexity, and one of their important functions is to control the motion of our eyes and organize our responses to specific details. The sonnets written for such later paintings as "Astarte Syriaca," "Lilith," "Sibylla Palmifera," "Venus," or "Pandora" attempt instead to evoke the mysterious powers of their central characters, to lure the viewer under their "spell." Rossetti's characteristic procedure is to give a portion of the history of the figure on the convas, in some cases to narrate the story associated with her in myth or literature, and to draw our attention only to those few details which seem to reflect her inner mystery. Typically he mentions the woman's eyes, which frequently provide the focus of the picture as well. The emphasis on such detail in a poem makes the corresponding painting seem alive in its power to enchant a viewer. The sonnet on "Lilith," for example, treats the flowers in the picture as symbols of the active potency of the mystical figure:

> The rose and poppy are her flowers; for where
> Is he not found, O Lilith, whom shed scent

And soft-shed kisses and soft sleep shall snare?
Lo! as that youth's eyes burned at thine, so went
Thy spell through him, and left his straight neck bent,
And round his heart one strangling golden hair.

"Venus," with "the apple in her hand for thee,"

Yet almost in her heart would hold it back;
She muses, with her eyes upon the track
Of that which in thy spirit they can see.

And Rossetti's poem on his painting "Astarte Syriaca" (see illustration) ascribes to her

That face, of Love's all-penetrative spell
Amulet, talisman, and oracle,—
Betwixt the sun and moon a mystery.

In the sonnets written for Rossetti's own paintings we respond especially to the ritual qualities of his interpretations of art. It is easier in verse than in prose to achieve incantatory rhythms, and Rossetti controls these through a mannered syntax and punctuation, through an elaborate vocabulary and frequent use of hyphenated words, and through the pause mid-way necessitated by the Italian sonnet form itself. His penchant for repeating phrases in the first and final lines stems from the same assumptions: the interpretation of art is an ongoing process, a ritual in which we must fully and continuously immerse ourselves if we are to experience a painting's transforming power. "Astarte Syriaca" begins and ends with the word "mystery," now wholly paganized as compared to the sonnets on Memling, and explicitly identified with the magical power of Astarte's face. The comparison between poem and picture reveals some enumeration of visual details, but these supply a "meaning" only in the most generalized sense. The presence in the painting of the two "sweet-ministers" reminds us that the goal of contemplation is worship, or at least a "witnessing" of the power of Beauty:

Mystery: lo! betwixt the sun and moon
Astarte of the Syrians: Venus Queen
Ere Aphrodite was. In silver sheen
Her twofold girdle clasps the infinite boon

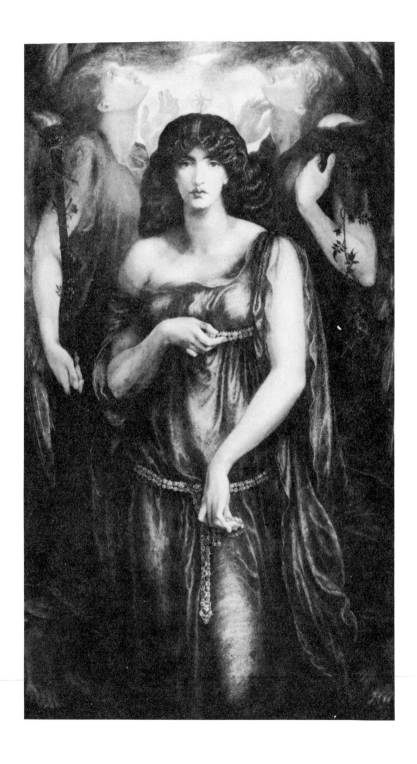

D. G. Rossetti, "Astarte Syriaca"

Of bliss whereof the heaven and earth commune:
  And from her neck's inclining flower-stem lean
  Love-freighted lips and absolute eyes that wean
The pulse of hearts to the spheres' dominant tune.

Torch-bearing, her sweet ministers compel
  All thrones of light beyond the sky and sea
  The witnesses of Beauty's face to be:
That face, of Love's all-penetrative spell
Amulet, talisman, and oracle,—
  Betwixt the sun and moon a mystery.

Exploring the causes of our submission to such an image, the
sonnet is about both the painting and itself. Astarte's power, in
fact, is ascribed to the agency of various forms of art: the
"Torch-bearing" ministers illuminate her beauty; her lips and
"absolute eyes" enchant us to the rhythm of the music of the
spheres. Similarly, in the sonnet and painting titled "A Sea-
Spell," the Siren's lute represents the depth and potency of her
"trance." With Rossetti, as with Pater, art "aspires to the condi-
tion of music" insofar as it assumes a subliminal control over
the being of a spectator. The "Sonnets for Pictures" consistently
lull us into a condition of psychic receptivity to enable us to
enter the magical realm of art.

Images of Reality

The compactness of the sonnet offers the most appropriate
context for Rossetti's ritual of interpretation, heightening the
intensity necessary in such a literary treatment of visal art. But
as with Ruskin and Pater, not all Rossetti's literature of art can
be termed ritualistic. There are different but equally important
examples of his poetic treatment of the fine arts in two long
narrative poems, "The Portrait" and "The Blessed Damozel,"
both written in the period of The Germ, where "The Blessed
Damozel" first appeared. Only "The Portrait" is explicitly con-
cerned with painting; but the themes and methods of "The
Blessed Damozel" lend it to the visual "gloss" of Rossetti's
subsequent paintings of the same name. The poems are impor-
tant, however, not for their relation to specific works of art but
for their exploration of a problem Rossetti pursues elsewhere in
connection with painting. Both use their narrative structures to
deal with the nature of reality and its relation to the imagi-
nation.

"The Portrait" tells the story of a specific but fictional paint-ing—the sort of "imaginary portrait" technique that Rossetti uses in "Hand and Soul" and "St. Agnes of Intercession"—but here painting also becomes a metaphor for particular forms of consciousness and perception. In view of the self-consciousness of his other writings dealing with visual art, it is not surprising to find this poem employing one of Rossetti's most elaborate formal structures. There are twelve nine-line stanzas, and the delicate rhyme scheme (*ababccddc*) of the octosyllabic lines provides an intricate formal expression of the theme of memory and meditation. The situation is quintessentially Pre-Raphaelite: the artist-speaker contemplates a portrait he painted of his dead lover. But the center of interest is not simply love or death. Rossetti uses the situation to dramatize a complicated range of mental associations. The focus of the poem is the process by which the painter connects different aspects of his experience. His thoughts move us back and forth in time: to the moment of actually painting the picture, to the scene that inspired the portrait in the firt place, to his life without the woman in the painting, even to a future transcendence which the vividness of the portrait encourages him to anticipate. These shifts in time and theme are always activated by the painting itself. The speaker refers to the picture repeatedly only to free-associate from it to the various memories and thoughts recorded in the poem; it is defined as the source and equivalent of his ranging thoughts. Thus, as in other poems dealing with the complex "mystery" of art, the subject is the psychological power and meaning of painting. The portrait is for Rossetti a symbol, again in Pater's sense of the word: the poem celebrates the picture's range and depth, its power to contain worlds of thought and feeling within a single image.

"The Portrait" begins by hinting that the picture's capacity to represent so much of its painter's mental life gives it a life of its own:

This is her picture as she was:
    It seems a thing to wonder on,
As though mine image in the glass
    Should tarry when myself am gone.
I gaze until she seems to stir,—
Until mine eyes almost aver
    That now, even now, the sweet lips part

To breathe the words of the sweet heart:—
And yet the earth is over her.

The suggestion that art resembles magic reappears at the con-
clusion of the poem, where the power of the image seems to
offer both the painter and his beloved the possibility of eternal
life:

Even so, where Heaven holds breath and hears
    The beating heart of Love's own breast,—
Where round the secret of all spheres
    All angels lay their wings to rest,—
How shall my soul stand rapt and awed,
When, by the new birth borne abroad
    Throughout the music of the suns,
    It enters in her soul at once
And knows the silence there for God!

Here with her face doth memory sit
    Meanwhile, and wait the day's decline,
Till other eyes shall look from it,
    Eyes of the spirit's Palestine,
Even than the old gaze tenderer:
While hopes and aims long lost with her
    Stand round her image side by side,
    Like tombs of pilgrims that have died
About the Holy Sepulchre.

It is clear by the end that the description of art is only the
premise for other kinds of poetry. "The Portrait" itself connects
physical and metaphysical worlds. Between the beginning and
concluding lines of the poem the speaker has advanced from one
form of vision to another, much as Ruskin does in the progress
of *Modern Painters*. The metaphor of painting implies that any
creative art—even one with the obvious constraints of portrait-
painting—requires an extensive exploration of the nature of
reality.

Rossetti organizes the entire poem around similar alterations
in the speaker's view of his own experience, around different
kinds of perception and thought. It is essentially a collection of
poetic variations on a single theme, that of "The Portrait" itself.
The shifts in time within the poem correspond as well to shifts
between different modes of poetry. The poem, we are asked to

believe, "resembles" the imaginary painting in its variety of expressive techniques. In the poem these techniques are held together by a rather thin narrative structure. Rossetti shifts between different modes abruptly and freely, as we notice when the artist, observing his picture in the present, recalls its beginnings:

In painting her I shrined her face
    Mid mystic trees, where light falls in
Hardly at all; a covert place
    Where you might think to find a din
Of doubtful talk, and a live flame
Wandering, and many a shape whose name
    Not itself knoweth, and old dew,
    And your own footsteps meeting you,
And all things going as they came.

Immediately noticeable are the discrepancies between the different sorts of "things" that coexist in this "mystic" setting. The poem continues:

A deep dim wood; and there she stands
    As in that wood that day: for so
Was the movement of her hands
    And such the pure line's gracious flow,
And passing fair the type must seem,
Unknown the presence and the dream.
    'Tis she: though of herself, alas!
    Less than her shadow on the grass
Or than her image in the stream.

That day we met there, I and she
    One with the other all alone;
And we were blithe; yet memory
    Saddens those hours, as when the moon
Looks upon daylight. And with her
I stooped to drink the spring-water,
    Athirst where other waters sprang;
    And where the echo is, she sang,—
My soul another echo there.

The recollection motivated by art provides an excuse for Rossetti to explore the interrelationship of different kinds of "reality." The three distinct points in time identified here, for

example, require at least three ways of viewing nature or depicting the world in art. In the first stanza the landscape is "mystic" and directly symbolic of spiritual conditions. Rossetti there describes the "portrait" as an allegorical painting. But as in much of his own art, the occult atmosphere is achieved through the use of physical details; the method of the imaginary painting is comparable to works like "Venus Verticordia" or "A Vision of Fiammetta," in which beautiful allegorical women are nestled in lush vegetation. In the next stanza Rossetti also refers to an actual landscape, a place in which the lovers met and "were blithe." Those details in turn become expressive of internal states, making the real scene fade into another kind of metaphor: the artist describes himself as "Athirst, where other waters sprang." Nature itself supplies metaphors for the relativity of realism in art. Thus, the portrait resembles the beloved "Less than her shadow on the grass/Or than her image in the stream."

Each of these distinct forms of poetic expression derives from an imagery that is treated as "actually" present in the portrait: the overhanging trees, shadowed grass, a stream, the moon shining in a daylight sky. What at first appears to be a profusion of decorative imagery is in fact the use of a single set of images in a number of different ways. The dramatic action of the poem consists of the successive transformations of these details into different kinds of landscape poetry. As in Ruskin, different views of reality are juxtaposed with one another; and as in Ruskin, the unity of the painting which is the subject demonstrates the interrelationship of these different forms of perception. Every shift in Rossetti's style begins with a reference back to the portrait itself, to suggest that the new vision of the world is also embodied in its imagery. Thus, the point of the verse is not to construct a description of the imaginary painting or to narrate the history of its creation, although both aims are partially achieved. As in Ruskin, the complexity of art is a metaphor for the complexity of reality. The real object of the poem is to demonstrate the necessity of seeing the world through a collection of distinct and opposing perspectives. As a metaphor, the painting suggests that such a complex vision is essential to the creative process.

The theme of the complexity of experience links Rossetti's poems about painting with another poem about love and death, "The Blessed Damozel." It is Rossetti's most famous poem and the one that most clearly defines the influences of painting on

his poetic forms and interests. The poem is not, of course, originally about a painting; indeed, the various oil paintings of the theme (see illustration) were based on the poem and produced later. But although Rossetti had not yet used the subject in a picture when the poem appeared in *The Germ*, this seems to have been contemplated from the start. Like his "Sonnets for Pictures," the poem concerns the problem of perception, the difficulty of understanding both the actual events of the phenomenal world and spiritual experiences, intuitively known but intangible. It is Rossetti's first attempt to define a relationship between the real world and a spiritual ideal, between human and divine forms of love. But the central focus of the poem is not the definition of ideal love or the evocation of a Pre-Raphaelite heaven. Rossetti uses these themes to dramatize the complexity of human experience and the difficulty of comprehending it.

"The Blessed Damozel" reads like an elaborate allegory on the tension between real and imagined worlds, fact and poetic vision, physical and spiritual dimensions of experience. Like most of his long poems and ballads, it employs simple diction, which contributes greatly to its effectiveness. But alongside this clarity, Rossetti dwells on the paradoxical elements in the poetic situation: in heaven, the departed maiden longs for human love; her spiritual "body," half-physical, warms the "gold bar" at the edge of Paradise. One of many small ironies in the poem is implicit in that last detail: the "bar" suggests the protective barrier placed in front of paintings in nineteenth century galleries; Rossetti is playfully underscoring the theme of the Damozel's unreality.

Most of the poem consists of her meditations. As a relatively new initiate into a Heaven of reunited lovers, she tries to imagine exactly what will occur when her physical love is consummated in divine form:

"I wish that he were come to me,
    For he will come," she said.
"Have I not prayed in solemn Heaven?
    On earth, has he not pray'd?
Are not two prayers a perfect strength?
    And shall I feel afraid?

"When round his head the aureole clings,
    And he is clothed in white,
I'll take his hand and go with him

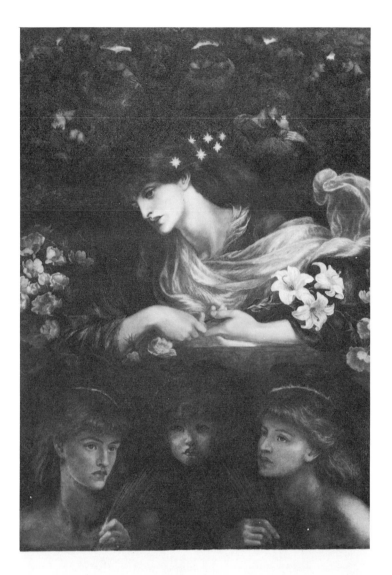

D. G. Rossetti, "The Blessed Damozel"

To the deep wells of light;
And we will step down as to a stream,
And bathe there in God's sight.

"We two will stand beside that shrine,
Occult, withheld, untrod,
Whose lamps tremble continually
With prayer sent up to God;
And where each need, revealed, expects
Its patient period."

Part of the irony of this situation is that, for all the beauty
with which she describes the interpenetration of physical and
spiritual worlds in the lives of heavenly lovers, the Damozel
fails to understand the plain truth about what is going on in the
real world below her. The meditations of her lover on earth,
interspersed parenthetically between her laments, suggest his
difficulty in believing that his lost mistress has another life. The
contrasting sections of the poem dramatize the distance between
his instinctive skepticism, rooted in nature, and her vividly
depicted existence in a spiritual world:

(To one, it is ten years of years.
. . . Yet now, here in this place.
Surely she leaned o'er me—her hair
Fell all about my face. . .
Nothing: the Autumn-fall of leaves.
The whole year sets apace.)

It was the terrace of God's house
That she was standing on,—
By God built over the sheer depth
In which is Space begun;
So high, that looking downward thence
She could scarce see the sun.

The relationship between the two figures in the poem finally
defines the greatest irony of all: the entire situation may be a
fabrication, within the fiction of the poem. The earthly lover's
remarks are enclosed within parenthesis, but those of the
Damozel are enclosed in single quotes. The Damozel is described
in the third person; he speaks in the first. It is as if he has been
the narrator of the heavenly scene all along, imagining (or trying
to believe in) all its precise but ethereal details. In fact, we are

*Dante Gabriel Rossetti*

allowed to glimpse this transformation in process. The paren-
thetical asides reveal that his powerful feelings may be influ-
enced by illusions in nature. The poem hints that the source of
the descriptions of Paradise may turn out to be simple, physical
facts. Stanzas added in a later version of the poem elaborate on
this theme:

> The sun was gone now; the curled moon
>    Was like a little feather
> Fluttering down the gulf; and now
>    She spoke through the still weather.
> Her voice was like the voice the stars
>    Had when they sang together.
>
> (Ah sweet! Even now, in that bird's song,
>    Strove not her accents there,
> Fain to be hearkened? When those bells
>    Possessed the mid-day air,
> Strove not her steps to reach my side
>    Down all the echoing stair?)
>
> "I wish that he were come to me."

If the lover on earth narrates the poem, then those bells and
"that bird's song" may have led his imagination into a pathetic
fallacy in the description of the Damozel's voice.

But by the conclusion of the poem it is clear that these ironies
cut two ways. "The Blessed Damozel" is equally about its title
character and her lover on earth. The detailed heavenly land-
scape is an index to the intensity of his grief for his lost lady.
Thus, even as her "existence" is questioned, the power of his
emotion is dramatized. Rossetti's point is not to belittle the idea
of a Paradise of lovers but to describe a simple but powerful
emotion by illustrating its operation. The briefness and rarity of
the first-person fragments make the lover more rather than less
convincing. Rossetti dramatizes the lover's emotion without
concentrating on it; and his simple diction and relatively plain
style help validate the genuineness of the lover's feelings. For he
is, at best, a skeptic; his closest approach to some form of belief
can be achieved only through the medium of poetry. In a
passage removed from later versions of the poem, the lover
meditates on the worthiness of his faith compared with that of
the Damozel. If he should ascend for judgment in the world he

believes her to inhabit, the only feelings that could possibly gain him admission would be those contained in the poem itself:

Alas, and though the end were reached . . .
Was *thy* part understood
Or borne in trust? And for her sake
Shall this too be found good?—
May the close lips that knew not prayer
Praise ever, though they would?

In this very dream there is an acceptance of its impossibility. Yet, by the end of the poem, such realism helps make the Damozel herself more convincing and almost brings the skeptical lover to the point of belief. The Damozel's moods and experiences seem to culminate in simple but powerful equivalents on earth, which he, no longer capable of fully dismissing his intuitions into the supernatural, accepts:

The light thrilled past her, fill'd
With Angels in strong level lapse.
Her eyes prayed, and she smiled.

(I saw her smile.) But soon their flight
Was vague in the poised spheres:
And then she cast her arms along
The golden barriers,
And laid her face betweend her hands,
And wept. (I heard her tears.)

In these final lines of "The Blessed Damozel" we are left with two experiences; in the context of the speaker's situation one is real and the other imagined. But rather than choose between them, the poem stresses their interdependence.

For Rossetti, as for Ruskin, the only "proof" of the reality of supernatural experience is in the style with which it is described. "The Blessed Damozel" is not so much a visionary portrait of another world as an encounter between two worlds and two views of experience. It is an account of the formation of a spiritual vision under the stress of grief and longing. We are asked not to accept the vision as somehow "true" but rather to concede that it might be experienced as real under the circumstances described in the poem. The central drama is psychological; we observe the mental process by which the earthly lover connects

the facts of his own world with what he imagines to be impressions from outside it. In this sense the poem is about the relationship of spiritual and naturalistic perception, a familiar theme from Ruskin. Indeed, when Rossetti finally paints "The Blessed Damozel," the picture gives symbolic form to the dialectic of the poem. In one of two painted versions of the theme he divides the canvas into two separated pictures (see illustration). The living male speaker, lying in the predella of the painting, looks toward the larger image of his dead mistress, who almost seems encased in a cartoonist's "thought balloon" above his head; his position thus becomes the "signature" at the bottom of the fuller work above. The use of the diptych, beyond its reference to medieval painting, has a dramatic function. It reminds us that Rossetti commits himself to exploring the relationship between imagination and reality in the form of his art, in a symbolic structure common to both poetry and painting.

Imaginary Portraits

The resemblances between Rossetti's aesthetics and Ruskin's are not so much signs of an intellectual debt as by-products of a common interest in the relationship between literature and art. Whereas in "The Blessed Damozel" this relation appears only marginally, it provides the central theme in the story "Hand and Soul," where the analysis of mystical painting is very close to Ruskin's. In fact, what is remarkable in Rossetti's early poetry and prose is the way they anticipate conclusions Ruskin had not yet fully drawn. Ruskin's concepts of visionary art and the relationship of naturalism, grotesque, and religious purism are not fully articulated until the completion of *The Stones of Venice* in 1853, or perhaps not even until *Modern Painters III*, three years later. But "Hand and Soul" appears in 1849 and contains in compressed, fictional form much of what Ruskin would have to say about the meaning and evolution of powerful religious imagery. Like Ruskin, Rossetti is trying to rationalize a fundamentally irrational form of art. His choice of writing in prose seems explicable as a way of making mystical painting more accessible to his reader, rendering the account of the supernatural event as real as an account of history. Almost identical themes appear in Rossetti's unfinished romance "St. Agnes of Intercession," which was to have appeared in a later issue of *The Germ*. It turns on the relationship of painted historical

doubles, perhaps under the influence of Poe's "William Wilson." Both stories also anticipate Pater's favorite mode of the literature of art, "imaginary portrait." Like Pater, Rossetti offers a fictional background to what he claims are actual works of art. His narrators visit the medieval paintings around which the supernatural episodes of the stories develop; this contact between life and art, in fact, is what provokes the action of the tales. The aesthetic "moral" of each seems to be that one cannot distinguish between the facts of real life and the products of the imagination. And Rossetti's historic point, as in Ruskin and Pater, is that this fusion of life and art was especially rich and complete at a particular stage of history, for him the Middle Ages.

"Hand and Soul" reads like a fictionalized version of Ruskin, directly invoking themes from *Modern Painters* to make its points about art and life. Ruskin's second volume, which appeared three years before the story, contains special praise for the art of Tuscany. Rossetti's opening remarks refer to many of Ruskin's favorite locales and place his fictional hero, the painter Chiaro dell' Erma, in Pisa, an important site for Ruskin as well as for the Pre-Raphaelites. In "St. Agnes of Intercession," the fictional Perugian artist Bucciuolo Angiolieri is said to have been a friend of Benozzo Gozzoli, whose naïve paintings had influenced the Pre-Raphaelites so profoundly; he is also the first to introduce "a perfectly nude figure in a devotional subject" (I, 414). Rossetti seems to be using Ruskin's interests as a premise for describing rebel artists very much like himself. In fact, there is a good deal of wishful autobiography in the portraits of Chiaro, Bucciuolo, and the modern "double" who relives Bucciuolo's experience. Graham Hough has pointed out that Chiaro's rivals sound a bit like Ford Madox Brown, Holman-Hunt, and especially Millais.[13] Thus, "Hand and Soul" quickly moves from an account of a historic situation to a parable of the role of art in the nineteenth century. Rossetti is defining his own aesthetic against the faint images of the other pre-Raphaelites and Ruskin.

Chiaro ignores the greater training and reputation of his contemporaries and quickly establishes his own niche. In Pisa, he enjoys a success much like that traditionally associated with Cimabue in Florence: crowds flock to examine his first paintings as they are carried through the streets. But Chiaro's demands for artistic purity bring him and his painting to a crisis. "There

had always been a feeling of worship and service" in his works—but was his faith genuine? "He became aware that much of that reverence which he had mistaken for faith had been no more than the worship of beauty" (I, 387). Rossetti is trying to resolve for himself another form of a problem more noticeable in Ruskin, a suspicion of art-for-art's-sake; he may even be referring to Ruskin's distinction in *Modern Painters II* between aesthetic and theoretic beauty. Chiaro resolves at this point that his future art will have moral effect. But it is precisely here, ironically, that he begins to lose touch with the realism his prior art had mastered. Following his moral commitment, he produces only "laboured" paintings which "multiplied abstractions," all seeming "cold and unemphatic" (I, 388). Chiaro's loss of power is dramatized when two rival families of Pisa fight viciously beneath the allegories of Peace he had painted in the portals of San Petronio. The episode portrays strikingly the insufficiency of ethical ideals as the sole guidelines for art. If Rossetti is concerned about art-for-art's-sake, he also senses that Ruskinian self-consciousness is not the best formula for producing great art, or even for restoring art to moral power.

At the height of dispair, Chiaro discovers that a beautiful woman has entered his room, dressed in a lovely costume of green and gray, her "hair a golden veil through which he beheld his own dreams" (I, 391–392). Hers is the same image with which Rossetti introduces the story, the "real" portrait that he uses the tale to explain. The description of her refers both to the vision and to the picture; it functions as a ritual of interpretation by virtue of the fact that both the narrator and Chiaro fall under the lady's spell and are transformed.

Before the scene concludes, it is evident that Chiaro will paint her, creating simultaneously a portrait and a visionary self-expression. For her speech is like his own, and she announces herself to be an image of his soul. The compelling power of the completed work in the nineteenth century affirms that artists will create enduring images if they will only paint what is within them, images of their own feelings. As the visionary woman pronounces essentially this message, it sounds a bit like Ruskin's appeal for artists to go "straight to nature, in all humbleness of purpose . . .": "In all thou doest, work from thine own heart, simply . . . Not till thou lean over the water shall thou see thine own image therein . . . Know that there is but this means whereby thou mayst serve God with man:—Set thine

hand and thy soul to serve man with God" (I, 394). As the woman instructs Chiaro to paint her, it sounds like a ritual of exorcism as much as one of creation: "so shall thy soul stand before thee always, and perplex thee no more" (I, 395). Similarly, she warns Chiaro not to preoccupy himself with the standards of other men: moral self-consciousness must be banished as a distraction from the true ends of art; religious art must above all be sincere. For Chiaro this means painting the world as he knows it (Rossetti makes a point of describing her clothes as simple and contemporary), expressing ideas in his natural style, and accepting his personal limits and the personal form of his love for God; it is the ethic of "The Nature of Gothic": "Who bade thee strike the point betwixt love and faith? Wouldst thou sift the warm breeze from the sun that quickens it? Who bade thee turn upon God and say: 'Behold, my offering is of earth, and not worthy . . .' Be not nice to seek out division; but possess thy love in sufficiency: assuredly this is faith, for the heart must believe first" (I, 393).

The argument of "Hand and Soul" is twofold. Rossetti is suggesting that mystical art presents visions which had reality for their painters. Genuine religious art has the quality of portraiture, giving its insights tangible and even profane physical form. Chiaro's mystic lady is beautiful, but she is also simply dressed. The related point is that this very simplicity makes religious painting more universal. Chiaro is told in his vision that a humbler, more honest style forms the basis of the most meaningful sort of moral contact with a spectator: "For his heart is as thine, when thine is wise and humble; and he shall have understanding with thee" (I, 394). Rossetti, then, is not just explaining the creation of mystical art; he is also describing the temper of mind in which such art must be perceived. The story begins with the English narrator's passionate discovery of Chiaro's beautiful lady in the Pitti Palace; it ends with the less serious responses of other visitors to the gallery. Some Italians joke about the vague, misty treatment of the painting; it is appropriate, they say, that such a work should be admired by an Englishman, who lives in a land of fogs. A French artist adds, "Je tiens que quand on ne comprend pas une chose, c'est qu'elle ne signifie rien." Rossetti answers this rationalistic quip ironically in the last sentence of the story: "My reader thinks possibly that the French student was right" (I, 398). This ending cautions us not to dismiss as meaningless whatever we fail to

understand. Indeed, it challenges us to test the fullness of our own sensibilities against the kinds of visions that have been achieved in past art. The real meaning of Chiaro's story is left for the reader to complete.

Medieval art enters into the life of the nineteenth century even more dramatically in "St. Agnes of Intercession." It is a simpler story than "Hand and Soul" but would have become more complex, and probably been the better of the two, if Rossetti had completed it. But it adds little to the sense of Rossetti's use of art as literature because his interest in aesthetics is dominated by an interest in creating suspense. The story narrates the career of a young artist, from his childhood admiration for engraving of naïve Italian painting to an initial public success. He paints a portrait of his beautiful fiancée in order to create a work "wrought out of the age itself" (I, 402), and it appears "on the line" at the opening of the Academy exhibition. But there a critic he knows, unaware whose picture he is discussing, points out that the painting directly copies the work of a medieval Italian artist, Bucciuolo Angiolieri, whom the hero recognizes as his childhood ideal. Fearing that his picture is an unconscious imitation, the artist rushes to Perugia in search of the original work. There he finds not only that Bucciuolo's St. Agnes is identical to his own "Mary Arden," but that the medieval artist's self-portrait, hanging in another room of the same gallery, is an exact image of himself.

At this point the story begins to evolve toward a Poesque mystery. The artist-narrator discovers that Bucciuolo's model for St. Agnes died shortly after he had painted her portrait. In fact, he began the original picture as a gesture of love, only to sanctify his subject as St. Agnes when completing the portrait after her death. These coincidences become increasingly convincing to the narrator who describes the Italian portraits as "painted by myself four hundred years ago." He compares their discovery to that of finding some lost necropolis in which one sees "a human body in his own exact image, embalmed" (I, 417). This morbidity increases when the artist returns to London, presumably to find an uncanny echo of history in modern life, falls sick for a few months to increase the suspense, and is about to visit his own fiancée when the story abruptly breaks off. It is difficult to imagine how Rossetti would have concluded the tale: to a certain extent the direction of its aesthetic argument is running counter to the tendency of the suspense, and

that may explain his refusal to complete it. Even in its fragmentary form, however, it is clear that the story explores the relation of past and present, life and art.

In a sense both stories are based on the same scheme, very much like that present in many of Rossetti's poems about painting. The basic elements are drawn from past and present: an artifact and an observer, both fictionally located in their respective historical and psychological milieus. The narratives show how these different worlds can be united through the medium of the historically enduring work of art. Indeed, the transcendent power of art is dramatized in the lives of all four main figures. The two medieval painters as well as the pair of nineteenth century viewers transform themselves under the influence of art. Chiaro and Bucciuolo construct religious images out of actual contemporary materials and thus endow their own lives with spiritual meaning; their pictures transmit the same possibility to an ideally receptive spectator. The story-within-a-story technique implies a complex and crucial analogy: just as visionary experience can be created in art, so the visionary experience of an artist can be approximated by the passionate contemplation of his work. It is fair to label these stories Pre-Raphaelite, and not simply because they describe naturalistically spiritual medieval painting. The characteristic element is the application of the meaning of art to the lives of modern spectators. As in Ruskin and Pater, the focus of Rossetti's narrative is the transformation of self through the contemplation of painting, a process that redirects present history toward the ideal imaginative conditions of the past.

# V

## Painting and Poetic Form

Rossetti's affinities to Ruskin and Pater are not solely a matter of common themes, for the literature of art can be characterized in terms of form as well as content. Throughout his career, Rossetti displays a fascination with art in the abstract, with an ideal of pure craftsmanship that anticipates Pater's more extreme formalism and ultimately may, by the 1870s, be influenced by it. Although this suggests a higher level of formal self-consciousness than can be found in Ruskin, the dialectic that pervades his analysis of landscape also appears in Rossetti's poetry, governing his practice of his favorite and most accomplished poetic form, the sonnet. As in Ruskin as well, an interest in history leads to experiments with traditional forms, in both Rossetti's writing and visual art. The concern with form and style emerges inevitably, perhaps, from a sensibility steeped in the arts and attuned to their subtle resonances and distinctions. Despite the fact that only a small portion of his verse directly touches on the fine arts, the influence of his broad aesthetic interests is felt everywhere. The continual effort to translate one form of expression into another seems to necessitate a search for ideal forms, the mode appropriate to a desired effect. Thus, the same impulse governing the Pre-Raphaelite translation of visual art into literature in the "Sonnets for Pic-

tures" ultimately produces the quasi-medieval, neo-Petrarchan account of modern experience in the sonnet sequence *The House of Life*.

The very importance of sonnets in his work perhaps reflects some concern over the formal limits inherent in the literature of art and its offshoots. Ruskin provides a continual object-lesson in the tendency toward imitative form, one not alway counter-balanced by the specificity of art. While Pater yields to the same urge, the tight control of his essays seems designed to curb some of the tendency toward expansiveness visible in Ruskin. Yet the emphasis of both on the individual, isolated masterpiece itself disrupts the larger structure of their writings. What results—in *The Renaissance* as in *Modern Painters*—is a kind of gallery motif of rough transitions between polished descriptions of great paintings. Their rituals of interpretation tend to stand as isolated set-pieces, soliloquies in prose, beside which the rest of their material recedes, thereby heightening the concentrated emotional effect. There is no identical issue in Rossetti largely because so much of his poetry is brief. The sonnet is suited for the treatment of the fine arts by virtue of its compactness: it is, like a painting, framed and self-contained. With Rossetti, the literature of art initiated by Ruskin becomes more compact and allusive, increasingly reliant on form itself to convey its symbolism. Indeed, the emphasis on structure leads Rossetti toward a kind of *poésie pure* which anticipates the modes and values of modern verse.

Formalism is apparent in Rossetti's longer poems as well as in his sonnets. For all its looseness, even the structure of *The House of Life* suggests an abstract use of form for symbolic purposes. The very choice of a format or mode of verse contributes to the specific atmosphere of feeling and thought in any given poem. A large measure of the beauty of such works as "Eden Bower," "Troy Town," "The King's Tragedy," or "The White Ship" depends on the associations of their traditional poetic forms and techniques. The ballad form, for example, alludes to history and to a climate of experience and belief essential to Rossetti's meaning. Even in long poems with original structures, form is an important ingredient of content. In "The Blessed Damozel," in fact, not only is the subject the relation of two worlds and two opposing modes of being, but Rossetti also organizes the poem around that relationship, so that we must shift from one figure to the other, almost in the

manner of a dialogue. The visual quality of the poetry intensifies this process, for we must interpret the nature and relationship of a number of isolated but vivid details to understand Rossetti's iconography. This is not narrative in the strictest sense, for it is less linear than cyclic (or a progressive spiral like the Yeatsean gyre), a network of interrelationships that must be understood dynamically. The structure of the poem prevents us from adopting a static, simplistic conception of its universe.

It is easier to identify the function of poetic structure in Rossetti's sonnets, where the brevity of the form necessitates abrupt transitions between different kinds of discourse: here the dialectic of form is particularly apparent. Characteristically, Rossetti delineates a naturalistic scene or a narrative incident in the opening octet, only to explore its significance on a higher metaphysical level in the sestet; the order can also be reversed. This is the arrangement of the charming verses on "Beauty and the Bird," based on a picture of Fanny Cornforth:

> She fluted with her mouth as when one sips,
>   And gently waved her golden head, inclin'd
>   Outside his cage close to the window blind;
> Till her fond bird, with little turns and dips,
> Piped low to her of sweet companionships.
>   And when he made an end, some seed took she
>   And fed him from her tongue, which rosily
> Peeped as a piercing bud between her lips.
>
> And like the child in Chaucer, on whose tongue
>   The Blessed Mary laid, when he was dead,
> A grain,—who straightway praised her name in song:
>   Even so, when she, a little lightly red,
> Now turned on me and laughed, I heard the throng
>   Of inner voices praise her golden head.

The same formula organizes a better-known poem from *The House of Life*, "Soul's Beauty." This at first appears to describe some sort of allegorical dream-vision; but in fact the octet refers to the details of a picture, "Sibylla Palmifera," for which the sonnet was written and after which it was originally named. Even without reference to the picture, however, the dialectical structure can be discerned, for the slight alteration in diction transforms an allegorical figure viewed at a distance into a more vivid personification of a personal ideal:

Under the arch of Life, where love and death,
Terror and mystery, guard her shrine, I saw
Beauty enthroned; and though her gaze struck awe,
I drew it in as simply as my breath.
Hers are the eyes which, over and beneath,
The sky and sea bend on thee,—which can draw,
By sea or sky or woman, to one law,
The allotted bondman of her palm and wreath.

This is that Lady Beauty, in whose praise
Thy voice and hand shake still,—long known to thee
By flying hair and fluttering hem,—the beat
Following her daily of thy heart and feet,
How passionately and irretrievably,
In what fond flight, how many ways and days!

By the end the heightened rhythms personalize the being of this
abstract woman; the sonnet dramatizes the tension between
allegory and intimate experience. This contradiction is not re-
solved but merely expressed by the poetry: the essential unity
between these two distinct views of the Lady Beauty is estab-
lished by the form of the sonnet itself and by its reference to a
single, specific work of art.

This format is not restricted to poems on pictures. Many of
the sonnets at the beginning of *The House of Life* structurally
balance passion and philosophy to present a composite view of
love. These are the poems Robert Buchanan attacked for sensu-
ality in his article of 1871 on "The Fleshly School of Poetry,"
but such censure completely ignores the point of Rossetti's
balanced account of love. Rossetti dramatizes the relation be-
tween two kinds of love by juxtaposing two kinds of poetry.
Their connection within the rigid structure of an individual
sonnet implicitly argues for the interdependence of sacred and
profane love, as in "The Kiss":

What smouldering senses in death's sick delay
Or seizure of malign vicissitude
Can rob this body of honour, or denude
This soul of wedding-raiment worn to-day?
For lo! even now my lady's lips did play
With these my lips such constant interlude
As laurelled Orpheus longed for when he wooed
The half-drawn hungering face with that last lay.

Rossetti answered Buchanan's attacks on his love poetry, on "Nuptial Sleep" in particular, by insisting on the necessity of reading the individual sonnets within the context of *The House of Life*.[1] The smaller context of the individual poem read in its entirety is equally indispensable. The point of many of these sonnets is to alternate between opposite versions of the same experience—to define love by identifying its alternate and most extreme forms. The greatest danger is to detach the most intense passages from the full dialectic of Rossetti's verse.

In the sonnets that refer to painting, the combination of a dialectical structure and allusions to another art have an additional effect: to increase our awareness of form and of the creative process, to call attention to the artifice behind the work. This is intentional. Much as his ritual of interpretation enables us to participate in the process of an artist's imagination, Rossetti's dialectical poems require that we actively reconstruct the ideas controlling the polarities of the verse. Even when his dialectic operates with a maximum of delicacy and grace, a trace of the artificial remains to remind us of the artist's presence.

"St. Luke the Painter" a Pre-Raphaelite poem of 1849, the period of *The Germ* and of the active collaboration of the Brotherhood, uses the theme of visual art to explore the relations between different stages of history. In the semi-allegorical tribute to the medieval painter, the references to "noon" and "twilight" seem to derive from the Brotherhood's private metaphors for the decline of civilization from the Middle Ages to the nineteenth century. Indeed, Rossetti's effort to translate painting into poetry is closely related to his desire to bridge this historical gap; and these dimensions of the poem's meaning are in turn closely related to his aesthetic psychology of an audience. Our attitude toward St. Luke and what he represents is the real subject of the sonnet. Rossetti dramatizes the urgency of studying a medieval religious painter, and his shifts in tone create the poem's dialectic. The sonnet begins by addressing the reader far more directly than do most of the "Sonnets for Pictures," as if (as in Ruskin) the ability to respond to historic art provides an intimate gauge of our aesthetic wholeness:

Give honour unto Luke Evangelist;
  For he it was (the aged legends say)
  Who first taught Art to fold her hands and pray.
Scarcely at once she dared to rend the mist

Of devious symbols: but soon having wist
  How sky-breadth and field-silence and this day
  Are symbols also in some deeper way,
She looked through these to God and was God's priest.

And if, past noon, her toil began to irk,
  And she sought talismans, and turned in vain
  To soulless self-reflections of man's skill,—
  Yet now, in this the twilight, she might still
  Kneel in the latter grass to pray again,
Ere the night cometh and she may not work.

The simplicity of the poem is deceptive. It does not just praise religious sincerity; it also dramatizes a way of seeing the world, and visual art provides the model for this apprehension. The tone of the opening lines is devotional, an effect created in the diction as well as in the use of archaic-sounding terms. But these change at the very end. The crucial moment for the sonnet's dialectic comes in a single clause, which reveals the connections between past and present, art and nature, material and spiritual vision—all of which, presumably, are fused in the work of the holy medieval painter himself. With the metrical stress on "now" in the twelfth line, a more intimate tone enters the verse; then in the next-to-final line, the sonnet's austerity seems to recede in favor of a brief flash of life. At this point, Rossetti introduces the sort of detail we might expect to find in Pre-Raphaelite art; in fact, "St. Luke" is written "For a Drawing." At the end of the poem Rossetti translates the abstract argument of the previous lines into a literal and descriptive moment. He re-examines the initial, quasi-mystical vocabulary and re-covers the outlines of an actual scene from the hints of "mist" and "sky-breadth." The personified "Art" that prayed with folded hands in an abstract landscape now appears in a more vivid setting to "Kneel in the latter grass." Metrically this is also the most direct and personal moment in the poem, just as it is the most particularized ("latter grass" suggesting something of the chill at nightfall). Rossetti's shift in poetic method gives the "night" of the final line the full set of possible meanings latent in his Biblical source: actual darkness and the metaphorical blackness of death.

Victorian readers might have recognized the Biblical warning as a favorite text for Carlyle, as it was also to become for

Ruskin. Rossetti uses it to underscore the Carlylean message that Ruskin also embraced, the possibility of natural supernaturalism, a simultaneous vision of the world as real and transcendent. The sonnet does not so much state a philosophy as dramatize one or, rather, dramatize a vision that characterizes the art of St. Luke and the Pre-Raphaelites. But what is interesting is not simply that Rossetti restates his belief in the necessary interrelationship of literal and figurative views of reality in great art. "St. Luke the Painter" translates this idea of visionary art into the basis of its poetic structure. St. Luke's double understanding of his medium supplies both the subject and the form of Rossetti's poem. Thus, the relation between the arts of painting and poetry depends on a common balance. Poetry does not imitate either the realism or the ornate medievalism of an artist like St. Luke: verse allies itself to visual art in its refusal to choose between these styles. As in "The Blessed Damozel," and as with the saintly painter himself, Rossetti refuses to sacrifice alternate modes of vision for each other, and strives for a poetic form that includes them both.

For Rossetti, a major attraction of the Petrarchan sonnet form is the ease of adapting it to such a dialectical vision of the world. He almost always divides his sonnets visually, so that octet and sestet are printed with a space between them, and often this gap also marks a shift in poetic technique. But the important point is not simply that a shift in perspective exists: Rossetti calls our attention to it, as if to insist on the importance of structure, to remind us that even the most seemingly spontaneous poetry is, by definition, artificial. His personalized and often eccentric punctuation and line-placement fosters the same impression. We are invited to feel the poetry at the same time that we contemplate it as an abstraction. The use of art as a theme or source of metaphors also contributes to this effect: the implicit comparison of two art forms reminds us that any art offers only one version of experience, which can be translated into the materials of another form of expression and appear quite different. The allusion to painting constitutes a gesture of self-consciousness, and a warning from the poet that the reader must be self-conscious as well.

Allusions to painting and to other nonliterary arts, then, enter Rossetti's poetry to remind us of the poetic process itself, of the presence of a controlling imagination behind any given artistic experience. This technique can be observed in two poems in

which Rossetti employs imagery from landscape painting. In the sonnet "The Portrait" an artist implores Love, the "Lord of all compassionate control," to help him bring his painting of his lover to life:

> let this my picture glow
> Under my hand to praise her name, and show
> Even of her inner self the perfect whole.
> That he who seeks her beauty's furthest goal,
> Beyond the light that the sweet glances throw
> And refluent wave of the sweet smile, may know
> The very sky and sea-line of her soul.

After this striking line the rest of the sonnet is conventional: the portrait having been completed, the speaker declares that those who "would look on her must come to me." Yet the emphasis of the poem is not on physical representation but on the painter's capacity to illustrate intangible spiritual qualities. The horizon metaphor ("sky and sea-line") reminds us, partly through the slightly awkward language itself, that such creation is abstract and artificial. Rossetti uses a similar image to define the relationship of lovers in "The Lovers' Walk." Their

> bodies lean unto
> Each other's visible sweetness amorously,—
> Whose passionate hearts lean by Love's high decree
> Together on his heart for ever true,
> As the cloud-foaming firmamental blue
> Rests on the blue line of a foamless sea.

The "blue line" suggests the illusion created by a horizon line in landscape painting. As in "The Portrait," the image from visual art stands out from its context to make us more rather than less aware of an artist's imagination creating the scene.

Marshall McLuhan has argued that Tennyson and other Victorian poets make their explorations in psychology by projecting mental states onto the landscape. Rossetti seems to understand both the advantages and limitations of such descriptive techniques. In the beginning of "The Lovers' Walk," for example, as William Michael Rossetti explains, "each detail of natural scenery is coupled with a somewhat analogous detail indicating the emotions of the lovers."[2] Thus, the octet describes:

*Dante Gabriel Rossetti*

Sweet twining hedgeflowers wind-stirred in no wise
  On this June day; and hand that clings in hand;—
  Still glades; and meeting faces scarcely fann'd;—
An osier-odoured stream that draws the skies
Deep to its heart; and mirrored eyes in eyes:—
  Fresh hourly wonder o'er the Summer land
Of light and cloud; and two souls softly spann'd
With one o'erarching heaven of smiles and sighs.

The value of the concluding and somewhat discontinuous image from painting is to remind us that this description of a psychological landscape involves a process of artistic abstraction. As in the artistic image in "The Portrait" the language is deliberately ornate: to call our attention to the decorative quality of "cloud-foaming firmamental blue," Rossetti *"rests"* it on "the blue line of a foamless sea." Similarly, the "sky and sea-line of her soul" is even out of context in a poem about art, and the meaning is not immediately clear. But by creating these obtrusive references to art in his love poetry, Rossetti makes his readers more self-conscious as well. We are, first of all, forced to confront the intellectual claims that Rossetti makes for the love relationship itself: love is a symbolic experience. But this view implies another: love poetry must be symbolic, abstract, complex. The references to painting in these sonnets remind us of the connection between the nature of art and love. Rossetti introduces them with striking, discontinuous images to imply that complex experiences can be depicted only with complex forms.

The same strategies appear in the relatively straightforward narrative poem "The Portrait." The twin subjects are art and love: Rossetti uses these themes to shift repeatedly between different forms of experience and between fundamentally opposite perceptions of the world. What is interesting about the form of "The Portrait" is that strength does not come from the clarity of the narrative—just the reverse. The poem's meaning is dramatized in its abruptness. The power of the shifting perspective depends on the fact that it is unexplained but unavoidable. The juxtaposition of alternative views of a single object and set of experiences becomes the central, formal pattern in the poem. The freely shifting thought of the speaker is made possible because the poem is not really organized as a narrative, or an argument, or a description. Its connections are in its very disjunctions, the points at which the style and verbal mode seem to

change direction and even change assumptions about the proper use of language. Rossetti constructs what Blackmur would call an expressive form, and his subject is the mental process implicit in all artistic creation. This accounts for the inclusion of totally different views of experience side by side, so that it becomes difficult at times to distinguish "real" events from metaphors created in the recollections of the speaker. This happens when the artist describes the moment when he actually began the picture:

> Next day the memories of these things,
>     Like leaves through which a bird has flown,
> Still vibrated with Love's warm wings;
>     Till I must make them all my own
> And paint this picture. So, 'twixt ease
> Of talk and sweet long silences,
>     She stood among the plants in bloom
>     At windows of a summer room,
> To feign the shadow of the trees.

Here, at the pivot of the entire poem, no line is clearly drawn between the descriptive, narrative, and metaphoric uses of nature in poetry: metaphor and reality as well as past and present seem fused in this moment of artistic creation. But Rossetti is not interested in explaining this fusion. Although the two halves of this stanza do refer to the poem's sketchy plot, and despite their reference to a definite action, they are not connected by narrative logic. Rossetti controls his verse by imposing an almost mechanical balance on it, expressed in the single causal link "so." The stanza is arranged to make the setting of the picture among leafy shadows result from a metaphoric recollection of the past, probably recalled after the picture was painted. All that really holds the poetry together is an interest in rendering abstractions literally, and transforming figurative language into natural description. The organizing principle is dialectic, as is the structure of the entire poem.

The title and subject of "The Portrait" suggests—and this stanza confirms—that such an approach to artistic form seems closer to painting than to poetry. The difference is primarily a matter of style. It is sufficient for the painter to represent the consequences of a complex idea, the products of an extended range of thought, without the poet's obligation to express the

stages of the process that gave birth to his imagery. Painting, that is, has a relatively finished and static quality when compared to even the least dramatic poetry. The passage from "The Portrait" in which Rossetti shifts from memory to an account of the act of painting has an important resemblance to this artistic fixity. The transformation is rough: "so" is plainly insufficient. Neither section of the stanza fully explains the thought behind it, the verbal or logical ties to its counterpart. Juxtaposition itself is the primary clue to the connection. This is not, then, an instance of a poet "thinking in verse." Rather, the thought is external to the poetry, appearing only in the structure of the stanza. Rossetti's language expresses only the products of his thought: the *process* is revealed only by his expressive form.

This is the most typical weakness of Rossetti's verse: a discontinuity of materials, a series of powerful images juxtaposed but not smoothly nor clearly linked by an orderly formal context. As in "The Lovers' Walk" or the sonnet called "The Portrait," his poetry seems to depend on the force of a few striking images rather than on generating its own organic structure of meaning. Form is, in a curious way, detached from content, at least on first inspection. The relations between form and content become apparent only after careful analysis; it is as if we are required to "read" in a new way—not according to a linear, verbal logic, moving from beginning to middle to end, but with a continual oscillation between different elements, in order to reconstruct an organizing form for ourselves; this is the manner in which Rossetti uses form in his painting. After such exercises of interpretation, form becomes not less but more important, and the dialectic between form and content even more intense. Before one can assess the difficulties of his poetry, therefore, it is necessary to examine the treatment of form in his painting and that of the other Pre-Raphaelites.

## Form and Function in Pre-Raphaelite Painting

The most obvious analogue to the dialectic of Rossetti's verse is to be found in the structure of Pre-Raphaelite painting. There are, of course, fundamental differences in the aims and techniques of the main figures in the movement, and Rossetti's own visual art alters significantly during his life. But there are common forms and motifs, and a distinct shared spirit, which can even be observed in Rossetti's most disparate productions.

The Pre-Raphaelites display similar attitudes toward color, the use of narrative, and the relation of the painting to a spectator. Even more important, in terms of Rossetti's verse, is the dynamic relationship among different aesthetic impulses within individual paintings, an inner drama of style and meaning which encourages the viewer to participate in the work. Mario Praz has identified broad patterns of aesthetic dualism running through much of Romantic and post-Romantic painting and literature.[3] Pre-Raphaelite painting shares in this tendency; their pictures rarely turn out to be as simple as they often first appear. Indeed, in their literary paintings, much as in the literature of art, complexity is functional: different forms of expression are juxtaposed to define fuller and more multiple views of human experience. Many critics have noticed a tension running through much Pre-Raphaelite painting between the elements of narration, naturalism, and symbolism. These modes frequently coexist in the same picture, where the artist may express several interpretations of the same subject, or treat specific details in various modes simultaneously. And insofar as any given image may possess multiple significance, the painting also allows for several distinct but equally meaningful forms of interpretation. The variety of Pre-Raphaelite technique at once increases the vitality of their images and multiplies the potential modes of the viewer's response.

This issue usually revolves around natural detail, for the treatment of landscape exhibits the fullest range of Pre-Raphaelite expressive modes. Despite all their propaganda about fidelity to nature, it is rare to find their scenery rendered solely for its own sake, or without any hints of imposed meanings or values. Holman-Hunt's microscopic naturalism usually contributes to an elaborate symbolic program, as Ruskin was quick to observe in his interpretations of such pictures as "The Awakening Conscience" or "The Light of the World." Every detail of a precise landscape is endowed with meaning for the spectator to "read." In "The Strayed Sheep," one of the most perfectly rendered Pre-Raphaelite landscapes, the title itself raises the issue of symbolism and visual allusion. Indeed, the very intensity of light and color—characteristic of much Pre-Raphaelite art—heightens the significance of the moment depicted. Whether or not there is a Biblical reference, Holman-Hunt alerts us to the possibility of different levels of meaning: we are encouraged to experiment with alternate modes of response.

*Dante Gabriel Rossetti*

Both Rossetti and Millais have their own, somewhat less consistent versions of Holman-Hunt's "natural supernaturalism." But the dialectical quality of Pre-Raphaelite art depends not on this or any other specific technique, but on the close and dynamic relationship of form and content themselves through a variety of disparate artistic productions. Form invariably becomes a part of content; we are encouraged to meditate on relations of figures and colors, or of men and women to their natural or artificial surroundings. In this way Holman-Hunt's attitude toward nature, expressed in the treatment of light and detail, forms an essential portion of an artistic "moral"; in "The Light of the World," light itself provides the visual metaphor for the religious theme. Especially in the work of Rossetti and Millais, form and content interact in less obvious ways, qualifying and commenting on one another to produce a dynamic intellectual structure in even the most seemingly static pictures. For example "Ophelia" (see illustration), which was painted by Millais at the same time and in the same region as "The Strayed Sheep," seems at first to embody a naturalistic stance much the same as can be found in Holman-Hunt; but the obvious formality of the painting involves very different attitudes. Even the basic materials—a literary theme, a scene Shakespeare never dramatizes directly, the subjects of love and madness—imply an aesthetic detachment from reality and suggest a questioning of the nature of nature. The physical shape of the framed canvas emphasizes the element of artifice present in the creation of even the most naturalistic imagery. The vividness of the rendering expresses an aesthetic passion that is like both love and madness (another Shakespearean pastoral analogy) but ultimately different from both. Millais thus insists on our distance from the event: we are not "immersed" in nature but studying it from a distinct artistic perspective; we are never allowed to forget that "Ophelia" is a design.

A sense of artifice proves equally important in the structure of Rossetti's pictues. They display little of Holman-Hunt's natural symbolism, although the affinities of Rossetti's poetry with this technique are obvious. Indeed, Rossetti's experiments with symbolic landscape may have preceded Holman-Hunt's, whose later work is often said to have been influenced by the symbolic details of Rossetti's "The Girlhood of the Virgin Mary," painted in 1849. But in most of Rossetti's work, the sense of nature is far less important than the sense of design, especially in terms

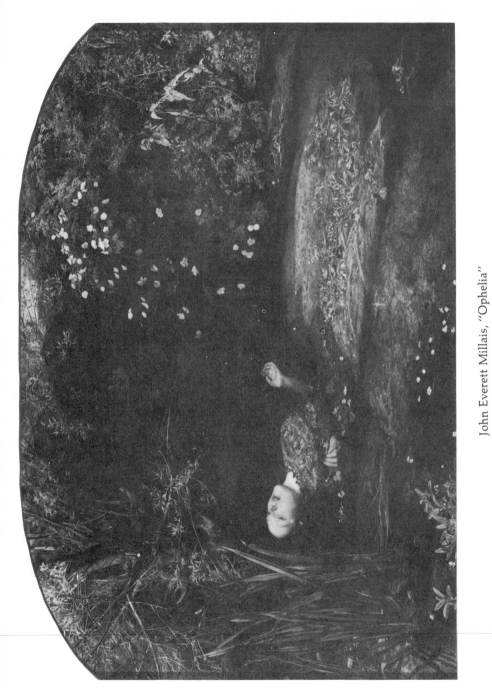

John Everett Millais, "Ophelia"

of the sort of external, framed shape that dominates "Ophelia." That the pictorial space and shape must be carefully calculated, and its frame designed by the artist himself, was a lesson learned from Ford Madox Brown, whose exposure to the work of the German Nazarenes may have spurred his interest in the frame's shape and potential meanings. Particularly in the case of Rossetti, designing a frame for one's own picture is more than a mere decorative addition. The frame mediates between the spectator and the painting, at once defining our separation from the image and extending the world of the canvas into the tangible reality of the space we inhabit. To invent an appropriate frame for a medieval theme, for example, is to further the adaptation of past to present: Rossetti's characteristically personal, modern, and yet quasi-Gothic frames illustrate the possibility of translating a historic vision into contemporary terms. The choice of a suitable frame, with proper historic connotations, seems a visual equivalent to Rossetti's search for traditional poetic forms with philosophic associations congenial to his themes. The frame defines a mood, elaborating on the atmosphere in the canvas and shaping our response to it; in this sense it resembles meter in verse. Above all, as one critic has shown, Rossetti's frames are decorative, but in a manner closely related to the meaning of his art, for they stress the decorative elements in the pictures they surround.[4]

Rossetti's diptychs and triptychs, which he usually employs for themes of great personal significance, carry the emphasis on physical structure to an extreme form. But the use of multiple panels is hardly gratuitous: the composite image necessitates a more complex and dynamic response, involving the spectator more fully in the picture. In his "Paolo and Francesca di Rimini" (see illustration), for example, a triptych of 1855, the structure of the painting organizes it intellectually and thus defines the structure of our response. The outer panels illustrate the beginning and end of the legend related in the *Inferno*. At the left, the two lovers drop the book containing the story of Launcelot to embrace passionately; on the right, they float together, clinging but powerless, their forms and the shape of the Hell-flames around them echoing Dante's description of them being blown through Hades like leaves. The center panel represents Dante and Virgil, the poetic observers whose presence makes possible the simultaneous view of past and present. By glimpsing the lovers through their perspective, we know Paolo and Francesca

D. G. Rossetti, "Paolo and Francesca di Rimini"

in their extreme conditions, and thus experience the beauty and pathos of both. But the portrait spanning time also implies the limits of such passion, a judgment which depends on the "central" perspective of the artist. The delicately clasped hands of Dante and Virgil comment visually on the embrances of Paolo and Francesca in their two worlds. In this sense, the three panels possess a moral as well as a narrative structure: Rossetti anatomizes three forms of love, of which only "the poetic passion," to use Pater's phrase, successfully mediates between flesh and spirit. As in *The House of Life* or the *Divina Commedia* itself, a world view is embodied in an artistic structure to make its constituent parts more apparent.

Related conclusions could be drawn from Rossetti's most famous diptychs, "Beata Beatrix" and "The Blessed Damozel," in which the divided panels anatomize the two forms of being represented in each. As an illustration of Rossetti's poem of the same title, "The Blessed Damozel" dramatizes visually the poem's verbal dialectic: the divided canvas supplies a format for the reconstruction of the complex intellectual world of the poem.[5] The painting of "The Blessed Damozel" demands even more strictly than the poem that we shift our attention from one figure to the other in order to define their relationship; meaning is disclosed through the process of interpretation. Only the form itself—the totality of the picture, including the predella, enclosed within the ornate frame decorated with fragments of the original verse—expresses that complete, balanced view of reality defined in the poem.

Single-panel pictures express the same dynamics through an extreme compression and fullness of imagery, characteristic of most of Rossetti's visual art. The very complexity of the visual field in his paintings necessitates an active process of response. In "Mary Magdalene at the Door of Simon the Pharisee" (see illustration), the scene is divided by the wall of the house outside which Mary hesitates between revelers in the street and Christ within. The cluttered background of figures and activity in the street depicts the entire world of "external" carnal pleasure that she will abandon for the "inner" life of soul represented in the room with the waiting, radiant Christ. The movement of our eyes over the picture surface reenacts her personal transition from one form of being to another; once again visual form defines the relation between fleshly and spiritual love which Rossetti explores in *The House of Life*. But it is

D. G. Rossetti, "Mary Magdalene at the Door of Simon the Pharisee"

not that theme so much as the dynamic structure of visual relationships expressing it which marks the resemblance of his painting to his verse. Both art-forms necessitate an active, complex response. Although it is impossible to assert without qualification that his poems and paintings are alike, it is clear that reading his poetry is very much like looking at his pictures.

Whether or not the crowded, patterned surfaces of all Rossetti's pictures can be "read" with so much coherence, their activity is never gratuitous. Indeed, visual complexity was one of the important ways the Pre-Raphaelites identified their art with that of the past. In Rossetti's earliest and most compressed images, the dynamics of form seem intended to recall the fullness of medieval art. This remains the case in later pictures, including those with no apparent historical themes. In fact, the introduction of design and pattern for their own sakes has counterparts in early painting; for Rossetti, the decorative comprises one of many potential allusions to stylistic modes of the Middle Ages. He is perhaps making the best of his own limitations in cultivating a naïve style, or in allowing pattern to dominate as it does in some later pictures. Nevertheless, there is a kind of aesthetic moral: we are expected to make the Ruskinian connection between the free play of visual impulses and the state of mind of the artist. The detailed, exhaustless, overbrimming universe of Pre-Raphaelite art suggests a limitless sympathy for nature and an uninhibited acceptance of human instincts; this is the attitude the Brotherhood associated with the artists who preceded Raphael. Style comprises a ritual evocation of the past in this sense, not merely as a statement of historic models but as a reenactment of history through the process of artistic creation.

The Pre-Raphaelites responded to the formal complexity of early Flemish and Italian painting, then, a range of interests and techniques which Rossetti also found in early Italian poetry. Academic conventions of the nineteenth century demanded uniformity of treatment, simplicity of composition, and observance of the "unities" of time and place; according to the dictates of Reynolds, painters were still discouraged from lavishing excessive attention on natural detail and from using color intensely. One can imagine the excitement with which Rossetti and Holman-Hunt discovered such a painter as Jan van Eyck on their European journey of 1848. The Ghent altarpiece literally creates an independent universe, comprehending many different

points in time and space, its rich landscape filled with symbolic detail and bathed in a brilliant light which is convincing on both realistic and religious grounds. The natural, almost accidental poses of the singing angels herald some of the more surprising, unconventional poses adopted in pre-Raphaelite art; the naturalistic-symbolic lamb reappears in paintings by both Rossetti and Holman-Hunt. It is possible to trace a number of details of Pre-Raphaelite art to costumes and furnishings in manuscripts, drawings, or early prints they admired.[6] But the important lesson of such models was that attention to detail itself can be consistent with the objectives of serious art. Medieval and early Renaissance art contained a precedent for plenitude, for the interdependence of vigor and variety. In fourteenth century painting and manuscript illumination, the grotesque enters religious themes; a similar mixture of impulses appears in fourteenth century literature, including some of the poetry translated by Rossetti. The Pre-Raphaelites responded to the blend of anecdote and devotion in the Campo Santo frescoes almost as early as Ruskin. And Lasinio's engravings of the fifteenth century pictures amplifies their naïve complexity: without color to focus our attention, the confusion of detail is exaggerated; the total effect is of compact variety, in which the mixture of religious episode with genre scene verges on disorder.[7]

Ultimately such early pictures are not disorganized nor intellectually diffuse, nor did the Pre-Raphaelites view them as such. The shared beliefs of painter and audience in the Middle Ages supplied a hierarchical formula for "reading" pictures as coherent religious statements; an articulated world-view made possible the integration of the most disparate details within a single, unified image. What matters, however, is not that medieval and early-Renaissance art achieves some abstract spiritual wholeness, but that the Pre-Raphaelites adopt this view of it. They share Ruskin's Romantic myth of the past as sheltering a unified sensibility; indeed, they instinctively embrace this view almost as early as he does. Like Ruskin, the Pre-Raphaelites seek to "revive" some of the most vigorous forms of medieval art in the hope of recreating the mental unity from which those forms originally developed. Tensions in Pre-Raphaelite painting are introduced to allude to this frame of mind, not merely as an achievement of the neo-Gothic artist, but as a condition that the

*Dante Gabriel Rossetti*

observer himself may attain. Our participation in the varied impulses that the Brotherhood associates with medieval art brings us into contact with the range and fullness of a lost, ideal form of historic consciousness. It is almost as if the Pre-Raphaelites assume the necessity of a ritual response to their art: reconstructing the links between the different aspects of their style ought to help heal the split between artists and public and, more important, some of the fundamental psychic divisions of Victorian life.

Yet many of the strains and limitations of Pre-Raphaelite painting arise from the same dream of aesthetic community that gives the movement so much of its force. The ideal remains only that: there is no public context of values and symbols from which their painting can derive power and meaning. Even within the group there seems to be no articulated set of common beliefs. One symptom of this lack is the debate (begun in the mid-nineteenth century and still continuing) over the preeminence of Rossetti or Holman-Hunt in the movement. This paradox is implicit from the inception of Pre-Raphaelitism, especially in the concept of a "Brotherhood." Rejecting not only the Academy but the very notion of artistic schools, they establish one of their own. With the aim of recreating that vital, intimate relationship between artists and public which they identify with the Middle Ages, they create a personal art that exacerbates the characteristically modern tension between the painter and his audience.

Perhaps the most famous casualty of this problem is Charles Dickens, whose vituperative remarks on Millais' "Christ in the House of His Parents" or "The Carpenter's Shop" (see illustration) appeared in *Household Words*. Without a key to Millais' method, and lacking the sympathy to decipher it, Dickens can perceive only details; his graphic description concentrates on the grotesque qualities of the figures, for which he can discover no significant rationale: "in the foreground of that carpenter's shop is a hideous, wry-necked, blubbering, red-haired boy in a night-gown, who appears to have received a poke in the hand from the stick of another boy with whom he has been playing in an adjacent gutter, and to be holding it up for the contemplation of a kneeling woman, so horrible in her ugliness that (supposing it were possible for any human creature to exist for a moment with that dislocated throat) she would stand out from the rest of

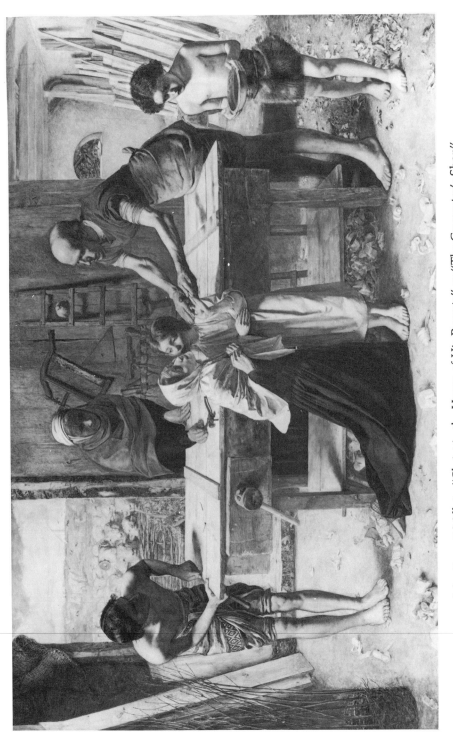

John Everett Millais, "Christ in the House of His Parents" or "The Carpenter's Shop"

the company as a monster in the vilest cabaret in France or in the lowest gin-shop in England." Dickens' attack is not completely wide of the mark: Millais, like Rossetti and Holman-Hunt, avoids using professional models in order to obtain unconventional features and gestures. The grotesque is not unwelcome as a break from academic stereotypes, as a way of giving the rendering of a traditional theme more uniqueness and sincerity. The choice of models is particularly important if the artist wishes to endow religious subjects with freshness and a sense of reality. This is precisely the aim of Millais, as of the Pre-Raphaelites generally. Much as the Higher Criticism revealed the historic sources of Biblical stories, the Pre-Raphaelites illustrate the simple, convincing, human situations from which even the most exalted Christian ideas grew. Grotesque gestures are as much a part of Millais' realism as the depiction of wood-shavings and carpenter's tools in "Christ in the House of His Parents," or naturalistic rendering of lambs and a dove to allude to Christ's divinity. Dickens grasps an essential part of this idea; the Holy Family is deliberately made to appear artistically untraditional, arresting, even "common" in a social sense. He only fails to place these visual attributes in their larger context of meaning, in the dramatic structure of the painting as a religious experience.

The relation of painter and audience to some extent depends on the perceived level of exclusively personal significance in a work. Holman-Hunt, for one, clearly believes himself engaged in the creation of a public medium; most Pre-Raphaelite religious painting seems aimed to intensify religious experience for the audience. But some of the meanings of any artifact can be known only by the maker, and personal messages play an especially important role in Pre-Raphaelite art. Even Holman-Hunt, the member of the group most dedicated to creating new, viable religious imagery for the nineteenth century, paints pictures that tell as much about the quality of his own faith as they do about public values. The publicity that surrounded the production of his "The Scapegoat" and "The Finding of Christ in the Temple," for instance, while adding to popular understanding of their religious messages, also helped make the story of their creation an integral part of their meaning. The first painting, a depiction of the sacrificial goat of the Old Testament, also alludes to the painter's arduous pilgrimage to the Holy Land to depict an actual goat in the same conditions described in the Bible. Simi-

larly, it is Holman-Hunt himself who "finds" Christ in the Temple through the research and labor that went into the work. Personal meanings of another kind are injected into his painting of "The Awakening Conscience," where the model for the suddenly repentant fallen woman is the artist's own mistress, Annie Miller. This kind of message, disclosed only when the identities of models are known, appears in a great deal of Pre-Raphaelite art, for they used each other and their friends as models for many of their figures; in this sense, there is a constant undercurrent of private allusion in their work. Millais used his father to pose for the head of Joseph in "Christ in the House of His Parents"; perhaps Dickens had an intuition that the religious theme was being endowed with personal symbolism.

This issue discloses the most extreme function of Pre-Raphaelite painting: a redefinition of life by injecting modern men and women into the worlds of literature or history. In this sense the identification with past modes of art and thought is only one aspect of a kind of aesthetic masquerade, in which all the Pre-Raphaelites engage to assist each other in a transformation of being. In this highly artificial translation of life into art we sense a form of sympathetic magic at work.[8] It is the ultimate and most literal type of participation in a ritual of interpretation. Both Holman-Hunt and Millais create pictures of this sort, and similar tendencies can be observed in the fictionalized treatments of autobiographical materials in the writings of Ruskin and Pater. But the issue is most central for Rossetti, and the search for fictional and historic equivalents to the events of his own life pervades both his painting and his poetry. As David Sondstroem explains, Rossetti "seems to have defined himself in the terms of the great literary, historical, or mythological characters that he portrayed, wrapping himself in the cloak of the heroes, and playing opposite the heroines."[9] As we are privy to the identities of his Beatrice, Lilith, or Mary Magdalene, to name a few, we sense how completely the work of art becomes for Rossetti a personal exploration of the nature and meaning of life.

It is only by interpreting the relations between the different parts and dimensions of a Rossetti painting that we can determine the connections between its public and private meanings. Perhaps the most interesting example is his "Ecce Ancilla Domini!" of 1849–1850, later retitled "The Annunciation" to sound less Catholic (see illustration), which translates a tradi-

*Dante Gabriel Rossetti*

D. G. Rossetti, "Ecce Ancilla Domini!" or "The Annunciation"

tional religious subject into particularly vivid Pre-Raphaelite form. The actors are human and the setting in Mary's bedchamber is convincing on both historical and sociological grounds. The Virgin is appropriately clothed in white, but for the sake of realism she wears a nightdress. The wingless angel floats, shod in flames, bringing into the room with him an intense white light of divinity that overpowers the small oil lamp on the rear wall. In the foreground is the lily-patterned embroidery that Mary had been working on in "The Girlhood of the Virgin Mary," painted a year earlier. The material representation of a religious symbol in this hanging is repeated in the realistic lily Gabriel holds. Mary's shrinking posture, along with the handwork of her girlhood, expresses her youthful innocence. The pervasive whiteness of the scene also connotes purity.

The style of the picture makes it difficult to avoid psychological interpretation, or to avoid considering how much we as well as Rossetti must participate in the work. Dazzled by the whiteness, we view the scene partly through Mary's eyes. The original title, "Ecce Ancilla Domini!" is Gabriel's salutation, implying that in it we share his vision of Mary; and the ambiguity of the Latin verb, which may be translated as either "I see" or, more passionately, "Behold," reminds us that the sight of such a being must move us deeply. Yet the whiteness also becomes an analogue for the clarity of the artist's conception; as in Blake, style authenticates vision. Indeed, the exaggerated perspective of the room both forces us swiftly into Mary's presence and allows us to experience the immediacy of the scene for Rossetti himself. He seems to have intentionally adopted the treatment of depth from medieval and early Renaissance painting to heighten the emotional effect.[10] The representation of space bears a striking resemblance to Vincent van Gogh's painting of his room at Arles thirty-five years later (see illustration): in both cases the perspective is expressionistic, illustrative of the painter's state of mind. The visual excitement suggests the importance of this journey into history to recreate sacred events, a personal involvement that is intensified by the presence of Christina Rossetti modeling the figure of the Virgin. It is significant that Rossetti's model is not only his own sister but a poetess who was to become one of the chief religious writers of the Victorian period. Her role—and that of William Michael Rossetti, who posed for the head of the angel—emphasizes that "Ecce Ancilla Domini!" beyond representing Biblical events, comments on the

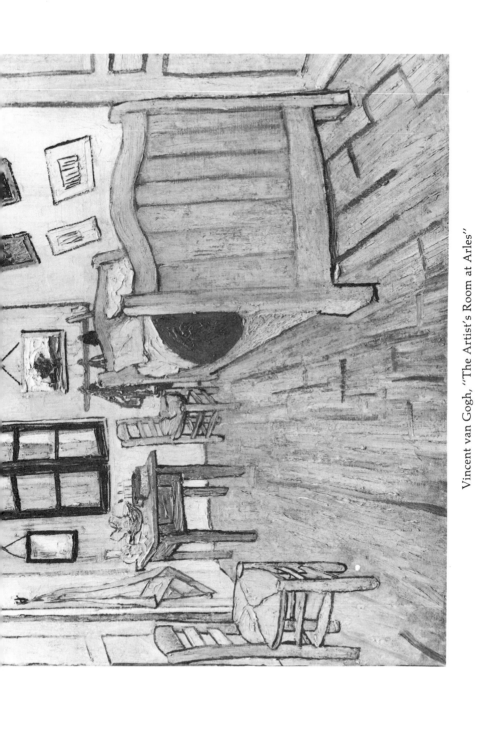

Vincent van Gogh, "The Artist's Room at Arles"

intensity with which religious experience can be enjoyed in the nineteenth century.

"Ecce Ancilla Domini!" achieves artistic integrity through a complexity that is not superficial. Some of its power is lost if it is considered simply as a representation of a traditional theme in a Pre-Raphaelite setting and style. For setting and style in themselves point out other relationships and dimensions of significance within the picture which give it, despite a stillness and hushed tone, dynamic strength. Our estimate rises when we feel and understand the tensions between detail and exaggerated perspective, between the religious context and Christina Rossetti's gawky, puzzled modeling of Mary. The luminous, uniform treatment, as in so much Pre-Raphaelite painting, implies the presence of a unifying concept, encouraging the viewer to fill in any perceived intellectual gaps by searching for the relationships that will resolve them. Here again the act of viewing allows us to participate in something very much like the act of creation: we must duplicate the mental processes rsponsible for the structure of the painting.

Yet as we assume a position approximating Rossetti's own, we gain new distance from the picture. Our sense of its structure, derived from our experience of its tensions and personal energies, enables us to view the painting as an artifact, an abstraction from experience. The overpowering gloss of white that gives unity to the work also maintains our sense of its surface as surface. During composition, Rossetti referred to the painting in terms of its pervasive tone, as "the white picture" or "the white daub."[11] In addition to the monochromatic quality, it has an ornate frame decorated with Rossetti's own interpretative sonnet, to remind us that the painting is only one of many potential artistic treatments of the theme. The combination of gilded frame and white canvas convey an unmistakable sense of design. Despite both the traditional religious subject and the deep personal and emotional connotations of the imagery, the painting anticipates in large measure the aestheticism of Whistler's "White Girls," first painted over a decade later. Rossetti himself observes this connection in a letter of 1874 to F. G. Stephens: the "Annunciation" is "in point of time the ancestor of all the *white* pictures which have since become so numerous—but here there was an ideal motive for the whiteness."[12]

In "Ecce Ancilla Domini!" form controls all the functions of

*Dante Gabriel Rossetti*

the image and mediates between its significances for public and private audiences. The whiteness expresses simultaneously the religious, personal, and decorative connotations of the image for Rossetti; it is at once the symbol of his own deep participation in the theme and the medium through which we enter the work and feel its intensity. The form itself balances all the elements of the painting's dialectic. It is in this vital complexity of form that Rossetti's art shows the greatest resemblances to Ruskin's, and not in any simple devotion to nature or ornate detail. Similarly, the link between Rossetti's own painting and poetry is their common complexity, determined by a controlling form. Form, in fact, tends to obtrude in both his arts, the dazzling whiteness of "The Annunciation" being only one of many examples. Just as his poetry frequently dramatizes its own ornateness to illustrate the process from which all art grows, his painting contains numerous reminders that art is never fully spontaneous, and that an imagination is always at work comparing, abstracting, transforming its materials. In Rossetti's earliest work the element of artificiality is held in a delicate balance with many other expressive modes. Later pictures become almost wholly decorative, much as later poems move in the direction of Swinburnean lushness; but the value of complexity is never absent, and Rossetti's late poems grow more difficult as they become more ornate. A recognition of the importance of dialectic in his art should lead us to study his paintings at least as self-consciously as we read his poetry. Conversely, we should extend to his most difficult poems the same tolerance for eccentricity that we allow to his visual art.

### The Rossetti Problem

Formalism, so often a source of visual harmony in Rossetti's pictures, also creates some of the most serious difficulties in his verse. The very ornateness of much of his poetry contributes to a quality of remoteness, an opacity that obscures even the moving human dramas of some of his love sonnets. As one recent critic has argued convincingly, the recurring discrepancy between form and content in his poems is the characteristic "Rossetti problem."[13] Yet the resulting vagueness reveals not a suspension of aesthetic values but their all-too-insistent application. It is as if difficulty becomes an end in itself. Aiming for the sort of allusive profundity he discovers in the paintings of

the "Sonnets for Pictures," Rossetti compresses and abbreviates in a kind of intellectual shorthand. The poetry is intensely allusive, but now without any relation to objective artifacts that illuminate meaning. As in his pictures, the most intricately dynamic arguments are expressed in the relation of static images. Form, in other words, seems self-consciously artificial rather than spontaneous or natural, less a product of a poem's materials than an external structure forced on them; there is little effort to create an illusion of organic form. Similarly, Rossetti is often guilty of a decorative use of language, the selection of words for their sounds or for an allusiveness not confined to the thoughts or issues of the surrounding verse; words, like many of the objects in his paintings, seem to have an independent life, in which we may, with effort, discover significance. Form in Rossetti's verse defines less of a pathway than a puzzle. The process of interpretation frequently becomes an exercise in decoding; as always, our participation is necessary to complete the meaning of his art.

Whether or not it is finally possible to condone such a view and treatment of poetry, Rossetti himself was aware of its difficulties. One of his sonnets, for example, constitutes a minor allegory on the problems created by complex, allusive works of art; and this poem has itself bewildered many critics.[14] "The Vase of Life" appears close to the end of *The House of Life* and, as the title suggests, comments on the entire sequence. Its focus, like that of such poems as "St. Luke the Painter," is the contrast between figurative and literal views of art, only here the problem of analysis becomes the subject. The vase, possessing both truth and beauty, recalls Keats's Grecian urn. But rather than an ode to the artifact, Rossetti has composed a parable of its interpretation, a task as profound as the interpretation of life itself:

Around the vase of Life at your slow pace
  He has not crept, but turned it with his hands,
  And all its sides already understands.
There, girt, one breathes alert for some great race;
Whose road runs far by sands and fruitful space;
  Who laughs, yet through the jolly throng has pass'd;
  Who weeps, nor stays for weeping; who at last,
A youth, stands somewhere crowned, with silent face.

*Dante Gabriel Rossetti*

And he has filled this vase with wine for blood,
  With blood for tears, with spice for burning vow,
  With watered flowers for buried love most fit;
And would have cast it shattered to the flood,
  Yet in Fate's name has kept it whole; which now
  Stands empty till his ashes fall in it.

It is not possible to trace all the autobiographical meanings at
which the poem seems to hint, or even to resolve fully the sig-
nificance of the imagery in the sestet. To a great extent Rossetti
is using language decoratively, with less concern for precise
meaning than for mood and suggestiveness. But this vagueness
is directly related to the subject of the poem. "The Vase of Life"
examines the difficulty of identifying any simple, paraphraseable
message in a profound work of art, and what it means to
attempt to "understand" such an object.

The sonnet explores these issues through a continually shift-
ing perspective on the vase. Rossetti begins by narrating some
of the scenes on the turning artifact; the sestet shifts from
narrative to ritual content, treating the vase not as a surface but
as an object to be held, filled, and emptied. The progression
between different forms of aesthetic interpretation ends with a
reference to the vase's final meaning: the interpreter discovers
its ultimate, funerary significance only when he actually enters
the vase, after death. Art, then, according to the metaphor of the
title, is like life in possessing infinite significance. Ironically, the
"character" in the sonnet fails to perceive this fact: the vase is
now, literally, "empty" for him.

It is not this idea but the structure of the poem that creates its
obscurity. Rossetti invariably insists on the variety of intellec-
tual attitudes needed in response to the variety of life, and here
he illustrates the complex reality of the vase by the use of sev-
eral distinct poetic modes. The difficulty in the sonnet arises
from the transitions between narrative, decorative, and allegori-
cal treatments of the same poetic materials; in fact, the poet
fails to resolve the different approaches to the same object. The
same problem and the identical technique appear in Rossetti's
pictures, as well as in his poetry on other arts. Possibly the
translation of painting into poetry sets the pattern for all
Rossetti's verse; perhaps the "Sonnets for Pictures" only pro-
vide the most appropriate format for the juxtaposition of differ-

ent poetic techniques. In any case, the theme of complexity becomes a technique in many poems unrelated to the fine arts as well, and without the reference to external artifacts Rossetti's varied style and ornate structure create problems that cannot always be solved.

In "Bridal Birth," for example, although no artifact is referred to, the situation is conceived according to the sort of scheme that can be observed in many of Rossetti's pictures and in many of his poems about art: two lovers meet in a vivid, allegorical landscape; their emotions are depicted in terms of a specific naturalistic setting and through various symbolic devices within it. But this pictorial conception is nearly obscured by another sort of imagery, referring to the same feelings. The sonnet compares love to the birth and growth of a child, concluding by anticipating a future rebirth of the two lovers as the married children of Death. That concluding scene is representative of the difficulties produced when Rossetti uses his poetry to dramatize different forms of reality:

> As when desire, long darkling, dawns, and first
>     The mother looks upon the newborn child,
>     Even so my Lady stood at gaze and smiled
> When her soul knew at length the Love it nurs'd.
> Born with her life, creature of poignant thirst
>     And exquisite hunger, at her heart Love lay
>     Quickening in darkness, till a voice that day
> Cried on him, and the bonds of birth were burst.
>
> Now, shadowed by his wings, our faces yearn
>     Together, as his fullgrown feet now range
>     The grove, and his warm hands our couch prepare;
> Till to his song our bodiless souls in turn
>     Be born his children, when Death's nuptial change
>     Leaves us for light the halo of his hair.

The difficulty arises from the shift of subject in the sestet. It is hard to see how the "full-grown" forest scene follows from the description of "birth," or why the poet introduces the final birth-death conceit at all. No connections are stated in the sonnet; the symbolic narrative does not really explain itself. But the full meaning of the poem, and the train of thought of which the sonnet presents only the results, can be inferred from the images that mark its beginning and end.

Unlike "The Vase of Life," "Bridal Birth" does not wither under close analysis. Nor is the final image either decorative or out of context. In a sense, in fact, it explains the elaborate metaphor on which the rest of the poem is based. In part it defines, as in "The Vase of Life," the precariousness of exis-tence in terms of the inevitable presence of death. But it ex-presses this philosophic conclusion in terms of familiar human experience: the allegoric and naturalistic levels of the poem fuse. The final line reinterprets the imagery of "dawning" Love at the beginning of the sonnet as referring to an actual phenomenon. Thus, the process that begins with "dawn" ends at sunset. Rossetti defines the divinity of Love in terms of a natural, inevitable event. The image of Love (which may also refer to Death at this point) illuminating the two lovers with a symbolic halo is in fact a description of back-lighting; as he does fre-quently in other poems, Rossetti attempts to render the effect of the sun sinking below a distant landscape and outlining inter-vening objects. The comparison of love to the sun recalls Rossetti's boast of ignorance about the Copernican universe: to call the sun "long darkling" implies a complete misconception of astronomy. But the sonnet uses this confusion functionally. Love is identified as both light-giving and the creature (formerly "darkling") newly dawned upon. Similarly, love is described as both mother and child. All these contradictory images dramatize the reciprocity of love, and to complete the portrait of this qual-ity, Rossetti makes Love's parents its children, who even appear diminished in size as the low sun casts long shadows from his wings over their faces.

In this case it is possible to trace seemingly decorative imagery to its source in the concept of love on which "Bridal Birth" is based. Indeed, the "natural" progress of love from birth to divinity, sunrise to sunset, also seems to refer to the idea of time implicit in the arrangement of The House of Life. The two sections of that volume are titled "Youth and Change" and "Change and Fate," and its growing sense of fate is mir-rored in this poem in miniature. Thus, the imagery of the poem is fully related to the broadest connotations of its meaning and to the structure of the sequence. In fact, the physical distance between this sonnet and "The Vase of Life" in The House of Life—one near the beginning, the other close to the end—is dramatized in the structure of each; and "fate" still has positive connotations in "Bridal Birth." "Bridal Birth," like The House

*of Life* as a whole, anatomizes the history of an idealized love relationship. Its complex imagery uses nature to suggest both the beauty and the inevitability of distinct forms of love.

It is, then, always difficult to generalize about Rossetti's hardest poetry. His ornateness need not imply mindlessness. In "Bridal Birth" and several other poems he calls attention to the artificiality of his own language to help us reconstruct the ideas he wants his imagery to represent. Rossetti's poetry is usually condensed, but in his best poems he suggests what it has been condensed from. When his poetry fails, it is often the result of too much rather than too little poetic effort: the intellectual framework has been abstracted too far. Early versions are often better than later revisions. Habitually he overworks his poetry, seeking the same sort of profuse decoration and condensation that characterizes his painting. It is for this reason that coming to terms with his most difficult poetry offers one of the best indications of how he thought and the way he composed.

The most celebrated problem associated with Rossetti is also, perhaps, the most offensive to the modern reader. He is particularly implausible as the nineteenth century mystic, the skeptical believer in an afterlife, a post-Darwinian stubbornly denying the Copernican solar system. The current suspicion of these roles (and Rossetti was an accomplished poser) accounts in large part for the notoriety of lines from "Heart's Hope," the fifth sonnet of *The House of Life:* "Thy soul I know not from thy body, nor/Thee from myself, neither our love from God." A reader should immediately question whether such a statement can be understood at all, and whether poetic meaning is expressed or only asserted.[15] But he should also recognize that Rossetti raises essentially the same questions in the poem, and uses the very complexity of his poetic form to try and solve them. In its context, the vagueness of such mystical "knowledge" is part of the point. Here is the octet with which the sonnet begins:

By what word's power, the key of paths untrod,
   Shall I the difficult deeps of Love explore,
   Till parted waves of Song yield up the shore
Even as that sea which Israel crossed dryshod?
For lo! in some poor rhythmic period,
   Lady, I fain would tell how evermore
   Thy soul I know not from thy body, nor
Thee from myself, neither our love from God.

The sonnet is chiefly about love poetry and only secondarily about love. In it Rossetti projects an ideal poem he wishes to write, so that the title refers to the desired future poem, his "Heart's Hope" for a verbal achievement. The metaphors refer not only to love but to poetry, and the Red Sea image is explicable only as an expression of the difficulty of this task. At this point the language is not entirely convincing, but in the more successful conclusion it becomes clearer how Rossetti is trying to define his poetic goal:

> Yea, in God's name, and Love's, and thine, would I
>   Draw from one loving heart such evidence
> As to all hearts all things shall signify;
>   Tender as dawn's first hill-fire, and intense
> As instantaneous penetrating sense,
>   In Spring's birth-hour, of other Springs gone by.

That poetic "evidence" of this kind is ambiguous is one of the points of "Heart's Hope." There is, for example, a deliberate, if understated paradox in the final lines suggested by the balancing of "tender" and "intense." The difference between the terms lumped together in the conclusion is itself representative of the range that a poet must command in order to make the body-soul identity felt. Thus, these images also describe the unwritten poem. Rossetti is neither explaining nor elaborating on the central assertion of the sonnet. Rather he is concerned with analyzing the intellectual difficulty of joining the opposite terms of this formula for ideal love.

Rossetti, then, does not attempt to describe mystical love; instead he dramatizes the poetic qualities that would be needed to define it. The opening lines of the sonnet do not entirely succeed because they deliberatly fuse different levels of metaphoric language in order to dramatize by the increasing particularity of their imagery the range of that ideal poem. A similar strategy is more effective toward the end. The last lines suggest that a poem about physical-spiritual love needs to express two contradictory qualities: the warmth and clarity found in beautiful natural images, and the sort of deep, intellectual perception evidenced when one looks past visible nature to the continuity of time and the seasons. For this effect Rossetti juxtaposes the brief, compact physical image of "dawn's first hill-fire" with the abstraction that follows it. And even within that abstraction he emphasizes opposition and paradox. The syntax of the last two

lines anatomizes the differences between related levels of experience by separating seasonal continuity from the visionary "instantaneous penetrating sense" which perceives it. The point of the poem is that all these alternatives belong within one continuum: the desired poem. Part of the sonnet's "lesson" is that the antitheses it points out, in both literal and metaphoric uses of language, coexist for the participant in the poem's intense emotional and spiritual experience.

Thus, seeing the verbal analogies to the difference between body and soul is the first step toward fully understanding their interrelationship. Even the sonnet's central weakness, the discrepancies in terms at the beginning and the end, can be seen as an attempt to establish the endpoints of this continuum. Here again Rossetti embodies his argument in a complex, highly abstract poetic form. Throughout "Heart's Hope" a stylistic movement is made to stand for the emotional breadth of the love experience he dares only *assert* in its own name. The implicit weakness in such poetry, as in much of the literature of art, is that a problem of thought is converted into a problem of aesthetics. The sonnet represents an attempt to solve the philosophic problems of a mystical concept of love not through argument, or even a dramatic situation, but through poetic form. What seems insufficient in the writing is in fact a strategy largely borrowed from visual art. Rossetti needed more effective poetry. Instead, he applied a symbolic structure to solve the problem of poetic belief.

It was precisely this demand for a form to embody his aesthetic interests and ideals that led Rossetti to the writing of sonnets early in his career. The importance of the sonnet as a vehicle for his most personal concerns is plain from the energy expended on *The House of Life*, which in terms of magnitude alone deserves to be considered, as Rossetti considered it, his major poetic work. But the significance of the poems in that sequence is not simply autobiographical. Sonnets provide him with another, perhaps his best opportunity to express in formal terms the fundamental dialectic of his vision. Rossetti's concept of the sonnet is explained and dramatized in the untitled introductory poem to *The House of Life*:

> A Sonnet is a moment's monument,—
> Memorial from the Soul's eternity
> To one dead deathless hour. Look that it be,

Whether for lustral rite or dire portent,
Of its own arduous fulness reverent:
   Carve it in ivory or in ebony,
     As Day or Night may rule; and let Time see
Its flowering crest impearled and orient.

A Sonnet is a coin: its face reveals
   The soul,—its converse, to what Power 'tis due:—
Whether for tribute to the august appeals
   Of Life, or dower in Love's high retinue,
It serve; or, 'mid the dark wharf's cavernous breath,
In Charon's palm it pay the toll to Death.

The list of opposing images seems almost mechanically exhaus-
tive, but this is part of Rossetti's point. A sonnet's first obliga-
tion is to "its own arduous fulness"—that range of experiences,
images, or poetic alternatives which defines the interrelationship
of different levels of experience. This poem alludes to both the
twofold nature of certain intense incidents in life and the
twofold nature of the sonnets that attempt to represent them.
Experience is at once fleeting and eternal, real and vaguely
mystical: the sonnet connects these two regions of the soul's
being, dramatizing at once its life in time and its link to a
"Power" controlling events from "the Soul's eternity." As either
a supernaturally-inspired "portent" or a man-made "rite," it
possesses an almost magical completeness.

Rossetti demands a great deal of poetic form, while often
neglecting to ensure that it performs its simplest but most neces-
sary tasks. The strain on form is evident in both his best and
least satisfactory work as a poet, and must be taken into
account whether or not we praise his writing. As a recent critic
explains, even Rossetti's best poetry "is too often . . . exactly
that and no more—just good *poetry;* he wrote only a few good
*poems.*"[16] In a sonnet like "Heart's Hope" the unity of the
poetic experience is damaged both by the force of a few lines
and by the preconceived idea that controls the shape and texture
of the verse. Ordinarily when we speak of ideas in poetry, we
refer either to philosophic arguments in verse or to concepts
developed within the progress and poetic structure of a specific
experience being described. To be successful, ideas like images
must have a defined place within a unified literary context. This
is what is usually meant by the notion of "organic" poetry—the
assumption that an integral relationship ought to exist between

form and content in verse. Rossetti's poetry seems almost deliberately to flaunt these assumptions. Our sense of context itself often seems uncertain. Images as well as ideas appear to be disembodied details within a relatively unstructured experience, just as many details in his visual art seem only mechanically related to their surroundings. Yet close examination usually reveals relationships around which Rossetti's art is constructed. He feels free merely to hint at the structure of complex thought which precedes the act of artistic creation. It is to this prior and separate intellectual process that Rossetti refers in his most celebrated and ambiguous aesthetic term, "fundamental brainwork."

In part "fundamental brainwork" is synonymous with what Rossetti calls "conception," by which he means the intuitive grasp of a poem before it is written.[17] The phrase also implies that poetry should be intellectual, allusive, and condensed. What this means in practice is that Rossetti bases his poetry not so much on the description of scenes or events as on the expression of various poetic "schemes" which provide images or ideas for use in diverse poetic settings. William Michael Rossetti's edition of the *Collected Works* includes a number of such so-called "schemes of poems," written in prose, seemingly constituting the "fundamental brainwork" for works never completed. Similarly, there is a collection of isolated images for which no contexts appear to have been evolved, which William prints as "Versicles and Fragments." They suggest that Rossetti may have characteristically begun his poetry from a sense of a particular effect. A few of these appear to be the germs of actual, finished poems, such as the autobiographical lines recalling the meditative speaker in "The Blessed Damozel"—

As much as in a hundred years, she's dead:
Yet is to-day the day on which she died.

A fragment inscribed "To Art," which nearly paraphrases the difficulties encountered in "Heart's Hope," provides a telling commentary on Rossetti's view of passion: "I loved thee ere I loved a woman, Love." This disembodied confession underscores the fact that poems like "Heart's Hope," which seem to originate in abstractions, are not far removed from Rossetti's more "fleshly" writing. Another fragment, in fact, seems to outline an analogy between an intellectualized concept of love and his

composite art: "Picture and poem bear the same relation to each other as beauty does in man and woman: the point of meeting where the two are most identical is the supreme perfection" (I, 510). Behind such purposeful opacity Rossetti reaffirms the value of a mixed aesthetic medium—combining painting and poetry—to achieve an expression of the complex, dialectical forms of beauty he cherishes most. This fragment may be one source of the situation in "Hand and Soul," where a male artist embodies the most perfect expression of his own soul in the form of a beautiful, visionary lady.

It is particularly easy to imagine Rossetti working from such particles to longer works in view of a letter written to William Bell Scott in 1871, the period in which many of Rossetti's obscure and discontinuous sonnets for *The House of Life* were composed. Rossetti explains: "I hardly ever do produce a sonnet . . . except on some basis of special momentary emotion; but I think there is another class admissible also—and that is the only other I practise, viz., the class depending on a line or two clearly given you, you know not whence, and calling up a sequence of ideas. This also is a just *raison d'être* for a sonnet, and such are all mine when they do not in some sense belong to the 'occasional' class."[18] The "second" type is quite different from that described in the introductory sonnet to *The House of Life*, where a sonnet is labeled "a moment's monument." I suspect that many of his seemingly "occasional" poems belong in fact to the second class, for this description of the origin of sonnets coincides with the reader's experience of much of Rossetti's writing, especially his most difficult poetry. There seems to be historical as well as formal validity to the observation that much of his verse consists of lines evoking a "sequence of ideas" *behind* the poetry. The charge that Rossetti writes about thinking rather than actually thinking in verse possesses a kind of literal truth.

Such poetry cannot always be excused on grounds of the nature of its origin or because of its objectives. Without gratuitously apologizing for what is bad in Rossetti, however, we should not let our judgments blind us to his goals. His treatment of numerous paintings and poems shows frank disregard for at least one important standard of value, the sense of organic unity created by the illusion of growth. Ideas are embodied in Rossetti's verse without necessarily being developed. He condenses his poetry to the point where, all traces of the process of

composition having been eliminated, the result is as static as a work of visual art. This throws the burden of meaning onto the form itself. In such paintings as "The Blessed Damozel" Rossetti found a physical form to embody the complex relation behind the imagery, and sonnets like "Heart's Hope" and "Bridal Birth" suggest that he sought a poetic equivalent as well.

Rossetti's contemporaries tended to respond to the sensuousness of his painting and poetry, and modern critics have generally adopted the same perspective. But there are hints that his conception of art was more formalistic and abstract. As a letter of 1869 observes, "The quality of complex structure in Art is more touching and pathetic to me always than even the emotional appeal of the subject matter."[19] From the assumed distinction here between form and content it is only a small step to a view of poetic form as independent of, even prior to, the actual subject of a given poem. Form becomes both the intellectual and affective center of poetry, containing its own meaning. To some extent this view necessitates a decorative treatment of verse, in which visual relationships, for example, take on nearly as much significance as clarity of statement. But the term "decorative" does not imply an inattention by Rossetti to his materials. The difficulties of his verse derive from overelaboration. His "decorative" tendency is not manifested in an absence of controlling form but in an intentional formal complexity which denies the familiar illusion that structure grows organically from a poetic situation or the natural process of thought. Instead, Rossetti alerts us to the pressure of structure on statement, poetic form as an artificial scheme with which specific feelings and incidents must be aligned.

Nonorganic form is hard to come by if the poet is not to destroy all the recognizable narrative or emotive qualities of his verse. Perhaps the most convincing evidence that Rossetti often wrote with such an end in view is his fascination with sonnets. The Petrarchan sonnet reappears continually as the basic pattern of his verse. Rossetti makes it the vehicle for every type of experience, situation, feeling, or idea that he attempts to express in the rest of his art. It becomes both form and format for all his aesthetic experience, a structural model to which every mode of life can be adapted. The House of Life, in this sense, can be seen as an experiment in translating the widest range of personal experience into the terms of a formal, relatively static aesthetic scheme. In unifying the facts of actual life around an aesthetic

pattern, the sequence follows a tendency observable in much of the literature of art. With Rossetti, the Petrarchan sonnet comes to represent an ideal mode of beauty according to which life itself can be transformed.

The Petrarchan sonnet form had special appropriateness for Rossetti's interests, and in recognizing this, he seems to have thought of the sonnet form as a way of embodying some of the ideas he did not wish to argue through in the verse itself. Petrarchan sonnets traditionally have involved the dramatic extremes of human love for divine objects. They originated in the milieu with which Rossetti feels his strongest historic affinities, an age of painters and poets whose own use of symbols and details is one of the chief models for Rossetti's style in art and literature. But he does not employ the Petrarchan sonnet merely to remind us of these connections, or to signal once more the complex experiences he wishes to contain in his art. The form implies a world, and a state of mind, in which all the contradictions and tensions of Rossetti's art are accepted and reconciled. In this sense form provides the historic context that justifies the problems Rossetti must inevitably raise. It also implies a formula by which these problems can be solved. William Fredeman has compared the octet-sestet divisions of Petrarchan sonnets to the divided version of the painting of "The Blessed Damozel" and also to the arrangement of *The House of Life* into two books of unequal length.[20] Rossetti, he suggests, uses such formal divisions symbolically. It is as if the Petrarchan sonnet physically contains the medieval wholeness of mind out of which it was conceived. In this sense the contradictions in Rossetti's sonnets become visual arrangements of separate figures or masses, to be balanced much as in a painting. Similarly, the compact size of a sonnet physically frames its paradoxes and tensions within a single unit in order to help organize the reader's response. Its two-part structure allows the poet to work in separate directions within the limits of a fixed, ideally balanced form.

The same instinct for symbolic balance organizes *The House of Life*. A single recurring pattern operates in individual sonnets and in the sequence as a whole, a pattern identical to the dialectical structure controlling the "Sonnets for Pictures." The poems alternate between two modes of being, between physical existence and metaphysical self-awareness; the pendulum movement between these poles of experience is the dominant motif of

the sequence. Thus we invariably discover that physical reality veils a higher spiritual existence, much as in Ruskin. In the early, "fleshly" poems, love itself carries us to this higher plane, and Rossetti personifies love to identify its joint physical and metaphysical significance. By the last part of the sequence, the personification of life and death increasingly allegorizes the poetic universe. But even in Rossetti's allegorical verse the emphasis falls on the necessary interdependence of several views of experience. A sonnet like "The Trees of the Garden" qualifies its own allegory, leaves it open, by describing the search for allegorical meanings among various objects in the landscape:

> Ye who have passed Death's haggard hills; and ye
>   Whom trees that knew your sires shall cease to know
>   And still stand silent:—is it all a show,—
> A wisp that laughs upon the wall?—decree
> Of some inexorable supremacy
>   Which ever, as man strains his blind surmise
> From depth to ominous depth, looks past his eyes,
> Sphinx-faced with unabashèd augury?
>
> Nay, rather question the Earth's self. Invoke
>   The storm-felled forest-trees moss-grown to-day
>   Whose roots are hillocks where the children play;
> Or ask the silver sapling 'neath what yoke
>   Those stars, his spray-crown's clustering gems, shall wage
> Their journey still when his boughs shrink with age.

One of the most compact evocations of a world at once naturalistic and spiritually symbolic appears in "The Monochord," a sonnet inspired by another art. Again the poetry focuses on the process of interpreting experience, only here the compelling but ambiguous landscape is evoked by music:

> Is it this sky's vast vault or ocean's sound
>   That is Life's self and draws my life from me,
>   And by instinct ineffable decree
> Holds my breath quailing on the bitter bound?
> Nay, is it Life or Death, thus thunder-crown'd,
>   That 'mid the tide of all emergency
>   Now notes my separate wave, and to what sea
> Its difficult eddies labour in the ground?

*Dante Gabriel Rossetti*

Oh! what is this that knows the road I came,
The flame turned cloud, the cloud returned to flame,
　The lifted shifted steeps and all the way?—
That draws round me at last this wind-warm space,
And in regenerate rapture turns my face
　Upon the devious coverts of dismay?

As Paull F. Baum remarks, this is "a prime example of poetry striving towards the condition of music—and almost ceasing to be intelligible." But what is clear is the relation of the very complexity of the poetry to the pressure of a second art. Beside the sonnet in his own copy of the 1870 *Poems*, Rossetti noted that it portrayed "That sublimated mood of the soul in which a separate essence of itself seems to oversoar and survey it." That the capacity of achieving this double perspective derives from aesthetic experience indicates the close relation of this dominant theme in *The House of Life* to the ideas and techniques of the literature of art.[21]

The references to aesthetic problems, and the recurrent theme of interpreting experience, emphasize the abstract structure of *The House of Life* and discourage a view of it as pure autobiography. The structure of the sequence is fictional, although many of the sonnets refer to specific incidents in Rossetti's life. Indeed, the shape of the whole was determined in the first version, published in *Poems*, 1870, containing only fifty sonnets and eleven additional songs. In the finished sequence, the emotional and intellectual structure of the first version is altered very little. Although a number of autobiographical poems were added in 1881, including those referring to Jane Morris, they fill out the sequence within the same lines of development defined eleven years before. There is a general movement from naturalistic to philosophic verse. We can follow what has been described as the narrator's progress from "fleshly" to spiritual views of love. The object of the sequence is to locate specific incidents within a general aesthetic structure, to translate the accidental into the typical, to represent not the actual details of Rossetti's biography but a universal pattern of experience. Much as in Rossetti's visual art, our attention is directed to the shape of the whole. In a letter of 1870 to Dr. Hake, Rossetti compares this emphasis on the framework of the sequence to an idea of visual abstraction: "As with recreated forms in painting, so I should wish to deal in poetry chiefly with personified emo-

tions; and in carrying out any scheme of *'The House of Life'* (if ever I do) shall try to put into action a complete dramatis personae of the soul."[22]

*The House of Life* "mirrors" actual life in the second sense of that word as defined in Johnson's dictionary, by constructing a paradigm, an inclusive, ideal pattern. Rossetti does not argue on behalf of sensuality, as his first critics complained, or insist on the necessity of any specific mystical belief, as some later readers would urge. The single belief that emerges unchanged by the end of the sequence is a belief in art as the key that unlocks the complex secrets of existence. In "Youth and Change," the first section of the sequence, the theme of love often introduces an exploration of the nature of art, as in "Heart's Hope." "Change and Fate," the second part, pays even more attention to aesthetic themes and treats them even more directly, including some poems about painting. In this portion of the sequence Rossetti focuses on mental process—memory, association, or artistic creation itself. His poetry is less immersed in compelling human situations than in the first sonnets. As the increased use of allegory suggests, he tends to view life at a distance, as the subject of abstract speculation. Indeed, by the end, the spiritual is often identified with the aesthetic: to abandon the world of body for that of soul is to enter "the soul's sphere of infinite images." Even the seemingly metaphysical conclusion of the sequence turns out to be a restatement of Rossetti's firm grounding in aesthetics. "The One Hope," the final sonnet, which seems in its title alone to contain a transcendent message, in fact prays for an afterlife illuminated not by faith but by language, and for an ultimate aesthetic utterance contained in a supremely magical word:

> Ah! when the wan soul in that golden air
>   Between the scriptured petals softly blown
>   Peers breathless for the gift of grace unknown,—
> Ah! let none other alien spell soe'er
> But only the one Hope's one name be there,—
> Not less nor more, but even that word alone.

The concluding emphasis on the importance of language recalls the centrality of verbal abstraction throughout *The House of Life* and, indeed, throughout Rossetti's career. His insistence on

the supremacy of art, even in the afterlife, as an almost magical power brings his work close to that of the symbolists.

## Rossetti As a Modern Writer

The fascination of what's difficult is only one of many modern assumptions behind Rossetti's writing. His translations and imitations of medieval poetry foreshadow those of Eliot and Pound, often stemming from the same kind of Romantic historical myth. In his mannered rhythms it is also possible to find anticipations of Yeats, whose own creation of a personal cosmology has a debt to *The House of Life* and to Rossetti's role in the revival of Blake. At times it seems that literature is regarded by Rossetti as a form of magic, especially in the rituals of interpretation, where the primary object seems to be the total immersion of the spectator in the mysterious rhythms of art. Here he only enlarges on Ruskin's example and points toward the work of Pater. Graham Hough has discerned in the "accomplished" prose of "Hand and Soul" a "new kind of writing in which the rhythm and vocabulary of Pater is already foreshadowed." Similarly, Oswald Doughty cites a passage of art criticism, written for William Michael Rossetti's regular columns in *The Critic* and *The Spectator* in 1850, as an ancestor of Pater's description of the "Mona Lisa."[23] Rossetti tries to evoke the "eccentricity" of Maroutti's statue of Sappho—a Paterean theme if ever there was one: "Sappho sits in abject languor, her feet hanging over the rock, her hands left in her lap, where her harp has sunk; its strings have made music assuredly for the last time. The poetry of the figure is like a pang of life in the stone; the sea is in her ears, and that desolate look in her eyes is upon the sea; and her countenance has fallen" (II, 499). As in the "Sonnets for Pictures," Rossetti attributes a personality to the artifact, creates a narrative time-sequence to explain it, and introduces into the account some of his own imagery (here, the sea). Yet to a greater extent than in those rituals of interpretation already discussed, the artifact itself is buried beneath the overwhelming mood of the passage. The evocation of mood reveals a concern with psychology that defines the last aspect of Rossetti's modernism. We can discover in some of his verse an effort to marshal every fact of a poetic world for the definition of a unique psychological condition; in so doing, he moves

toward the techniques and concerns of the imagist poets at the beginning of the twentieth century.

"My Sister's Sleep" exemplifies the psychological elements by which Rossetti's poetry bridges the concerns of Romantic and modern poetics. The decorative midnight narrative culminates in an intense, understated moment of revelation. The poem usually is taken as a model of Pre-Raphaelite style for its abundance of painterly detail, but in fact its details are as often heard as seen. The subject is consciousness itself, the hyperaesthesia experienced under the pressure of strong emotion. The narrator sits with his mother on Christmas Eve awaiting the outcome of his sister's fatal illness. The room is described in some detail: we note the "glare/Made by her candle," the light of the moon seen through a window, and the "subtle sound/Of flames" in the fireplace, while "In the dim alcove/The mirror shed a clearness round." When midnight strikes, the noise of chimes fills the room and then recedes:

> The ruffled silence spread again,
> Like water a pebble stirs.

At twelve the mother lays down her knitting needles with a click; with that motion "her silken gown/Settled: no other noise than that." When "a pushing back of chairs" upstairs disturbs the quiet, mother and son enter the sickroom to see if "my sister" has awakened. They find her dead—"there all white, my sister slept"—and kneel to invoke "Christ's blessing on the newly born!" The conclusion is effective as religious poetry in the sense that it describes a religious experience; the focus remains internal and psychological, as in "The Blessed Damozel." Metaphysical affirmation is shown to be contingent, predicated on a specific emotional condition. Rossetti stresses the interdependence of spiritual insights and personal, "aesthetic experience."[24] The intensity of sensuous apprehension, which keeps the small world of the poem from claiming too much metaphysical significance, provides the distinctly modern note. Rossetti's modernism develops directly out of the assumptions of a Pre-Raphaelite aesthetic: it is, most simply, an extension of the Romantic fascination with consciousness; psychology passes into phenomenonology. Another early Pre-Raphaelite poem that deals with the impact of intense experience on consciousness is "The Carillon," where the medium between

internal and external worlds is art. There are, in fact, two arts in the poem: the painting of Memling and Van Eyck and the traditional music of the carillon bells. Here too the presence of the fine arts allows the writer to enter history imaginatively. "The Carillon" describes how the synaesthetic impact of the bells in the churches of Antwerp and Bruges transports Rossetti into the world of those early Renaissance painters. The poem begins in Antwerp, where he listens to the bells in the church at the harbor:

> The mist was near my face;
> Deep on, the flow was heard and felt.
> The carillon kept pause, and dwelt
> In music through the silent place.

At Bruges, where the Flemish masters "hold state," Rosetti feels "sore shame" at viewing their works, perhaps reflecting a Pre-Raphaelite longing to duplicate the mastery of past art. But the tolling of the church-bells seems to bridge the chasm of history:

> The carillon, which then did strike
> Mine ears, was heard of theirs alike:
> It set me closer unto them.

The poem ends one stanza later, where this slight explanation of the effect of the bells is replaced by a description of their physical impact. Rossetti climbs the belfry to immerse himself in sound and transform himself under the influence of music:

> For leagues I saw the east wind blown;
> The earth was grey, the sky was white.
> I stood so near upon the height
> That my flesh felt the carillon.

Rosetti has transformed a Ruskinian encounter with the past into a Paterean one; or, perhaps, he has fused them in an ecstasy of feeling and apprehension. He has entered history through the intensity of his sensations. Such poetry "aspires to the condition of music" in a sense that Ruskin as well as Pater would approve.

The most remarkable example of such modernism does not appear in *The Germ*, but might have if the journal had continued to be published. It is a poem produced during the same

continental journey of 1848 with Holman-Hunt on which Rossetti wrote "The Carillon." Its informality and spontaneity result from the fact that it is less a poem than a letter: the five "poems" in the series were composed as verse epistles to Rossetti's brother, who was responsible for giving the group a single title, "A Trip to Paris and Belgium." But they do not form "poems" in the usual sense. There is no structure to the poetic experience except that produced by the rush of images past the windows of a speeding railroad carriage:

> A constant keeping-past of shaken trees,
> And a bewildered glitter of loose road;
> Banks of bright growth, with single blades atop
> Against white sky: and wires—a constant chain—
> That seem to draw the clouds along with them
> (Things which one stoops against the light to see
> Through the low window; shaking by at rest,
> Or fierce like water as the swiftness grows);
> And, seen through fences or a bridge far off,
> Trees that in moving keep their intervals
> Still one 'twixt bar and bar; and then at times
> Long reaches of green level, where one cow,
> Feeding among her fellows that feed on,
> Lifts her slow neck, and gazes for the sound.

That stanza begins the first stage of the journey from "London to Folkestone." It is impressive not merely for the poetry but for Rossetti's instinctive impressionism, related to the speed and energy of the train itself. Indeed, the poem was written just after the period when Turner's illuminated description of "Rain, Steam, and Speed" had first appeared and been popularized by Ruskin: their impressionism has a common source in the exhilaration of the landscape experienced anew through the medium of the machine.

In the finest section of the verse epistle, titled "Antwerp to Ghent," the rapid motion of the railroad seems to function as an implicit metaphoric precondition for the coalescence of all levels of physical and mental experience on the journey. Here is the entire poem:

> We are upon the Scheldt. We know we move
> Because there is a floating at our eyes
> Whatso they seek; and because all the things

*Dante Gabriel Rossetti*

Which on our outset were distinct and large
Are smaller and much weaker and quite grey,
And at last gone from us. No motion else.

We are upon the road. The thin swift moon
Runs with the running clouds that are the sky,
And with the running water runs—at whiles
Weak 'neath the film and heavy growth of reeds.
The country swims with motion. Time itself
Is consciously beside us, and perceived.
Our speed is such the sparks our engine leaves
Are burning after the whole train has passed.
The darkness is a tumult. We tear on,
The roll behind us and the cry before,
Constantly, in a lull of intense speed
And thunder. Any other sound is known
Merely by sight. The shrubs, the trees your eye
Scans for their growth, are far along in haze.
The sky has lost its clouds, and lies away
Oppressively at calm: the moon has failed:
Our speed has set the wind against us. Now
Our engine's heat is fiercer, and flings up
Great glares alongside. Wind and steam and speed
And clamour in the night. We are in Ghent.

At the end of the poem there appears to be an intentional refer-
ence to Turner, in which Rossetti anticipates impressionist liter-
ature as well as impressionist art. He experiences the world as
relativistic and in motion. As in Pater's Conclusion to *The
Renaissance*, this vision is at least partly derived from condi-
tions established by modern science and technology. But as with
Turner, it is technology filtered through a painter's eye. The
world is seen as a collection of partial glimpses. Perception is the
only reality. The whole of experience is a composite portrait of
those aspects of life that find material expression from moment
to moment. This is Rossetti's most radical poetic fusion of
imagination and reality, as well as his finest account of the way
in which experience is apprehended. It is achieved not through
the creation of a powerful imaginary world but through a total
immersion in sensation. Feelings, ideas, or abstractions of any
sort only exist—at least at the end of this series of poetic frag-
ments—insofar as they are embodied in tangible facts. Indeed,
all forms of experience are reduced to the visible, the clearest

sign that this modernism is linked to Rossetti's imaginative legacy as a painter.

The moment of purest objectivity in the series of verse epistles comes in "The Paris Railway Station," where the impulse to record everything that enters the travelers' field of vision produces another radical anticipation of modern poetry, in a glimpse of reality in its starkest form:

> the other day
> In passing by the Morgue, we saw a man
> (The thing is common, and we never should .
> Have known of it, only we passed that way)
> Who had been stabbed and tumbled in the Seine,
> Where he had stayed some days. The face was black,
> And, like a negro's, swollen; all the flesh
> Had furred, and broken into a green mould.

It might be a passage from Baudelaire, but the *Fleurs du mal* was still some years off. Rossetti's literary model, in fact, is a poem by his brother, "Mrs. Holmes Gray," in which, as William Michael Rossetti explains, "the subject is a conversation about the death of a lady . . . and a newspaper report of the coroner's inquest occupies a large space in the composition." Rossetti, who had received his brother's poem only ten days before composing "The Paris Railway Station," congratulated William on the honesty of "a painful story, told without compromise, and with very little moral . . . beyond commonplace." It is "less healthy and at times more poetical" than the verse of Crabbe, "not lacking no small share of his harsh reality." As William's note in the *Rossetti Family Letters* argues, all the seemingly modern values Rossetti recognizes in the poem stem from the assumptions of Pre-Raphaelitism: "The informing idea of the poem was to apply to verse-writing the same principle of strict actuality and probability of detail which the Preraphaelites upheld in their pictures. It was in short a Preraphaelite poem."[25] William Michael Rossetti was to apply the same principles to his series of poems, "Fancies at Leisure," published in *The Germ*.

Rossetti experiments with unconventionally realistic poetry elsewhere, as in the Browningesque "A Last Confession" or in his open treatment of prostitution in "Jenny." But it is his method, rather than his subject, which makes the verse epistle

modern. Impressionism is perhaps the best term for the aesthetic governing poetry of this sort: as in impressionistic painting, knowledge of the world is confined to what can be glimpsed from a single, subjective perspective; and as in Pater's Conclusion to *The Renaissance,* even that perspective is limited by the rapid flow of time. Consciousness itself seems to dissolve into a sequence of perceptual moments, as in the succession of views from the window of the moving train. The brevity of the encounter at the Paris station is emphasized by a heading of the verse epistle: "11 P.M. 15 October, to half-past 1 P.M. 16." Rossetti binds his verse to a specific time and place, much as some Pre-Raphaelite painting or the later art of Whistler.

The relation of painting and poetry in Rossetti's career is sometimes explained as a yearning after lost beauty, or as Romanticism in the sense of escape. Yet I have tried to suggest something different, that the relation of the arts provides a stimulus for the analysis of psychological experience. Rossetti's poetry deserves to be called Pre-Raphaelite for its exploration of the nature of perception, and of the relation between imagination and experience. In the verse epistle of 1848, this aspect of his Pre-Raphaelite concerns moves toward a radical Romanticism, a modernist poetry of consciousness which anticipates the imagist aesthetic. In imagism, of course, there is no narrative such as in Rossetti. But like Rossetti, the imagist poet creates psychological realism by describing the world only as it is experienced by a single consciousness. In imagism, nature is used primarily "to represent emotional states," as Graham Hough notes in *Image and Experience.* Indeed, that title helps suggest how closely connected is the imagist aesthetic to the writing that grew around the contemplation of condensed, allusive images of the sort Rossetti finds in art: by particularizing such images, the writer articulates every phase of a complex emotional response; the image thus embodies his experience. Hough points out that the unity of an imagist poem depends on the carefully planned coherence of its details. To explain this intellectual ordering, he quotes T. S. Eliot, who in turn uses Rossetti's own phrase for it, "fundamental brainwork."[26]

Perhaps the earliest analysis of Rossetti's modernism as a painter-poet comes from Pater, who seems to have profited from it most immediately. He is probably referring to Rossetti (and Ruskin as well) when he remarks at the beginning of the essay "Style" in 1888 that for a quarter-century, "English . . . has

been assimilating the phraseology of pictorial art" (*Appreciations*, 15). And Pater's essay on Rossetti makes clear that he views him, especially as a painter writing poetry, to be primarily an innovator within the Romantic tradition, one who added "to poetry . . . fresh material . . . a new order of phenomena" (218). Those phenomena, and the phenomenology that accompanies them, mark Rossetti's clearest link to the concerns of Pater and Ruskin alike, and grow directly out of his interest in visual art.

Part Three

# *Walter Pater*

# VI

## History As Fiction

### in

## The Renaissance

Pater is a transitional figure, who even sees himself as such. Embracing the young tradition of the literature of art initiated by Ruskin and Rossetti, he attempts to direct it toward new aesthetic ends. Through his influence the literature of the arts makes its most significant contact with twentieth century writing, for his sense of the genre as a genre makes it adaptable to other genres and newer styles. In consequence, he is usually read as a background or an "influence," through the medium of writers like Conrad, James, Joyce, Wilde, or Yeats. It is fitting that the finest tribute to his first and greatest book should have been uttered by Wilde in the pages of Yeats's autobiography. The episode splendidly dramatizes the quintessential Pater as he appeared in the nineties, translated through the voice of a "disciple."[1] On the evening Yeats first met his fellow Irishman, Wilde—"a triumphant figure, and to some of us a figure from another age, an audacious Italian fifteenth century figure"—praised *Studies in the History of the Renaissance:* "It is my golden book! I never travel anywhere without it; but it is the very flower of decadence: the last trumpet should have been sounded the moment it was written." Wilde was interrupted, according to Yeats, by a "dull" listener's inquiry if he would not allow time to read the book before the Day of Judgment: " 'Oh

no,' was the retort, 'there would have been plenty of time afterwards—in either world.' "[2] This wit turns on a deliberate play on Pater's themes. *The Renaissance* blends its appreciations with the motif of travel, much like *Modern Painters* or *The Stones of Venice*. Furthermore, "the last trumpet" sounds repeatedly in the condemned world of its final pages, where aesthetics offers a "sense of freedom" (231) to relieve mankind from the ever-present shadow of death. Wilde delightfully proves that he has become a Paterean man, a transformation Yeats confirms by describing him as a Renaissance figure, in a sentence itself molded on Pater's style. Both men assume that their lives could be given artistic unity; and both rightly identify the idea of treating life in an aesthetic spirit with Pater himself.

With *The Renaissance*, and with Pater's career as a whole, the literature of art focuses increasingly on temperament. As he proclaims in the essay on Winckelmann, "The demand of the intellect is to feel itself alive. It must see into the laws, the operation, the intellectual reward of every divided form of culture; but only that it may measure the relation between itself and them. It struggles with those forms till its secret is won from each, and then lets each fall back into its place, in the supreme, artistic view of life" (229). The contemplation of art becomes an exercise leading to a final, refined, aesthetic contemplation of life. Mankind is included among the objects of this "supreme, artistic view," by which the Paterean critic questions every new source of intellectual pleasure: "What is this song or picture, this engaging personality presented in life or in a book, to *me*?" (viii). Similarly, nearly every one of the essays in *The Renaissance* is balanced between biographical, historical, and more purely aesthetic criticism, for the beauty of the past is to be found in society as well as in the arts. Throughout his writings Pater seeks out epochs in which the relation between history and private imagination, culture and individuals, seems particularly rich. In both criticism and fiction he constructs what he calls "imaginary portraits," rhythmic evocations of a world half-way between reality and the imagination, one where he can most fully dramatize the ideal mingling of life and art.

Pater's humanistic emphasis on man, like his choice of the Renaissance as a theme, seems a far cry from Ruskin's position as a critic. The taste for portraits apparent throughout *The Renaissance* is much closer to Rossetti's interests. There is little of the "landscape instinct" of *Modern Painters I* or even *The*

*Walter Pater*

*Stones of Venice*. Pater reserves his greatest admiration for images of living people, works that display life being lived with the utmost grace and intensity, for these provide the most direct models for the spectator's own development. Even if, as in Ruskin, the "use" of art is for self-transformation, the ideal Paterean sensibility experiences no illuminating glimpse of the divine. Not simply is the first responsibility of the Paterean spectator to himself; that is his only responsibility. The theoretical Preface to *The Renaissance* makes it clear that one questions only the nature of a given work of art "to *me*. What effect does it really produce on me? . . . How is my nature modified by its presence, and under its influence?" (viii). The concreteness of art, and the consequent necessity of intense perception, precludes any speculation on absolutes: "To define beauty, not in the most abstract but in the most concrete terms possible, to find not its universal formula, but the formula which expresses most adequately this or that special manifestation of it, is the aim of the true student of aesthetics" (vii-viii). Pater is probably aiming at Ruskin here, and he seems even more pointed in the essay on Winckelmann: "a taste for metaphysics is one of those things which we must renounce, if we mean to mould our lives to artistic perfection" (229–230).

The lives of artists are the most conspicuous examples in *The Renaissance* of the ideal of life to which Pater urges us to aspire. But these are not the principal models he offers. His major concern is to dramatize the transformation of self through an aesthetic perception of the world. It is not so much that we are being asked to live like artists—although Pater, like Wilde, would not rule this out. It is that the temperament developed through the contemplation of past art supplies the main basis for the ideal modern sensibility. The central figure in the book, revealed most completely in the texture of Pater's style, is the critic himself. The criticism of art forms a model not only for other kinds of criticism but also for the critical attitude that a sensitive nineteenth century reader should cultivate in response to all experience. *The Renaissance*, then, is not written to be translated into some sort of action, as the moral critics of the volume seemed to fear, but to be used as the stimulus of a particular sort of temperament. As Oscar Wilde observed of Marius, the Paterean hero is "an ideal spectator indeed . . . yet a spectator merely."[3]

If one's first and clearest image of temperament is always

provided in style, Pater's is remarkably intellectual and austere, as compared with either Ruskin's or Rossetti's, and especially when placed against the background of the contemporary moral outrage over his book. With Rossetti and Ruskin the interpretation of art always involves something personal and spontaneous; with Pater, however, every intonation seems calculated and contrived. This is not to deny the existence of a self behind *The Renaissance*, or to dispute that for Pater "the style is the man," as he remarks of Flaubert. But in the words of one critic, his is a "literary character," one wholly created in art.[4] We might describe Pater as he describes Mérimée: "a man of erudition turned artist," whose "superb self-effacement, his impersonality, is itself but an effective personal trait" (*Miscellaneous Studies*, 20, 37). By "impersonality," a term that was to become central for modern literary aesthetics, Pater means the capacity to control every facet of style. He uses the word in the essay on "Style" in *Appreciations* to praise Flaubert for the precision with which expression serves thought. Only when such impersonality is achieved can it be said that the style is the man: "The style, the manner, would be the man, not in his unreasoned and really uncharacteristic caprices, involuntary or affected, but in absolutely sincere apprehension of what is most real to him" (*Appreciations*, 36). As in the Preface to *The Renaissance*, the act of apprehension is the key to perfection of the self; yet the ultimate temperament to which it leads is in a sense "impersonal," artificial, formed self-consciously and under the guidance of an external object or thought that gives it final shape. Pater's idea of temperament comes remarkably close to Yeats's conception of mask.

Pater's style operates as both mask and self, an identity created in art and a living voice. While his prose is intensely personal, unmistakeably "Paterean," it achieves as well an almost total self-effacement, of the sort he ascribes to Mérimée. Like Mérimée, with his collection of exotic characters and themes, Pater is an impersonator, fully engaging his responsive art in the spirit of others. Criticism necessarily involves an element of selflessness, and many of his remarks on "impersonality" seem to refer to the necessity of a critical spirit. Like Mérimée and especially Flaubert, Pater brings his detachment as critic to bear on his fiction as well: his style is always fastidious; he tries to remain true to his subject. In fiction or essays, then, criticism involves a kind of translation, and in "Style" Pater

takes translation as a metaphor for all language. The translator reveals his personality in subtle matters, such as rhythm, diction, vocabulary, even in the very selection of a subject or text. Yet his work is objective, formed according to the demands of his text. As in the criticism of art, translation allows objective and subjective impulses to mingle—a mingling at least as important to Pater as it is to Ruskin. Pater's translations usually leave some original phrases beside the English versions of them, juxtaposing the "portrait" and its source. Throughout his work, in both essays and fiction, we are meant to compare his prose with our sense of its subject, to appreciate both the assertion and the suppression of self.

In what is probably his earliest essay extant, "Diaphaneitè," Pater describes such a dramatization of self through intellectual finesse. The essay also reveals the image of himself that he sought to impress on a select audience. Pater's friend and editor, C. L. Shadwell, describes "Diaphaneitè" as one of those early unpublished essays "by which his literary gifts were first made known to the small circle of his Oxford friends" (*Miscellaneous Studies*, 2). In it, Pater defines an ideal "diaphanous" or "transparent" personal type. Outward appearance is only "the veil or mask of such a nature" (251). Whereas the diaphanous temperament is almost an "accident of birth or constitution," it is also a product of intellect, which can be deliberately sought:

> As language, expression, is the function of intellect, as art, the
> supreme expression, is the highest product of intellect, so
> this desire for simplicity is a kind of indirect self-assertion of
> the intellectual part of such natures. Simplicity in purpose
> and act is a kind of determinate expression in dextrous
> outline of one's personality. It is a kind of moral expressive-
> ness; there is an intellectual triumph implied in it. Such
> a simplicity is characteristic of the repose of perfect
> intellectual culture. The artist and he who has treated life
> in the spirit of art desires only to be shown to the world as he
> really is; as he comes nearer and nearer to perfection, the
> veil of an outer life not simply expressive of the inward
> becomes thinner and thinner. (*Miscellaneous Studies*, 249)

The concept of self implied here reappears in different historic guises in Pater's later essays, most especially in *The Renaissance*. In this early essay he observes that in a diaphanous type, "no single gift, or virtue, or idea, has an unmusical predomi-

nance" (*Miscellaneous Studies*, 262). The same analogy of musical unity reappears in his essay "The School of Giorgione" as an image of both the Ruskinian harmony of the painter's culture and the more Paterean harmony of his own art. It recurs in *Plato and Platonism* to describe the order and symmetry of Plato's *Republic*, in which "organic unity with one's self . . . supplies the true definition, of the well being of . . . the state" (*Plato and Platonism*, 239). Other phrases from "Diaphaneite" are transposed to later writings, and this habit of self-quotation reveals an important, if intuitive, artistic procedure. It is as if Pater as historian and critic searches for corroboration in history and the arts for his early dream of a life molded to artistic perfection, where an "outer" being is wholly "expressive of the inward" ideal. As readers of his work, we search for the same correspondence. One of the delights in reading Pater is to discover, time after time, that the most mannered, personal effects of his writing bear a close relation to their historical subjects, that he has found in the actual details of past art or literature perfect images for the expression of his own personality.

"The School of Giorgione"

"The School of Giorgione" commands a central position in Pater's oeuvre for three reasons. To begin with, it is one of his finest essays. The passages on Giorgione's art, for example, include some of his best evocative prose. The essay also contains his most complete theoretical discussion of the nature of art. It is usually remembered, in fact, for the sentence that encapsulates much of his aesthetic thought into a concise credo: "all art constantly aspires towards the condition of music." Finally, the essay describes a painter who not only supplies an attractive personal subject for critical contemplation but seems to translate Pater's principles of aesthetic criticism into the texture of his own work. In all three senses the essay provides a comprehensive glimpse of "the supreme, artistic view of life." Pater explains and dramatizes his fundamental attitude toward art and, through the figure of Giorgione, reveals art transforming the nature of existence.

The pronouncement at the heart of the essay suggests the importance for Pater, as for Ruskin and Rossetti, of the relation between form and content. He repeats and italicizes the statement to stress its importance: "*all art constantly aspires towards*

*Walter Pater*

*the condition of music."* To some extent it seems to imply a rationale for the quality of his own style, a justification for evocative writing. For what he means by this suggestive formula is not so much that art should provide a coherent intellectual structure for its own apprehension as that within it different kinds of effects should merge to produce a rich and satisfyng confusion. In music, the prototype for this "diaphanous" art, there is no form that is not content and no content that is not form. Pater's example of the use of this model in other arts is Giorgione himself. Giorgione paints musical themes and subjects musically, in misty, subdued tones. He himself is only barely separable from a legend that grew up around his name or from the "school" that is attached to his name and influence. It is possible to know Giorgione only through the Giorgionesque, for his unification of form and content makes his personality inseparable from his art. He becomes an instance of the Paterean ideal, an object of his own creation, only visible in the transparency of the outward form of his art. And just as Pater wishes his use of aesthetic images to become a model for the contemporary temperament, so Giorgione's manner is not only a perfect image of himself but also a symbol for the quality of life pervading the world around him. Indeed, the world for which Giorgione is a symbol is the same one Ruskin idealized in *The Stones of Venice*. Very much as in Ruskin's biographical sketch of the painter in "The Two Boyhoods" (*Modern Painters V*), Pater sees Giogione as a human embodiment of the ideals of a beautiful historic civilization: he is an "impersonation of Venice" (148).

In "The School of Giorgione" it is perhaps clearest how much Pater belongs to the tradition of the literature of art and how much he adds to it, and finally how far his interpretation of art and history strays from Ruskin's, or for that matter Rossetti's, although they are closer in spirit. The essay appears for the first time in the third edition of *The Renaissance*, but there is external evidence that it was composed for the first edition in 1873.[5] Internal evidence supports this conjecture as well, for the essay seems an appropriate justification of Pater's critical and historical method against that of men like Ruskin or Rossetti, with whom he was likely to be compared. Pater's themes come very close to those introduced in Ruskin's and Rossetti's descriptions of Giorgione. Like Rossetti (and Pater refers to the sonnet on the "Pastoral" in a footnote), he stresses the sense of

expectancy in the art, the pensiveness of Giorgione's figures, which seems related to the presence of music and water as visual themes: "In . . . the favourite incidents of Giorgione's school, music or the musical intervals in our existence, life itself is conceived as a sort of listening—listening to music, to the reading of Bandello's novels, to the sound of water, to time as it flies" (151).

Rossetti's sonnet dramatized the beautiful gestures of the figures in the "Venetian Pastoral," hinting that in Giorgione's world, life attained a kind of "immortality." In "The Two Boyhoods," written after *The Stones of Venice* and after Rossetti's poem, Ruskin enlarged on the loveliness of this historical existence:

> Have you ever thought what a world his eyes opened
> on—fair, searching eyes of youth? What a world of mighty
> life, from those mountain roots to the shore;—of loveliest
> life, when he went down, yet so young, to the marble city—
> and became himself as a fiery heart to it?
> A city of marble, did I say? Nay, rather a golden city, paved
> with emerald. . . Deep-hearted, majestic, terrible as the
> sea,—the men of Venice moved in sway of power and
> war; pure as her pillars of alabaster, stood her mothers and
> maidens; from foot to brow, all noble, walked her knights. . .
> A wonderful piece of world. Rather, itself a world. . .
> Brighter and brighter the cities of Italy had been rising
> and broadening on hill and plain, for three hundred years.
> He saw only strength and immortality, could not but paint
> both, conceived the form of man as deathless, calm with
> power, and fiery with life. (VII, 374, 385)

As do both Rossetti and Ruskin, Pater regards Giorgione's portrait of Venetian life as giving that world itself the harmony and delicacy of a fine work of art. Viewing his "exquisite pauses in time . . . we seem to be spectators of all the fulness of existence," of "some consummate extract or quintessence of life" (150). Indeed, "all that was intense or desirable" in Venice seems in his art to be "crystallizing about the memory of this wonderful young man" (148).

Yet the main thrust of Pater's essay is away from Rossetti and especially from Ruskin. *The Renaissance* interprets art and history with none of the moral or religious overtones of *Modern Painters*, *The Stones of Venice*, or the work of the Pre-Raphael-

ites. Rossetti's description of the "Pastoral" seems implicitly to agree with Ruskin's classification of the artist in "an abstract contemplative school" (VII, 381). Rossetti took the ambiguity of the painting as a reference to a mysterious and unnameable ideal behind it, occult and vaguely religious. Ruskin, while admitting that Giorgione himself may have gone to Venice from Castlefranco "somewhat recusant or insentient, concerning the usual priestly doctrines of his day," and that the power of Venetian religion was often oppressive and hypocritical, nevertheless insisted that the contact of the man with the institution must have had a decisive and positive effect on his art. For all its faults, the Venetian faith was "a goodly system . . . in aspect; gorgeous, harmonious, mysterious . . . A religion towering over all the city—many-buttressed—luminous in marble stateliness . . . many-voiced, also" (VII, 381). Pater, in contrast, sees the essential drama of art and history as wholly distinct from religion. He traces the history of Venetian art before Giorgione in order to emphasize its freedom from nonaesthetic intellectual concerns:

Unassisted, and therefore unperplexed, by naturalism,
religious mysticism, philosophic theories . . . Exempt from
the stress of thought and sentiment, which taxed so severely
the resources of the generations of Florentine artists, those
earlier Venetian painters, down to Carpaccio and the
Bellini, seem never for a moment to have been so much as
tempted to lose sight of the scope of their art in its strictness,
or to forget that painting must be before all things decorative,
a thing for the eye, a space of colour on the wall. (140)

Pater seems directly contradicting the views on the same period of art history held by Ruskin, who in the 1870s was trumpeting the virtues of Carpaccio's religious art in *Fors Clavigera*. Giorgione consummates what Pater considers the aesthetic tradition of Venetian art, one only marginally directed to any religious or moral purpose, which he sees beginning as early as the Byzantine period. Giorgione carries this to a refined culmination: "He is the inventor of *genre*, of those easily movable pictures which serve neither for uses of devotion, nor of allegorical or historic teaching—little groups of real men or women, amid congruous furniture or landscape." Framed and portable, such scenes, like "a poem in manuscript, or a musical instru-

ment," may "be used, at will, as a means of self-education, stimulus or solace, coming like an animated presence, into one's cabinet, to enrich the air as with some choice aroma, and, like persons, live with us, for a day or a lifetime" (141).

"The School of Giorgione" is the theoretical center of the argument implicit throughout *The Renaissance* that the fine arts should receive no ideological interpretation. Pater not only attacks Ruskin's concept of the Renaissance as an immoral and therefore essentially unartistic age, but he attacks the method of art criticism by which such evaluations are made possible. The essay opens by referring not to Giorgione specifically or to his circle, but to the views of art that might limit the rank of their work:

> It is the mistake of much popular criticism to regard poetry, music, and painting—all the various products of art—as but translations into different languages of one and the same fixed quality of imaginative thought, supplemented by certain technical qualities of colour, in painting; of sound, in music; of rhythmical words, in poetry. In this way, the sensuous element in art, and with it almost everything in art that is essentially artistic, is made a matter of indifference; and a clear apprehension of the opposite principle—that the sensuous material of each art brings with it a special phase or quality of beauty, untranslatable into the forms of any other, an order of impressions distinct in kind—is the beginning of all true aesthetic criticism. (130)

It would be unfair to Ruskin to say that Pater means this to be a direct reference; but he seems to have in mind the definition in *Modern Painters I* of great art as the sum of great ideas, and also Ruskin's general suspicion of the "sensuous" objectives of an art created for its own sake. Ruskin offered only guarded praise for Giorgione in the second volume of *Modern Painters*, uneasy about precisely the elements in which Pater seems to delight. The "Fête Champêtre" in the Louvre, for example, had to be abstracted before Ruskin would tolerate its potentially "ignoble" subject. Through the "mere power of perfect and glowing colour . . . the sense of nudity is utterly lost, and there is no need nor desire of concealment any more, but his naked figures move among the trees like fiery pillars, and lie on the grass like flakes of sunshine" (IV, 195–196). Although Pater does not defend an art which "addresses . . . pure sense, still

less the pure intellect," he does insist that the appreciation of art must begin in delight and emotional, sensual response, and that no analysis of beauty does justice to its medium when it abstracts ideas from the sensuous form in which they are expressed. Even the most elaborately iconographical imagery must first appeal through its "essential pictorial qualities" if it is ever to awaken our thought (132).

Pater's "aesthetic critic" is less a thinker than a connoisseur, who finds less interest in truth than in beauty and less inspiration in nature than in art. Pater's method of "impressionism" may even tend to detach the objects he examines, themselves mere impressions, from their larger contexts of ideas and history: "In its primary aspect, a great picture has no more definite message for us than an accidental play of sunlight and shadow for a few moments on the wall or floor: is itself, in truth, a space of such fallen light, caught as the colours are in an Eastern carpet, but refined upon, and dealt with more subtly and exquisitely than by nature itself" (133). Art addresses itself to the "imaginative reason," he explains, quoting Arnold's phrase—"that complex faculty for which every thought and feeling is twin-born with its sensible analogue or symbol" (138). Music embodies this simultaneity in its most perfect form, the "perfect identification of matter and form" (139). In this sense, all the arts, insofar as they aspire to a harmony between ends and means, subject and expression, are "continually struggling after the law or principle of music." Yet Pater's description of this unity in Giorgione, although it demonstrates a blending of form and content, seems to emphasize feeling at the expense of thought. Giorgione's school "exercises a wonderful tact in the selecting of such matter as lends itself most readily and entirely to pictorial form, to complete expression by drawing and colour. For although its productions are painted poems, they belong to a sort of poetry which tells itself without an articulated story" (149). The union of form and content is achieved by the limitation of content to what is appropriate to a particular form. Pater admires such art for its indifference to content except as material for form, and his description of the Giorgionesque is largely an evocation of moods. For the viewer, then, the ideal double identity is invariably realized instinctually and through the senses in advance of, if not instead of, being apprehended intellectually. As Pater announces in the same paragraph in which he employs Arnold's phrase, "Art . . . is thus always striving to be inde-

pendent of the *mere* intelligence, to become a matter of pure perception" (138, italics mine).

In effect, with the substitution of "perception" for "intelligence," Pater dissolves Giorgione's "school" as an actual, distinct historic phenomena. Giorgione's art is characterized not by specific themes or methods but by a particular aesthetic effect. The very existence of the painter himself becomes increasingly obscure: the "Fête Champêtre" about which Rossetti and Ruskin wrote "is assigned to an imitator of Sebastian del Piombo" (145). Modern scholars tend to attribute the picture to Titian, so Pater's skepticism is not unwarranted. But he is concerned less with the evidence for a specific historical judgment than with the broad problem of the relativity of all knowledge—a problem Giorgione, obscure in life and art, personifies. It is clear throughout *The Renaissance* that Pater's subjective aesthetic, especially as articulated in "The School of Giorgione," militates against history, acknowledging the reality of the past only as it survives in vivid "impressions" in the present.

The Art of History

Aesthetic criticism commits Pater to discovering history through the senses. Ruskin exercised much the same method in his journey into history in the second volume of *The Stones of Venice*, but the treatment of the past in *The Renaissance* is even more radically personalized. Pater engages in little of the original research that bolstered Ruskin's interpretation of Venetian culture. The tendency of *The Renaissance* is to simplify its material, to reduce the Renaissance itself to a few major figures, and to reduce their own significance to the meaning of a few central episodes or works. Pater's object is to merge the roles of historian and aesthetic critic, presenting history as a series of intense sensations, until it is impossible to distinguish the form from the content of the past. Far more than Ruskin, Pater self-consciously develops an art of history, which involves new techniques for the analysis of the past and new standards for the sort of materials that characterize an epoch. The revolutionary quality of *The Renaissance* depends not merely on a reinterpretation of the meaning of a particular historic period but also on a reassessment of the nature of history itself.

Pater insists that history contains no independent order or meaning of its own. His skepticism about the coherence of the

past is apparent even in his emphasis on style, or in the repeated use of works of art to symbolize entire ages. The very notion of an age is an abstraction: time has no natural divisions. Only the self-consciously artificial removes one from the anarchic flow of time: the doctrine of Heraclitean flux enunciated in the Conclusion to *The Renaissance* provides a philosophic justification for the aestheticism of Pater's historic method. A successful account of history must therefore impose its own order on the randomness of human events. Indeed, as implied in the Biblical epigraph to *The Renaissance*, later to be adopted by Henry James, only the metaphoric captures the essence of events or human relations: "Yet shall ye be as the wings of a dove." The emphasis on metaphor is repeated in the opening of the first historical study in the book, "Two Early French Stories," with a rhythmic evocation of the past in the language of a fairy tale: "The history of the Renàissance ends in France, and carries us away from Italy to the beautiful cities of the country of the Loire." This wistfully contemplative tone persists throughout the book, as does the image of time as a flowing stream. Rivers reappear as metaphors for time and history in the essays on Leonardo and Giorgione, as well as in the language of the Conclusion, where Pater describes the "whirlpool" of thought, the endless "drift" of experience, and the "flood of external objects" which constitutes our impression of the world (234). The force of these metaphors, as of the entire Conclusion, suggests that experience is a rich, mysterious, elusive process, which art alone can arrest into significant moments. The artists and art works Pater chooses as subjects form a series of such beautiful historic moments through which the vague phenomenon called "Renaissance" makes itself known and gains its only real existence.

Thus, as in Ruskin, the meaning of the past is made convincing by its potential to be treated as fiction. Indeed, *The Renaissance* reads like a novel. Despite the seeming limits of history and actual artifacts, Pater creates the illusion we demand from any successful fictional work—that it engross us in a self-contained, orderly world entirely of the author's making. In *The Renaissance*, history becomes a delightful fable, narrated with soothing precision, a prose poem formed out of the materials of biography, literature, and art. Fact is transformed consistently by a fictional impulse; and it is finally to the fiction, a unified collection of interpretations of the past, that Pater assigns the label "history."

Personality is at the center of Pater's fictional view of the past. Yet *The Renaissance* divides its attention between the personalities of great historical figures and the implicit, personal role of the modern critic, studying the past as a stimulus for his own temperament. Even more than in Ruskin, an entire period of history becomes expressive of the aesthetic possibilities of a unified modern sensibility. Especially in the Conclusion, the relativity of experience makes historic study an activity of aesthetic redemption for the modern spirit. Thus it becomes our task "to burn always with this hard, gemlike flame," not simply by reliving the biographies of Pater's Renaissance heroes but primarily by contemplating them from the present. Criticism itself forms a model for the ideal conduct of life. T. S. Eliot was right to insist that the Conclusion, with its attack on conventional morals, "is itself a theory of ethics . . . concerned not with art but with life."[6] The Conclusion organizes *The Renaissance* by defining most explicitly the attitude according to which the rest of the essays should be interpreted, an attitude Pater invites us to extend to our own lives.

One of the central fictional themes of the book is the narration of an historic evolution of temperament, culminating in Pater's ideal modern type. The essays written expressly for *The Renaissance*—the Preface "Two Early French Stories," "Luca della Robbia," and "Joachim Du Bellay"—form conspicuous links in an effort to arrange the rest of the volume into a gradual but distinct progress toward this terminl point. Luca della Robbia, for example, who is not particularly colorful in and for himself, appears as a transitional sculptor in the progress leading to Michelangelo. The essay on Joachim Du Bellay is laced with the themes of the essays on Leonardo and Winckelmann, and serves as a bridge between them. Pater himself remarks in the Preface (also appearing for the first time) that the newly published essay on "Two Early French Stories" and the essay on Du Bellay help define "the unity of the series" (xii). His description of this unity makes clear that it is not merely chronological but a personal harmony as well, as if *The Renaissance* will define a perfect, universal type of life: "The Renaissance, in truth, put forth in France an aftermath, a wonderful later growth, the products of which have to the full that subtle and delicate sweetness which belongs to a refined and comely decadence, just as its earliest phases have the freshness which belongs to all

*Walter Pater*

periods of growth in art, the charm of *ascesis*, of the austere and serious girding of the loins in youth" (xii–xiii).

Pater's biographies outline the characteristics of a general Renaissance type, dressed in assorted historical costumes, defining the most vital possibilities of human personality as they have been expressed from the twelfth century to the present day. The Conclusion only solidifies the impression which should have grown since the Preface that the book defines an ideal form of selfhood. There is, in this sense, a "hero" of Pater's *Renaissance*, a disembodied sensibility whose identity is gradually characterized over time. This form of being, which is most prominent in the lives of great artists and thinkers, is to be recovered in the nineteenth century not only through the creation of great art but through the study of great art and artists in the past. Thus, in the Conclusion the modern form of an ideal past existence merges with the role of Pater's "aesthetic critic"— "How shall we pass most swiftly from point to point, and be present always at the focus where the greatest number of vital forces unite in their purest energy?" (236).

Before that final "success in life" when he will "burn always with this hard, gemlike flame," Pater's disembodied "hero" passes through a gradual cultural development. He enjoys his infancy and youth in the guises of the naïve characters of the "early French stories" and in Pico della Mirandola's "childish" ideal of a simple, "limited" world, still as lovely and manageable as "a painted toy" (41). The middle of the book describes a kind of historical summer, in which minor advances in the progress of the human spirit are stored up for the use of greater men. With Michelangelo this growth attains "immense, patriarchal age" (89), until in the person of Leonardo da Vinci, "Italian art dies away as a French exotic" (128). As Leonardo retires to the court at Amboise, one of "the beautiful cities of the country of the Loire," the cycle projected in the first pages of the volume is complete. Returning to the homeland of Abelard, also discussed in the first essay, Pater introduces in Leonardo's dying place the locale in which Du Bellay and the Pleiad wrote. Thus, the themes of decay and death link the aging Renaissance figure—introduced in a number of essays but consummated in Leonardo da Vinci—to the tragic condition of modern life depicted at the end of the essay on Winckelmann and in the Conclusion.

Du Bellay's "decadence" most explicitly suggests the point at

which the Renaissance begins to merge with the contemporary world. His environment is "a little jaded," for as men "play, real passions insinuate themselves, and at least the reality of death" (170, 169). Du Bellay's modern ennui and tragic early death link him to Winckelmann, whose murder is a symbol within *The Renaissance* for the fate of the modern aesthetic consciousness. The point of the parallel is partly that the ideal Renaissance man cannot survive long in the contemporary world—but his is still a possible condition to which the modern mind can aspire. By ending with an eighteenth-century art critic, a figure sharply resembling himself, as well as with the modern references of the Conclusion itself, Pater insists that his Renaissance "hero" has a role in the nineteenth century, that as he suggests in "Winckelmann," such "culture" is not "a lost art" (227).

The only illustration in the book confirms this sense that Pater's object is to define a single, consummate Renaissance type. The frontispiece by Leonardo (see illustration) reminds us not only of the centrality of his genius to the Renaissance as a whole but of the power of his enigmatic images to symbolize complex intellectual and historical traditions. Pater describes the drawing as "a face of doubtful sex," which suggests that he also found in it a more personal significance and appeal. As the first image to be encountered on opening the book, it stands as a concrete if slightly ambiguous illustration that life itself can become symbolic and gain aesthetic unity. In his chapter on Leonardo, Pater compares the drawing to another series of bizarre bisexual images by the artist, which Pater calls "Daughters of Herodias." Pater's language suggests the almost magical ambiance of these figures:

> They are the clairvoyants, through whom, as through
> delicate instruments, one becomes aware of the subtler
> forces of nature, and the modes of their action, all that is
> magnetic in it, all those finer conditions wherein material
> things rise to that subtlety of operation which constitutes them
> spiritual, where only the final nerve and the keener touch
> can follow. It is as if in certain significant examples we
> actually saw those forces at their work on human flesh.
> Nervous, electric, faint always with some inexplicable
> faintness, these people seem to be subject to exceptional
> conditions, to feel powers at work in the common air unfelt
> by others, to become, as it were, the receptacle of them, and
> pass them on to us in a chain of secret influences. (116)

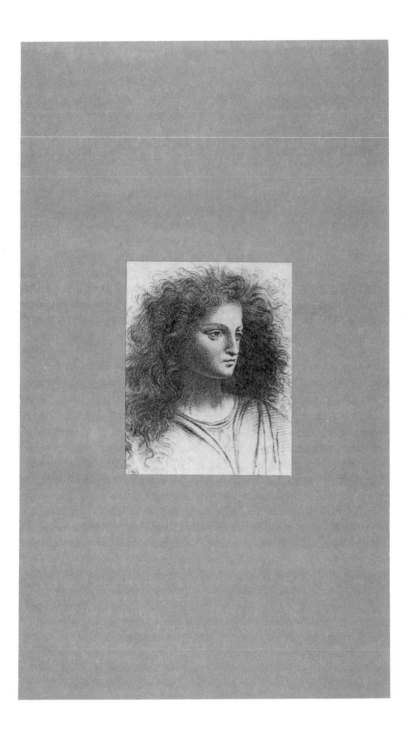

Leonardo da Vinci, "Head of a Man"

Such images not only reveal life being transformed into higher and subtler forms; they possess the power, as apparently does the frontispiece itself, to lure us under the spell of the same magic. And *The Renaissance* as a whole implies that such an experience reveals to us the essence of the past.

As history for Pater is subsumed within the history of the fine arts, art history in turn is contained within the history of its masterpieces. In tracing the history of this "many-sided movement," he passes "swiftly from point to point" in order to focus on the essential, formative moments in the past, to contemplate the intense creations through which history is made. Pater's history thus divides into a series of essays on individual geniuses, and he selects artists whose work lends itself to a masterpiece approach. One motive for his interest in such figures as Giorgione and Du Bellay surely lies in their relatively limited output: of the former he is eager to inform us that modern "criticism . . . freely diminishes the number of his authentic works" (146), just as De Bellay can be considered "the poet of one poem" (175). Perhaps the most radically abbreviated portrait of a broad span of time appears in the first chapter, where the entire "middle age" is represented by the "Two Early French Stories." With literature as with painting, the masterpiece serves as a kind of prism to history, refracting all its varied forms of light onto a brilliant, unified image of crystalline beauty. Similarly, the greatest artists are those who manage to express forces larger than themselves; aesthetic, social, and historical "centrality" represents the very quintessence of genius for Pater. It is precisely this quality that fifteen years later in the essay on "Style" he defines as the keynote of "great art"—the condition of art when "it has something of the soul of humanity in it, and finds its logical, its architectural place, in the great structure of human life" (*Appreciations*, 38).

*The Renaissance* concentrates on masterpieces of the fine arts (in which Pater seems to include philosophy) in order to locate them within a larger "structure" of culture and history. In every work subject to close examination one can discover the resonance of associations from the memory of the individual and, indeed, of the entire race; history is concentrated and recapitulated in every decisive aesthetic moment. The very format of the book implies a view of the composite presence of history in art which anticipates the argument of T. S. Eliot in "Tradition and the Individual Talent" that any great work of art rearranges the

tradition preceding it, every great addition to the past changes the shape of history. But Pater is primarily interested in the capacity of the masterpiece to coalesce tradition and history in the eyes of the observer. It is not merely a vehicle of a wide range of intense "impressions" but the medium in which one can enjoy the distilled experience of other epochs. Very much as does Ruskin, he implies that we actually enter history through our sympathetic appreciation of the arts. Contemplating artistic masterpieces, especially under the guidance of a Paterean ritual of interpretation, we participate in the essential energies of the past.

It is not surprising that Pater's "descriptive" passages tend toward allusiveness and mystery rather than clarity, as in this they imitate what he considers to be the nature of the greatest art. His object, properly speaking, is not the description of art at all, but a ritual evocation of its spirit. Similarly, *The Renaissance* as a whole sacrifices comprehensive chronology and sociological accuracy for the vague but powerful flavor of certain significant moments. Its structure imitates the progress of history, the flowering of its energies, by moving from masterpiece to masterpiece in a series of deliberate crescendo effects. We are forced to view events and personalities through the isolated but pregnant images of the arts. The structure of the book makes an understanding of history dependent on a full response to its central aesthetic creations. Graham Hough has complained that the essays "tend to split up in the mind of the reader into a few famous purple passages."[7] But this is an intentional consequence of the expressive form of the book. History for Pater is a series of dramatic flowerings and realizations. Great personalities, significant events, consummate works of art all embody the potential of vital human impulses to find new and exciting forms of expression. *The Renaissance* demonstrates that history becomes meaningful only when it fuses with art—when, as in Ruskin's Venice, reality and the imagination wholly interpenetrate one another. The body of each separate essay forms a background of distinct events, personalities, and artistic traditions that Pater will draw together at a few central moments, usually moments of artistic creation. In this way the chief works of art celebrated in *The Renaissance* sum up all the varied contexts defined in the rest of the book, and give the rest of history a kind of fictional unity. Pater's remarks on the "Mona Lisa," the "Primavera," "Du Bellay's "D'un vanneur de blé aux

vents," or the great images created by Michelangelo or Giorgione make us feel that the largest currents in Renaissance history have condensed into a few masterpieces.

Pater traces the history of civilization through its chief artifacts in much the same way as Ruskin did with architecture in *The Stones of Venice*. But the distinction between their subject matter immediately underscores the extent of Pater's achievement, for unlike Ruskin, he is not dealing with public arts. Ruskin deliberately excluded painting from the chronology of the Venetian mind that he established by the evidence of Gothic. He argued that painting lags slightly behind the public consciousness, that as a personal creation, it can be secluded and even anachronistic. Pater not only traces the history of the Renaissance mind through private creations but offers as examples relatively minor artists, who stood out of the cultural mainstream and probably exerted only a small influence on it. Della Robbia is the most obvious example, but the interest in minor achievements is observed elsewhere. Pater limits his discussion of Michelangelo to his poetry, as if to concentrate on the least public aspect of his genius. The "early French stories" are chosen precisely for their quiet uniqueness. Botticelli was a minor, almost unknown artist for the audience of the 1870s. Even Giorgione, by virtue of the reattribution of most of the famous pictures once ascribed to him, becomes an increasingly shadowy figure. Winckelmann himself would have figured larger in history had a meeting with Goethe taken place: "German literary history seems to have lost the chance of one of those famous friendships, the very tradition of which becomes a stimulus to culture, and exercises an imperishable influence" (197). We find ourselves in a tenuous, "perishable" realm of history. Pater establishes an intentionally personal tradition, so that questions of influence become ambiguous and subtle. For him the progress of civilization is as complex and "many-sided" as for Ruskin it was simple, direct, and morally explicit. Pater's almost eccentric choice of Renaissance subjects enables him to keep his version of history from becoming a Ruskinian moral chronology, and indeed, the ethical status of many of the figures he treats is kept deliberately uncertain.

Personal history requires an interpreter. We must be guided through the beautiful confusion of the past. The very unfamiliarity of Pater's "heroes" makes it unlikely that our preconceptions about the past will distract us from the unity of his

argument. He is not reciting old lessons. Rather, history is a voyage of discovery, exciting enough to seem highly relevant as an education for the modern sensibility. The remoteness of certain figures or artifacts makes them only the more stimulating. Botticelli "has the freshness, the uncertain and diffident promise, which belong to the earlier Renaissance itself, and make it perhaps the most interesting period in the history of the mind" (61–62). The "personal" sculpture of Della Robbia and his school, "in the absence of much positive information about their actual history, seems to bring those workmen themselves very near us" (71); almost magnetically we are drawn to investigate "the secret of their charm" (72). It is precisely these lesser figures who "are often the object of a special diligence and consideration wholly affectionate, just because there is not about them the stress of a great name and authority" (61). Pico della Mirandola, a figure both "picturesque" and "attractive . . . will not let one go; he wins one on, in spite of one's self, to turn again to the pages of his forgotten books" (48). Indeed, the lesson of Pico's humanism could be taken as the motto of *The Renaissance* itself: "nothing which has ever interested living men and women can wholly lose its vitality."

To distinguish between "major" and "minor" figures in history implies an assessment of the individual in terms of his culture; Pater's technique is precisely the reverse. He defines the period in terms of its most suggestive figures. There is an implicit equation between the personalities that yield the most "impressions" to an aesthetic historian and those that, like artistic masterpieces, sum up within themselves major currents of history. To depict the spirit of the Renaissance as a whole, then, Pater needs only to assemble a series of suggestive individual portraits, creating a composite portrait of the complete, ideal Renaissance type. The volume as a whole narrates the development of this disembodied figure. Each study adds another contour to the outline; each new personality discussed supplies another element of the richness of mind to which the period as a whole aspired. Including subjects of so many different sorts, "major" as well as seemingly "minor" artists and works, illustrates the scope of aesthetic interests and human accomplishments contained within the age. Pater implies through the very breadth of figures under consideration that no human impulse is excluded from his concept of the harmonious, complete Renaissance type.

There is an assumed revision of Ruskin's idea of history in this view, as if his interpretation of past forms of life was ultimately too bloodless and simplistic. Pater's Giorgione, for example, is more passionate and specifically more erotic than Ruskin's. Pater calls attention to the seductive themes of Giorgione's painting and suggests the ambiguous circumstances of the artist's life: Giorgione is a "natural child of the Barbarelli by a peasant-girl of Vedalgo"; his life is marked by an intense love-relationship, which in some versions of the legend is the cause of his death. Similarly, the chapter on the "Two Early French Stories," in extending the Renaissance into the twelfth century, seems aimed at exploding Ruskin's concept of the purity of the Middle Ages. Pater concentrates on the passion of the age, exemplified not only in the loves of Abelard and Eloise or Amis and Amile, but also in a medieval form of "antinomianism, its spirit of rebellion and revolt against the moral and religious ideas of the time. In their search after the pleasures of the senses and the imagination, in their care for beauty, in their worship of the body, people were impelled beyond the bounds of the Christian ideal; and their love became sometimes a strange idolatry, a strange rival religion" (24). There are traces of the same spirit in the poems of Michelangelo, the various works and deeds of Leonardo, and the life and art of Du Bellay and the Pleiad, whose "decadence" most explicitly connects the world of the Renaissance as Pater defines it with his conception of the nineteenth century. Pico's humanistic doctrine that "nothing which has ever interested living men and women can wholly lose its vitality" comes to mean that no form of human expression can ever cease to have a place in the vital wholeness of man.

### The Italian Studies

Pater locates the main action of the Renaissance in Italy and, more specifically, in the lives of a few great men. This double focus follows Burckhardt. As Ian Fletcher has observed, *The Civilization of the Renaissance in Italy*, published in 1860, provided "a way of concentrating on sudden luminous moments of a period, of a movement, rather than attempting to draw a flat systematic map of it."[8] For all its tendency to dissolve into a series of brilliant highlights, then, Pater's method does not renounce broad cultural history. In the Preface he quotes Blake's

assertion of the supremacy of the creative mind over history: "The ages are all equal, but genius is always above its age." But he also suggests that the aesthetic critic studies genius to identify a climate of thought: "The question he asks is always:—In whom did the stir, the genius, the sentiment of the period find itself? where was the receptacle of its refinement, its elevation, its taste?" (x). We investigate the great thinkers of the Renaissance not simply to discover their own uniqueness but to identify their "centrality" within the larger period. Pater seeks out, in men as in masterpieces, the capacity to concentrate prismatically all the light and energy of an age. Among the various essays of *The Renaissance* he repeats certain key phrases and images to create the illusion that history is repeating itself before our eyes, that we are witnessing broad cultural movements, and to suggest that essential human impulses recur despite differences in time, place, and personality.

Pico della Mirandola, for example, is valued for the "centrality" of his life as well as that of his work. In this essay, as at various points in *The Renaissance*, it is suggested that certain figures embody past forms of life reborn in a "modern" shape. In art there is the "Mona Lisa," or the Venus in Botticelli's "Primavera," which Pater interprets as the "central myth" of an entire "imaginative system" (59). Pico is similarly compared to one of Heine's gods-in-exile, especially in his first appearance before Marsilio Ficino: "when a young man, not unlike the archangel Raphael, as the Florentines of that age depicted him in his wonderful walk with Tobit, or Mercury, as he might have appeared in a painting by Sandro Botticelli or Piero di Cosimo, entered his chamber, he seems to have thought there was something not wholly earthly about him" (37–38). The reference to Botticelli hints that Pico's sensibility prophesies the achievement of the high Renaissance; and the description of him as a "young man" connects him with Pater's image of his own modern audience, to which he addresses the Conclusion.

Pico is linked to later eras not only by his appearance but by the general texture of his thought. As Pater remarks, many of the goals and aspirations realized "imperfectly" in the fifteenth century were "accomplished in what is called the *éclaircissement* of the eighteenth century, or in our own generation; and what really belongs to the revival of the fifteenth century is but the leading instinct, the curiosity, the initiatory idea" (33). Pico, then, embodies the continuity of the philosophical spirit

throughout history and fuses within himself all the traditions that produced the Renaissance. His work, a "picturesque union of contrasts" (48), expresses a complex genius resembling that "new flower . . . unlike any flower men had seen before, the anemone with its concentric rings of strangely blended colour," which grew when "the ship-load of sacred earth from the soil of Jerusalem was mingled with the common clay in the *Campo Santo* at Pisa" (47). The allusion suggests that the tradition represented in Pico's "union of contrasts" can be traced into the nineteenth-century literature of art.

Just as centrality is the touchstone of genius in *The Renaissance*, so is its chief manifestation in painting. Pater isolates the few masterpieces of Italian art which seem to possess an almost magical universality from the moment of their creation; their enduring appeal, identified in the ritual of interpretation, corroborates that initial symbolic relation to their own age. Such universality is at least as apparent in Botticelli's "Birth of Venus" (see illustration) as in the "Mona Lisa" itself. As a representative of the Renaissance rediscovery of antiquity, the painting displays affinities not only with other products of its own era but with the art and thought of the classical world. Through the medium of Botticelli's pagan imagery it is possible for a modern aesthetic critic to enter history, not only the Renaissance but the classical past, and to experience the universal appeal of Greek mythology. The "quaint design" provides "a more direct inlet into the Greek temper than the works of the Greeks themselves," for Botticelli has depicted in Venus an ideal always compelling, "the depository of a great power over the lives of men" (58, 60).

As a joint product of aesthetic subtlety and specific religious beliefs, "The Birth of Venus" is a perfect vehicle for Pater's ritual of interpretation. He stresses the close relation between form and content, treating style as an expression of Botticelli's sympathy with his subject: "the passion, the energy, the industry of realisation . . . is the exact measure of the legitimate influence over the human mind of the imaginative system of which this is perhaps the central myth." The emotional force of the painting depends on its subtle artificiality: "The light is indeed cold—mere sunless dawn; but a later painter would have cloyed you with sunshine; and you can see the better for that quietness in the morning air each long promontory, as it slopes down to the water's edge. Men go forth

*Walter Pater*

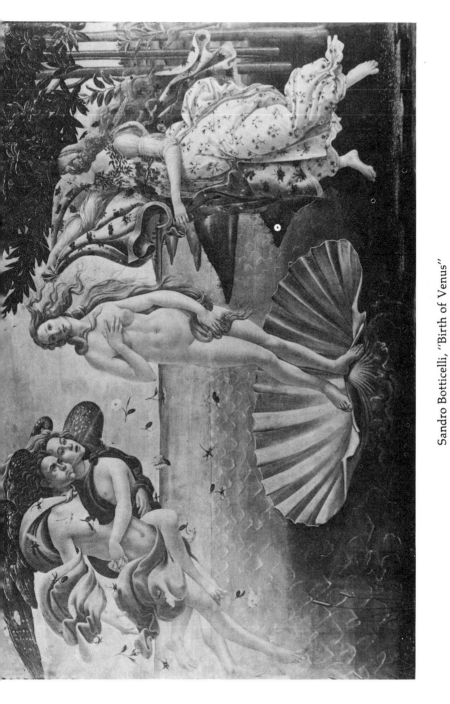

Sandro Botticelli, "Birth of Venus"

to their labours until the evening; but she is awake before them, and you might think that the sorrow in her face was at the thought of the whole long day of love yet to come" (59). The blend of art and nature appears in both form and content. This is, after all, a goddess, floating weightless, magically, over the waters in her timeless moment of birth. The ritual intensity of Pater's language reminds us that the picture represents that instant when the divinity of Love was endowed with perfect human form, in a supernatural transformation of being. The hints that we are actually present in the scene encourage us to participate in this process, and to feel the "legitimate influence" of Botticelli's vision. In this experience we imbibe the spirit of the Renaissance.

Botticelli's contribution to the Renaissance and to the history of art is in creating a uniquely convincing ideal portrait of mankind. The wistful ambiguity of his figures expresses at once the limitations of man and his potential perfection as a work of living art. This visionary naturalism produces a new balanced type, apparent in that "peculiar sentiment with which he infuses his profane and sacred persons, comely, and in a certain sense like angels, but with a sense of displacement about them" (55). His very unorthodoxy enables him to blend images of "humanity in its uncertain condition, its attractiveness, its investiture at rarer moments in a character of loveliness and energy, with his consciousness of the shadow upon it of the great things from which it shrinks" (60). By confining his art to "that middle world in which men take no side in great conflicts, and decide no great causes, and make great refusals," Botticelli finds truer ground for a utopian image of man. He "thus sets for himself the limits within which art, undisturbed by any moral ambition, does its most sincere and surest work." His interest is "with men and women, in their mixed and uncertain condition, always attractive, clothed sometimes by a passion with a character of loveliness and energy, but saddened perpetually by the shadow upon them of the great things from which they shrink. His morality is all sympathy; and it is this sympathy, conveying into his work somewhat more than is usual of the true complexion of humanity, which makes him, visionary as he is, so forcible a realist" (55–56).

Pater makes it easy to forget that Botticelli is a religious and allegorical painter. The emphasis of the essay falls on the aesthetic transformation of mere allegory into more ambiguous and

*Walter Pater*

more appealing visual forms: "if he painted religious incidents, [he] painted them with an under-current of original sentiment, which touches you as the real matter of the picture through the veil of its ostensible subject" (50). "He is before all things a poetical painter, blending the charm of story and sentiment, the medium of the art of poetry, with the charm of line and colour, the medium of abstract painting" (52). Similarly, Pater calls attention to the human dimension of Botticelli's religious art. The long description of his "peevish madonnas," as in similar passages on Giorgione and Leonardo, creates a composite portrait from various representations of this type, making Botticelli's seemingly ideal being as vivid and alive as a real woman. Botticelli drew the figure of the Madonna "over and over again, sometimes one might think almost mechanically"; but the ritual of interpretation dramatizes the unique vitality of these figures, in which Botticelli "worked out . . . a distinct and peculiar type, definite enough in his own mind" (56). The passage begins by comparing Botticelli's women to those of Fra Angelico or to "the Sistine Madonna":

At first . . . you may have thought that there was some-
thing in them mean or abject even, for the abstract lines
of the face have little nobleness, and the colour is wan.
For Botticelli she too, though she holds in her hands the
"Desire of all nations," is one of those who are neither for
Jehovah nor for His enemies; and her choice is on her
face. The white light on it is cast up hard and cheerless from
below, as when snow lies upon the ground, and the children
look up with surprise at the strange whiteness of the ceiling.
Her trouble is in the very caress of the mysterious child,
whose gaze is always far from her, and in the latter that
sweet look of devotion which men have never been able
altogether to love, and which still makes the born saint
an object almost of suspicion to his earthly brethren. Once,
indeed, he guides her hand to transcribe in a book the words
of her exaltation, the *Ave*, and the *Magnificat*, and the
*Gaude Maria*, and the young angels, glad to rouse her for
a moment from her dejection, are eager to hold the inkhorn
and support the book. But the pen almost drops from her
hand, and the high cold words have no meaning for her, and
her true children are those others, among whom, in her rude
home, the intolerable honour came to her, with that look
of wistful inquiry on their irregular faces which you see
in startled animals—gipsy children, such as those who, in

Appenine villages, still hold out their long arms to beg of you, but on Sundays become *enfants du choeur*, with their thick black hair nicely combed, and fair white linen on their sunburnt throats. (56–57)

What begins as a generalized portrait concludes as an account of a specific work, Botticelli's "Madonna of the Magnificat" (see illustration). Yet this progression only sharpens the focus on living beings: the Madonna herself, engaged in an act of interpretation, refers us back to our own world. As Pater's final, modern references suggest, Botticelli's sympathetic ideal enables us to perceive life and art in terms of one another.

The "Mona Lisa" contains the same achievement writ large, because Leonardo combines even more fully than Botticelli the different impulses of the Renaissance within a vital and complex imagination. The epigraph of Pater's essay on Leonardo provides the first definition of the artist's double role: "Homo Minister at Interpres Naturae." Leonardo, according to this phrase, is both an instrument and controller of the world around him, naturalist and visionary, student of the real and the occult. As servant and interpreter of nature in art, he attains that perfect Romantic balance of perception and creation which both Ruskin and Rossetti idealized in their comments on painting. But Pater's originality in defining an art of opposing strengths is to identify each aspect of Leonardo's complex genius with the general cultural movement in which he was engaged; even his most eccentric traits demonstrate his centrality. The phrase that echoes throughout the essay—"curiosity and the desire of beauty"—refers to Leonardo's delicate fusion of the elements that marked the different phases of the Renaissance as a whole. His "return to nature" corresponds to Raphael's "return to antiquity" as a chief tendency of the "twofold . . . movement of the fifteenth century," and this quality in turn allies him not only to the Renaissance but to "the coming of what is called the 'modern spirit,' with its realism, its appeal to experience" (109). Indeed, corresponding to Leonardo's complexity, Pater displays the fullest balance between his own critical techniques of any essay in the book. There is more biography and history than in any other study, and also more detailed description of art. To dramatize the complexity of his subject, Pater shifts between views of a mysterious isolated artist and of a spokesman for an age; between criticism, biog-

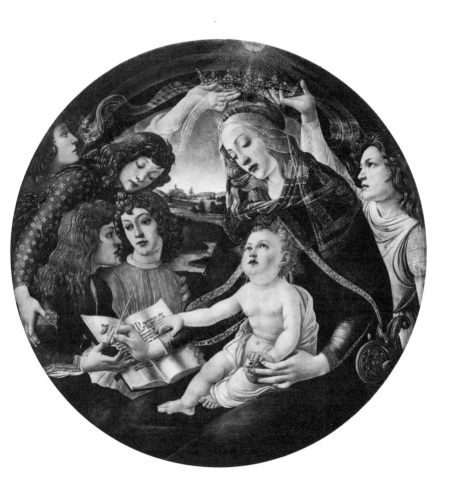

Sandro Botticelli, "Madonna of the Magnificat"

raphy, and history. Leonardo seems to release him to expand as fully as possible on all the implications of his own complex role as "aesthetic critic," and to employ all the disciplines at his command.

One of the objects of the essay is to connect Leonardo's science with his art, and to demonstrate the link in his painting between an interest in speculative or visionary subjects and a detailed, often grotesque naturalism. A special type of naturalism underlines Leonardo's occultism, his use of landscape, and his fascination with human subjects:

> He who thus penetrated into the most secret parts of
> nature preferred always the more to the less remote, what,
> seeming exceptional, was an instance of law more refined . . .
> In him first appears the taste for what is *bizarre* or *recherché*
> in landscape . . . It is the landscape, not of dreams or of
> fancy, but of places far withdrawn . . . Through Leonardo's
> strange veil of sight things reach him so; in no ordinary
> night or day, but as in faint light of eclipse, or in some brief
> interval of falling rain at daybreak, or through deep water.
> And not into nature only; but he plunged also into human
> nature, and became above all a painter of portraits; faces
> of a modelling more skilful than has been seen before or
> since, embodied with a reality which almost amounts to
> illusion, on the dark air. (110–111)

As a recent critic has shown, the portrait of Leonardo may derive from Goethe's concept of the artist as a man of science.[9] Pater depicts Leonardo's science as a flexible instrument accommodating every aspect of his varied and unique imagination:

> The science of that age was all divination, clairvoyance,
> unsubjected to our exact modern formulas, seeking in an
> instant of vision to concentrate a thousand experiences . . .
> Poring over his crucibles, making experiments with colour,
> trying, by a strange variation of the alchemist's dream, to
> discover the secret, not of an elixir to make man's natural life
> immortal, but of giving immortality to the subtlest and most
> delicate effects of painting, he seemed . . . rather the
> sorcerer or the magician, possessed of curious secrets and
> a hidden knowledge, living in a world of which he alone
> possessed the key . . . To him philosophy was to be
> something giving strange swiftness and double sight, divining
> the sources of springs beneath the earth or of expression

*Walter Pater*

beneath the human countenance, clairvoyant of occult gifts in common or uncommon things. (106–107)

Science and art are inseparable. Comparing Leonardo to Goethe, Pater remarks that "with all that curious science the German would have thought nothing more was needed" (113).

"Leonardo da Vinci" focuses all the major themes of *The Renaissance* and, in so doing, defines Leonardo as the central, complete Renaissance man. His naturalism, for example, is the legacy of the French romancers, della Robbia, and Botticelli. His fascination with death and human features derives from the school in which Michelangelo sculpted his Pietas. Even Leonardo's philosophic originality—and the essay begins by referring to Vasari's account of him as a "bold speculator," holding lightly by other men's beliefs" (98)—links him to the hermetic tradition and Pico, who "had sought knowledge, and passed from system to system, and hazarded much" (49). Moreover, Leonardo appears as both pupil and teacher, the culmination of major artistic traditions as well as the initiator of new ones. Pater traces his growth from apprenticeship to Verrocchio, his first and principal teacher, whose influence is visible "to the last" (102). In all respects, Leonardo mirrors his age.

Yet, in his last years, Leonardo attains a stage of self-contained genius, in the guise of a kind of visionary prophet, surrounded by pupils. Pater openly alludes to the homosexual implications of these relationships and seems to find in them some satisfaction for his own fantasies of the great artist's narcissism and unlimited power.[10] Here, in fact, Pater's unconscious interests merge with his critical ideal; it is precisely in this erotic, isolated bliss that Leonardo becomes the perfect examplar of art-for-art's-sake. Despite what appears from a historical distance as the universality of his pictures, Leonardo works "for the present hour, and for a few only, perhaps chiefly for himself" (117). This solipsism involves a kind of magic. He will "never work till the happy moment comes—that moment of *bien-être*, which to imaginative men is a moment of invention." Only then is "the alchemy complete: the idea is stricken into colour and imagery; a cloudy mysticism is refined to a subdued and graceful mystery" (113–114). Leonardo's "solitary culture of beauty seems to have hung upon a kind of self-love, and a carelessness in the work of art of all but art itself. Out of the secret places of a unique temperament he brought strange blos-

soms and fruits hitherto unknown; and for him, the novel impression conveyed, the exquisite effect woven, counted as an end in itself—a perfect end" (117).

Leonardo sums up the values of Pater's aestheticism. This is particularly apparent in his conduct of art and life beyond the limits of morality. The descriptions of his search for "strange blossoms and fruits" or for "the sources of springs beneath the earth" almost self-consciously seem to recall the language with which Ruskin condemned the pride and science of Renaissance Venice: "Thenceforward, year after year, the nation drank with deeper thirst from the fountains of forbidden pleasure, and dug for springs, hitherto unknown, in the dark places of the earth" (XI, 195). In Pater's essay on Leonardo, Ruskin's attitudes are wholly inverted: now secret "springs" bring art new power. Far from condemning Leonardo's lack of faith, Pater takes particular delight in the resemblance of his saints to some of Heine's "decayed gods" (as also in the essay on Pico): "We recognize one of those symbolical inventions in which the ostensible subject is used, not as matter for definite pictorial realisation, but as the starting-point of a train of sentiment, subtle and vague as a piece of music. No one ever ruled over the mere *subject* in hand more entirely than Leonardo, or bent it more dextrously to purely artistic ends. And so it comes to pass that though he handles sacred subjects continually, he is the most profane of painters" (118–119).

Pater describes how as an inventor, Leonardo creates lethal machines of war for Ludovico Sforza, whom he seeks out in Milan. Yet while that city seems to embody all the moral deviations and failures of the Italian Renaissance, Leonardo is impervious to this danger. Treating life in the spirit of art, he can only profit from every new atmosphere he confronts. In the streets of Milan, beneath the "fantastic" transalpine outlines of the Duomo, "moved a people as fantastic, changeful, and dreamlike. To Leonardo least of all men could there be anything poisonous in the exotic flowers of sentiment which grew there. It was a life of brilliant sins and exquisite amusements; Leonardo became a celebrated designer of pageants; and it suited the quality of his genius, composed, in almost equal parts, of curiosity and the desire of beauty, to take things as they came" (109). Leonardo balances art and critical detachment—precisely the dual role Pater advocates for his own "aesthetic critic."

Leonardo's detachment through the medium of art represents

the first stage in the transformation of his own life to artistic order. Of course, no small part of Pater's delight in the beauty of Leonardo's life depends on the painter's homosexuality, and the beautiful men and boys with whom he surrounded himself. But though the essay alludes to this theme, it endorses Leonardo for devoting all his energies to art: Pater shares Freud's view that the largest portion of the artist's sexuality was sublimated in the service of his work.[11] Pater, therefore, emphasizes the obscurity of many periods in Leonardo's life, when seemingly life was sacrificed to art. It is as if some years had been left deliberately blank, so that only the evidence of style remained to describe the man. In the period in which he created his greatest work, including the "Mona Lisa," "Leonardo's history is the history of his art; for himself, he is lost in the bright cloud of it" (126). Even in the known portions of his history, Leonardo seems half-real and half-magic, a figure of his own creation, creating new life through art. After he leaves Milan, we have a "glimpse of Leonardo . . . at Rome in 1514, surrounded by his mirrors and vials and furnaces, making strange toys that seemed alive of wax and quicksilver" (127).

"Leonardo da Vinci" concludes with the artist's death. Yet this becomes, as we might expect, the most intense moment of his life. In a world where he is clearly out of place, his detachment gives rise to political suspicions; and despite Leonardo's "political indifferentism," he is banished from Rome for possible treason. But Pater considers this a fortunate fall. As court painter to Francis I at Amboise, Leonardo carries the role of the artist-critic to its ultimate perfection. The last moments of his life achieve an ideal aesthetic detachment—an artistic vision of life, despite its tragedy. The painter's death culminates the fusion of the two central impulses of his life, "curiosity and the desire of beauty." Pater speculates on "how one who had been always so desirous of beauty, but desired it always in such precise and definite forms, as hands or flowers or hair, looked forward now into the vague land, and experienced the last curiosity" (129). This most beautiful moment in Leonardo's life is also, perhaps, the most symbolic. The modern reader can learn from it how the very act of refined perception can bestow a kind of grace even in the face of death.

The last half of *The Renaissance* focuses increasingly on death and decay. Pater incorporates "decadence" into his definition of the Renaissance itself. This is the main reason that in his

essay on Michelangelo he examines a neglected phase of the artist's career. Usually we think of Michelangelo as a sculptor or painter, and in terms of his strength and power. Yet another kind of impulse is at play in his work. Only by contrasting his visual art with his poetry can we appreciate that sense of a force subdued which links his work to "the whole character of medieval art." There is "the presence of a convulsive energy in it, becoming in lower hands merely monstrous or forbidding, and felt, even in its most graceful products, as a subdued quaintness or grotesque" (73–74). Again Pater is modifying Ruskin's concept of the Renaissance by showing its continuity with the essential texture of medieval art. Ruskin had attacked the overt physicality of Michelangelo's painting and sculpture. Pater concentrates his essay on the serene and understated delicacy of Michelangelo's sonnets, which exposed to view for the first time, in newly published texts, a neglected phase of his career, a "charmed and temperate space in Michelangelo's life" (85). Standing apart from the more familiar patterns of his biography, "Their prevailing tone is a calm and meditative sweetness." In a life otherwise dominated by passion and "strong hatreds" (78), they define an area of artificiality, grace, and "suavity" (85).

The calm of this poetry demonstrates Michelangelo's ability to view his own emotions from a distance, with a critical detachment much like that of Leonardo: "The interest of Michelangelo's poems is that they make us spectators of this struggle; the struggle of a strong nature to adorn and attune itself; the struggle of a desolating passion, which yearns to be resigned and sweet and pensive, as Dante's was" (82). The poems supply a kind of history-in-miniature of an artist's attempt to transform his own life into a work of art: "We know how Goethe escaped from the stress of sentiments too strong for him by making a book about them; and for Michelangelo, to write down his passionate thoughts at all, to express them in a sonnet, was already in some measure to command, and have his way with them" (85). Through poetry, Michelangelo learns to become a spectator of his own experience—and the reference to Goethe, for Pater the pre-eminent modern artist, underscores the importance of this detachment as a model for "aesthetic criticism."

The modernity of this stance becomes apparent in Pater's account of the artist's last years. Amid the growing decadence of the early seventeenth century, himself under the shadow of

death, Michelangelo continues to treat life in the spirit of art and gains an ideal detachment from his world. For Pater the Sistine ceiling expresses a retreat from imperfect reality toward the pristine origins of man and history. Michelangelo's reconciliation with the church stems less from faith than a pure ritualism, a need to embrace any form of artifice that can be applied to life. And as in the essay on Leonardo, the triumph of this attitude occurs at the approach of death. Without actually portraying Michelangelo's last moments, Pater describes his long process of dying as essentially heroic, achieving an ideally balanced and detached aesthetic view of life. The ritual tone of Pater's language suggests that we are meant to worship the man as intently as we would one of his works:

Some of those whom the gods love die young. This man, because the gods loved him, lingered on to be of immense, patriarchal age, till the sweetness it had taken so long to secrete in him was found at last. Out of the strong came forth sweetness, *ex forti dulcedo*. The world had changed around him . . . And now he began to feel the soothing influence which since that time the Roman Church has often exerted over spirits too independent to be its subjects, yet brought within the neighbourhood of its action; consoled and tranquillised, as a traveller might be, resting for one evening in a strange city, by its stately aspect and the sentiment of its many fortunes, just because with those fortunes he has nothing to do. So he lingers on; a *revenant*, as the French say, a ghost out of another age, in a world too coarse to touch his faint sensibilities very closely; dreaming, in a worn-out society, theatrical in its life, theatrical in its art, theatrical even in its devotion, on the morning of the world's history, on the primitive form of man, on the images under which that primitive world had conceived of spiritual forces. (88–90)

There is an image of our own activity as "aesthetic historians" in these wistful glances backward, as there is in Michelangelo's stoic contemplation of decadence and death. The Conclusion of *The Renaissance* identifies such a tragic vision as the precondition of "the supreme, artistic view of life." The desire to fill each moment with the highest degree of aesthetic intensity derives from a consciousness of universal fatality, a view of which Pater makes Victor Hugo the spokesman: "we are all *condamnés*, as

Victor Hugo says: we are all under sentence of death but with a sort of indefinite reprieve" (238). Hugo, similarly, is named as one of Michelangelo's "true sons," artists "who, though not of his school, and unaware . . . help us to understand him, as he in turn interprets and justifies them" (97). Michelangelo, dying in 1564, almost fifty years after Leonardo, bridges the gap between the Renaissance and the modern era. The tragic themes of both his art and his life foreshadow the preoccupations of the figures Pater finds typical in the ages to follow.

### From Renaissance to Modern

The last essays in *The Renaissance* form a transition between past and present, moving from the seventeenth century of Du Bellay to the eighteenth century of Winckelmann, and at last to the modern world represented in Pater's Conclusion. In the first edition of the book, before the inclusion of the Giorgione essay, there is a clear progression from Michelangelo's decadence and aged "sweetness" to Leonardo's final "exotic" French phase, and then to the world of Joachim Du Bellay. The latter, like much in the art and personality of Michelangelo, merely extends the quality of a medieval tradition: "What is called the *Renaissance in France* is . . . not so much the introduction of a wholly new taste ready-made from Italy, but rather the finest and subtlest phase of the middle age itself, its last fleeting splendour and temperate Saint Martin's summer . . . There was indeed something in the native French taste naturally akin to that Italian *finesse*" (156). Du Bellay's poetry belongs to a Gothic revival, much like the one advocated by both Ruskin and Rossetti. But with the French poet, as with Pater himself, the Gothic involves elegance and refinement above all, a style attenuated into mannerism. Ronsard and the poets of the Pleiad use Gothic to achieve a highly personal style. Renaissance influence "gilds" the "surfaces" of traditional forms "with a strange, delightful, foreign aspect . . . in itself neither deeper nor more permanent than a chance effect of light" (158). These are the qualities and aesthetic values that Pater depicts as modern in the Conclusion, and similar imagery reappears in his interpretation of Du Bellay's greatest poem. Even as he discusses Ronsard, it is clear that he is praising something much like what he called (in connection with William Morris) "aesthetic poetry": "He reinforces, he doubles the French daintiness by Italian *finesse*.

Thereupon, nearly all the force and all the seriousness of French work disappear; only the elegance, the aërial touch, the perfect manner remain. But this elegance, this manner, this daintiness of execution are consummate, and have an unmistakable aesthetic value" (158).

The poetry of the Pleiad was "poetry à la mode . . . part of the manner of a time—a time which made much of manner, and carried it to a high degree of perfection. It is one of the decorations of an age which threw a large part of its energy into the work of decoration" (166). The style, aims, and values of this school and this period are close to Pater's own. Sixteenth century France was, he explains, "an age of translations" (162). He admits that Du Bellay himself is "just a little pedantic," but manages to justify this quality in the poet's own terms: when an artist desires immortality, "to be natural is not enough" (168).

Du Bellay's poetry and biography come closest to the modern world in their tragic themes. Pater's central argument in the essay is that the decadence of Du Bellay's style grows in response to the declining condition of his world. The Pleiad are like the storytellers in Boccaccio: "They form a circle which in an age of great troubles, losses, anxieties, can amuse itself with art, poetry, intrigue." But, Pater adds, "they amuse themselves with wonderful elegance" (169). The lightness and polish of their poems on serious themes gives decadence itself the overtones of heroism. The entire school manages to "trifle" with death; morbid imagery "serves for delicate ornament."

Du Bellay himself lives in the shadow of fatality. "Born in the disastrous year 1525" (164), he dies "suddenly" at an "early age" (165). His finest work seems to grow out of his contact with decay and grief. "The sweetest flower of his genius sprung up" (174) after his return from a journey to Italy, which he "deplored as the greatest misfortune of his life" (173). In Rome, Du Bellay had experienced a wistful "feeling for landscape . . . often described as a modern one." Ruins especially fascinate him: "The duration of the hard, sharp outlines of things is a grief to him, and passing his wearisome days among the ruins of ancient Rome, he is consoled by the thought that all must one day end, by the sentiment of the grandeur of nothingness . . . With a strange touch of far-off mysticism, he thinks that the great whole . . . into which all other things pass and lose themselves, ought itself sometimes to perish and pass away. Nothing less can relieve his weariness" (173–174). Du Bellay's

"modern" concept of the flux of time leads to a tragic vision much like that expressed in the Conclusion. From the disintegrating external world the poet instinctively seizes the moments of greatest intensity and beauty, knowing them to be few, rare, and transitory. This sense of life produces "D'un vanneur de blé aux vents," which Pater considers his finest poem, reminiscent "of a whole generation of self-pitying poets in modern times" (173).

Pater remarks that Du Bellay "has almost been the poet of one poem" (175), and the rhythm of the essay builds toward the evocation of that central work. "D'un vanneur de blé aux vents" forms a delicate and moving conclusion to the discussion of the poet's life and work:

A vous trouppe legère
Qui d'aile passagère
Par le monde volez,
Et d'un sifflant murmure
L'ombrageuse verdure
Doulcement esbranlez.

[To you, troop so fleet,
That with winged wandering feet,
Through the wide world pass,
And with soft murmuring
Toss the green shades of spring
In woods and grass.[12]]

Pater includes all three stanzas, then adds his own prose variation on the same theme. In it, however, this intimate verse is replaced by a more detached literary mode, in which the emphasis shifts from nature to the observation of nature. The control apparent in the interpretation implies that in Du Bellay both poet and reader remain "spectators," even when the subject is a mood created by landscape:

The sweetness of it is by no means to be got at by crushing, as you crush wild herbs to get at their perfume. One seems to hear the measured motion of the fans, with a child's pleasure on coming across the incident for the first time, in one of those great barns of Du Bellay's own country, La Beauce, the granary of France. A sudden light transfigures some trivial thing, a weather-vane, a windmill, a winnowing

fan, the dust in the barn door. A moment—and the thing
has vanished, because it was pure effect; but it leaves a relish
behind it, a longing that the accident may happen again. (176)

Pater shifts our interest from the material of the poem to its
effect upon us. We respond to the lush poetry as critics rather
than as mere participants. "Nearly all the pleasure . . . is in
the surprise at the happy and dextrous way in which a thing
slight in itself is handled." It is more than coincidental that
"Joachim Du Bellay," composed especially for *The Renaissance*,
immediately precedes the only essay on another actual critic of
art.

"Winckelmann," Pater's second published essay when it ap-
peared in the *Westminster Review* in 1867, most completely
expresses the temperament associated with the other "Renais-
sance" figures. Although the German critic postdates the
Renaissance by several centuries, this merely reminds us that
Pater's subject is the study of history—our contact with the
past—as well as history itself. Winckelmann, especially through
his impact on Goethe, embodies the enduring relevance of
classical studies and of an absorption in art. The opening sen-
tences of the essay offer several images of this modernity:
"Goethe's fragments of art-criticism contain a few pages of
strange pregnancy on the character of Winckelmann. He speaks
of the teacher who had made his career possible, but whom he
had never seen, as of an abstract type of culture, consummate,
tranquil, withdrawn already into the region of ideals, yet retain-
ing colour from the incidents of a passionate intellectual life. He
classes him with certain works of art, possessing an inexhaust-
ible gift of suggestion, to which criticism may return again and
again with renewed freshness" (177). Winckelmann represents
not only the artist as critic but the critic as a work of art.
Already within his own lifetime he suggests the possibility of an
"abstract type" of human perfection, conveying past ideals to
others in perfect form. His is a cultivation of the self only
comparable to Leonardo's, and Pater echoes his description of
the artist-scientist when he characterizes the critic's tempera-
ment: "Occupied ever with himself, perfecting himself and
developing his genius." Winckelmann's "culture . . . main-
tained the well-rounded unity of his life through a thousand
distractions" (220).

Criticism, moreover, enables Winckelmann to incorporate

personally the strengths and virtues of the art he examines. As in the literature of art of Ruskin and Rossetti, an intense appreciation of art brings one into contact with the character of the artist. Winckelmann serves as Pater's model for the transformation of the self through a ritual of interpretation. As a student of Hellenic culture, he becomes "simple, primeval, Greek" (189). It is this reorganization of his temperament which makes Winckelmann so powerful an influence on Goethe, to whom he appears as "a fragment of Greek art itself" (228). More fully than any artist discussed in *The Renaissance*, Winckelmann expresses Pater's ideal of an artistic, "diaphanous" life; and his image as "a relic of classical antiquity, laid open by accident to our alien, modern atmosphere" (220), is taken directly from "Diaphaneitè" (*Miscellaneous Studies*, 219). What changes in the context of this essay and of the entire book is that the ideal, transparent personality is now identified with a specific intellectual technique and a particular form of life: criticism.

The problem addressed throughout *The Renaissance* is how to transmit the virtues and beauties of past art and artist to a modern generation, composed not of artists but, at best, of amateurs. For all his Hellenism, Pater must question whether one can "bring down that ideal into the gaudy, perplexed light of modern life." He puts the question another way: "Breadth, centrality, with blitheness and repose, are the marks of Hellenic culture. Is such culture a lost art?" (227). That final pun dramatically asserts the answer to the rhetorical question. Winckelmann embodies the viability of treating the self as a work of art. He "defines, in clearest outline, the eternal problem of culture—balance, unity with one's self, consummate Greek modelling" (228). He solves, in other words, a problem that is nothing less than the problem of discovering "the perfect life" (222), a way to "mould our lives to artistic perfection" (230). In this sense his contribution is not merely a set of ideas or insights but the creation of a newly constituted man, revolutionary not only for the quality of his interests but for the power of his being. Winckelmann provides what becomes an almost physical tool for the process of "self-culture" (229). Throughout the essay Pater echoes Hegel's praise of the critic, quoted on the first page immediately after Goethe's description of him: "Winckelmann, by contemplation of the ideal works of the ancients,

received a sort of inspiration, through which he opened a new sense for the study of art. He is to be regarded as one of those who, in the sphere of art, have known how to initiate a new organ for the human spirit" (177). With him, in other words, criticism earns a place as an essential human faculty. It is only by the gift of this new sense that he can bring humanity into contact with the "transforming power" of "many types of perfection" (188).

In this essay, as in *The Renaissance* as a whole, Pater's task is twofold: to define an ideal attitude toward experience, and to describe the conditions that make it both desirable and necessary. "Winckelmann" serves both functions, for the temperament of the critic is carefully drawn against a background of tragedy and fate. His life and death are chronicles of sacrifice and even martyrdom for the sake of art, although his first immersion in Greek culture rescues him from the narrow Protestantism of his provincial German upbringing. Pater accepts Goethe's view that Winckelmann's Catholicism was a "disguise" assumed to gain him entry to the papal treasures of classic art. But even this escape from "the crabbed Protestantism" and "the *ennui* of his youth," involves a definite sacrifice: "to that transparent nature, with its simplicity as of the earlier world, the loss of absolute sincerity must have been a real loss . . . Yet at the bar of the highest criticism, perhaps, Winckelmann may be absolved. The insincerity of his religious profession was only one incident of a culture in which the moral instinct, like the religious or the political, was merged in the artistic" (187). If life involves choices, something will be lost even in pursuit of the highest goals. But this also implies that each sacrifice is a step on the road to a kind of heroism.

Pater's account of Winckelmann's death balances these themes and possibilities to suggest that even the horror of his murder is a measure of the achievement of the life it climaxed. Like Joachim Du Bellay, Winckelmann makes a fatal Roman journey, the return from which precipitates his early death. But with more than a trace of his usual morbidity Pater makes his murder, in a vaguely homosexual encounter, a beautiful experience. Even the name of the killer, Arcangeli, suggests that it is another of the human encounters with the divine that have been narrated throughout the book. As Pater remarks incongruously after summarizing the sordid details, "It seemed as if the gods,

in reward for his devotion to them, had given him a death which, for its swiftness and its opportunity, he might well have desired" (196).

The tragic overtones are converted into heroic ones in another way. In Germany, Goethe "was awaiting Winckelmann with a curiosity of the worthiest kind. As it was, Winckelmann became to him something like what Virgil was to Dante" (197). There is a kind of victory over death in Winckelmann's subsequent influence over the greater writer. The term "curiosity," the keynote of the essay on Leonardo, suggests that even in death Winckelmann's image can transform others into ideal spectators, participating in "the supreme artistic view of life" (229). That phrase appears late in the essay, when Pater is referring to Goethe more than to Winckelmann. But it defines the sort of critical detachment which can turn the contemplation even of fatality into an ideal mental act:

The demand of the intellect is to feel itself alive. It must
see into the laws, the operations, the intellectual reward
of every divided form of culture; but only that it may
measure the relation between itself and them. It struggles
with these forms till its secret is won from each, and then
lets each fall back into its place, in the supreme, artistic
view of life. With a kind of passionate coldness, such natures
rejoice to be away from and past their former selves, and
above all, they are jealous of that abandonment to one
special gift which really limits their capabilities. (229)

"Self-culture," then, willingly embraces all forms of experience as a challenge to consummate aesthetic perception. Of this vision, Winckelmann himself seems to have fallen short: "His conception of art excludes that bolder type of it, which deals confidently and serenely with life, conflict, evil. Living in a world of exquisite but abstract and colourless form, he could hardly have conceived of the subtle and penetrative, yet somewhat grotesque art of the modern world" (223). Yet in an important sense modern art derives from his example, at least in the poetry of Goethe, whose name reappears throughout Pater's book in contexts that define him as the quintessentially modern artist. By the end of the essay, Pater identifies Goethe with that ideal disembodied temperament which he has attempted to cultivate and delineate throughout the book. This attitude is measured

against the universal human predicament, for which "aesthetic criticism" thus becomes the best solution:

> For us, necessity is not, as of old, a sort of mythological personage without us, with whom we can do warfare. It is rather a magic web woven through and through us, like that magnetic system of which modern science speaks, penetrating us with a network, subtler than our subtlest nerves, yet bearing in it the central forces of the world. Can art represent men and women in these bewildering toils so as to give the spirit at least an equivalent for the sense of freedom? Certainly, in Goethe's romances, and even more in the romances of Victor Hugo, we have high examples of modern art dealing thus with modern life, regarding that life as the modern mind must regard it, yet reflecting upon it blitheness and repose. Natural laws we shall never modify, embarrass us as they may; but there is still something in the nobler or less noble attitude with which we watch their fatal combinations. In those romances of Goethe and Victor Hugo, in some excellent work done after them, this entanglement, this network of law, becomes the tragic situation, in which certain groups of noble men and women work out for themselves a supreme *Dénouement*. Who, if he saw through all, would fret against the chain of circumstances which endows one at the end with those great experiences? (231–232)

As we might expect from a volume in which the focus is on the appreciation of art, vision itself, controlled but impassioned, becomes the hallmark of the ideal Renaissance temperament.

Only after the account of Winckelmann's self-imposed martyrdom to art, and after the evocation of Goethe's tragic concept of life, does the meaning of the tragic vision described in the Conclusion become fully clear. There is an almost deliberate vagueness in the most notable phrases in that fragment, a confusion which is meant to refer us back to a larger context: "To burn always with this hard, gemlike flame, to maintain this ecstasy, is success in life." The qualities of Pater's ideal type are detached from a full personal sketch, with the consequence that there is a sense of titillation and moral ambiguity if the essay is read in the wrong spirit. Pater seems to invite his readers to taste life in any way they find possible: "Every moment some form grows perfect in hand or face; some tone on the hills or the

*The Renaissance*  255

sea is choicer than the rest; some mood of passion or insight or intellectual excitement is irresistibly real and attractive to us,— for that moment only. Not the fruit of experience, but experience itself, is the end" (236).

But closer reading suggests that even if such writing encourages us to admire the beauty of life, persons, and personalities, our admiration is assumed to remain intellectual and detached. In a sense, the response to the tragic flux of experience defined in the Conclusion is less passionate than the corresponding ideal in "Winckelmann":

> We are all *condamnés*, as Victor Hugo says: we are all under sentence of death but with a sort of indefinite reprieve . . . we have an interval, and then our place knows us no more. Some spend this interval in listlessness, some in high passions, the wisest, at least among "the children of this world," in art and song. For our one chance lies in expanding that interval, in getting as many pulsations as possible into the given time. Great passions may give us this quickened sense of life, ecstasy and sorrow of love, the various forms of enthusiastic activity, disinterested or otherwise, which come naturally to many of us. Only be sure it is passion— that it does yield you this fruit of a quickened, multiplied consciousness. Of such wisdom, the poetic passion, the desire of beauty, the love of art for its own sake, has most. For art comes to you proposing frankly to give nothing but the highest quality to your moments as they pass, and simply for those moments' sake. (238–239)

From the first, Pater seems tacitly conscious of the moral objections that caused him to withdraw the Conclusion from the second edition of the book, as apt to "mislead some of those young men into whose hands it might fall" (233n). He carefully defines "passion" as that which yields the "fruit of a quickened, multiplied consciousness," making it a form of "wisdom." Such an interpretation forms an extreme Conclusion to the rest of the book. It suggests that the task for the nineteenth century is to concentrate, or even sublimate, all the vital energies of past artists in mental experience, in passive if intense contemplation. The Conclusion is almost anticlimactic, for it translates a life of "artistic perfection" as simply a purer form of the life of the mind.

What I am really discussing here is Pater's moral self-awareness, and the diffidence with which he presents the most explicit treatment of his theme. The same self-consciousness is apparent in "Winckelmann," but there the ideal is more full-blooded. The moral problem in that essay is to defend Winckelmann's passionate life, and his homosexuality in particular, in terms of the critical vision that negates all conventional moral categories. It is a far more subversive and unorthodox statement than the one in the Conclusion; indeed, in the 1867 version, Pater uses the critic as a mouthpiece for an attack on Christianity. Although this object is barely visible in the text printed in *The Renaissance*, Pater still must defend Winckelmann's personal relationships and the fascination with the body expressed in his love for classic sculpture. Pater manages to make each excuse the other: "His romantic, fervent friendships with young men" (the same young men, incidentally, as those Pater felt the Conclusion "might possibly mislead") brought "him into contact with the pride of human form, and staining the thoughts with its bloom, perfected his reconciliation to the spirit of Greek sculpture" (191). Pater even admits that, "of that beauty of living form which regulated Winckelmann's friendships, it could not be said that it gave no pain" (193). Nevertheless, criticism purifies this passion. Winckelmann's relation to the world he studies is embodied in the consummate moral neutrality achieved by his critical detachment.

Pater notes that the same sublimation marked the history of classical art. Greek sculpture derived from intense emotions, but in art passion is controlled: "To the Greek this immersion in the sensuous was, religiously, at least, indifferent. Greek sensuousness, therefore, does not fever the conscience: it is shameless and childlike" (221–222). By partaking of this spirit, Winckelmann achieves a higher morality, one passing beyond the limited categories of Christianity, especially strict Protestantism, into a broad, artistic sympathy. Signs remain of Pater's uneasiness over the still active tradition of Christian asceticism (witness Ruskin), which from the Middle Ages onward had attached a burden of guilt to the appreciation of sensuous elements in art. This view "imparts to genuine artistic interests a kind of intoxication" as they find themselves forced violently to disavow spiritual goals. But "from this intoxication Winckelmann is free: he fingers those pagan marbles with unsinged hands, with no

sense of shame or loss. That is to deal with the sensuous side of art in the pagan manner" (222).

This "pagan" stoicism characterizes the harmony and "response" Winckelmann achieves as a personal work of art. At one point it is impossible to decide whether Pater describes Hellenic art or the German critic himself: "The beauty of the Greek statues was a sexless beauty: the statues of the gods had the least traces of sex. Here there is a moral sexlessness, a kind of ineffectual wholeness of nature, yet with a true beauty and significance of its own" (220–221). The last sentence, once again, is adopted directly from "Diaphaneitè" (*Miscellaneous Studies*, 220). As in "Leonardo da Vinci," the ideal type also acts in the world, but converts every action to the service of his personal artistic conceptions. Pater's Renaissance man is not immoral, just because he is above conventional standards: he makes his own laws. Here, as in other books by Pater, we have the sense that he was a careful reader of Nietzsche.[13]

This context gives the fullest definition to the meaning of the essay on "The School of Giorgione," added to *The Renaissance* in 1888, at the same time that Pater decided to restore the Conclusion to the text. The motives for this alteration are clear. With the addition of "The School of Giorgione," *The Renaissance* as a whole appears to be a more theoretical book. Even in itself the essay offers a kind of defense for the dubious morals of the rest of the volume, and for the Conclusion in particular. Pater argues, after all, that art has real "responsibilities" to medium and technique. It is as if he asks us to excuse his neglect of moral issues in the other essays, as only stemming from concentration on the perfection of art and refinement of critical standards. But for all this implicit denial, a genuinely subversive message is contained in *The Renaissance;* and despite Pater's self-consciousness, signs of it emerge in the Giorgione essay. As soon as he begins to illustrate Giorgione's application of the principles described in the first half of the essay, it becomes apparent that Pater feels strong affinities not only to the form but to the content of his art: "The master is pre-eminent for the resolution, the ease and quickness, with which he reproduces instantaneous motion—the lacing-on of armour, with the head bent back so stately—the fainting lady—the embrace, rapid as the kiss, caught with death itself from dying lips—some momentary conjunction of mirrors and polished armour and still water, by which all the sides of a solid image are exhibited at

*Walter Pater*

once . . . The sudden act, the rapid transition of thought, the passing expression" (149–150). He goes on to define the appeal of such subjects more explicitly: "Such ideal instants the school of Giorgione selects, with its admirable tact, from that feverish, tumultuously coloured world of the old citizens of Venice—exquisite pauses in time, in which, arrested thus, we seem to be spectators of all the fulness of existence, and which are like some consummate extract or quintessence of life" (150). The thinly veiled erotic portrait of Venetian culture also forms perhaps the final stage in Pater's revision of Ruskinian history and ethics. Even more than Ruskin's, his history carries us out of time, to an ideal world inhabited by "aesthetic critics" and the few consummate personalities with whom they can feel the greatest affinities.

History, then, becomes a pretext for what Pater regards as an essential form of intense intellectual contemplation. Richard Ellmann has called The Renaissance, "exercises in the seduction of young men by the wiles of culture."[14] The description is apt. The real focus of the book is not on history, or even on Pater's standards for an ideal art, but on the intense emotions and personalities, available in art and history, with which he hopes to provide his readers a stimulus for passionate self-awareness. Pater's attitude toward this message is not fully apparent in The Renaissance. But it becomes plainer as his career continues not only with more "aesthetic criticism" but also with fiction, a medium in which rhetoric and emotional effect are even more customary, and in which an author needs feel no constraints about the presentation of a world of his own making.

# VII

## Imaginary Portraits
## and the
## New Moral Aesthetic

The problems and achievements of *The Renaissance* reverberate through the remaining twenty years of Pater's brief literary career, ending with his death in 1894. His fiction records a persisting conflict, stemming from a deep ambivalence over his first book and its doctrine of art-for-art's-sake. Despite his attacks on Ruskin, both implied and direct, Pater is sensitive to moral issues and moralistic critics. Almost as much as Ruskin, he feels inner sympathy with the most puritanic complaints raised against his style and ideas. His uneasiness receives classic expression in the footnote with which he "restores" the Conclusion to the third edition of *The Renaissance* in 1888. The suspect chapter is reprinted only because it has been explained by his novel: "I have dealt more fully in *Marius the Epicurean* with the thoughts suggested by it." He encourages us to read his novel as confession, conversion, and aesthetic-moral apologia. As an early biographer informs us, he wrote the novel "as a kind of duty."[1] The same moral self-consciousness is apparent throughout his "imaginary portraits." All of Pater's fiction attempts to mediate between aesthetics and morality, to create, while defining a position distinct from Ruskin's, a new "moral aesthetic." In this sense, his fiction can be read as a series of thinly disguised revisions of his first elegant vision of history.

Yet his fictional attempt to moralize *The Renaissance* often seems to defeat itself. As in the case of Ruskin, new ideas emerge in Pater's late writing and yet remain subordinated within an essentially aesthetic context. Although his vision changes, the mode of vision remains constant. Pater continues to focus on lives conducted in the spirit of art, and works in which a wide range of associations coalesce into intense but ambiguous symbols. But as in *The Renaissance*, his subjects have no more importance in themselves than the method he offers for "appreciating" them. *Marius the Epicurean*, for example, is usually taken as a point of division in Pater's career: the "drift" toward Christianity seems to repudiate specifically some of the overtones of "Winckelmann" and the Conclusion. Yet Marius is an aesthetic being. However we evaluate his final religious position, he identity is defined, and to some extent limited, by its form: ideas, even ethical ideas, depend on temperament. This holds true for all Pater's fictional heroes, and the problem of *Marius* is characteristic of the imaginary portraits in general: the mode of his vision invariably dominates its content. Similarly, the persistence of stylistic refinement undercuts a great deal of Pater's supposed ethical development. His is a style in which it is almost impossible to make convincing moral assertions. Thus, even Pater's "confessions" have the feel of artful gestures rather than sincere declarations of conscience. The dominant spirit throughout his career is the spirit of art. Pater's new moral aesthetic, far more than Ruskin's, is an aesthetic before it is a morality.

The Conclusion to *The Renaissance* contains the clearest philosophic rationale for the primacy of aesthetics: in a world of flux, the only clear or certain values are personal, and Pater resorts to such terms as "passion" and "intensity" to explain his creed. The study of history itself turns one inward. The imaginary portraits enlarge upon that first statement of relativism, making even more explicit the central assumption of his history writing: it is impossible fully to distinguish truth, reality, from the world of the imagination. Genuine history is human history; it is therefore meaningless to separate history from fiction. The term Pater uses to identify his stories—"imaginary portrait"— expresses this belief in the continuity between objective and subjective treatments of history, between essays and fiction. The phrase suggests some of the likely models for Pater's stories: Petrarch's imaginary letters to the ancients, or more recently

Landor's *Imaginary Conversations*. Perhaps Pater's most important debt is to Rossetti, in stories like "Hand and Soul" or "St. Agnes of Intercession," where the impulse for historical fiction begins with a confrontation with painting. Many of Pater's own character sketches are based on figures in pictures. And the phrase itself, "imaginary portrait," identifies the balance of artifice and reality in the prose genre with visual art. As one critic has noted, it is "the fiction of an art critic. Just as Pater the critic of the *Mona Lisa* needs an 'actual' painting which he may then transcend imaginatively through his prose, so Pater the creative portraitist needs a fixed delineation of a figure, whose sensations and ideas he can then interpret freely in relation to changing 'environments' or 'atmospheres.' "[2] Although necessarily fixed and static, the portrait suggests something of that larger world of flowing time from which it has been arrested. Pater writes that he expects his own "readers, as they might do on seeing a portrait, to begin speculating—what came of him?"[3]

Just as *The Renaissance* narrated history as fiction, so the imaginary portraits employ fiction as a mode of history writing, in which the image of a single, semihistorical figure suggests some of the ideas and feelings of a larger period. The main characters in these stories possess the same symbolic centrality that Pater earlier ascribed to certain artistic masterpieces. Indeed, the four stories collected in the volume titled *Imaginary Portraits*, published in 1887, all center around images taken (or said to be taken) from actual works of art. The setting and the major characters in "A Prince of Court Painters," the first story in that volume, derive from pictures by Watteau and his circle. Denys l'Auxerrois, we are told, still may be seen in stained glass and tapestry in the Champagne country. Similarly, Pater claims that the handsome figure recurring in indoor and outdoor genre scenes of seventeenth century Holland is that of Sebastian van Storck. Only Duke Carl of Rosenmold leaves no image behind, yet the spirit of the man seems itself reborn in the description of young Goethe recorded by the poet's mother. The existence of actual portraits of Pater's fictional heroes verifies the authenticity of his stories—it implies a claim of objectivity: all these characters are "real." But at the same time, the supposed "evidence" of the arts demonstrates that Pater's characters are not so much individually true as they are typical or universal. We turn to the arts to remind ourselves that any of these personal-

ities—or ones like them—could have existed. Even actual artists contemporary with Pater's imaginary heroes found in their features something representative of the age.

The strategy of the imaginary portraits is clearest in "A Prince of Court Painters," which probably achieves the most successful merger of fictional and essayistic techniques in all of Pater's fiction. He organizes the narrative as a series of pseudo-historical observations by a contemporary of Watteau who, more important, was a subject of one of Watteau's unfinished pictures. The story is a "portrait," then, in the most literal sense. The personality of the narrator is abstracted from a painting in the museum at Valenciennes by a pupil of Antony Watteau, Jean Baptiste Pater, portraying his sister, Marie-Marguerite Pater (see illustration). The story is a personal account of Watteau's life in Valenciennes by this woman, narrated in the form of a diary or journal.[4] The journal form itself augments the illusion of reality. We glimpse history in known events from Watteau's life and in the provincial but elegant, dated voice of the narrator herself. Pater takes many of her "descriptions" from pictures by Watteau. Her style, deliberately modeled on the moods in Watteau's genre scenes, has a naïve grace which persuades us that we are reading an eighteenth century diary in translation:

> June, 1714
> He [Watteau] has completed the ovals:—The Four Seasons. Oh! the summerlike grace, the freedom and softness, of the "Summer"—a hayfield such as we visited to-day, but boundless, and with touches of level Italian architecture in the hot, white, elusive distance, and wreaths of flowers, fairy hayrakes and the like, suspended from tree to tree, with that wonderful lightness which is one of the charms of his work. (22–23)

> August, 1717
> Himself really of the old time—that serious old time which is passing away, the impress of which he carries on his physiognomy—he dignifies, by what in him is neither more nor less than a profound melancholy, the essential insignificance of what he wills to touch in all that, transforming its mere pettiness into grace. It looks certainly very graceful, fresh, animated, "piquant," as they love to say— yes! and withal, I repeat, perfectly pure, and may well congratulate itself on the loan of a fallacious grace, not its

*Walter Pater*

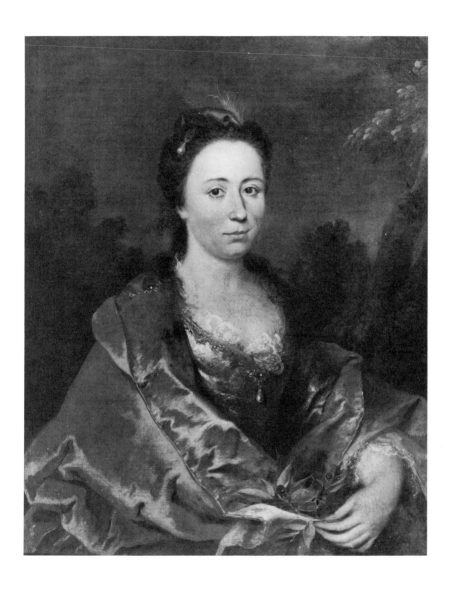

Jean Baptiste Pater, "The Painter's Sister, Marie Marguerite Pater"

own . . . he reaches with a wonderful sagacity the secret
of an adjustment of colours, a *coiffure*, a toilette, setting
I know not what air of real authority on such things. (33–34)

The feminine voice of Marie-Marguerite Pater is almost too
detached from Pater's to be considered a persona, yet it enables
him to dramatize again the personal ideal of *The Renaissance:*
the blending of art and life. Through her, he locates this fusion
in two distinct historical worlds: the public world of Paris
society, and the private, more obscure world of Valenciennes. As
an observer of court life, she is uncritical enough to respond
fully to its elegance and contrived grace. She praises Watteau
for participating in the creation of an artificial environment, in
which painting, like all the fine arts of the age, serves as an
almost musical background to dress, conversation, gesture, even
"physiognomy." She imagines that at the home of Watteau's
Parisian patron, "the antiquities, beautiful curiosities of all sorts
. . . are arranged all around one . . . that the influence, the
genius, of those things may imperceptibly play upon and enter
into one, and form what one does" (30). She views this use
of the arts as essentially moral, at least as it is translated into
the rooms Watteau decorates in his village: "I am struck by the
purity of the room he has re-fashioned for us—a sort of moral
purity . . . in the *forms* and *colours* of things. Is the actual life
of Paris . . . equally pure, that it relishes this kind of thing so
strongly?" (23). The irony of her question lies in its contrast of
her world to a more decadent court society; yet her naïveté
finally vindicates Watteau himself. The moral value potential in
even his aestheticism emerges from her interpretations of his art.
    Like the aesthetic critics of *The Renaissance*, Marie-Margue-
rite retains her mental purity even while admiring potentially
immoral arts. Reading the notorious story of "poor Manon
Lascaut," a "great favourite" of Watteau, who had left it behind
on one of his visits home, she is baffled by the ability of Parisian
society to amuse itself with such matters. Yet it contains "an art
like Watteau's own, for lightness and grace," and her natural
response is to moralize the book's beauties: "Incapacity of truth,
yet with such tenderness, such a gift of tears, on the one side:
on the other, a faith so absolute as to give to an illicit love
almost the regularity of marriage!" (37). As a sort of amateur
critic, she possesses a delicacy of taste that ennobles whatever
art she regards, including Watteau's own: "The world he sets

before us so engagingly has its care for purity, its cleanly prefer-
ences, in what one is to *see*—in the outsides of things—and
there is something, a sign, a memento, at the least, of what
makes life really valuable even in that. There, is my simple
notion, wholly womanly perhaps, of the purpose of the arts"
(33).

To some extent Pater's narrator is herself transformed by
Watteau's influence, for her voice reveals the Watteau style
becoming a mode of perception. Indeed, it is her sensibility
that the imaginary portrait dramatizes most fully: she, rather
than Watteau, is the central figure, just as it is her picture on
which the story is based. She paints the relatively bare country
setting through a series of delicate motifs. One comes to her
mind "by mere force of contrast" when, after reading *Manon
Lescaut*, she recalls "the true colour, ruddy with blossom and
fruit, of the past summer, among the streets and gardens of
some of our old towns we visited . . . The summer was indeed
a fine one; and the whole country seemed bewitched. A kind of
infectious sentiment passed upon us, like an efflux from its
flowers and flower-like architecture—flower-like to me at least,
but of which I never felt the beauty before" (38). Her subtle
observations of life reduce the world to moments of feeling and
perception, creating a vision of the tactile universe in flux, but
composed by passionate contemplation. The attitude is that
presented in the Conclusion to *The Renaissance*, only moralized
by the personality of the narrator. Pater is not defending
Watteau's art in moral terms, but he does present a viewpoint
from which one can apprehend such art, or any art, morally.

With certain variations the same situation recurs in all the
*Imaginary Portraits*. Each story examines the relation of a par-
ticular civilization and a single figure, as if to test the proposi-
tion that under the right conditions culture can produce a
harmonious temperament. From this perspective, Pater's fiction
is the laboratory for the assumptions of *The Renaissance*, al-
though he is honest enough to introduce into evidence both
successful and unsuccessful experiments. Both Denys l'Auxer-
rois and Sebastian van Storck fail, in different ways, to turn
culture to moral and personal advantage. Even Watteau dies in
an ambiguous relationship to his world. His art is redeemed only
through the passive intercession of the feminine "critic," who
remains detached from Parisian society and official culture.

Generally, then, Pater has difficulty establishing a relation

between society and an individual who possesses a properly moral aesthetic temperament. Denys and Sebastian, the two figures whose personal development meets with the least success, live in what might be considered the most organic societies Pater depicts—a medieval French village and a prosperous community in seventeenth century Holland. They stand, perhaps, too close to the centers of their cultures to achieve the detachment that characterizes the ideal Paterean temperament, which may also require actual detachment in space or time. Leonardo, after all, secluded himself to perfect his art; and Michelangelo's poetry reveals him living as a kind of ghost after his own age had passed. Duke Carl of Rosenmold brings the arts into the life of the German provinciality he rules, but his full success is posthumous, and the fruition of his sensibility must be realized in the being of another, later German, Goethe. Although in the Duke's life the conflict of individuality and culture is not fully resolved, his story points toward a solution in the future. And as the final story in *Imaginary Portraits*, it serves as a kind of moral companion-piece to the first one, "A Prince of Court Painters." Together, they provide an ethical frame surrounding the portraits of Sebastian and Denys, and contrasting with their ambiguous morals.

In "Denys l'Auxerrois" the moral extremes are violent. The story is one of Pater's many treatments of a Greek god in exile, a medieval Dionysus, as his name suggests.[5] Like his classic model, Denys is an exemplar of the music and beauty of youth, inhabiting a space of the Middle Ages which, like the world of the "Two Early French Stories," "was a period, as older men took note, of young men and their influence" (60). Although recalling the "young men" for whom the Conclusion was written, Denys is clearly an ambiguous figure. He exercises a profound creative influence on the world around him: the arts flourish when he returns to the countryside; liberty is in the air; wine and food (he works as a fruit-seller for a time) attain new freshness and purity. Yet even at the height of this premature Renaissance, as Pater calls it, Denys encourages immoral, antisocial activities, "a wild social license" (68). In the early sections of the portrait, Pater's style betrays his deep sympathy with this sort of energy:

The hot nights were noisy with swarming troops of
dishevelled women and youths with red-stained limbs and

faces, carrying their lighted torches over the vine-clad hills, or rushing down the streets, to the horror of the timid watchers, towards the cool spaces by the river. A shrill music, a laughter at all things was everywhere. And the new spirit repaired even to church to take part in the novel offices of the Feast of Fools. Heads flung back in ecstasy—the morning sleep among the vines, when the fatigue of the night was over—dew-drenched garments—the serf lying at his ease at last . . . And the powers of nature concurred. It seemed there would be winter no more. (61)

Pater's description of the sexual license that Denys embodies and inspires directly contradicts Ruskin's view of the Middle Ages. Indeed, there are several thinly-veiled references to the Ruskinian mode of the literature of art. The story begins with an abbreviated French travel journal in much the manner of the late Ruskin, as in such books as *The Flamboyant Architecture of the Valley of the Somme,* and Pater remarks on the Turnerian character of the landscape. The story is introduced by an antiquarian narrator, who reports his discovery of the strange image of Denys in motifs on tapestries and stained glass from the Middle Ages. We are perhaps meant to think of a Ruskin confronting new forms of Gothic life. Elsewhere in the portrait Pater borrows phrases from "Leonardo da Vinci" to shatter further the Ruskinian moral distinction between the medieval and Renaissance worlds. Denys is "a lover of fertility in all its forms . . . curious and penetrative concerning the habits of water, and had the secret of the divining-rod." On one of his seasonal journeys south—journeys that make him most plainly resemble a latter-day Greek god—he "trafficked with sailors from all parts of the world . . . and bought their wares . . . wine and incense . . . seeds of marvellous new flowers, creatures wild and tame." After such a journey the darker side of Denys' character begins to emerge, revealing the demonic aspect of the Dionysian role. Here, in fact, he seems to embody Pater's redefinition of Ruskin's idea of the grotesque. He "ate flesh for the first time, tearing the hot, red morsels with his delicate fingers in a kind of wild greed" (64–65). His personality begins to infect society with a new "degeneration" and "coarseness" (66): "a darkness had grown upon him. The kind creature had lost something of his gentleness. Strange motiveless misdeeds had happened; and, at a loss for other causes, not the envious

only would fain have traced the blame to Denys. He was making the younger world go mad" (65).

It is at this point that Pater's style achieves its own grotesque intensity. Although he attains a vision of the world as art, that world is neither placid nor moral, the qualities usually connoted by the merger of art and life in his other work in the genre. As the story progresses, Denys' identity with Dionysus becomes increasingly pronounced; he becomes more and more unreal, detached from the world around him. Finally, after a last magnificent display of his powers on a disused church-organ, he becomes an actor in the town pageant. The ritual of the drama, the *Return from the East*, transforms the entire community into pagan worshipers, enacting a sacrifice. Denys plays the figure of Winter, who must be destroyed: "The pretended hunting of the unholy creature became a real one, which brought out, in rapid increase, men's evil passions" (76). Maddened by a trickle of blood on his lips, the townspeople tear Denys to pieces—"the men stuck little shreds of his flesh . . . into their caps; the women lending their long hairpins for the purpose" (77). The distinction between art and life has been lost, realizing, perhaps, Pater's worst unconscious fears about the message of the Conclusion that we should live for art and passion.

Pater frames the violence and ambiguous morality of this portrait with more decisively ethical statements about art and society, as *Imaginary Portraits* begins with the moral voice of Marie-Marguerite Pater, and ends with the story about an Apollonian aesthetic king. Structurally, the Dionysian element is contained. Pater also provides a framework within the story to demonstrate how the dangerous connotations of past art can be contemplated without moral infection. He makes us conscious of our critical distance from Denys and the past as observers of art. This is one of the functions of the Ruskinian introduction. We are made aware of the fact that the real meaning of artifacts of the past depends on a point of view. The significance of perspective is illustrated in a description of the approach to a flamboyant church: "In one of the richest of its windows . . . certain lines of pearly white run hither and thither, with a delightful distant effect, upon ruby and dark blue. Approaching nearer, you find it to be a Travellers' window, and those odd lines of white the long walking-staves in the hands of Abraham, Raphael, the Magi" (49). The effects of history are also "impressions," which can be altered at different perspectives. Through-

out "Denys" we are conscious that he is being observed and interpreted, by a detached, scholarly figure much like Pater himself: "Even the sage monk, Hermes, devoted to study and experiment, was unable to keep the fruit-seller out of his mind, and would fain have discovered the secret of his charm" (60). The phrase from "Leonardo da Vinci" confirms the sense that from a sufficient critical distance even a Dionysian figure can be contemplated with safety. Indeed, it is Hermes who outlives Denys' fatal ritual and buries his heart under a "stone, marked with a cross . . . in a dark corner of the cathedral aisle" (77). When the antiquarian narrator returns in the final paragraph of the portrait, the taming of this dangerous figure is complete: "On days of a certain atmosphere, when the trace of the Middle Age comes out, like old marks in the stones in rainy weather, I seemed actually to have seen the tortured figure there—to have met Denys L'Auxerrois in the streets" (77). The tone establishes a position of critical neutrality from which intense images of art can be observed in safety and, for that matter, from which living equivalents to the frenzied moments of past art can be contemplated in detached tranquillity.

The final pair of *Imaginary Portraits* are less convincing aesthetically, perhaps owing to the steadily growing moral content. In "Duke Carl of Rosenmold," Pater concludes the volume with a healthier instance of the renewed life of an exiled god, Apollo instead of Dionysus. As in "Denys," art enters life, but now in a socially positive manner, to the benefit of general culture. Duke Carl, ambitiously preparing his dowdy kingdom for a new cultural epoch, becomes himself the "hyperborean Apollo" whom he hopes to invoke. Pater models the story of Duke Carl on themes from Goethe, to suggest at once that the efforts of this "fictional" figure were to be realized in history, and that his life attains the quality of a fine work of art. Carl's youthful cultivation of taste nearly leads him out of Germany, on the familiar pilgrimage of Pater's real and imaginary heroes toward the south. But as he is poised on the border of France, this remarkable young man chooses to commit himself to national rather than to personal enlightenment, "the real need being that of an interpreter—Apollo, illuminant rather as the revealer than as the bringer of light" (144). Once again the ideal expression of culture is in the role of critic and, in this case, patron. Carl chooses to be an observer; and Pater, by allusion, makes clear that such a decision involves no social or personal

loss. Pater deliberately makes this perception of duty, in which Carl decides to return to Germany, echo—or foreshadow—*Wilhelm Meister:* "For you, France, Italy, Hellas, is here!" (143). Duke Carl thus enters a real, historic tradition, of which Winckelmann was also a part, and which would culminate in Goethe. Through such an "imaginary" figure the actual *Aufklärung* was to be achieved.

Pater's clear intention is that this story should be read as a companion piece to "Sebastian van Storck." They were published in 1886 and 1887, respectively, the last year also being the one in which the four *Imaginary Portraits* appeared together in a volume. The nearness of their composition suggests that "Duke Carl of Rosenmold" may have been conceived to balance the dubious morality of the portrait of the young Dutch skeptic. While the Duke fully involves himself in the public life of Rosenmold and the emerging German nation, Sebastian's obvious moral weakness lies in his refusal to participate in the rich social culture of seventeenth century Holland. Pater repeatedly employs imagery from Dutch art to evoke the warmth and gaiety of this milieu, contrasting it to the bleakness of Sebastian's abstract idealism, mainly borrowed from Spinoza: "For him, that one abstract being was the pallid Arctic sun, disclosing itself over the dead level of a glacial, a barren and absolutely lonely sea. The lively purpose of life had been frozen out of it. What he must admire, and love if he could, was 'equilibrium,' the void" (108). In his pursuit of abstraction, Sebastian takes little interest in the arts. "Why add," he reflects, "by a forced and artificial production, to the monotonous tide of a competing, fleeting existence?" (88). Sebastian's response to the consciousness of flux is wholly opposite to the attitude outlined in the Conclusion to *The Renaissance*. He retreats from the dissolving world into philosophy and speculation, isolating himself from the *Zeitgeist*. Pater notes later in the story that "all his singularities appeared to be summed up in his refusal to take his place in the life-sized family group (*trés distingué et trés soigné* remarks a modern critic of the work) painted about this time" (100). Indeed, Sebastian shuns the lively society of Albert Cuyp, Gerard Dow, Thomas de Keyser, and other artists who flock to the prosperous home of his father, the Burgomaster van Storck. Pater hints that Sebastian's moral and social isolation begins in a failure of taste.

But Sebastian is responsible for more serious types of miscon-

duct. Much of the portrait follows the progress of his journals, which record an "argument" with himself, a mental "equation" through which he tries to establish the proper consequences of philosophy in action. Unlike Duke Carl, whose philosophy ("go straight to life") leads him straight to love and then marriage, Sebastian follows "duties towards the intellect . . . which women can but rarely understand" (100). His commitment to abstraction results in cruel treatment of the girl with whom his family hopes to arrange his marriage. Pater describes her "cheerful warmth" to illustrate by sharp contrast the inhumanity of Sebastian's philosophy when applied to his own world: "while, in the eyes of all around him to-night, this courtship seemed to promise him, thus early in life, a kind of quiet happiness, he was coming to an estimate of the situation, with strict regard to that ideal of a calm, intellectual indifference, of which he was the sworn chevalier. Set in the cold, hard light of that ideal, this girl, with the pronounced personal views of her mother, and in the very effectiveness of arts prompted by real affection, bringing the warm life they prefigured so close to him, seemed vulgar!" (101–102). Rarely are Pater's ironies so heavy. A page later, the "chevalier" of "intellectual indifference" sharply rejects Mademoiselle van Westrheene and the love she represents. He writes her an accusing letter, "with a very deliberate fineness." The girl, "so natural, and simply loyal," withdraws permanently from society.

"Sebastian van Storck" becomes even more melodramatic at the end. The hero pursues his commitment to total self-effacement and negation to the point, it seems, of suicide. But Pater offers him an ambiguous pardon and once again manages to direct the destructive mental tendencies portrayed in his fiction toward a positive social goal. There is the hint of an impending moral resolution when his mother's confessor winks aside the seeming sinfulness of Sebastian's letter to the young lady: "The aged man smiled, observing how, even for minds by no means superficial, the mere dress it wears alters the look of a familiar thought; with a happy sort of smile, as he added . . . 'in Him, we live, and move, and have our being' " (112). But explicit moral justification comes as a result of Sebastian's own actions. He retreats to a family dwelling, a symbolic tower alone beside the sea, in order to contemplate and complete his "mental equation." A storm rises, his servants leave, the surrounding dikes break, and he dies. But when his body is found, it is plain

that his failure to escape was not at the end a sign of total nihilism. Near the body is a living, swaddled infant, saved in a high room from the rising tide—"And it was in the saving of this child, with a great effort, as certain circumstances seemed to indicate, that Sebastian had lost his life" (114). Pater also notes how reassuring these circumstances are for Sebastian's parents. Early in the portrait, Sebastian's father had urged him to "be stimulated to action!" (85). His plea reveals the moral values according to which we judge Sebastian throughout. The concluding touch of pathos does not alter Pater's main point. Sebastian is finally vindicated by the same values he had violated up to the moment of his death. Dying he manages at last to become, like Carl, a familial and paternal figure.

Despite its oppressive morality, "Sebastian van Storck" contains some of Pater's best scenes, which are written as if copied from Dutch genre painting. He even takes a moment to refute Ruskin's attack on Dutch realism, which for Pater contains precisely those qualities of humane imagination Sebastian so dangerously lacks: "The Dutch had just begun to see what a picture their country was—its canals, and *boompjis*, and endless, broadly-lighted meadows, and thousands of miles of quaint water-side" (87). The focus of this art is the family, no less a sacred unit than the community of Christians in *Marius*. It seems that Sebastian himself, in rejecting this world and the culture that grows out of it, ignores a realization of his own professed intellectual goal, the interpenetration of ideas and action, life based on an artificial order. That fusion is expressed in Dutch art:

Those innumerable *genre* pieces—conversation, music, play —were in truth the equivalent of novel-reading for that day; its own actual life, in its own proper circumstances, reflected in various degrees of idealisation, with no diminution of the sense of reality . . . Themselves illustrating . . . the good-fellowship of family life, it was the ideal of that life which these artists depicted; the ideal of home in a country where the preponderant interest of life, after all, could not well be out of doors. Of the earth earthy—genuine red earth of the old Adam—it was an ideal very different from that which the sacred Italian painters had evoked from the life of Italy, yet, in its best types, was not without a kind of natural religiousness. (87–88)

Pater illustrates this merger of life and art in the banquet at Sebastian's house, where he rejects Mademoiselle Westrheene. It is precisely at the moment when the hero feels most sharply alienated from his milieu that we observe it as the consummate art of Holland:

> The guests were seen arriving on foot in the fine weather, some of them accompanied by their wives and daughters, against the light of the low sun, falling red on the old trees of the avenue and the faces of those who advanced along it: Willem van Aelst, expecting to find hints for a flower portrait in the exotics which would decorate the banqueting-room; Gerard Dow, to feed his eyes, amid all that glittering luxury, on the combat between candle-light and the last rays of the departing sun; Thomas de Keyser, to catch by stealth the likeness of Sebastian the younger. (90-91)

That final "likeness" is presumably the "real" image of the young Sebastian from which Pater takes his own portrait.

The most self-conscious tour de force of this kind appears in the opening scene, one which is also echoed in "Duke Carl of Rosenmold." It is an outdoor genre scene, in which "Dutch aristocracy had put forth all its graces to become the winter morn" (84). In this graceful transformation of man and nature into artificial arrangements, Sebastian is again at the center:

> It was a winter-scene, by Adrian van de Velde, or by Isaac van Ostade. All the delicate poetry together with all the delicate comfort of the frosty season was in the leafless branches turned to silver, the furred dresses of the skaters, the warmth of the red-brick house-fronts under the gauze of white fog, the gleams of pale sunlight on the cuirasses of the mounted soldiers as they receded into the distance. Sebastian van Storck, confessedly the most graceful performer in all that skating multitude, moving in endless maze over the vast surface of the frozen water-meadow, liked best this season of the year for its expression of a perfect impassivity, or at least of a perfect repose. (81)

Sebastian "reads" this scene as a barren landscape, imagining it without humanity, focusing on the icy hints of lifelessness. The rest of the story examines the limits implicit in such a response.

But Pater's initial description itself demonstrates an alternative vision of this world. His prose links the repose of nature to the civilization that bustles around it: the art implicit in the homes, costumes, and especially in Sebastian's own "graceful" skating. By viewing winter through the medium of landscape painting, he makes the repose of nature dependent on man. Even if the scene is only imaginary—and Pater does not specify the painter or the genre piece he alludes to—it still invites us to measure all the semihistorical worlds of "Sebastian van Storck" against the ideal of artful humanity, civilization harmonized under the influence of art.

In the last of the *Imaginary Portraits* Pater returns to an almost identical scene; this time, however, it is an actual incident from history. The scene thus seems to demonstrate that the ideal glimpsed, but not realized, in Sebastian's Holland can be re-created, especially when a harmonious Renaissance type stands at the center of his world. Pater chooses a moment from the life of Goethe, to explain the influence Duke Carl exerted on the German Enlightenment he could not live to see. But the incident also reenacts the consummate historical moments dramatized in *The Renaissance*, and there, too, Goethe offers the most modern proof that "self-culture" need not be "a lost art." Pater identifies Carl with the "aspirations" of men like Lessing and Herder, "brilliant precursors of the age of genius . . . awakening each other to the permanent reality of a poetic ideal in human life, slowly forming that public consciousness to which Goethe actually addressed himself" (151–152). The ideals Pater tries to "embody" in Carl flower even more vividly in Goethe, as expressed in a single, dramatic moment in his life. Pater first quotes a description of that moment by Goethe himself:

A hard winter had covered the Main with a firm footing
of ice. The liveliest social intercourse was quickened thereon.
I was unfailing from early morning onwards; and, being
lightly clad, found myself, when my mother drove up later
to look on, quite frozen. My mother sat in the carriage,
quite stately in her furred cloak of red velvet, fastened on
the breast with thick gold cord and tassels.
    "Dear mother," I said, on the spur of the moment, "give
me your furs, I am frozen."
    She was equally ready. In a moment I had on the cloak.
Falling below the knee, with its rich trimming of sables, and

enriched with gold, it became me excellently. So clad I made my way up and down with a cheerful heart. (152–153)

At first the account seems out of place, with only the vaguely regal costume linking it to the story of Duke Carl. But Pater goes on to add the description of the same events by Goethe's mother: "There, skated my son, like an arrow among the groups. Away he went over the ice like a son of the gods. Anything so beautiful is not to be seen now. I clapped my hands for joy. Never shall I forget him as he darted out from one arch of the bridge, and in again under the other, the wind carrying the train behind him as he flew." Pater then adds, in his own voice: "In that amiable figure I seem to see the fulfilment of the *Resurgam* on Carl's empty coffin—the aspiring soul of Carl himself, in freedom and effective, at last" (153). Not only is Carl brought to life in the real Appolonian figure of Goethe, but he is portrayed in the "imaginary" form earlier associated with the skating Sebastian.

This moment seems to sum up all the *Imaginary Portraits*. Goethe is depicted as a reborn God, like Denys; the scene is narrated by a woman, as in "A Prince of Court Painters." It is as if all the assumptions of the "imaginary portrait" genre have found expression in an actual moment in history, which realizes at the same time the ideals of the Conclusion to *The Renaissance*. This is the composite message of the *Imaginary Portraits* as a whole. Man progresses in those great historical moments when art passes into life, and ideals become manifest in human form; the vital lessons of the past are disclosed when new forms of life arise in the present. As in "Winckelmann," Goethe embodies the perfect modern form of such a type, one in which history and culture fuse to create the "blitheness" and "centrality" that characterize a harmonious personality. In *Imaginary Portraits*, as in *The Renaissance*, the German poet reenacts the essence of all the values Pater locates in the past.

The habitual choice of a single figure to epitomize an age or a long historical tradition reflects Pater's view of personality as well as history. The development of the individual encapsulates the development of the race. There is something of Darwin in this notion, and perhaps Newman's idea of development as well.[6] The most innovative application of the concept appears in *Marius the Epicurean*, where the moral and philosophical atmosphere of Antonine Rome is compared to numerous later West-

ern cultures, and where the hero's development rehearses all the urges, yearnings, doubts, and crises of a typical nineteenth-century "young man." And the same assumptions are present in a more limited portrait of an evolving consciousness, in the story titled "The Child in the House," which in 1878 was the first of Pater's fictional works to appear under the heading "imaginary portrait." Even within this narrowest of all his fictional atmospheres, the description of a child's world of house and garden with the associations they contain, Pater manages to invoke the central themes of his broadest historical studies. The story of "the child" reflects in miniature the development of the aesthetic sensibility that he traced in *The Renaissance*. There are specific echoes of "Leonardo da Vinci" in the child's "desire of beauty" or in his freeing of caged birds (*Miscellaneous Studies*, 175, 184). There is even more of Leonardo in his "certain capacity of fascination by bright colour and choice form—the sweet curvings, for instance, of the lips of those who seemed to him comely persons, modulated in the things they said or sang" (*Miscellaneous Studies*, 181). Most striking, the child feels "a curious questioning how the last impressions of eye and ear might happen to him" (*Miscellaneous Studies*, 189).

The theme of sensibility brings "The Child in the House" within the margins of the literature of art. Through the subject of childhood, Pater describes the beginning of tastes and capacities that come to fruition only in a mature aesthetic temperament. The sudden discovery, for example, of "a great red hawthorne in full flower" (a passage Proust may have read) stimulates a passion to be perpetually reanimated—"the goodly crimson, still alive in the works of old Venetian masters or old Flemish tapestries" (*Miscellaneous Studies*, 185). Both Rossetti and Ruskin traced the development of the aesthetic sense in various writings, and Pater's imaginary portrait seems to draw on both. In Pater's essay on Dante Gabriel Rossetti there is a long, allusive passage on the connotations of the phrase "house of life," which applies as well to Pater's own story, published five years earlier than the essay, as to Rossetti's sonnet sequence: "The dwelling-place in which one finds oneself by chance or destiny, yet can partly fashion for oneself; never properly one's own at all, if it be changed too lightly; in which every object has its associations—the dim mirrors, the portraits, the lamps, the books, the hair-tresses of the dead . . . the house one must quit, yet taking perhaps, how much of its

quietly active light and colour along with us!—grown now to be a kind of raiment to one's body, as the body . . . is but the raiment of the soul" (*Appreciations*, 214). This sounds, save for the reference to "the hair-tresses of the dead," like a general outline of the thin "plot" of "The Child in the House."

Much like *The House of Life*, "The Child in the House," as the introductory paragraphs explain, is the author's "story of his spirit . . . that process of brain-building by which we are, each one of us, what we are." Supposedly the story is narrated by the child, Florian Deleal, later in his life. He imagines a "half-spiritualised house" in which "he could watch the better, over again, the gradual expansion of the soul which had come to be there—of which indeed, through the law which makes the material objects about them so large an element in children's lives, it had actually become a part; inward and outward being woven through and through each other into one inextricable texture—half, tint and trace and accident of homely colour and form, from the wood and the bricks; half, mere soul-stuff, floated thither from who knows how far" (*Miscellaneous Studies*, 173). In the essay on Rossetti there are numerous references to the quality of soul in his poetry and to a stylistic "sincerity" characterized by the perfect blending of "inward and outward," the spiritual and the material.

An equally important model for Pater's portrait of the child's developing temperament is found in the first versions of Ruskin's autobiography, which started appearing in *Fors Clavigera* as early as 1871.[7] The portions most sharply resembling "The Child in the House," which were incorporated later in the chapters "The Springs of Wandel" and "Herne Hill Almond Blossoms," appeared in 1875, shortly before Pater must have begun writing his story. The young Ruskin develops a highly refined aesthetic sense within the world of a house far more narrowly limited than that of Florian Deleal, or probably of Pater himself. Ruskin's responses, however, are to the same kinds of stimuli: a rich garden, "the colours of my carpet . . . the knots in the wood of the floor . . . the bricks in the opposite houses" (XXVIII, 272). All of these "impressions" reappear in "The Child in the House." But the important resemblance is not in specific images but in the treatment of the child's world as the birthplace of sensibility. As Ruskin explains, "What powers of imagination I possessed, either fastened themselves on inanimate things—the sky, the leaves, the pebbles, observable within

the walls of Eden, or caught at any opportunity of flight into the regions of romance, compatible with the objective realities of existence in the nineteenth century, within a mile and a quarter of Camberwell Green" (XXVIII, 346). Pater's "child" also ventures forth imaginatively "into the regions of romance" believed to lie beyond the garden gate. But it is in describing that enclosed world itself that his prose begins to sound almost Ruskinian: "The perfume of the little flowers of the lime-tree fell through the air like rain; while time seemed to move ever more slowly to the murmur of the bees in it, till it almost stood still on June afternoons" (*Miscellaneous Studies*, 177). The related themes of sensibility, memory, and association stimulate both Ruskin and Pater to evoke the world of childhood with some of their richest descriptive prose. In the final version of Ruskin's autobiography, published as *Praeterita* in 1885, he reorganizes his opening chapters around the images which had provided the central "impressions" of his childhood environment: one wonders if these revisions were influenced by Pater's variations on Ruskin's original theme.

Even within the confined, sensuous, ahistorical realm of "The Child in the House," the issue of morality is introduced. Indeed, it is in the simultaneous evolution of aesthetic and moral sensibility that the history of the child anticipates the development of Pater's later fictional heroes, down to Marius himself. The pattern established is simple but fundamental to an understanding of Pater's later fiction: every moral attitude must be grounded in an aesthetic preference; every religious ideal must be manifested in sensible form. In this we hear again the echoes of Rossetti's influence: "he came more and more to be unable to care for, or think of soul but as in an actual body, or of any world but that wherein are water and trees, and where men and women look, so or so, and press actual hands" (*Miscellaneous Studies*, 187). The child's concept of sorrow becomes associated with David's drawing of Marie Antoinette: "he took note of that . . . as a thing to look at again, if he should at any time find himself tempted to be cruel" (*Miscellaneous Studies*, 183).

Religion for the child becomes an essentially picturesque mode of thought, an imaginative system for translating human behavior into its most perfect potential forms: "a sacred history indeed, but still more a sacred ideal, a transcendent version or representation, under intenser and more expressive light and shade, of human life and its familiar or exceptional incidents,

birth, death, marriage, youth, age, tears, joy, rest, sleep, waking —a mirror, towards which men might turn away their eyes from vanity and dullness, and see themselves therein as angels" (*Miscellaneous Studies*, 193–194). The value of religion is as the highest mode of contemplation in the continuum of aesthetic development traced in the child's growth. There is no distinction between his religious sense and his more general quality of aesthetic temperament: "Sensibility—the desire of physical beauty—a strange biblical awe, which made any reference to the unseen act on him like solemn music—these qualities the child took away with him, when, at about the age of twelve years, he left the old house." (*Miscellaneous Studies*, 195). *Marius the Epicurean* explores in far greater detail the relation between these different emotions (or "qualities"), seven years after publication of "The Child in the House." The theme of the house reappears in the novel, forming a link between the religious poles of Marius' development: he leaves his ancestral home, White Nights, with its traditional religion, and finally comes into the ambiance of the villa of Cecilia, a beautiful Christian. But there, too, Pater tends rather to merge aesthetics and religion than to distinguish between them. The dominant mode of sensibility, first established as the theme of "The Child in the House," finally limits and to some extent undermines the moral argument of Pater's major fictional work.

## Marius the Epicurean

*Marius the Epicurean* belongs only marginally to the genre of the literature of art, although it was first conceived as a short "imaginary portrait." It was planned as an extended fictional elaboration on the aesthetic principles of *The Renaissance*, as Pater indicates in a footnote added when he restored the Conclusion to the third edition in 1888: "This brief 'Conclusion' was omitted in the second edition of this book, as I conceived it might possibly mislead some of those young men into whose hands it might fall. On the whole, I have thought it best to reprint it here, with some slight changes which bring it closer to my original meaning. I have dealt more fully in *Marius the Epicurean* with the thoughts suggested by it" (233n).

If this statement is placed beside the claim that *Marius* was written "to demonstrate the necessity of religion,"[8] it is apparent what sort of "original meaning" Pater has in mind. His novel

seems intended to argue that the passionate contemplation characterized in *The Renaissance* necessarily allies itself with the religious spirit and remains consistent with some form of Christian worship. Marius himself, a sensitive, critical observer of his own life, moves through a variety of ethical sympathies, culminating just before his sudden death in a fascination with Christianity. Although his final attitude toward Christian revelation is left deliberately in doubt, it is clear that the novel examines the same problem of the relation between morality and aesthetics that Pater explored in *Imaginary Portraits*.

In the person of his hero, Pater exposes to the widest possible range of experience and thought one of those aesthetic "young men" for whom the Conclusion to *The Renaissance* was written. He traces the growth of Marius both physically and mentally, but the focus is on his response to a series of philosophic and moral systems. It is not so much the story of a life as the story of a consciousness: the subject, as the subtitle explains, is *Marius the Epicurean—His Sensations and Ideas*. His mental development begins under the influence of the ancient, ceremonial "religion of Numa" and continues, once he leaves his family's ancestral country home, in examinations of and flirtations with the thought of Heraclitus, the Epicureans, and the Stoics. Marius' exposure to the Stoics brings him directly under the guidance of Marcus Aurelius, for whom Marius serves as secretary, enabling him to be the first reader of the *Meditations* in manuscript. By the second half of the novel, Marius has fallen under the spell of a handsome Christian knight, Cornelius, whose personal charm increases the attraction of the Christian services that Marius witnesses for the first time. But this gradual drift toward Christianity is interrupted by an early death. And although he is sanctified as a martyr by the Christians who bury him, Marius himself never wholly embraces Christianity—just as he never wholly adopts any ethical system in the novel.

Keeping Marius detached from all philosophic schools is one of several ways in which Pater makes his history "modern." The breadth of Marius' experience makes him seem less like a citizen of Antonine Rome than a nineteenth century student of philosophy. His intellectual interests, and Pater's frequent allusions to parallel historical epochs, make Marius' progress representative of a distilled confrontation with the entire tradition of Western thought. But the most "modern" aspect of this "great education" is the hero's attitude toward it. He is above all an honest

skeptic, possessing a capacity for doubt and detachment that Pater considers most characteristic of the modern frame of mind. In the Conclusion to *The Renaissance* Pater had written: "The theory or idea or system which requires of us the sacrifice of any part of this experience, in consideration of some interest into which we cannot enter, or some abstract theory we have not identified with ourselves, or of what is only conventional, has no real claim upon us" (237–238). Marius refuses all such sacrifices, pursuing, instead, "sensations" and "ideas" for their own sake. His principled quest for intellectual identity represents the perfect response, by a sensitive, thoughtful, and receptive "young man," to Pater's demand that we live for "the fruit of a quickened, multiplied consciousness."

Yet if Marius remains uncommitted at the end of his life, the circumstances of his story seem to affirm the moral validity of his aesthetic temperament. An ethical argument is implicit at two levels of the novel—style and plot. In both, Pater uses *Marius* to defend the ideas of his first book. Again and again he introduces phrases from *The Renaissance* into the novel, to advise us as to the proper way of interpreting his earlier pronouncements. The concept of "flux," for example, appears throughout the novel, especially at the end, clothed in phrases lifted from the essays on Leonardo and Winckelmann or from the Conclusion itself. Just before his fatal illness Marius reflects that "Death . . . must be for every one nothing less than the fifth or last act of a drama, and, as such, was likely to have something of the stirring character of a *dénouement*" (II, 209). In "Winckelmann" the identical phrase describes the heroic modern attitude visible in the writings of Hugo and Goethe. Similarly, just before his death Marius assumes the guise of the dying Leonardo: "for a moment, he experienced a singular curiosity, almost an ardent desire to enter upon a future, the possibilities of which seemed so large" (II, 221). That "future" refers jointly to subsequent Christian history and to the possibility of an afterlife held open to believers. In either case, as in the prior quotation, we are encouraged to anticipate a conversion; or at the very least we sense that Marius' temperament has prepared him for the reception of Christian truth. As in "Leonardo da Vinci" or "Winckelmann," then, *Marius* locates the highest values not in a system but in a sensibility. But Pater also hints that his hero's perfection of self becomes the equivalent of gaining Christian virtue. By the end of the novel, Marius

embodies an ideal aesthetic morality, and the issue of his con-
version has little bearing on his ultimate ethical status.

In fact, Marius does manage to accept a kind of martyrdom at
the end of the book. He and Cornelius are arrested in a roundup
of suspected Christians. When it is known that at least one of
the prisoners is an unbeliever, Marius arranges for Cornelius to
be released in his place, thus guaranteeing his own death. At this
point, for the first time in the novel, Pater's language hints that
Marius has achieved the kind of "success in life" which *The
Renaissance* posits as the goal of burning with a "hard, gemlike
flame." Summarizing his hero's thoughts in the language of the
Conclusion, Pater exclaims, "Surely, he had prospered in life!"
(II, 218).

Yet it is difficult to feel that *Marius* wholly succeeds in its
attempt to mediate between aesthetics and morality. The novel
seems less successful as an ethical revision of *The Renaissance*
than as a fictional restatement of its aesthetic assumptions:
Pater's moral aesthetic appears weighted on the side of feeling.
All the crucial moral choices Marius makes in his progress
toward a quasi-Christian ethic are predicated on an aesthetic
judgment. Marius himself shows less interest in the Good than
in the Beautiful; his morality is an incidental and often acci-
dental consequence of the desire to contemplate the artistic
potential in life. Although it is Pater's intention to show that
morality can be subsumed in a perfectly refined taste, he demon-
strates little more than the way they coincide in certain select
circumstances. The spheres of morals and aesthetics remain
detached and distinct.

The limits of Pater's design are apparent at most of the moral
turning-points in the book. There is a good example in his
explanation of why Marius parts philosophic company from
Marcus Aurelius, after concluding that the emperor's stoic im-
passivity at the gladiatorial games constitutes a toleration of
evil, that such "cruel amusements were . . . the sin of blind-
ness":

> what was needed was the heart that would make it impossible
> to witness all this; and the future would be with the forces
> that could beget a heart like that. His chosen philosophy
> had said,—Trust the eye: Strive to be right always in regard
> to the concrete experience: Beware of falsifying your im-
> pressions. And its sanctions had at least been effective in

protesting: 'This, and this, is what you may not look upon!'—
Surely evil was a real thing, and the wise man wanting in
the sense of it, where, not to have been, by instinctive
election, on the right side, was to have failed in life.
(I, 242–243)

Pater's explanation of his desired form of righteousness, in the phrase "instinctive election," begs the central question in *Marius*. By instinct, Marius himself is a wholly aesthetic being, which qualifies him to join a moral elite. But such a phrase, like "the sin of blindness," created in the tenuous merger of the vocabularies of sensation and theology, just reminds us that all the moral discoveries in the novel are only justified in terms of their beauty. There is no ethical standard against which to measure the hero's progress. There is, in other words, no coherent morality in the novel.

The tension between aesthetics and morality in *Marius* becomes most intense when the hero discovers Christianity. Marius admires the ritual rather than the meaning of Christian worship, the aesthetic structure of religion rather than its distinctive beliefs. Oscar Wilde in *De Profundis* perfectly characterized the division in the novel between Pater's loyalties to the Beautiful and the True: "In *Marius the Epicurean* Pater seeks to reconcile the artistic life with the life of religion in the deep, sweet and austere sense of the word. But Marius is little more than a spectator: an ideal spectator indeed . . . yet a spectator merely, and perhaps a little too much occupied with the comeliness of the vessels of the Sanctuary to notice that it is the Sanctuary of Sorrow that he is gazing at."[9] Marius does not so much sympathize with Christianity as admire it, in the Latin sense of gazing with wonder. His experience of religion, which the reader shares through Pater's interpretation of Christian services, remains fundamentally aesthetic.

The most beautiful appearance of Christianity is in the chapter entitled "Divine Service," where the mass is described explicitly as a work of art. Its power over Marius is that of a consummate ritual, orchestrating his "sensations and ideas" into a beautiful and complex order. Pater's description of the mass stands as a kind of quintessential example of his own rituals of interpretation as they have appeared through all his writing about art. He takes pains to remind us that the service is symbolic, not simply as an expression of Christian belief but also in

the sense first defined in the essay on Leonardo: with "the unity of a single appeal to eye and ear," thus "summing up . . . an entire world of complex associations under some single form" (II, 128). The mass incorporates traces of older religious practices into its forms, making it a product of all time. Part of its hold on Marius, for instance, stems from his recognition in it of elements derived from the "religion of Numa." For the participants, the ceremony also has the power to transform life into a work of art. It is this dimension of Christianity to which Marius most fully responds: "And so it came to pass that on this morning Marius saw for the first time the wonderful spectacle— wonderful, especially, in its evidential power over himself, over his own thoughts—of those who believe" (II, 130). As Pater suggested in the essay on Giogione, this transformation of life is based on a musical unity in the aesthetic ritual: "The entire office . . . with its interchange of lessons, hymns, prayer, silence, was itself like a single piece of highly composite, dramatic music . . . the entire ceremonial process, like the place in which it was enacted, was weighty with symbolic significance, seemed to express a single leading motive" (II, 135). By representing the mass through the perspective of an unbeliever, Pater can reduce it to its artistic elements alone. Marius finds this "intellectually . . . for him at least, the most beautiful thing in the world" (II, 128).

Because Christianity in *Marius* has only beauty to recommend it, Pater's formulation of a new moral aesthetic must be regarded as unsuccessful. His admiration for the ritual that transforms the world into art far exceeds his interest in the Christian story itself. It remains almost irrelevant whether this key to the formation of an ideal temperament contains any elements of religious truth: although Marius has glimpsed perfection, he has not found God. Indeed, when the name of Jesus finally enters the service, Marius responds to the "image of a young man" whose presence embodies the "centre of the supposed facts which for these people were becoming so constraining a motive of hopefulness" (II, 138–139). Christ is a figure in art, not a part of history—a formal element of the mass, not a source of its content. His importance is as symbol rather than as savior, for he gives the ceremony the unity of a single human personality. Pater enunciates this concept of order even more forcefully in connection with the figure of Socrates in *Plato and Platonism*. In *Marius*, Christianity is little more than a literary theme, a

metaphor of sorts. Its use, like the use of art in Pater's early writings, is to define one source of the kind of beauty and harmony he hopes to translate into the lives of his contemporaries. Pater's fundamental religion remains the religion of beauty; his greatest objective remains the creation of an aesthetic man.

## Utopian Biography

On the whole, the treatment of the fine arts provides a starting point, chronologically and intellectually, in the careers of Ruskin, Rossetti, and Pater. But one conspicuous dimension of their late writing confirms the importance of this common impulse: their interest in giving more definite form to their disembodied aesthetic ideals. All three, in different ways, seek to identify actual, living examples of the new forms of consciousness implicit in their writing about art. Their late writing is at once biographical and utopian, exploring the nature of an ideal but possible human temperament, and the nature of the society in which such an individual could exist. In the 1880s all three wrote books of utopian biography, studies of personality mixing fiction and even some autobiography to construct an image of what Rossetti calls "transfigured life."[10] *The House of Life* (in which the sonnet "Transfigured Life" appears), *Marius the Epicurean,* and *Praeterita* sketch the intellectual biographies appropriate to each writer's concept of an ideal temperament. Although Ruskin's *Praeterita* is the most openly autobiographical of the three, the others contain elements of autobiography as well. All three proceed from the same impulse, a desire to represent life as a work of art, to describe, in terms convincing and probable for a contemporary audience, the aesthetic perfection of the self.

Utopian biography also turns to history for its material. The "use" of the past in Ruskin, Rossetti, and Pater is entirely consistent with their "use of pictures": history objectifies present ideals; one studies the past selectively, to isolate moments that seem to embody vivid equivalents of a mode of being desirable for the present. The very act of writing history becomes an exercise in recreating the frame of mind that permeated an ideal past culture. In Rossetti's medieval paintings or writings (including his imitations and translations of early Italian poetry), as in Pater's Renaissance portraits, or in Ruskin's treatment of

Venice, the contemplation of history leads toward a magical reenactment of it, a ritual of interpretation by which the line of historical development is bent into a circle. This regressive historiography reaches its most extreme form in *Fors Clavigera*, where Ruskin proposes the establishment of the Guild of St. George, an English mini-utopia based on medieval guilds and civic laws and organized around the kind of ceremonies he had discovered in Gothic Venice. St. George's Company, as the Guild is also called, is Ruskin's version of Plato's ideal Republic, ordering a new society in terms of an elaborate aesthetic ritual in which each member or "companion" has a defined and meaningful place. Yet the ritual is grounded in history. Ruskin bases both the costumes and the laws of the Guild on those of fourteenth century Florence. Indeed, the various historical studies of medieval Italy and classical Greece that he produced at about the same time as his utopian writings can be viewed as substantiations of his social vision, bolstering the ideal with historic models that demonstrate its viability.

Pater in *Plato and Platonism* carries the aesthetic assumptions behind Ruskin's version of *The Republic* to their ultimate conclusion. Pater imagines a culture in which society and the individual exist in harmony, at least insofar as each citizen fulfills his aesthetic potential: "Organic unity with one's self, body and soul, is the well-being, the rightness, or righteousness, or justice of the individual, of the microcosm; but is the idea also, it supplies the true definition, of the well-being of the macrocosm, of the social organism, the state" (239). This assessment of Plato's ideal state deliberately mixes political with aesthetic terminology: there should finally be no difference, Pater implies, between "rightness," "righteousness," and "justice." Similarly he stresses the fact that *The Republic* bases a visionary political regime on sociological observation of the actual condition of particular states. Pater treats Plato's work as a magnificent historical novel, a combination of idealization and portrait, originating in Plato's admiration for the political and aesthetic order of Sparta. Plato's *Republic*, like Pater's *Plato and Platonism*, balances fact and fiction; the strength of both their utopian dreams is founded on the same model in reality.

The civilization of Sparta—or Lacedaemon, as Pater prefers to call it—projects a "true valuation of humanity" onto the structure of public life. For Pater, Sparta represents the extension of his *Renaissance* ideal of "self-culture" to an entire politi-

cal system. His description of this state in *Plato and Platonism* focuses on its young men, graceful and disciplined, keen of sense and practised in the arts. In Sparta, "music was everywhere" (200); education included singing and "the famous Lacedaemonian dancing." As in Ruskin's Guild, such education is the first and most essential phase in the perfection of the rituals of public life. Pater explains that "the proper art of the Perfect City is in fact the art of discipline" (275–276). Yet perfection is achieved because discipline becomes inward, instinctive, and natural. Spartan dance "was the perfect flower of their correction," in which, as in "perfect" poetry, sculpture, or painting, "not a note, a glance, a touch, but told obediently in the promotion of a firmly grasped mental conception" (225). The image of a graceful, swaying utopia anticipates the interpretations of dance in the nineties, as in Arthur Symons' essay on "The World as Ballet."[11] The Lacedaemonian dance "was in fact a ballet-dance," as well as something of a "military inspection" and a liturgy. But "in spite of its severity of rule," it "was a natural expression of the delight of all who took part in it." Thus, the model for Plato's *Republic* is an essentially aesthetic society. Spartan youth treat themselves in the spirit of art. Pater remarks at one point that they are "cut and carved" like fine diamonds (282).

*Plato and Platonism*, published in 1893, was first presented as a series of lectures, an appropriate format for Pater's most public utterance. Plato serves as both historical model and philosophic authority for an undisguised appeal to merge aesthetics and ethics. The same plea emanated from both *The Renaissance* and *Marius*, but now it is linked to an even weightier moral tradition. The choice of Plato may have involved an effort on Pater's part to regain the favor of Benjamin Jowett, whose antipathy had deprived him of a Baliol fellowship following publication of *The Renaissance*, and who was closely associated with Oxford officialdom's rejection of that book's tenets. But Pater's Plato is fundamentally different from Jowett's, primarily insofar as he becomes a mouthpiece for the values of art-for-art's-sake. Pater manages to portray the idealist-philosopher as an artist, using phrases that link Plato to the tradition of Romantic writers described in *Appreciations*. Like Rossetti, for example, Plato is a "lover" after the manner of Dante, displaying an "intimate concern with, his power over, the sensible world." "In the impassioned glow of his conceptions,"

Pater continues, using language directly from "Dante Gabriel Rossetti," "the material and spiritual are fused together" (135). Plato's "genius" reduces itself to the sort of intuitive capacity Pater identifies in his most admired artists and critics. Like Wincklemann, who discovers a "new organ" for the human spirit, Plato possesses a "supreme faculty" upon which all his insights turn. Pater quotes his favorite phrase from Arnold to underscore the relevance of Platonism to a modern critical spirit: "For him, all gifts of sense and intelligence converge in one supreme faculty of theoretic vision, θεωρία, the imaginative reason" (140). Here the consummate faculty identified with Plato and Arnold turns out as well to be Ruskin's theoria, defined in the second volume of *Modern Painters* as the highest form of imagination. Thus, above all, Pater's interpretation of Plato stresses the importance of the senses in his philosophy, and of his admiration for the arts. He is, in fact, "the earliest critic of the fine arts," who "anticipates the modern notion that art as such has no end but its own perfection,—'art for art's sake' " (268).

Pater's attitude toward Plato and Platonism can be distinguished from Ruskin's or Rossetti's, in that Pater's thought is always grounded in the actual, the transitory, and the visible, while Ruskin and Rossetti display clearer affinities to traditions of idealist thought. But *Plato and Platonism* offers a revisionist interpretation of its subject in order to place Pater firmly within Platonic tradition, in terms which define his position very close to that of Ruskin and Rossetti. Pater argues that the distinctive note of Platonic thought is apparent in its form. Plato concerns himself not just with the ideal, but with its apprehension, and with the translation of the ideal into the current of life. Pater insistently refuses to separate Platonic philosophy from the body of Plato's thought as an abstract, disembodied doctrine: "Platonic aesthetics, remember! as such, are ever in close connection with Plato's ethics. It is life itself, action and character, he proposes to colour, to get something of that irrepressible conscience of art, that spirit of control, into the general course of life, above all into its energetic or impassioned acts" (282).

That Plato's influence on Western thought has been decisive may be owing to the language with which he presents his ideas as much as to his philosophic system itself. For Plato treats philosophy as a fine art. The power of his thought depends on its consummate expression in finely wrought prose, in a kind of

poetry, and above all in the drama of dialogue. As an art form, dialogue possesses that perfect unity which Pater demands throughout his criticism. It forms itself around a central speaker, Socrates, whose living habit of mind makes this form of argument at once personal and objective. For Plato, Pater remarks, the "highest sort of knowledge," indeed all knowledge, was "like knowing a *person*. The Dialogue itself, being, as it is, the special creation of his literary art, becomes in his hands, and by his masterly conduct of it, like a single living person" (129). The emphasis on argument, on changes of thought, implies the "modern" belief that "philosophic truth depends on philosophic temper"—"it does but put one into a duly receptive attitude . . . it does not provide a proposition, nor a system of propositions, but forms a temper" (188).

The literature of art in Ruskin, Rossetti, and Pater consistently strives for a fusion of the ideal and the real. Thus, in their utopian biography they depict lives in which aesthetic harmony becomes a governing personal trait. *Plato and Platonism* associates this achievement not so much with Plato himself as with Socrates, his spokesman and philosophic mask. His role is that of an "imaginary portrait" within Plato's dialogues, an embodiment of the human meaning of Platonic thought. Not only does Socrates express the living quality of Platonic idealism, but he also dramatizes the necessity of fully embracing Platonism, as a philosophy which addresses not just the reason but the entire being. "For we judge truth," Pater explains, "not by the intellect exclusively . . . but with the whole complex man" (88).

Pater locates the quintessential Socrates not in a debate but in the most intimate scene recorded by his biographer. His perfection of temperament displays itself most dramatically in precisely the sort of tragic moment narrated at the close of *The Renaissance*. It is the interlude in *Phaedo* before the death of Socrates, when "in the privacy of his last hours" he considers the possible existence of another world. No issue could more directly test the extent of Plato's idealism, and Socrates, in fact, as he addresses his disciples for the last time, affirms the likelihood of existence "in Hades." As Pater explains, "the formula of probability could not have been more aptly put" (95). "Probability," in Pater's relativistic world-view, is the closest approach to religious conviction that most serious modern thinkers can hope to achieve.[12] The use of the term implies that Socrates, in this final moment, embodies a religious as well as a philosophical

ideal. But even in this scene, Pater's concern with what he also calls "the great possibility" of an afterlife is balanced, perhaps even overbalanced, by a fascination with the mode in which it is conceived. With evident delight he stresses the fact that such "vision" has two aspects. Its dualism is quite clearly the same as that I have traced through Ruskin and Rossetti, the necessity of grounding the spiritual in material form: "Socrates too, even Socrates, who had always turned away so persistently from what he had thought the vanity of the eye, just before the bodily eye finally closes, and his last moment being now at hand, ascends to, or declines upon, the fancy of a quite visible paradise awaiting him" (96).

Pater does not merely report this final scene but includes an extensive quotation from Plato of Socrates speculating on that "visible paradise." Socrates' vision under the shadow of death comprises the most exquisite display of aesthetic temperament in Pater: his momentary victory over death is one of the finest passages of Pater's utopian biography. In his speech Socrates imagines the earth as seen from the heavens. Pater may introduce it to remind us of Ruskin's airborne utopian vision of the earth in "The Nature of Gothic"—and Ruskin's description may have been modeled on this passage as well. Socrates explains: "It is said that the world, if one gaze down upon it from above, is to look on like those leathern balls of twelve pieces, variegated in divers colours, of which the colours here—those our painters use—are as it were samples. There, the whole world is formed of such, and far brighter and purer than they; part sea-purple of a wonderful beauty; a part like gold; a part whiter than alabaster or snow; aye, composed thus of other colours of like quality, of greater loveliness than ours—colours we have never seen." Mountains and rocks in the afterlife "have a smoothness and transparency and colours lovelier than here." Seasons blend, producing a race without sickness, living to "years more numerous far than ours," while "for sight and scent and hearing and the like they stand as far from us, as air from water, in respect of purity, and the aether from air. There are thrones moreover and temples of the gods among them, wherein in very deed the gods abide; voices and oracles and sensible apprehensions of them; and occasions of intercourse with their very selves. The sun, the moon and the stars they see as they really are" (96–97). This is a synaesthetic heaven, a veritable paradise of all the values celebrated in the literature of art. As if to affirm

that tradition through reference to an ultimate authority, Pater treats this description by Socrates as an aesthetic vision rather than as a metaphysical speculation. He comments on the difference between its vividness of apprehension and the total commitment to idealism that is usually ascribed to Plato: "The great assertor of the abstract, the impalpable, the unseen, at any cost, shows there a mastery of visual expression equal to that of his greatest disciple.—Ah, good master! was the eye so contemptible an organ of knowledge after all?" (97). This question seems to address all the "masters" of philosophic and ethical tradition whom Ruskin, Rossetti, and Pater modify through the century. Socrates' vision forms a final and perhaps ultimate recapitulation of their insistence on the primacy of vision, of the aesthetic sense. For the last time Pater uses the past to reassert the validity of art and to make the largest possible claim for his aesthetic ideal.

*Notes*

*Index*

# Notes

## 1. Introduction

1. Oscar Wilde, "Pen, Pencil, and Poison," January 1889, in *The Artist As Critic: Critical Writings of Oscar Wilde*, ed. Richard Ellmann (New York, Vintage, 1970), p. 328.

2. *Appreciations*, pp. 15–16.

3. *Appreciations*, p. 15.

4. Yeats's phrase appears in "Coole Park and Ballylee, 1931" and is applied to this entire aesthetic tradition in Graham Hough, *The Last Romantics* (New York, Barnes and Noble, 1961).

5. Jean Hagstrum, *The Sister Arts: The Tradition of Literary Pictorialism and English Poetry from Dryden to Gray* (Chicago, University of Chicago Press, 1958), p. 129.

6. I. A. Richards outlines his aesthetics in *Principles of Literary Criticism* (New York, Harcourt, Brace, and World, n.d.), esp. pp. 228–238.

7. John Holloway, *The Victorian Sage: Studies in Argument* (New York, Norton, 1965), pp. 10–11.

8. Oswald Doughty, *Dante Gabriel Rossetti: A Victorian Romantic* (New Haven, Yale University Press, 1960).

9. M. H. Abrams, *The Mirror and the Lamp: Romantic Theory and the Critical Tradition* (New York, Norton, 1958), p. 329.

10. For the intellectual background to Ruskin's criticism, see George

Landow, *The Aesthetic and Critical Theories of John Ruskin* (Princeton, Princeton University Press, 1971).

11. Abrams, *The Mirror and the Lamp*, p. 25.

12. G. Robert Stange, "Art Criticism As a Prose Genre," in *The Art of Victorian Prose*, ed. George Levine and William Madden (New York, Oxford University Press, 1968), p. 50.

13. R. P. Blackmur, "D. H. Lawrence and Expressive Form," in *Form and Value in Modern Poetry* (New York, Anchor, 1957), pp. 256, 254.

14. Blackmur, "D. H. Lawrence," pp. 261–262.

15. Stange, "Art Criticism As a Prose Genre," pp. 51–52.

16. Jack Lindsay also identifies the fusion of space and time as one characteristic of the painter's genius, particularly in "The Slave Ship" and more generally in his work of the late 1830s and the 1840s. Lindsay, *J.M.W. Turner: A Critical Biography* (Greenwich, New York Graphic Society, 1966), pp. 189, 201–202. Turner's poem "Slavers Throwing Overboard the Dead and Dying—Typhon Coming On" (supposedly taken from the longer manuscript titled "The Fallacies of Hope"), which he meant to accompany his painting, contradicts Ruskin's assumption that the picture records the aftermath of a storm:

> Aloft all hands, strike the top-masts and belay;
> Yon angry setting sun and fierce-edged clouds
>   Declare the Typhon's coming.
>   Before it sweeps your decks, throw overboard
>   The dead and dying—ne'er heed their chains.
>   Hope, Hope, fallacious Hope!
>   Where is thy market now?

*The Sunset Ship: The Poems of J.M.W. Turner*, ed. Jack Lindsay (London, Scorpion, 1966), no. 21, p. 86.

17. Emile Durkheim, *The Elementary Forms of the Religious Life* (London, 1912), quoted in Edmund Leach, "Ritual," in *The International Encyclopedia of the Social Sciences* (New York, Macmillan and Free Press, 1968), XIII, 521.

18. Although art historians now attribute the "Fête Champêtre" mainly, if not entirely, to Titian, I follow nineteenth century practice in discussing it as a picture by Giorgione. The first version of the sonnet on the "Venetian Pastoral," which appeared in *The Germ*, reads:

> Water, for anguish of the solstice,—yea,
>   Over the vessel's mouth still widening
>   Listlessly dipt to let the water in
> With slow vague gurgle. Blue, and deep away
> The heat lies silent at the brink of day.

Now the hand trails upon the viol-string
That sobs, and the brown faces cease to sing,
Mournful with complete pleasure. Her eyes stray
In distance; through her lips the pipe doth creep
  And leaves them pouting; the green shadowed grass
    Is cool against her naked flesh. Let be:
Do not now speak unto her lest she weep,—
  Nor name this ever. Be it as it was:—
    Silence of heat, and solemn poetry.

See the fourth number of *The Germ*, which was then titled *Art and Poetry: Being Thoughts Towards Nature Conducted Principally by Artists* (May 1850, reprinted Portland, Me., 1898), p. 181.
19. The final lines may also refer to the second figure, the nude woman with recorder, and to whatever it is toward which her eyes stray. But this possibility only reinforces our relation as viewers to the meaning of the picture and to the nature of the action it depicts.
20. Max Beerbohm, *Works* (London, 1895), p. 150.
21. Mario Praz, *The Romantic Agony* (New York, Meridian, 1956).
22. Ian Fletcher, *Walter Pater* (London, British Council, 1959), pp. 6–7.
23. Frank Kermode, *Romantic Image* (New York, Vintage, 1964), p. 62.
24. Leach, "Ritual," pp. 526, 522.
25. V. W. Turner, *The Ritual Process: Structure and Anti-Structure* (Chicago, Aldine, 1969), p. 133.
26. Turner, *The Ritual Process*, pp. 167, 103.
27. Fritz Saxl, *Lectures* (London, Warburg, 1957), I, 215–227, esp. pp. 215–218; Lawrence Lipking, *The Ordering of the Arts in Eighteenth-Century England* (Princeton, Princeton University Press, 1970), p. 472.
28. See John Rosenberg, *The Darkening Glass: A Portrait of Ruskin's Genius* (New York, Columbia, 1961), pp. 131–132.

2. The Two Landscapes of *Modern Painters*

1. Rosenberg, *The Darkening Glass*, p. 11.
2. Hough, *The Last Romantics*, p. 12.
3. Alexis François Rio, *De la poesie crétienne, dans son principe, dans sa matière, et dans ses formes* (Paris, 1836)—Ruskin did not read this until 1844–1845; Lord Lindsay, *Sketches for a History of Christian Art* (London, 1847).
4. M. H. Abrams, *Natural Supernaturalism: Tradition and Revolution in Romantic Literature* (New York, Norton, 1971), p. 187.

5. *The Poetical Works of William Wordsworth,* ed. Thomas Hutchinson and Ernest de Selincourt, rev. ed. (Oxford, Oxford University Press, 1964), p. 735.

6. For Ruskin's periods of mental exhaustion in relation to his views on religion, nature, and art, see Rosenberg, *The Darkening Glass,* pp. 30–41; Frances G. Townsend, *Ruskin and the Landscape Feeling: A Critical Analysis of His Thought During the Crucial Years of His Life, 1843–65,* Illinois Studies in Language and Literature, vol. 35, no. 3 (Urbana, University of Illinois Press, 1951). R. H. Wilenski, *John Ruskin: An Introduction to Further Study of His Life and Work* (London, Faber and Faber, 1933), analyzes related manic-depressive patterns running throughout Ruskin's life.

7. In 1874 Ruskin wrote that "myriads of people have been wrong by reading *Modern Painters.* But that is because they pick out the bits they like" (XXXVII, 84).

8. Van Aiken Burd, "Another Light on the Writing of *Modern Painters,*" *PMLA* 68 (September 1953): 763. Burd analyzes Ruskin's creation of a Wordsworthian self-image for the writer of *Modern Painters* in the pages of *Praeterita.*

9. Basil Willey, *The Eighteenth Century Background* (Boston, Beacon Press, 1961), p. 5. M. H. Abrams points out Wordsworth's belief that "poetry . . . incorporates . . . the narrower 'knowledge' of science." Abrams, *The Mirror and the Lamp,* p. 309.

10. Humphrey House, *All in Due Time* (London, Rupert Hart-Davis, 1955), p. 144.

11. The "Lake of Zug" is one of three plates added in the 1888 edition of *Modern Painters,* all of which were etched by Ruskin in 1859 for *Modern Painters V* but were never included (VII, lxix).

12. Jerome H. Buckley, *The Victorian Temper* (New York, Vintage, n.d.), ch. 8, "The Moral Aesthetic" (dealing mainly with Ruskin), pp. 143–160.

13. Landow, *The Aesthetic and Critical Theories of John Ruskin,* p. 157.

14. T. S. Eliot, *Selected Essays* (New York, Harcourt, Brace, and World, 1960), p. 248. For the nineteenth century tradition of attacking "dissociation of sensibility," see Kermode, *Romantic Image,* pp. 138–161.

15. Landow, *The Aesthetical and Critical Theories of John Ruskin,* p. 387.

### 3. Venice: The Drama of Architecture

1. Rogers himself is more than slightly indebted to Byron. The fourth canto of "Childe Harold's Pilgrimage" describes Venice as both

miraculous and majestic, and at several points laments her "fall." In *Fiction, Fair and Foul,* Ruskin observes that the "fall of Venice . . . was measured by Byron in a single line," although the passage he quotes refers to the decline of the city's political independence (XXXIV, 360).

2. After "Juliet and Her Hurse," Turner continued to paint Venice, but with decreasing emphasis on architecture and detail and increasing attention to atmosphere, water, and the brilliant effects of light.

3. See Kenneth Clark, *The Gothic Revival,* rev. ed. (London, Pelican, 1964), p. 177.

4. Rosenberg, *The Darkening Glass,* pp. 50–52.

5. See e.g. Landow, *The Aesthetic and Critical Theories of John Ruskin,* pp. 440–441; Lindsay, *Turner, passim.*

6. Clark, *The Gothic Revival,* pp. 128–133. For the influence of Pugin and the tradition of "contrasts" between past and present, see also Raymond Williams, *Culture and Society, 1780–1950* (New York, Harper, 1958), pp. 130–148.

7. *Ruskin's Letters from Venice, 1851–1852,* ed. John Lewis Bradley, Yale Studies in English, vol. 129 (New Haven, Yale University Press, 1955), p. 40.

8. Rosenberg, *The Darkening Glass,* ch. 3, pp. 47–63.

9. Rosenberg, *The Darkening Glass,* pp. 71–78, points out and discusses the relation between Ruskin and Frank Lloyd Wright.

10. The aerial map may originate in a suggestion of Byron in a note to his own image of the city as Cybele in "Childe Harold" (IV, ii): "Sabellicus, describing the appearance of Venice, made use of the above image, which would not be poetical were it not true . . . 'And hence it is that whoso regard the City from above, as from a watch tower or loftier eminence, might fancy that he beheld a towery counterfeit of Mother Earth erected in midmost Ocean.' " Byron also describes Venice with the metaphor of the throne, which Ruskin adopts for a chapter title and which is implicit in the aerial view of the city as the ruling seat of the Adriatic.

11. Wolfgang Kayser, *The Grotesque in Art and Literature* (Bloomington, Indiana University Press, 1963).

12. Only the "visible commencement" of the fall occurs in 1423. Ruskin dates the actual beginning slightly earlier, at the death of Carlo Zeno on May 8, 1418. Richard Ellmann speculates on a psychic meaning of this specific date: it "was, putatively, four hundred years to the day before his own conception . . . That the moment of Venice's fall should be reiterated in the moment of his own begetting and be followed by his birth into an England only too ready . . . to fall . . . anchored firmly the relationships Ruskin wished to dwell upon. In his parents' fall, as in that of our first parents, he saw the determination of an age's character and of his own." Ellmann,

"Overtures to *Salome*," in *Oscar Wilde: A Collection of Critical Essays*, ed. Richard Ellmann (Englewood Cliffs, Prentice-Hall, 1969), p. 81.

13. Ruskin first discovered the metaphor of Venice as a festive hall in "Childe Harold" (IV, iii):

> Those days are gone—but Beauty still is here,
> States fall—Arts fade—but Nature doth not die,
> Nor yet forget how Venice once was dear,
> The pleasant place of all festivity,
> The Revel of the earth—the Masque of Italy.

Here Ruskin alludes to Byron only to refute his moral assumptions. As Ruskin remarked earlier, "She became in after times the revel of the earth, the masque of Italy; and *therefore* is she now desolate" (X, 177).

### 4. The Literature of Pre-Raphaelitism

1. Herbert Sussman notes Ruskin's dual influence in "Hunt, Ruskin, and the Scapegoat," *Victorian Studies*, 12, no. 1 (September 1968): 83–90. He also analyzes the relation between symbolism and naturalism in Holman-Hunt's art and in Ruskin's theory.

2. *Dante Gabriel Rossetti: His Family Letters, with a Memoir*, ed. William Michael Rossetti (London, 1895), I, 125.

3. William Holman-Hunt, *Pre-Raphaelitism and the Pre-Raphaelite Brotherhood* (New York, Macmillan, 1914), I, 91.

4. Holman-Hunt, *Pre-Raphaelitism*, I, 91–93.

5. The closest Ruskin comes to a recognition of these affinities is his suggestion in *Modern Painters III* that in the art of Turner, Watts, and Rossetti—as once in the art of Blake—there may be the beginning of a new modern school producing a "true union of the grotesque with the realistic power" (V, 137–138).

6. Harold Rosenberg discusses the importance of shock in revolutionary art-movements in *The Tradition of the New* (New York, Grove, 1961). His epigraph is taken from Carlyle: "There is a deeplying struggle in the whole fabric of society; a boundless grinding collision of the New with the Old."

7. By contrast, Holman-Hunt's monumental survey *Pre-Raphaelitism and the Pre-Raphaelite Brotherhood* (New York, Macmillan, 1914), 2 vols., published fifty years after *The Germ*, depends on the clarity of hindsight and the author's desire to explain the Brotherhood in terms of his own ideas. Although the title suggests a history, the book is closer to autobiography.

8. J. L. Tupper, "The Subject in Art," *The Germ* (Portland, 1898), p. 18.

9. *The Germ*, p. 71.

10. Hough, *The Last Romantics*, p. 54.

11. *The Germ* was first subtitled *Thoughts Towards Nature in Poetry, Literature and Art*. After two issues the title became *Art and Poetry, Being Thoughts Towards Nature, Conducted Principally by Artists*.

12. *The Letters of Dante Gabriel Rossetti*, ed. Oswald Doughty and J. R. Wahl (Oxford, Oxford University Press, 1965, 1967), II, 727. For the fullest treatment of Rossetti's concept of woman, see David Sondstroem, *Rossetti and the Fair Lady* (Middletown, Wesleyan University Press, 1970). Although Sondstroem stresses the divisions between Rossetti's ideal and fallen women, he recognizes the potential for women to appear as a symbol in the Paterean sense: "In *The House of Life* Rossetti treats the lady as a micro-heaven, in whom may be discerned the answer to all ultimate mysteries" (p. 141).

13. Hough, *The Last Romantics*, p. 51.

5. Painting and Poetic Form

1. See Rossetti, "The Stealthy School of Criticism" (in response to Robert Buchanan's "The Fleshly School of Poetry"), *Works*, I, 481–482, originally published in the *Athenaeum* in 1871.

2. H. Marshall McLuhan, "Tennyson and Picturesque Poetry," *Essays in Criticism* 1 (1951): 262–282; William Michael Rossetti, quoted in *The House of Life*, ed. Paull F. Baum (Cambridge, Harvard University Press, 1928), p. 84.

3. Mario Praz, *Mnemosyne: The Parallel Between Literature and the Visual Arts* (Princeton, Princeton University Press, 1970), p. 159 and *passim*.

4. See Alastair Grieve, "The Applied Art of D. G. Rossetti: I. His Picture Frames," *The Burlington Magazine*, January 1973, pp. 16–24.

5. For the division of the painting, see Wendell Stacy Johnson, "D. G. Rossetti: Painter and Poet," *Victorian Poetry* 3 (Winter 1965), 15.

6. See John Christian, "Early German Sources for Pre-Raphaelite Designs," *Art Quarterly*, Summer 1973, pp. 56–83. He stresses the impact of Dürer, whose prints were popularized largely through the efforts of Ruskin.

7. As G. H. Fleming notes, "Each picture is overbrimming with vitality, and each shows a fine feeling for nature, in everything from the expressions and gestures of the human and angelic beings to the garments, buildings, and trees. Neither scene contains one center of interest, and it does not appear that more attention was devoted to the principal figures than to secondary detail." Fleming, *Rossetti and*

*the Pre-Raphaelite Brotherhood* (London, Rupert Hart-Davis, 1967), p. 64.

8. I am indebted to Professor L. D. Ettlinger for this observation, which he made in a lecture on "The Portrait of the Artist As Artist."

9. Sondstroem, *Rossetti*, p. 5.

10. Holman-Hunt, *Pre-Raphaelitism* I, 91, complains about the "immature perspective" in the Campo Santo frescoes, an aspect of primitive art to which Rossetti responds with sympathy.

11. *The Letters of Dante Gabriel Rossetti*, I, 126 (14 January 1853), 120 (1, 8 January 1953).

12. Alastair Grieve, "Whistler and the Pre-Raphaelites," *Art Quarterly*, Summer 1971, pp. 219–224, discusses this relationship and quotes in part the letter, which also appears in Virginia Surtees, *Dante Gabriel Rossetti, 1828–1882, The Paintings and Drawings: A Catalogue Raisonée*, 2 vols. (Oxford, Oxford University Press, 1971), I, 14.

✓ 13. Harold Weatherby, "Problems of Form and Content in the Poetry of Dante Gabriel Rossetti," *Victorian Poetry* 2 (Winter 1964): 11–19.

14. See e.g. *The House of Life*, pp. 212–214.

15. Masao Miyoshi objects to "Heart's Hope" on these grounds in *The Divided Self: A Perspective on the Literature of the Victorians* (New York, New York University Press, 1969), p. 253.

16. Weatherby, "Problems of Form and Content," p. 19.

17. See Doughty, *A Victorian Romantic*, p. 618; *The Letters of Dante Gabriel Rossetti*, III, 985–986. Doughty underrates the formal significance of the term, interpreting it as an excuse, developed late in Rossetti's career, for declining poetic powers: "what he used to call 'inspiration,' was now largely absent from his work" (p. 619).

18. Quoted in Doughty, *A Victorian Romantic*, p. 475.

19. *The Letters of Dante Gabriel Rossetti*, II, 750. "The pouring forth of poetical material is the greatest danger with which an affluent imagination has to contend, and in my own view it needs not only a concrete form of some kind, but immense concentration brought to bear on that also, before material can be said to have become absolutely anything else" (II, 914).

20. William Fredeman, "Rossetti's 'In Memoriam': An Elegiac Reading of *The House of Life*," *Bulletin of the John Rylands Memorial Library* 47 (March 1965): 308–310.

21. *The House of Life*, pp. 187–188.

✓ 22. Houston A. Baker, Jr., "The Poet's Progress: Rossetti's *The House of Life*," *Victorian Poetry*, 1970, pp. 1–14; *The Letters of Dante Gabriel Rossetti*, II, 850.

23. Hough, *The Last Romantics*, p. 50; Oswald Doughty, "Rossetti's Concept of the 'Poetic' in Poetry and Painting," *Essays by Divers Hands, Transactions of the Royal Society of Literature* (London,

1953), p. 98. For Rossetti's description, see *The Letters of Dante Gabriel Rossetti*, II, 499.

24. My view is close to that of James G. Nelson, "Aesthetic Experience in 'My Sister's Sleep,' " *Victorian Poetry* 7, no. 2 (Summer 1969): 154–158. For another approach, see Herbert Sussman, "Rossetti's Changing Style: The Revisions of 'My Sister's Sleep,' " *Victorian Newsletter*, Spring 1972, pp. 6–8. Sussman argues that there is an essential change in the spirit of Rossetti's verse between the period of *The Germ*, when the poem was first published, and 1870, when Rossetti's *Poems* appeared. He shows that a number of specifically religious passages were removed in the revised poem, which shifts its emphasis from "a figural or typological symbolism" to a "wholly secular, purely psychological moment" (p. 8). In fact, both versions of the poem dramatize the interdependence of two kinds of perception for a full understanding of the nature of life. In this sense, the realized "psychological moment" is at the center of each.

25. *The Letters of Dante Gabriel Rossetti*, I, 69 (8 October 1849), 68n.

26. Graham Hough, *Image and Experience: Studies in a Literary Revolution* (Lincoln, University of Nebraska Press, 1962), pp. 17, 19.

## 6. History As Fiction in *The Renaissance*

1. See John Pick, "Divergent Disciples of Walter Pater," *Thought* 13 (March 1948): 114–128.

2. *The Autobiography of William Butler Yeats* (New York, Collier 1958), p. 87.

3. *The Letters of Oscar Wilde*, ed. Rupert Hart-Davis (London, Rupert Hart-Davis, 1962), p. 476.

4. Gordon McKenzie, *The Literary Character of Walter Pater* (Berkeley and Los Angeles, University of California Press, 1967).

5. For support of the conjecture that "The School of Giorgione" was written in 1873, see *The Letters of Walter Pater*, ed. Lawrence Evans (Oxford, Oxford University Press, 1970), pp. 7–8.

6. T. S. Eliot, "Arnold and Pater," *Selected Essays*, p. 390.

7. Hough, *The Last Romantics*, p. 165.

8. Ian Fletcher, *Walter Pater*, rev. ed. (London, British Council, 1971), p. 14.

9. Anthony Ward, *Walter Pater: The Idea in Nature* (London, Macgibbon and Kee, 1966).

10. See Richard L. Stein, "The Private Themes of Pater's *Renaissance*," in *Psychoanalysis and Literary Process*, ed. Frederic Crews (Cambridge, Winthrop, 1970), pp. 163–218.

11. See Sigmund Freud, "Leonardo da Vinci and a Memory of His Childhood," *The Standard Edition of the Complete Psychological*

Works of Sigmund Freud, ed. James Strachey et al., 24 vols. (London, Hogarth, 1953–1966), vol. XI.

12. The Poetical Works of Andrew Lang, 4 vols. (London, Longmans, Green, 1923), II, 138. Pater admired this translation.

13. Thomas Flanagan first suggested to me the Pater-Nietzsche relationship.

14. Ellmann, "Overtures to Salome," p. 86.

## 7. Imaginary Portraits and the New Moral Aesthetic

1. Pater to Violet Paget, in Edward Thomas, Walter Pater New York, Kennerley, 1913), p. 55, and in A. C. Benson, Walter Pater (New York, Macmillan, 1906), p. 90.

2. U. C. Knoepflmacher, Religious Humanism and the Victorian Novel: George Eliot, Walter Pater, and Samuel Butler (Princeton, Princeton University Press, 1965), p. 159.

3. Pater to George Grove, in reference to "The Child in the House," 17 April 1878, The Letters of Walter Pater, pp. 29–30.

4. Arthur Symons reports Pater's reply to a question about whether he was actually related to the painter Jean-Baptiste Pater: "I think so; I believe so; I always say so." Symons, A Study of Walter Pater (London, Charles Sawyer, Grafton House, 1932), p. 104.

5. For Apollonian and Dionysian patterns in Pater's writing, see Gerald Cornelius Monsman, Pater's Portraits: Mythic Patterns in the Fiction of Walter Pater (Baltimore, Johns Hopkins Press, 1967).

6. For Pater's relation to Newman, see David deLaura, Hebrew and Hellene in Victorian England (Austin, University of Texas Press, 1969).

7. Ruskin's earliest analysis of the relation between childhood and sensibility appears in one of the most famous chapters in Modern Painters, "The Two Boyhoods," which contrasts the developments of Giorgione and Turner.

8. Quoted in Thomas Wright, The Life of Walter Pater, 2 vols. (New York, Putnam, 1907), II, 87. Thomas Moore's The Epicurean (London, 1827) provides one model for the confrontation of Epicurean and Christian thought. Introduced to Christianity by a beautiful Egyptian maiden, Moore's hero, like Marius, is falsely imprisoned and nearly martyred for the faith he has not embraced; but the martyrdom of his beloved finally leads him to convert. The book has a special relation to the literature of art inasmuch as the edition of 1839 is illustrated by several Turner vignettes. Within Pater's oeuvre, furthermore, Marius was intended as the first volume in an aesthetic trilogy, including Gaston de Latour and a novel-length version of "The Child in the House," depicting the lives of ideally

sensitive Paterean heroes in the sixteenth and nineteenth centuries respectively.

9. *The Letters of Oscar Wilde*, p. 476. Another view of Marius' death is expressed by Lionel Johnson, a convert to Catholicism and a friend and "disciple" of Pater as well as a friend of Yeats: "Marius himself is not, in fact, converted, though his death was 'full of grace.' Yet the sweetness and the greatness of Christianity steal over him, as over the reader, as though the writer "willed" it almost without words; whilst it is through his austere delicacy in using them that the miracle is worked upon us." Johnson, "The Work of Mr. Pater," *Fortnightly Review* 56 (Sept. 1, 1894): 352–367.

10. The phrase comes from Rossetti's sonnet of the same name. Oswald Doughy uses it in his biography of Rossetti to account for the blend of fictional and autobiographical material throughout *The House of Life*. Doughty, *A Victorian Romantic*, p. 9. William Fredeman also observes that in *The House of Life* Rossetti "transfigured his own life, distilling the essences into a monument, which, though personal, may . . . be construed as universal." Fredeman, "Rossetti's *in Memoriam*," p. 334.

11. For the interpretation of dance as symbol by Symons and others, see Kermode, *Romantic Image*, pp. 49–91.

12. In a review of Mrs. Humphrey Ward's *Robert Elsmere*, published in "The Guardian" in March 1888, shortly after the publication of *Marius*, Peter writes: "Robert Elsmere was a type of a large class of minds which cannot be sure that the sacred story is true . . . But then there is a large class of minds which cannot be sure it is false —minds of many various degrees of conscientiousness and intellectual powers, up to the highest . . . For their part, they make allowance in their scheme of life for a great possibility, and with some of them that bare concession of possibility (the subject of it being what it is) becomes the most important fact in the world. The recognition of it straightway opens wide the door to hope and love; and such persons are, as we long they always will be, the nucleus of a Church . . . They knit themselves to believers, in various degrees, of all ages." Similar views and words appear in a review by Pater of Amiel's *Journal Intime*, which was published only a year after *Marius*. Pater is quoting Amiel: " 'Welcome the unforseen,' he says . . . by way of a counsel of perfection in the matter of culture, 'but give to your life unity, and bring the unforseen within the lines of your plan.' Bring we should add, the Great Possibility within the lines of your plan— your plan of action or production; or morality; especially of your conceptions of religion." Pater, *Essays from "The Guardian,"* pp. 67–68, 34–35.

# Index

Company), 32, 83, 96, 118, 285, 288, 289

Hagstrum, Jean, 3
Hake, Dr. Thomas G., 201–202
Harrison, Jane, 30–31
Hazlitt, William, 3, 39
Hegel, Georg Wilhelm Frederich, 252–253
Heine, Heinrich, 235, 244
Heraclitus, 225, 282. *See also* Pater, Walter: *The Renaissance*, "Conclusion"
Higher Criticism, 181
Holloway, John, 6
Holman-Hunt, William, 121, 122, 124, 125, 154, 170, 171, 177, 179, 181–182, 206, 304; "The Awakening Conscience," 125, 170, 182; "The Finding of Christ in the Temple," 181; "The Light of the World," 170, 171; *Pre-Raphaelitism and the Pre-Raphaelite Brotherhood*, 302; "The Scapegoat," 181; "The Strayed Sheep," 170, 171
Homer, 113; *Iliad*, 114
Homosexuality, 245, 253, 257, 258
Hopkins, Gerard Manly, 134
Hough, Graham, 38, 131, 154, 203, 231; *Image and Experience*, 209
House, Humphrey, 45
Hugo, Victor, 247–248, 255

Iconic poetry, 3, 7
Imagism, 10, 204, 209
Imitation, 38, 80
Imitative form. *See* Expressive form
Impersonality, 216–217
Impressionism, 41–42, 207, 209, 223, 224, 231, 233, 270, 278, 279–280
Ingres, Jean Auguste Dominique, "Roger Freeing Angelica," 114. *See also* Rossetti, Dante Gabriel: "For Ruggiero and Angelica"

James, Henry, 213, 225
Johnson, Lionel, 307
Johnson, Samuel, *Dictionary*, 4–5, 202
Jowett, Benjamin, 289
Joyce, James, 2, 213
Jung, Carl, 38

Keats, John, 3; "Ode on a Grecian Urn," 7, 23, 188; "Ode to a Nightingale," 8

Kelmscott Press, 33
Kermode, Frank, 26
Keyser, Wolfgang, 107
Kingsley, Charles, *Alton Locke*, 63

Lacedaemon. *See* Sparta
Lamb, Charles, 3, 39
Landor, Walter Savage, *Imaginary Conversations*, 263
Landow, George, 62, 64
Landscape instinct. *See* Ruskin, John: *Modern Painters*, vol. III
Lasinio, Carlo, 121, 178
Lawrence, D. H., 9–10
Leach, Edmund, 31
Leonardo da Vinci: "Mona Lisa," 23–30, 203, 231, 235, 236, 263; "St. Anne and the Virgin," 27; "Virgin of the Rocks," 132, 133. *See also* Pater, Walter: *The Renaissance*, "Leonardo da Vinci"; Rossetti, Dante Gabriel: "For the Virgin of the Rocks"
Lilith, 182
Lindsay, Alexander William Crawford, Lord, 39
Lipking, Lawrence, 32
Locke, John, 44

Maestre, Italy, 87, 89
*Manon Lascaut*, 266, 267
Mantegna, Andrea, "Parnassus," 135–136. *See also* Rossetti, Dante Gabriel: "For an Allegorical Dance of Women"
Maroutti, "Sappho," 203
Mary, 171, 182, 184
McLuhan, H. Marshall, 166
Memling, Hans, 205; "Marriage of St. Catherine," 134; "Virgin and Child," 133–134. *See also* Rossetti, Dante Gabriel: "For a Marriage of St. Catherine," "For a Virgin and Child, by Memling"
Mérimée, Prosper, 216. *See also* Pater, Walter: "Prosper Mérimée"
Milan, Italy, Duomo, 244
Millais, John Everett, 121, 124, 154; "The Blind Girl," 125; "Christ in the House of His Parents" or "The Carpenter's Shop," 179–181; "Ophelia," 171, 173
Milton, John, 55, 85
Mirror, 4–5, 202
Mocenigo, Thomaso, doge of Venice, 80, 95, 117